Americans in Paris

1860–1900

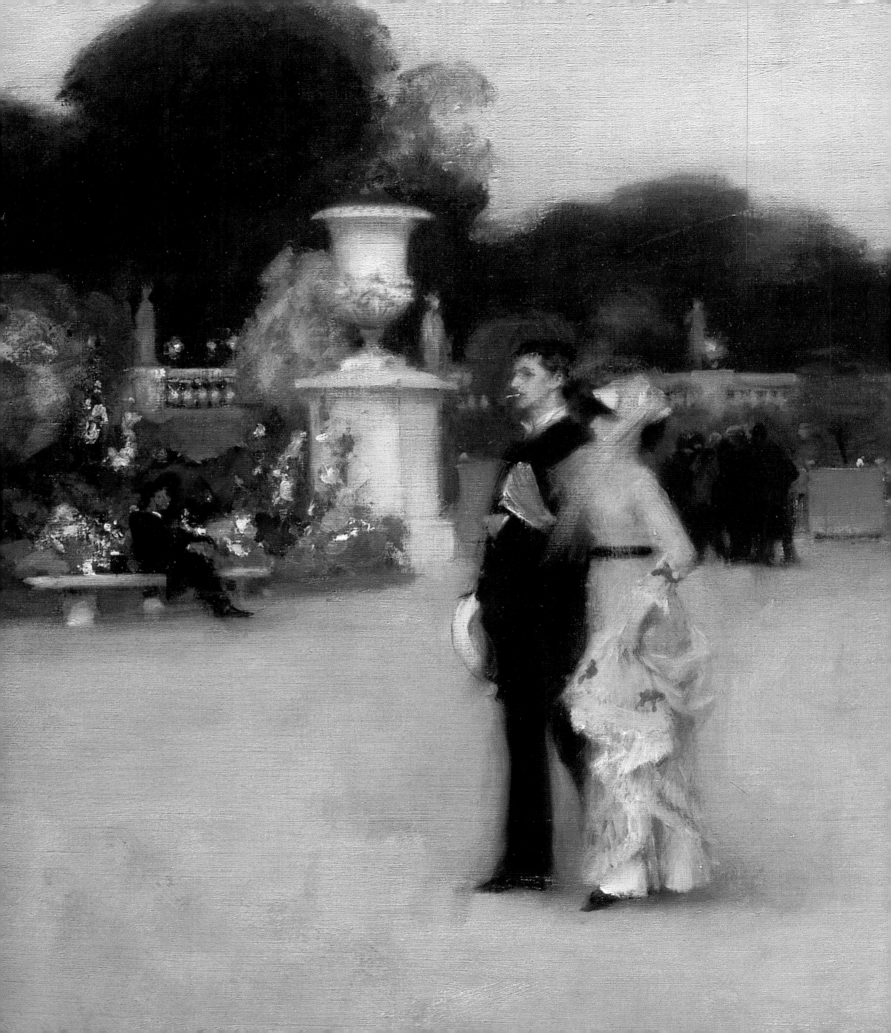

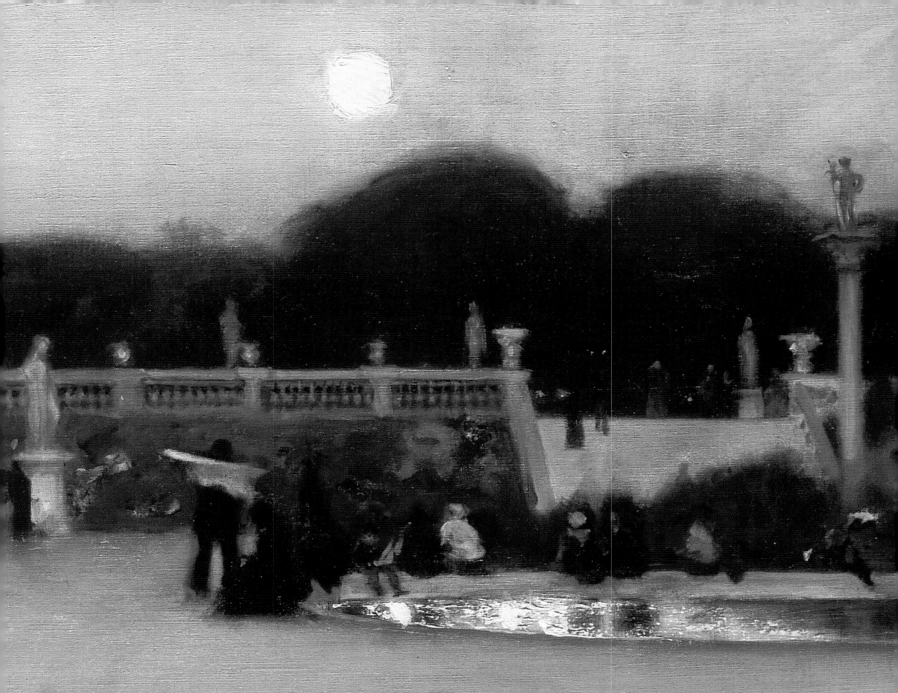

Americans in Paris
1860–1900

Kathleen Adler, Erica E. Hirshler, H. Barbara Weinberg
With contributions from David Park Curry, Rodolphe Rapetti and Christopher Riopelle
And with the assistance of Megan Holloway Fort and Kathleen Mrachek

Published to accompany the exhibition *Americans in Paris, 1860–1900*, at the National Gallery, London, 22 February – 21 May 2006, the Museum of Fine Arts, Boston, 25 June – 24 September 2006, and The Metropolitan Museum of Art, New York, 17 October 2006 – 28 January 2007

The exhibition in Boston and New York is made possible by Bank of America.

In New York, additional support has been provided by the Marguerite and Frank A. Cosgrove Jr. Fund.

The exhibition was organised by the National Gallery, London and the Museum of Fine Arts, Boston, in association with The Metropolitan Museum of Art, New York.

The exhibition is supported by an indemnity from the Federal Council on the Arts and the Humanities.

First published in Great Britain in 2006 by
National Gallery Company Limited
St Vincent House, 30 Orange Street
London WC2H 7HH

www.nationalgallery.co.uk

ISBN Hardback 1 85709 301 1
525477
ISBN Paperback 1 85709 306 2
525478

British Library Cataloguing in Publication Data
A catalogue record is available from the British Library

Library of Congress Catalog Card Number 2005928884

Publisher Kate Bell
Project manager Jan Green
Editor Jennifer Speake
Designers Libanus Press
Picture research Xenia Corcoran, Kim Klehmet,
 Rocio del Casar Ximenez and Tamsin Wright
Production Jane Hyne and Penny Le Tissier

Printed in Italy by Conti Tipocolor

Cover and page 178 (detail): John Singer Sargent, *Madame X (Madame Pierre Gautreau)*, 1883–4 (cat. 35)

Frontispiece: John Singer Sargent, *In the Luxembourg Gardens* (detail), 1879 (cat. 42)

Page 10: Jefferson David Chalfant, *Bouguereau's Atelier at the Académie Julian, Paris* (detail), 1891 (cat. 12)

Page 56: Charles Courtney Curran, *In the Luxembourg Garden* (detail), 1889 (cat. 28)

Page 114: John Singer Sargent, *Claude Monet painting by the Edge of a Wood* (detail), 1885 (cat. 71)

Page 190: Frederick Childe Hassam, *Allies Day, May 1917* (detail), 1917 (cat. 94)

Page 206: Mary Cassatt, *Portrait of Alexander J. Cassatt and his Son Robert Kelso Cassatt* (detail), 1884–5 (cat. 101)

Page 222: Charles Courtney Curran, *Afternoon in the Cluny Garden, Paris* (detail), 1889 (cat. 29)

Contents

Sponsor's Foreword

Museum of Fine Arts, Boston, June 25 – September 24, 2006
The Metropolitan Museum of Art, New York, October 17, 2006 – January 28, 2007

Bank of America is proud to be the United States sponsor of *Americans in Paris, 1860–1900.* This magnificent exhibition explores the magnetic appeal of the French capital to America's greatest painters, including Mary Cassatt, Thomas Eakins, John Singer Sargent, Winslow Homer and James McNeill Whistler.

The exhibition, which features more than one hundred paintings, traces the artists' attraction to Paris in the period following the American Civil War. American painters who were drawn to Paris created a new direction for their own nation's art. The exhibition enriches our appreciation of these artists' accomplishments and reveals a great deal about American cultural aspirations.

At Bank of America we strive for higher standards in everything we do for our customers, shareholders, associates and communities. It is therefore fitting that for this exhibition we are partnering with two of our country's – indeed the world's – greatest cultural institutions. By supporting this exhibition in two locations in the Northeast and enabling a longer United States run, we hope to create an extended viewing opportunity for all Americans who travel to these great cultural centers.

It is our hope that you will enjoy the opportunity to visit *Americans in Paris, 1860–1900* in either New York or Boston.

KENNETH D. LEWIS
Chairman and Chief Executive Officer

Bank of America

Directors' Foreword

Americans in Paris, 1860–1900 is the result of a partnership between the National Gallery, London, and the Museum of Fine Arts, Boston, in association with The Metropolitan Museum of Art, New York; a collaboration which enables us to explore in depth the relationship between the Old and New Worlds, the traditions of European painting and the study, practice and ambition of artists from the United States. The National Gallery has an outstanding collection of western European painting from the mid-twelfth century to the end of the nineteenth, but its holdings of American painting are limited to just two works: George Inness's *Delaware Water Gap* and, more obviously at home in London, John Singer Sargent's imposing portrait of Lord Ribblesdale, a trustee of the Gallery from 1909 until 1925. This exhibition allows audiences in London to experience some of America's masterpieces, and visitors in Boston and New York to consider their compatriots' achievements in a cosmopolitan context. The three-way discussion and development of the project has been rewarding and stimulating for all three institutions. The London partner, although bringing nothing to the table in terms of exhibits, has never been made to feel like a poor relation. Spectacular loans from both Boston and New York ensure that the public will see the very best of American painting. Notably, Sargent's large and extraordinary portrait of the four daughters of Edward Darley Boit travels across the Atlantic, while *Madame X* is a star wherever she goes. We are grateful to many museums, galleries and private collectors both in the United States and in Europe. Their generosity has ensured that we are able to show the diversity and depth of response of artists for whom Paris was such a magnet. Several institutions – the Fine Arts Museums of San Francisco, the National Gallery of Art in Washington, the Pennsylvania Academy of the Fine Arts, the Philadelphia Museum of Art and the Terra Foundation for American Art – have honoured our exhibition with multiple loans and we are truly indebted to them for their strong support. We are particularly grateful for the Musée d'Orsay's loan of Whistler's portrait of his mother, *Arrangement in Grey and Black, No. 1*, today the most famous American in Paris, to the show's first two venues.

As we see here, American artists in Paris explored a range of different styles and practices, from the most academic and traditional to the radical experiments of Mary Cassatt, the only American invited to show with the Impressionists. We follow the artists as they sought to prove themselves through their experience of Paris, adapting to French methods of instruction, struggling with the rigours of the teaching and exhibition systems and, finally, returning to the United States to develop new approaches both to the representation of their own country and to the challenge of making their reputations at home.

For the exhibition's selection, breadth and vision we owe thanks to its curators: Kathleen Adler, for the National Gallery, and Erica E. Hirshler, for the Museum of Fine Arts, with H. Barbara Weinberg for The Metropolitan Museum of Art. They are ably supported in the catalogue by their fellow authors, David Park Curry, Rodolphe Rapetti and Christopher Riopelle.

The National Gallery is deeply grateful to Rothschild for making this exhibition possible in London. The Museum of Fine Arts, Boston and The Metropolitan Museum of Art, New York offer profound thanks to Bank of America for its generous sponsorship in the United States. We remain indebted to the Federal Council on the Arts and the Humanities for their crucial assistance. The Metropolitan Museum would also like to thank the Marguerite and Frank A. Cosgrove Jr. Fund for their support.

CHARLES SAUMAREZ SMITH *Director, The National Gallery, London*
MALCOLM ROGERS *Ann and Graham Gund Director, The Museum of Fine Arts, Boston*
PHILIPPE DE MONTEBELLO *Director, The Metropolitan Museum of Art, New York*

Acknowledgements

An exhibition such as this, shown in three venues, on both sides of the Atlantic, is the result of an extraordinary collaboration between institutions and individuals at every level, and is planned over a very long period. The inspiration for it came from Michael Wilson, former Head of Exhibitions at the National Gallery, who first suggested the idea, which was greeted with enthusiasm at every turn. The authors are particularly thankful to the many lenders, both public and private, whose generosity has made the exhibition possible. We are enormously grateful to our sponsors, Rothschild, in London, Bank of America, in Boston and New York, and the Marguerite and Frank A. Cosgrove Jr. Fund, in New York, for their support for this ambitious undertaking.

Since we began this project, we have lost three dear friends, Ann Barwick and Raymond and Margaret Horowitz. All were dedicated to searching out the best in American paintings of this period, and we hope that in some small way our exhibition and this book celebrate their perspicacious vision. David Park Curry, Rodolphe Rapetti and Christopher Riopelle have encouraged us with their cosmopolitan expertise and expanded our topic with their insightful essays.

Kathleen Adler is grateful to the J. Paul Getty Museum, Los Angeles, for a term as a Museum Scholar, and to the assistance there of Christopher Bedford. She would like to thank Adam Gopnik, for his wonderful writing on Americans and Paris; her son Daniel Jones, for his support and his comments on her essay; her sister Sue Adler; David Katz; National Gallery Education for their patience; and above all, her co-curator Erica Hirshler, whose company and conversation, often revolving round food, during the course of researching the exhibition, was always stimulating and encouraging. The contribution made by Barbara Weinberg at The Metropolitan Museum of Art cannot be overestimated.

Erica Hirshler thanks her husband Harry Clark for his unbridled enthusiasm for research trips to Paris and for his devotion, support and patience. The experience of working with such gifted, generous and genial colleagues has been a real joy, and special gratitude is due to Kathy Adler, for her vision and discipline, and to Barbara Weinberg, for her intellect and passion. At the Museum of Fine Arts, Boston, we are obliged to Malcolm Rogers for his enthusiasm for the project from its inception. Katie Getchell and Jennifer Bose were steadfast advocates, and Elliot Bostwick Davis encouraged us to reach deeply into the MFA's collection. Conservators Rhona Macbeth, Jean Woodward, Andrew Haines and Gary Rattigan made things look their best. George T. M. Shackelford has been a good friend, advisor, editor and negotiator par excellence for this exhibition, and we are profoundly indebted to him for employing his expertise on our behalf. Katy Mrachek has been a devoted researcher, writer and administrator, and we are truly grateful to her.

H. Barbara Weinberg notes with gratitude the stimulating collaboration she has enjoyed with Kathleen Adler and Erica E. Hirshler in preparing the exhibition and thanks the colleagues who contributed to its success at the Metropolitan. Among the many who deserve mention are Philippe de Montebello, who recognised the importance of the lure of Paris to American artists and encouraged us, as did Emily Kernan Rafferty and Doralynn Pines. Mahrukh Tarapor coordinated preparations with help from Martha Deese, Linda M. Sylling, and Rebecca Noonan Murray. Dorothy Mahon cared for our own paintings and our valued loans. In The American Wing, Morrison H. Heckscher offered advice and Thayer Tolles shared her knowledge of sculpture. Megan Holloway Fort, a talented researcher and writer for this publication, also handled innumerable organisational tasks, along with Elizabeth Athens. Finally, Michael B. Weinberg provided constant support and invaluable counsel throughout the project.

Almost every department at each of the participating venues has contributed to the successful implementation of the show, while the National Gallery Company has worked closely with us throughout to realise this handsome catalogue. We also thank the following friends and colleagues: Warren Adelson, Rosayn D. Anderson, Danielle Archibald, Julie Aronson, Ramona Austin, Elaine Rice Bachmann, Katie Banser, James Barter, Judith A. Barter, Lorien Bianchi, Jonathan Boos, Katherine Bourguignon, Martine Bozon, Elaine Bradson, Timothy Anglin Burgard, Gary Burnett, Teresa A. Carbone, Sarah Cash, Alan Chong, Trinkett Clark, Erin Budis Coe, Clint Coller, Janet Comey, Philip Conisbee, Margaret C. Conrads, Helen A. Cooper, Keith Crippen, Deanna D. Cross, Deborah Davis, Rob Davis, Kirk Delman, Nina McN. Diefenbach, Shauna Doyle, Amélie Dubois, Claudia Einecke, Eleanor of Tappahannock, Sean Farrell, Susan Faxon, Linda Ferber, Kathleen A. Foster, Marsha Gallagher, Barbara Dayer Gallati, William H. Gerdts, Kelly Gifford, Derek Gillman, Elizabeth Glassman, Kerry Greaves, Randi Jean Greenberg, Dawn Griffin, John Hagan, Jonathan P. Harding, Kathleen Harleman, Jefferson Harrison, William R. Harvey, Harold Holzer, Mary Lou Hultgren, Ted James, Sona Johnston, Paige Johnston, Franklin Kelly, Elizabeth Kennedy, Peter M. Kenny, Daniel Kershaw, Elaine Kilmurray, Elizabeth Mankin Kornhauser, Dorothy Kosinski, Laureen of Omaha, Carol Lekarew, Serge Lemoine, Sophie Lévy, Rich Lichte, Hilde Limondjian, Richard Lingner, Patricia Loiko, Mary Lublin, Kent Lydecker, Mary Davis MacNaughton, Lynn Marsden-Atlass, Barbara Martin, Caroline Mathieu, William McAvoy, Rebecca McGinnis, Olivier Meslay, Emil Micha, Ellen Miles, Taylor Miller, Peter Milloy, Herbert M. Moskowitz, Jennifer Liston Munson, Ursula Murphy, Kenneth Myers, Maureen O'Brien, Richard Ormond, Kim Pashko, Jennifer Riley, Joseph Rishel, Ellen Roberts, Bruce Robertson, William Robinson, Laurette Roche, Kim Sajet, Catherine Scandalis, Suzanne Singletary, Marc Simpson, Timothy J. Standring, Gail Stavitsky, Charles Steiner, Don E. Templeton, Kate Wallis Thweatt, Elyse Topalian, James Tottis, William H. Truettner, Emilie Vanhaesebroucke, Charles Venable, Elizabeth Wallace, Harriet Warkel, Ben Weiss, John Woolf, A. D. Yates and Egle Zygas.

KATHLEEN ADLER, ERICA E. HIRSHLER, H. BARBARA WEINBERG

'We'll Always Have Paris': Paris as Training Ground and Proving Ground

Kathleen Adler

Paris in the second half of the nineteenth century was 'the Mecca of art students of both sexes'. As May Alcott Nieriker said, being in Paris meant being plunged into an 'art atmosphere' and it was 'apt to strike the newcomer as being but one art studio'.[1] Americans came to Paris, as did visitors of many other nationalities, for the excitement and stimulus of the greatest city of the age – 'the capital of the nineteenth century', as Walter Benjamin declared it in the twentieth.[2] Paris superseded both Rome and London – previously the cities to which Americans made pilgrimages in search of the culture of Old Europe – as the place to be. It was the centre of the art world and, especially after the end of the American Civil War in 1865, thousands of American artists were attracted to Paris to study, to visit exhibitions (particularly the huge annual Salons) and to show their own work (fig. 1). As travel became easier, and the process of becoming a student became more familiar, Americans flocked to the city – at least 1,000 in one year, 1888, alone. Of these, a high proportion, perhaps as many as a third, were women. Paris was where artistic maturity was attained, where reputations and friends were made and collectors found. What they found in the city, how they responded to it and what they retained of their experience is the subject of this essay and of the exhibition which this book accompanies. As Henry James memorably said: 'It sounds like a paradox, but it is a simple truth, that when to-day we look for American art, we find it mainly in Paris. When we find it out of Paris, we at least find a great deal of Paris in it.'[3]

The dynamism and flux of the city were part of its appeal. From the 1860s to the end of the century, Paris changed dramatically, creating striking contrasts between the old and the new. In his letters home Thomas Eakins noted the dramatic changes taking

Fig. 1 Edgar Degas (1834–1917)
Visit to a Museum, about 1879–90
Oil on canvas, 91.8 x 68 cm. Museum of Fine Arts, Boston, Massachusetts. Gift of Mr and Mrs John McAndrew, 1969 (69.49)

place. One letter vividly reveals the extraordinary architectural transformation during the Second Empire: 'Bill [William Sartain] and I went all over yesterday afternoon hunting studios and when almost despairing of our day's work found just what we wanted. . . . It is in the big new street of Rennes not far from the Church of Saint Germain des Près . . . I would give you the address so you could send my letters there only the place is not numbered yet.'[4]

The Paris of the Second Empire – Napoleon III's and Haussmann's Paris – was only completed during the Third Republic and is essentially the Paris we know today, a city of wide boulevards, new parks, ruthless rebuilding and social control. The physical remodelling of the city topography was the visible manifestation of a more profound transformation of urban society. As Priscilla Ferguson argues in *Paris as Revolution*, the city was 'revolutionary because it is modern . . . with individuals crossing geographical and social boundaries and with the boundaries themselves shifting'.[5] Paris grew very fast, doubling in size each decade and drawing people to it from all over France and the rest of the world. Each decade a universal exhibition (Exposition Universelle) focused the world's attention on it, bringing world cultures and curiosities to the city and showing achievements in art and industry. The significance of these exhibitions is discussed in David Park Curry's essay 'American Art, American Power at the Paris Expositions Universelles' (pp. 191–205). Coming to Paris from a small town in America, as so many artists did, was almost unimaginably exciting, and nearly everyone agreed that it was, as Lorelei Lee later says in *Gentleman Prefer Blondes*, 'devine'.

Every one of these artists had their own vision and fantasy of Paris: its beauty, its light, its myriad attractions, its vibrancy (cat. 1). The combination of old and new building, the splendours of the new boulevards and the Bois de Boulogne, the profusion of cafés, the theatres, the contrasting opulence and seediness of the different neighbourhoods, the smells of the city, its strange ways, indeed even the strangeness of the language: all these aspects of the city exerted a spell on visitors. Whether artists remained in the city for a few weeks or for many years, the experience always profoundly affected them and their subsequent artistic careers. Wherever they went, they did indeed 'have Paris'[6] as a special experience or turning point in their lives. The fascination with Paris was not something unique to artists: France as a whole and Paris in particular exerted a powerful attraction for many Americans. The sense of affinity between the two countries had been summed up by Thomas Jefferson earlier in the century: 'Every man has two countries: his own and France.'[7] Thomas Gold Appleton, eminent Bostonian and noted wit, encapsulated this intimate connection in mid-century when he said: 'Good Americans, when they die, go to Paris.' Oscar Wilde, characteristically, borrowed this in his play *A Woman of No Importance*: 'Mrs ALLONBY: They say, Lady Hunstanton, that when good Americans die they go to Paris. Lady HUNSTANTON: Indeed? And when bad Americans die, where do they go to? Lord ILLINGWORTH: Oh, they go to America.'[8]

The *New Yorker* critic Adam Gopnik has recently written memorably and evocatively of the

1 ABBOTT FULLER GRAVES
The Boating Party, late 1880s
Oil on academy board, 16.5 x 24.1 cm (6 ½ x 9 ½ in.)
Collection of Remak Ramsay

appeal of Paris.[9] He claims that 'for two centuries, Paris has been attached for Americans to an idea of happiness – happiness large, one of new art made and new writing written and independence attained, and happiness small, one of good things eaten and new clothes bought and a sentimental education achieved'. Writing in 1930, looking back at her student years in Paris, the painter Cecilia Beaux expressed similar sentiments: 'The immense value, to the student, in Paris, lies in the place itself. . . . Everything is there. It is his own fault if he does not perceive.'[10] Like most American visitors, Beaux found the cold and damp depressing, but all that was forgotten in spring (cat. 2): 'Spring in Paris; I ask only for language equivalent to one aspect of this miracle. . . . The lilacs, rhododendrons, acacias, were all out, perhaps lilies-of-the-valley. There had been a light shower. The exhalation reached my keen senses by way of Paris street and boulevard, yet unsullied, pristine, tender. How could it be? The answer is "Spring in Paris". What else?'[11] And for her as for Gopnik and so many others, Paris was a place of unrivalled sensory and culinary delights: 'Unforgettable the first tiny pâtisserie to which my aunt led us, and where, in an exhausted moment, I was restored by my first "Ba-Ba".'[12]

As Gopnik points out:

> happiness is multiple, and ours [Americans'] tends to cluster around two poles: one essentially bourgeois, the other bohemian. There are Americans who have come to Paris for the food, so to speak. They are in Paris to enjoy the haute-bourgeois civilization of comfort and pleasure and learning and formal beauty – to walk in the Luxembourg Gardens and study at the Bibliothèque and sketch at the Louvre. In contrast are those who . . . come for the drink – for the dazzlement of new art and new experience, and, usually, for the drinks, too.[13]

The painters who flocked to Paris from the 1860s to the turn of the century came both for the food and the drink. And almost all of them asked Gopnik's question: 'Why am I happy in Paris in a way that I am not happy in Altoona? Is it me, the place, or the time, or a little bit of all three?'[14]

William Merritt Chase, who had studied in Munich rather than Paris, but who visited Paris frequently and chose to exhibit there, remarked before he ever travelled: 'My God, I would rather go to Europe than go to Heaven.'[15] His words about Americans abroad still strike a chord today: 'We are a new people in a new country. Watch the crowds along Piccadilly or the Champs Elysées – you spot the Americans among them almost as easily as if they wore our flag in their buttonholes. It means that already a new type has appeared, the offspring, as we know, of European stock, but which no longer resembles it.'[16] The struggle to reconcile the allure of Europe, especially Paris, with a growing sense of a specific identity as an American, is one that preoccupied many artists. They searched for ways to address the issue of how the experience of Paris informed and altered their perception of America and their desire to assert their American identity. The ambivalence of the relationship between the two countries was neatly encapsulated

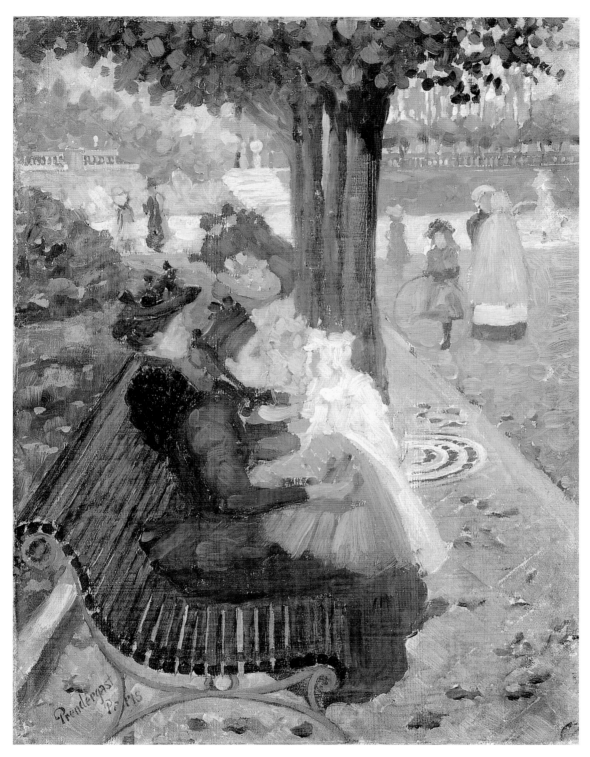

2 MAURICE BRAZIL PRENDERGAST
The Luxembourg Garden, Paris, 1892–4
Oil on canvas, 32.7 x 24.4 cm (12⅞ x 9⅝ in.)
Terra Foundation for American Art, Chicago, Illinois
Daniel J. Terra Collection (1992.68)

in the person of Thomas Gold Appleton, who was said to be 'homesick on both continents', and who crossed the Atlantic restlessly and repeatedly.[17]

The idea of Bohemia was very important to many Americans in Paris, and part of the huge attraction the city held for them (see also Erica Hirshler's essay 'At Home in Paris', pp. 57–113). Henri Murger's celebrated *Bohemians of the Latin Quarter*, first published as a play in 1849 and as a book in 1851, was translated into English in 1888, and this translation gave it a new significance, particularly for Americans. For Murger, the largest class of Bohemians was made up of poor artists, condemned to be unknown, a race of obstinate dreamers for whom art remained a faith and not a profession. Murger said that Bohemia only exists and is only possible in Paris. By the late 1880s many French artists regarded 'the legend of the down-at-heel artist with a threadbare cardigan, and smashed up hat, [as] a good story which doesn't hold true anymore',[18] but Americans clung to the idea. The contrast between the freedom they enjoyed in Paris, the potential for breaking social rules and behaving in unconventional ways, and the strictures of life at home was liberating – if often frightening. Julian Alden Weir captured the excitement of it all in this letter to his brother:

> We had our banquet last night and Gérôme was in all his glory. At the end of the dinner each of the students rung glasses with him and champagne flowed freely. . . . Imagine over fifty assembled with him with eager desire to drink to the everlasting health of our more than loved patron. From here we went to the reception room where we had cigars and café and there it was that I had the pleasure of speaking to him. . . . Afterwards a bunch of the students, some fifteen or twenty of us, went to a celebrated café in the Latin Quarter, danced, raised a row, sang, and those who could walk dragged their miserable carcasses to repose in their respective garrets. It was the jolliest evening I think I have ever spent.[19]

Bohemia linked all the arts, and several paintings of American Bohemians stress the connection between painting and music. Frank Benson's portrait of his fellow painter Joseph Lindon Smith, playing his banjo in a simply furnished studio, perfectly illustrates the Bohemian ideal (cat. 3). The men had travelled together to Paris from Boston, lived in the same Right Bank pension and studied at the Académie Julian. The portrait shows the simplicity of their surroundings and their self-made entertainments as they struggled to economise. Winslow Homer's *The Studio* (cat. 4) similarly shows the painter's studio as a venue for chamber music, with a cellist and violinist intent on their music-making. Thomas Hovenden's striking self portrait (cat. 26) exemplifies the Bohemian life. Cigarette in mouth, the painter focuses intently on the large canvas in front of him, his playing of the violin temporarily interrupted. Painting and the art of music feature equally prominently, and the Bohemian's disregard for personal appearance is signalled by the artist's disordered hair and the gaping sole of his boot.

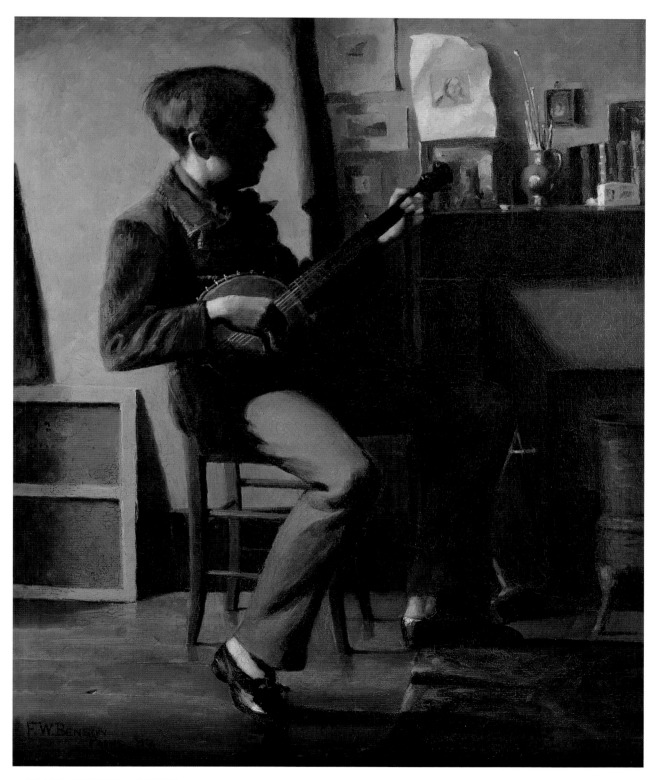

3 FRANK WESTON BENSON
Portrait of Joseph Lindon Smith, 1884
Oil on canvas, 64.8 x 52.7 cm (25½ x 20¾ in.)
Collection of Grant and Carol Nelson

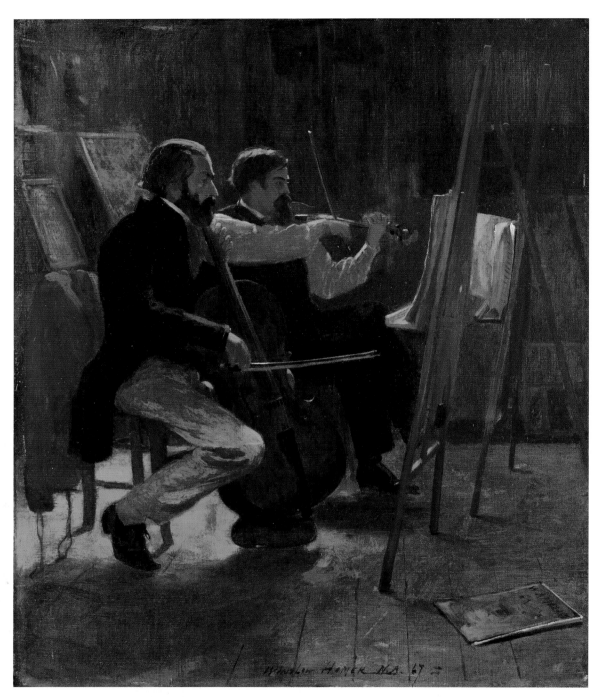

4 WINSLOW HOMER
The Studio, 1867
Oil on canvas, 45.7 x 38.1 cm (18 x 15 in.)
The Metropolitan Museum of Art, New York
Samuel D. Lee Fund, 1939 (39.14)

The flâneur, or dandy, was another Parisian type. Made famous by Baudelaire in his essays 30 years before some American painters adopted this pose,[20] the flâneur was the true man-about-town, totally at his ease on the boulevards and in the arcades of the city, always consummately well dressed and wandering through the crowds without being one of them. William Merritt Chase was a perfect example of the American who had thoroughly assimilated French ways. He was described in New York as being 'more French than the Latin Quarter itself, but he got away with it, and was altogether charming'.[21] Sargent's portrait of his master Carolus (cat. 11) depicts one such flâneur, and portraits by J. Carroll Beckwith (cat. 5), Dennis Miller Bunker (cat. 6), Robert Vonnoh (cat. 7) and Charles Sprague Pearce (cat. 8) indicate the wholehearted embrace of this Parisian phenomenon by Americans. Pearce's portrait of the sculptor Paul Wayland Bartlett shows him in lofty profile, his hand in his pocket to draw aside the jacket and reveal the waistcoat, cigarette casually held in hand. The elegance of the pale grey suit, the haughtiness of demeanour and the remoteness from the viewer suggest an individual completely at ease with the ways of the city. There is no hint here of the physical nature of Bartlett's work.

Bunker's portrait of his fellow student Kenneth Cranford (cat. 6) suggests the impact on several American painters of Edouard Manet's portrait of the writer and critic Emile Zola (fig. 2), shown at the Paris Salon of 1868 and again at the posthumous exhibition of Manet's work at the Ecole des Beaux-Arts in 1884. Manet's portrait showed his severely dressed friend surrounded by attributes which relate to Manet himself. In Bunker's portrait, Cranford, too, is shown as the perfect flâneur in his severe black suit. Beckwith's portrait of the artist and critic William Walton (cat. 5) reveals Carolus's influence in the handling of the suit, offset by the impeccable white shirt, the precision of the placing of the handkerchief in the pocket, the elegance with which Walton holds his cigarette – seemingly an essential prop for the scruffiest Bohemian and most elegant flâneur alike. Beckwith's own landscape studies, and, in the top right-hand corner, his fencing mask, provide the background, and suggest the impact here too of Manet's portrait of Zola. Walton is both urban and urbane, his moustaches groomed to perfection, every detail of his toilet immaculate, and the contrast with the freedom of the landscape studies behind him heightens his severity and sense of self worth.

In French terms, the concepts both of Bohemia and of the flâneur were gendered terms that precluded women from

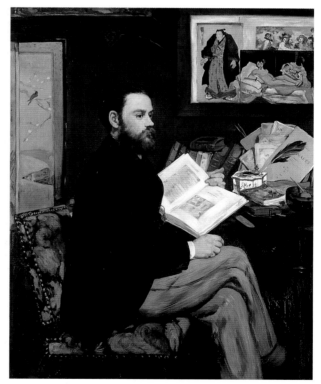

Fig. 2 Edouard Manet (1832–1883)
Portrait of Emile Zola, 1868
Oil on canvas, 146 x 114 cm. Musée d'Orsay, Paris
Gift of Mme Emile Zola, 1918 (RF2205)

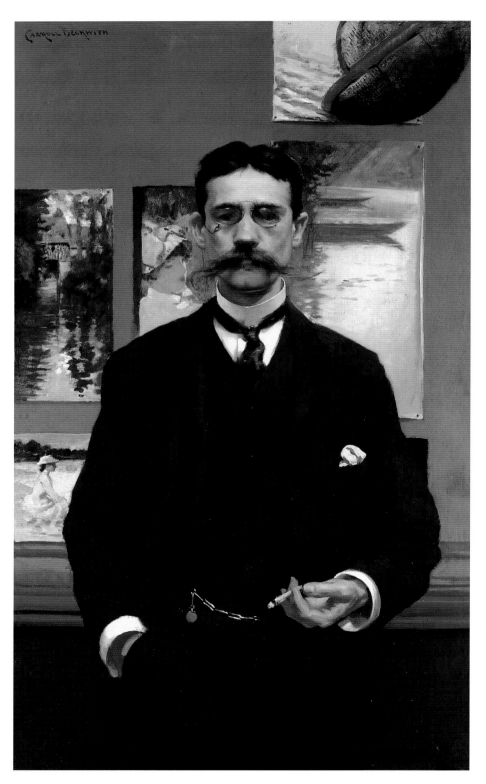

5 JAMES CARROLL BECKWITH
Portrait of William Walton, 1886
Oil on canvas, 121.6 x 72.2 cm (47⅞ x 23⅜ in.)
The Century Association, New York (1918.1)

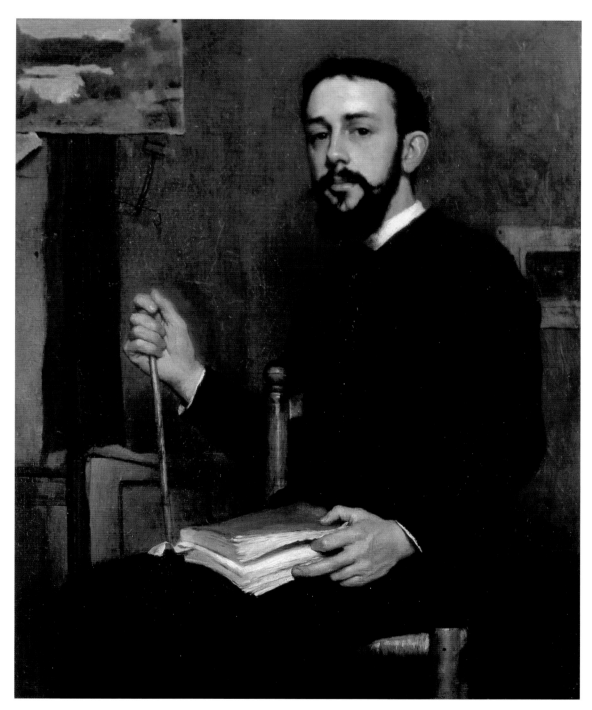

6 DENNIS MILLER BUNKER
Portrait of Kenneth R. Cranford, 1884
Oil on canvas laid down on board, 41.9 x 33 cm (16¼ x 13 in.)
Lent by Mr Graham D. Williford

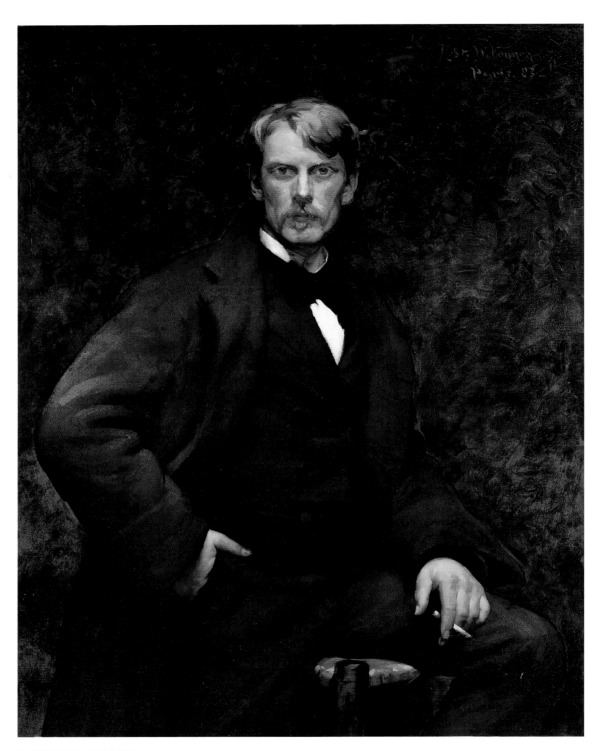

7 ROBERT VONNOH
Portrait of John Severinus Conway, 1883
Oil on canvas, 114.3 x 89.2 cm (45 x 35⅛ in.)
Florence Griswold Museum, Old Lyme, Connecticut
Gift of the Hartford Steam Boiler Inspection and Insurance Company (2002.1.49)

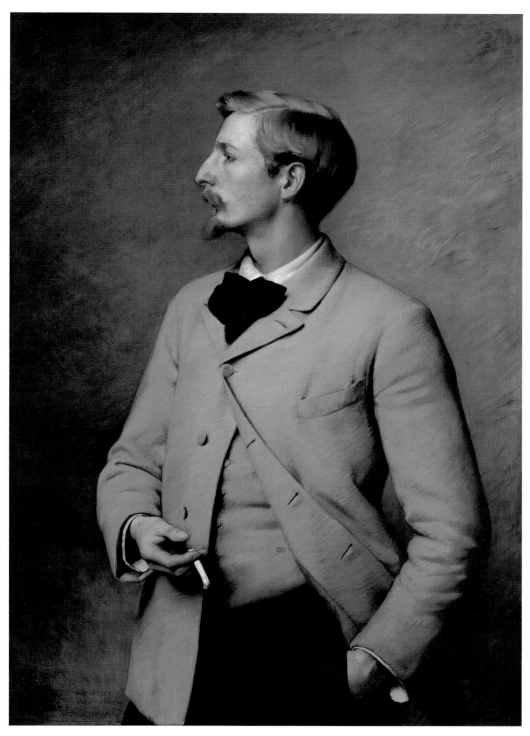

8 CHARLES SPRAGUE PEARCE
Paul Wayland Bartlett, about 1890
Oil on canvas, 108.6 x 76.2 cm (42¾ x 30 in.)
National Portrait Gallery, Smithsonian Institution
Gift of Caroline Peter (Mrs Armistead Peter III), 1958 (NPG.65.20)

participation except as models and mistresses, but Americans seem sometimes to have been unaware of this. Ellen Day Hale painted her self portrait (cat. 9) in the final months of her second stay in Paris, in 1885. She depicts herself as a tough, curious, independent, modern woman, surely a flâneuse. Her black cap frames her severely cut fringe almost like a halo, while her protruding ears and strong chin add to the androgynous appeal of the face, an effect that is feminised by the inclusion of an ostrich feather fan. A fashionable Japanese wall covering or screen in the background heightens the sense of modishness.

Hale grew up in Boston, in a prominent religious and political family. She began studying with William Morris Hunt (see cat. 99 and pp. 208–11) in 1874, at the age of 19, and later described him as her 'artistic father'. While Hale said that Hunt had formed her as an artist, at the same time she was advising other women to beware imitating their masters and doing nothing original.[22] Hale first travelled to Europe in 1881 and studied with Carolus and then at Julian's. She admired Gustave Courbet, which indicates her fearlessness of spirit, describing him as 'violent enough in all conscience, but . . . he knows when to be astonishingly precise; in fact he knows a great deal about drawing, [even] if he was a Communist . . . Well, he's dead now and I'm sorry for it. I should have liked some advice from him'.[23] She also embraced the strength of Manet's work, probably visiting his posthumous exhibition in 1884. Both artists were unusual and challenging exemplars.

Bohemia held no fears for another woman artist, Mary Fairchild, later MacMonnies. Awarded a scholarship to study in Paris from 1885 to 1888, she enrolled at Julian's and quickly established herself as a leading presence among the many foreign women there. She lived at 53 rue Bonaparte, a short distance from the studio and at the heart of the Bohemian world of the Left Bank. After meeting the sculptor Frederick MacMonnies in 1887, she elected to delay marriage until days after her scholarship expired, since marriage would have invalidated its terms. In 1890 the couple visited Giverny, part of the first wave of Americans in the art colony that grew up there after Claude Monet settled in the village in 1883. Monet resented this invasion and the demands they made on his time, and by the mid 1890s many American visitors found a warmer welcome at the MacMonnies' first summer residence, Villa Bêsche, known for its beautiful flower garden. This must be where *In the Nursery* (cat. 10), probably painted in 1897, was made. The nursery doubles as a studio, and although Fairchild does not include herself, this is a portrait of her life and her practice as a painter. She was pregnant at the time with her second child, Marjorie Eudora, born on 18 October of that year. Her daughter Berthe, known as Betty, was about two. She is seated on her high chair next to her French nursemaid, while the governess is absorbed in needlework. Betty looks out at the viewer from behind the easel, on which is another image of her, *C'est la fête à bébé* (about 1896–7; Terra Foundation for American Art, Chicago). On the walls are some of Fairchild's decorative paintings and a study for the mural *Primitive Woman*, which she executed for the

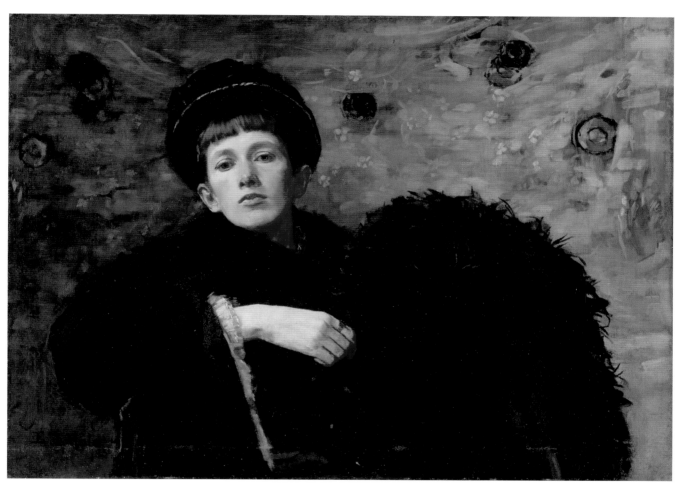

9 ELLEN DAY HALE
Self Portrait, 1885
Oil on canvas, 72.4 x 99.1 cm (28½ x 39 in.)
Museum of Fine Arts, Boston, Massachusetts
Gift of Nancy Hale Bowers (1986.645)

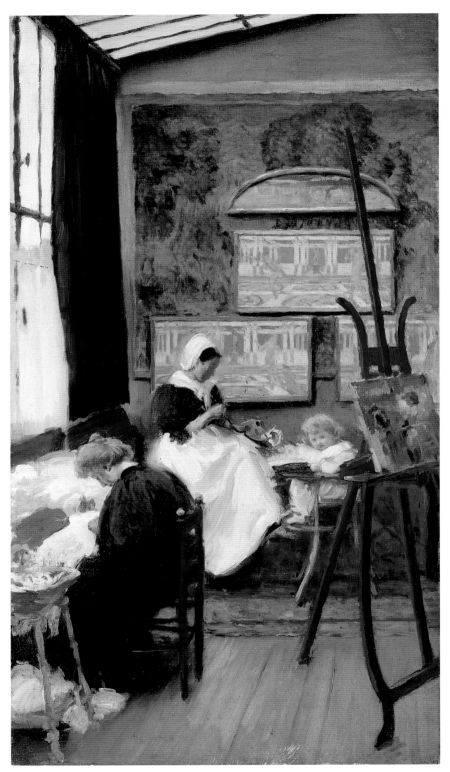

10 MARY FAIRCHILD
In the Nursery – Giverny Studio (*Dans la nursery*), about 1896–8
Oil on canvas, 81.3 x 43.2 cm (32 x 17 in.)
Terra Foundation for American Art, Chicago, Illinois
Daniel J. Terra Collection (1999.91)

north tympanum of the Women's Building of the 1893 World's Columbian Exposition in Chicago, a commission that indicates the regard in which she was held. This mural was positioned opposite its counterpart, Mary Cassatt's *Modern Woman*. The murals were commissioned by Mrs Potter Palmer, but the organising genius of the exposition was Sara Tyson Hallowell (see cat. 102, and pp. 216–18).

Americans came to France thinking themselves well prepared by the reading they had done about the art world. Expansion of the illustrated and art press in 1870s and 1880s made information easy to obtain. Foreign periodicals were available in the United States, but there were also new American journals which gave extensive coverage to foreign artists and exhibitions. As the art historian Michael Quick has noted: 'Jean François Millet and Mariano Fortuny were names known and discussed in Midwestern towns, where it was possible to follow the main successes of the Paris Salon (and the fortunes of the Americans exhibiting in it).'[24] It is hard to overestimate the importance of the press's influence, particularly on expectations for subject matter in paintings and as a source of motifs. The press coverage also gave credibility to returning artists, ensuring that they could point to Salon success when beginning to establish their careers back in the United States. The innate conservatism of most American buyers of art meant that such credentials were of great importance.

No amount of reading could prepare the first-time visitor for the reality of the city itself – it was inevitably a shock, usually an immensely pleasurable one. For most artists, the first obstacle to be overcome, once lodgings of some kind had been found, was where to study. To be an art student meant negotiating a highly competitive system. Admission to matriculation at the Ecole des Beaux-Arts, established in 1648, was by a rigorous and demanding process of competition, open only to men until 1897. The crucial part of the *concours* was the execution of a drawing, either from the antique or from life, over two six-hour sessions. Only students who had satisfied the criteria for matriculation could call themselves students in the Ecole, but the masters who taught at the Ecole also ran studios for other students. In spite of the advantages and cachet of study at the Ecole, of the numerous American artists working in Paris in the last four decades of the nineteenth century, relatively few matriculated at the Ecole or enrolled in any of its three ateliers for painting. Kenyon Cox described the arrangement of the Ecole in a letter home in 1879:

> The 'Beaux-Arts' is arranged after this fashion. There are several large halls filled with plasters from the antique and the Renaissance sculptors, and in these halls the primary pupils of all the masters work together, the masters coming round twice a week to criticize. Upstairs there are three ateliers, taught by Gérôme, Cabanel and Lehmann. There the students work from life, the professors coming to criticize the same as in 'the antique'.[25]

The private studios operated along similar lines, but with a greater degree of freedom. Teachers such as Alexandre Cabanel at the Ecole or Léon Bonnat, an independent teacher, would visit the studio at best a few times a week, indicate on students' work where they had gone wrong and leave again. The emphasis was on drawing, whether from life or from plaster casts, as it was at the Ecole itself, and painting was practised only after sufficient proficiency in drawing was deemed to have been attained.

The studio of Charles-Emile-Auguste Durand, or Carolus-Duran, was a contrast to this. Not only was Carolus far younger than most other masters, being only 36 at the time John Singer Sargent joined him in 1874 at the age of 18, his studio was notable for its emphasis on painting rather than drawing. Carolus often taught by demonstration, and praised Spanish painting, which he valued more than any other. Julian Alden Weir noted that one of the differences in Carolus's method of instruction from that of most masters, or of the ateliers of the Ecole, was that he 'puts them in front of the living model with the brushes in their hands to represent the model as well as possible, making them draw and paint both at the same time'.[26] Carolus's studio on the rue Notre-Dame des Champs was small, with about 30 students at any one time, and attracted many American and British students. Female students were taught in separate premises.

The arrival of Sargent in the studio was noted by the artist and writer Will H. Low, who had until then been the youngest student there:

> He made his appearance in the Atelier Carolus-Duran almost bashfully, bringing a great roll of canvases and papers, which unrolled displayed to the eyes of Carolus and his pupils gathered about him sketches and studies in various mediums, seeming the work of many years . . . an amazement to the class, and to the youth [Low himself] in particular a sensation he has never forgotten.[27]

Sargent quickly accustomed himself to the studio, smaller and much less rowdy than some others. The initiation rites common at other studios were forbidden here, and as Low said, although the practices of the studio were seen as revolutionary, it was 'one of the quietest places to study in Paris'.[28] After three weeks there Sargent wrote to his father that he was quite delighted with it.

Sargent began to paint his master in 1878, the year he left Carolus's studio, and showed the work at the Salon the following year (cat. 11). Carolus was a renowned flâneur of whom it was said: 'his costume is always at the height of the mode, his hat always a little in advance of it.'[29] This is how Sargent shows him: he leans forward slightly, his left arm bent to reveal the frilled cuff of his shirt and to display his elegant long fingers to maximum effect. The ribbon of the Légion d'honneur is a prominent accent against the yellow jacket, his eyes gleam with self-confidence and pride in his impeccable self-presentation. When the painting was shown in

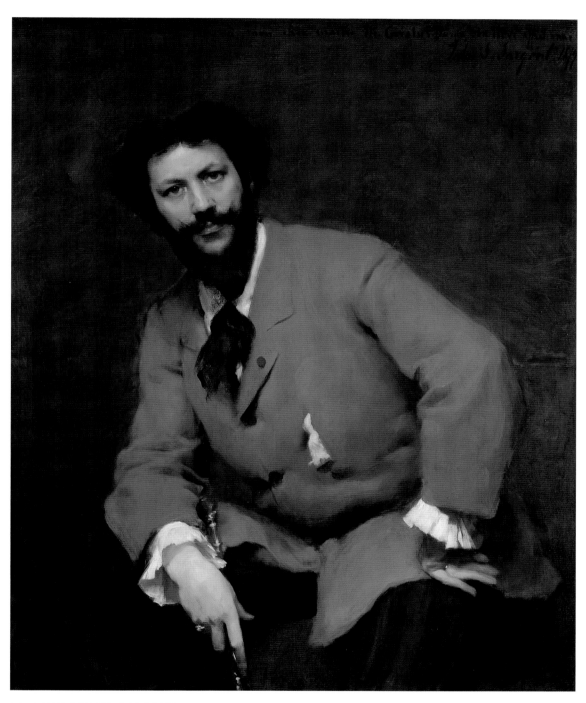

11 JOHN SINGER SARGENT
Portrait of Carolus-Duran, 1879
Oil on canvas, 116.8 x 96.2 cm (46 x 37¾ in.)
Sterling and Francine Clark Art Institute, Williamstown, Massachusetts
Acquired by Sterling and Francine Clark

New York in 1880, the critic Mariana van Rensselaer commented that it was 'French through and through. French no less in the technique . . . than in its feeling and meaning as a work of art'.[30]

The atmosphere at Carolus's studio was in marked contrast to that of other studios, particularly those run by Rodolphe Julian, which had about 400 students in 1885.[31] Rodolphe Julian was enormously successful, and by that date, he had nine studios, five for men and four for women; more were subsequently added. Masters such as William Adolphe Bouguereau and Jules-Joseph Lefebvre gave instruction there (cat. 12). The first studio for women opened about 1880 at 51 rue Vivienne, and in 1888 the female branch of Julian's, with three separate studios, opened at 5 rue de Berri. By 1890, the principal studio was established at 31 rue du Dragon on the Left Bank.[32] By offering women students the same course of instruction as was available to men, although at double the cost, at a time when the Ecole des Beaux-Arts remained closed to them, Julian's was the obvious choice for many women artists.

The regime was demanding: for all students, men and women, the day began at eight in the morning, when they took their places round the model according to the previous week's competition rankings. They were crowded together and worked without a break until midday, needing to learn how to work without being distracted. The studio system was intensely competitive, with weekly awards and an ongoing sense of rivalry. One former student recalled: 'None but those who try it know the tension on the student of working in a crowded room. She must be deaf to voices, learn to reef in her elbows, to wait without fretting for the model to sway back in to the chosen pose, and to keep in mind the first effect of light.'[33]

The African-American painter Henry Ossawa Tanner, who had studied at the Pennsylvania Academy of the Fine Arts, enrolled at Julian's when he settled in Paris. His fellow student Hermann Dudley Murphy painted Tanner's portrait in about 1896 (cat. 13). He and Tanner shared not only lodgings but also an admiration for the work of James McNeill Whistler, and the thin application of paint, limited range of tones and monogrammed signature of the portrait are all thoroughly Whistlerian.

Tanner had first intended to study in Rome, but fell completely under the spell of Paris, and later wrote: 'Strange that after having been in Paris a week, I should find conditions so much to my liking that I completely forgot when I left New York I had made my plans to study in Rome and was really on my way there when I arrived in Paris.'[34] This happened frequently to American students in Paris. A few years later, the playwright and reporter Richard Harding Davis wrote: 'On no one class of visitors does Paris lay her spell more heavily than on the American art student. For, no matter where he has studied at home, or under what master, he finds when he reaches Paris so much that is new and beautiful and full of inspiration that he becomes as intolerant as are all new converts.'[35]

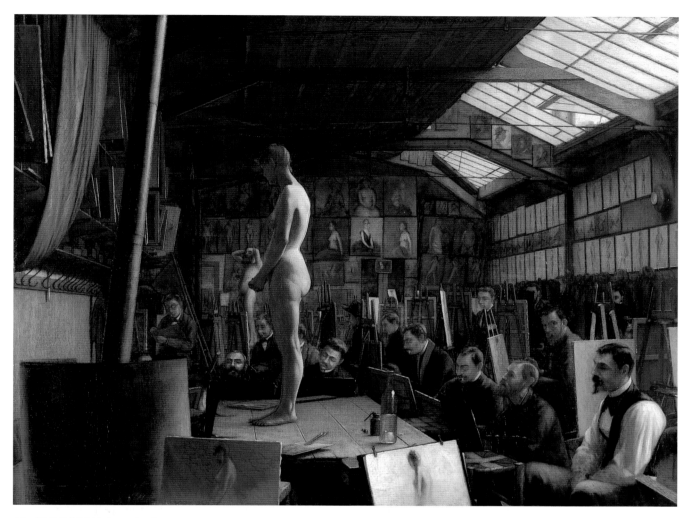

12 JEFFERSON DAVID CHALFANT
Bouguereau's Atelier at the Académie Julian, Paris, 1891
Oil on wood panel, 28.6 x 36.8 cm (11¼ x 14½ in.)
Fine Arts Museums of San Francisco, California
Gift of Mr and Mrs John D. Rockefeller III (1979.7.26)

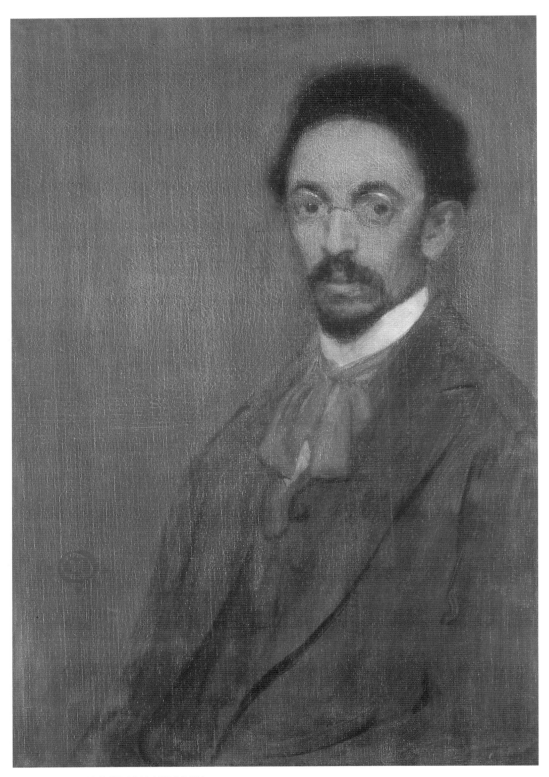

13 HERMANN DUDLEY MURPHY
Henry Ossawa Tanner, about 1896
Oil on canvas, 73 x 50.2 cm (28¾ x 19¾ in.)
The Art Institute of Chicago, Illinois
Friends of American Art Collection (1924.37)

His love of Paris notwithstanding, Tanner found the conditions in Julian's studio appalling:

> Never had I seen or heard such a bedlam . . . I had often seen rooms full of tobacco smoke, but not as here in a room never ventilated – and when I say never, I mean not rarely but never, during the five or six months of cold weather. Never were windows opened. They were nailed fast at the beginning of the cold season. Fifty or sixty men smoking in such a room for two or three hours would make it so that those on the back rows could hardly see the model.[36]

His Philadelphia friend Charles Fromuth was equally horrified by the conditions:

> I who had come from the elegant modern . . . Philadelphia Academy was shocked at the dilapidated condition of these various ateliers. . . . The reposing moments of the model in the various ateliers was the same and the hundreds of students of these various ateliers began to circulate from one atelier to another by the simple narrow doorway of circulation from one studio to the other; this on the top floor of a very old building. . . . After an inspection of the various ateliers all crowded with students from all nations and without a preference for any of the professors, I chose the largest because one had the choice of two models posing at the same time. It was also nearest to the stairway of exit.[37]

Women artists at this time tended to operate within female professional networks, studying and living together, but largely segregated from the men's art world, although they competed on equal terms for awards and recognition at the annual Salons. They regularly worked on composition assignments together, copied each other's work and augmented the often meagre criticism they received in the studio with criticisms of each other's work in the supportive atmosphere of comradeship. The networks they formed provided a safe haven amidst the excitement and turmoil of Paris. Like their male counterparts, they devised various strategies to pay for their studies, from selling copies of works in the Louvre to attempting to find portraiture commissions. Many of them regarded the expense of their studies as an investment, a necessary part of a plan for future success and earnings, particularly on their return to the United States. As Kirsten Swinth has written so eloquently, in the period from the 1860s to the end of the century, American women's position within the art world at large shifted dramatically. Initially, they were concerned to be recognised as professionals, but by 1890 commentators and critics claimed that women were winning the 'race' for art and outpacing men in their achievement.[38]

Elizabeth Jane Gardner was a model for many women artists; she was among the first three women to enter Julian's studio in the 1870s, and she recalled: 'This number soon increased, for, the precedent established, women not only flocked thither from all parts of the world, but they divided honors with the men.'[39] Gardner eventually established herself as a very successful painter, exhibiting at the Salon from 1868 and becoming the first American woman to win a

medal in 1887 for her painting *The Farmer's Daughter* (present location unknown). Her studio on the rue Notre Dame des Champs became a haven for visiting American artists. *The Shepherd David* (cat. 17) was shown at the Salon of 1895 and was included as a full-page illustration in the first volume the dealer Adolphe Goupil published of the best pictures of the year. Gardner wrote that the painting had been 'the great success of my life with the artists etc. It has done much for my reputation'.[40]

Following Gardner, many women studied at Julian's in the 1880s. They included Cecilia Beaux (cats 15, 23 and 24), Anna Klumpke (cat. 18), Elizabeth Nourse (cat. 39), Ellen Day Hale (cat. 9) and Mary Fairchild (cats 10 and 102). Dora Wheeler, the subject of Chase's splendid portrait (cat. 14), was another Julian student.

Beaux had studied in Philadelphia, and while there had painted a double portrait of her sister Etta (Aimée Ernesta) and her first-born nephew Henry Sandwith Drinker, *Les derniers jours d'enfance* (cat. 15). She showed it with some success in New York and Philadelphia, winning the Mary Smith Prize in 1885 at the Pennsylvania Academy of the Fine Arts. Success in Paris was paramount for her, and two years later she exhibited the painting at the Paris Salon. Like Chase's portrait of Dora Wheeler, Beaux's double portrait was greatly indebted to Whistler's celebrated *Arrangement in Grey and Black, No. 1: Portrait of the Artist's Mother* (cat. 16), painted in 1871 and shown in Philadelphia in 1881. Whistler's painting has been an icon ever since its first exhibition in Paris at the 1883 Salon and its subsequent acquisition by the French state in 1891 (see also p. 105).

In 1888 Beaux went to Paris to study at Julian's and at the studio run by Colarossi, another popular choice with women students. The success of *Les derniers jours* made her aware that she had turned 'a very sharp corner . . . into a new world which was to be continuously mine'.[41] She began her studies at the studio on the rue de Berri and later moved to the passage des Panoramas, which she found 'much less dilettante than the rue de Berri'.[42] Like so many other women in Paris, Beaux had to contend with the fears of her relatives in America about the wickedness of French ways. Her aunt warned her: 'Only remember that you are first of all a Christian – then a Woman and last of all an Artist.'[43]

Anna Klumpke, who achieved considerable succcess in her studies at Julian's, and also at the Salon, where she won an honourable mention in 1885, paid for her studies in part by the proceeds of the sale of a copy of Rosa Bonheur's *Ploughing in Nivernais* (1850; The John and Mable Ringling Museum of Art, Sarasota, Florida). She received many portrait commissions from American sitters, and finally wrote to Bonheur to request permission to paint her portrait. This portrait was made a year before Bonheur's death (cat. 18).

Cincinnati-born Elizabeth Nourse, who travelled to Paris in 1887 with her sister Louise, wrote home: 'Paris is wonderful.' One of the attractions of Paris, and of Julian's, was meeting fellow artists of all nationalities: 'It is interesting to hear them talk, and to see how little we

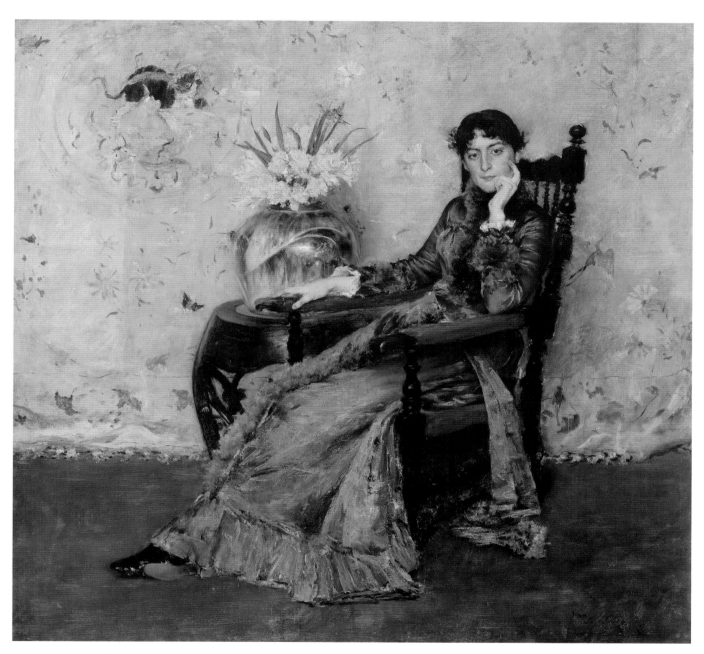

14 WILLIAM MERRITT CHASE
Portrait of Miss Dora Wheeler, 1883
Oil on canvas, 158.8 x 165.7 cm (62½ x 65¼ in.)
The Cleveland Museum of Art, Ohio
Gift of Mrs Boudinot Keith in memory of Mr and Mrs J. H. Wade, 1921 (1921.1239)

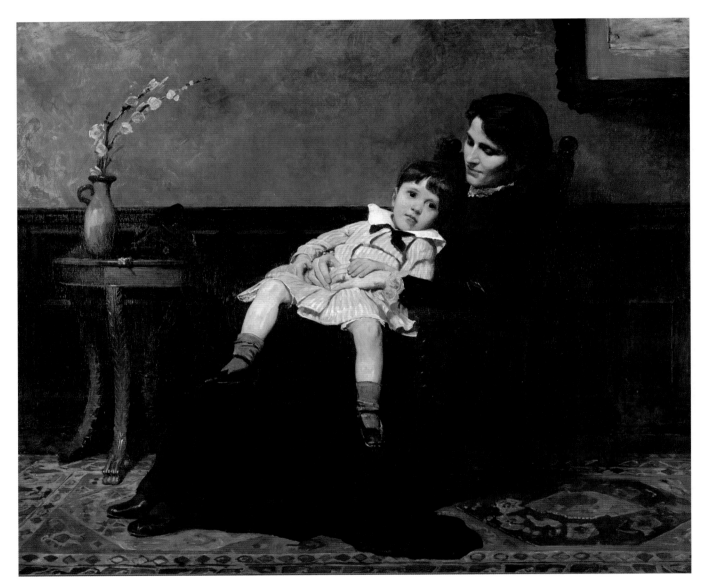

15 CECILIA BEAUX
Les derniers jours d'enfance, 1885
Oil on canvas, 116.8 x 137.2 cm (46 x 54 in.)
Courtesy of the Pennsylvania Academy of the Fine Arts, Philadelphia
Gift of Cecilia Drinker Saltonstall

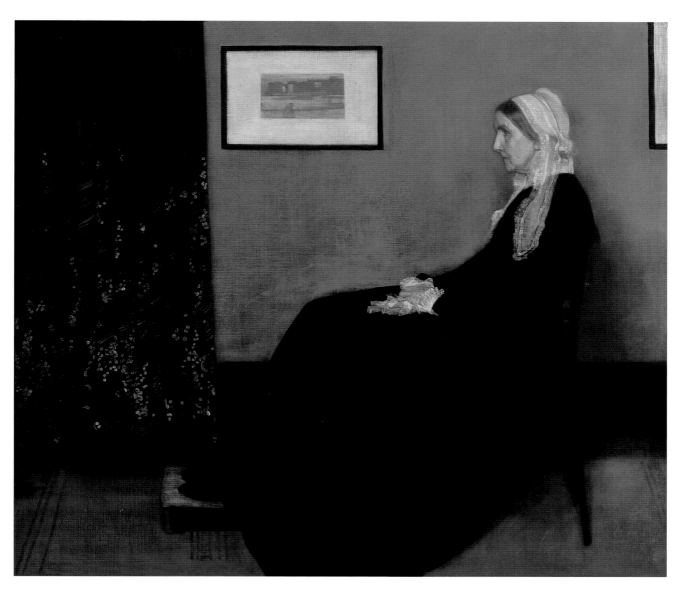

16 JAMES ABBOTT McNEILL WHISTLER
Arrangement in Grey and Black, No. 1: Portrait of the Artist's Mother, 1871
Oil on canvas, 144.1 x 162.6 cm (56¾ x 64 in.)
Musée d'Orsay, Paris (699)

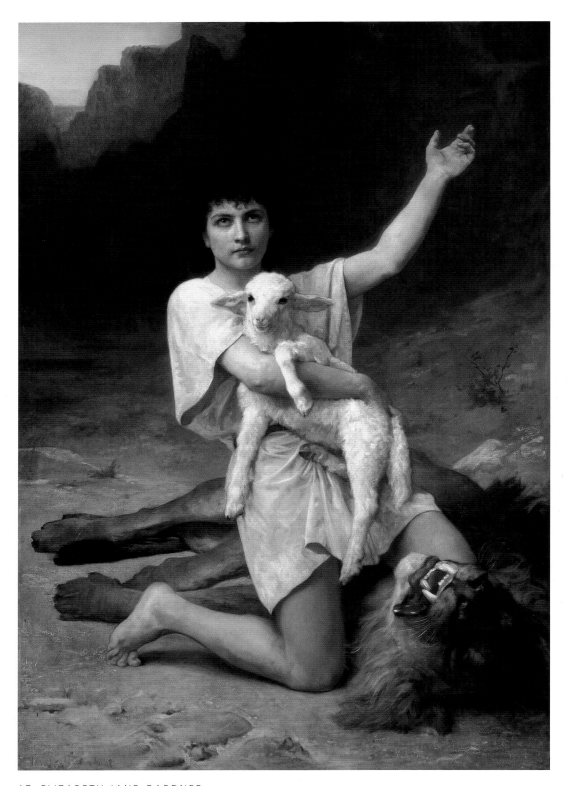

17 ELIZABETH JANE GARDNER
The Shepherd David, about 1895
Oil on canvas, 156.2 x 107.6 cm (60½ x 41⅜ in.)
National Museum of Women in the Arts, Washington, D.C.
Gift of Wallace and Wilhelmina Holladay (1986.24)

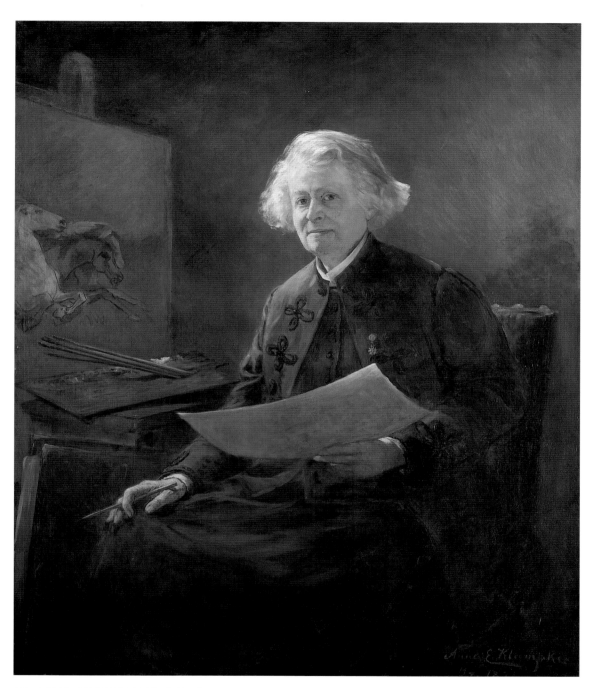

18 ANNA ELIZABETH KLUMPKE
Rosa Bonheur, 1898
Oil on canvas, 117.2 x 98.1 cm (46⅛ x 38⅝ in.)
The Metropolitan Museum of Art, New York
Gift of the artist in memory of Rosa Bonheur, 1922 (22.222)

know of the ways of other countries; you will find that everybody has a different way, and one is as good as the next.'[44] *La mère* (cat. 39) was her first Salon entry, made shortly after she was advised to leave Julian's to develop her own style. She also studied with Carolus-Duran and Henner in 1887. The painting was not only accepted, but was hung 'on the line', so that it was clearly visible to all, a remarkable achievement for any artist's first year in Paris. She signed it 'E. Nourse', since, like many women artists, she believed that she would be more successful if it was not known that she was a woman; it was only in 1891 that she began to sign her full name.

Whatever strategies were adopted for study in Paris, most artists – men and women – acknowledged that despite the drawbacks of the system, success at the Salon was a necessary precursor to wider recognition and acclaim in both Europe and America. The Salon was held annually from the middle of the Second Empire until 1898 in the vast spaces of the Palais de l'Industrie, and saw crowds of up to 10,000 a day attempting to look at thousands of paintings and works of sculpture. The way in which works were displayed would be unthinkable for an exhibition today: frames of paintings sometimes overlapped, the main aim being to cram as many as possible onto a wall. Rooms were arranged alphabetically by artists' names, so that there was no sense of coherence or unity in the displays. Quite frequently, even when an artist had a work accepted, and acceptance was a difficult matter since it depended entirely on the vagaries of the jury, they would find that it was hung so high as to be almost invisible. The entire system was competitive, with medals awarded in different categories. The winning of a medal ensured that an artist was *hors concours* for future selection, and gave artists far greater freedom in their submissions to subsequent Salons.

Cecilia Beaux wrote of her 'blues and anxieties' in preparing her Salon submissions because she felt that so much was 'at stake'.[45] Submitting to the Salon meant an assertion of the mastery of one's profession, and it is small wonder that it provoked such concern. While some artists such as Elizabeth Jane Gardner attained considerable recognition, which, as she said: 'gives one at once a position among foreign artists and raises the value of what I paint',[46] many of the painters listed in Lois Marie Fink's magisterial study of American participation at the Salon, *American Art at the Nineteenth-Century Paris Salons*,[47] remained stubbornly unknown. The risks attached to Salon success were usually regarded as less than those attached to aligning oneself with avant-garde practices, and most artists tended to place their hopes on academic art. Failure to meet the standards of the jury, and then to occupy a place where the work could be seen, was held to mean oblivion not only in Paris but on returning to compete in the art market in America.

While critical oblivion meant one might sink without trace, critical notoriety could also constitute a danger. Whistler's *Symphony in White, No. 1: The White Girl* (cat. 19) was rejected by the Royal Academy in London in 1862. Whistler then determined to submit it to the Paris Salon of 1863, writing: 'I have set my heart upon this succeeding, and it would be a crusher

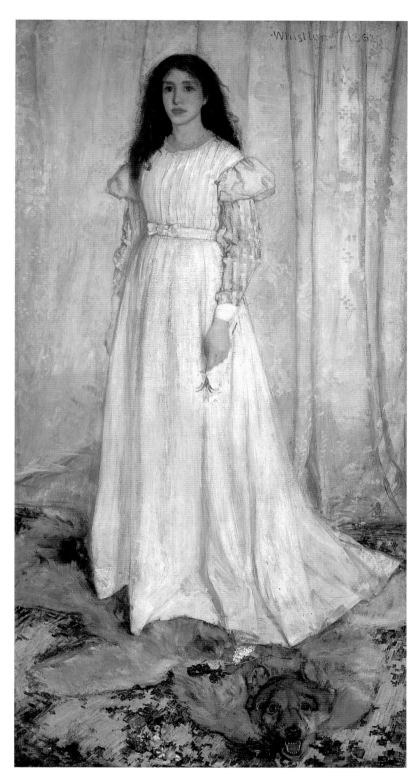

19 JAMES ABBOTT McNEILL WHISTLER
Symphony in White, No. 1: The White Girl, 1862
Oil on canvas, 213 x 107.9 cm (83⅞ x 42½ in.)
National Gallery of Art, Washington, D.C.
Harris Whittemore Collection (1943.6.2)

for the Royal Academy here, if what they refused were received at the Salon in Paris and thought well of.'[48] But the Paris Salon jury rejected it too, as one of the many hundreds of paintings that failed to be accepted. There was such an outcry at this wholesale rejection that the Emperor himself, Napoleon III, agreed to the display of the rejected works in an alternative Salon, the now-infamous 'Salon des Refusés'. Whistler's painting, exhibited as *Dame blanche*, was one of the most commented-on of the works on display, many of which induced responses of ridicule and derision in the throng of viewers. The critic Paul Mantz, writing generally supportively in the *Gazette des Beaux-Arts*, asked: 'Whence comes this white apparition? What does she want from us with her dishevelled hair, her great eyes swimming in ecstacy, her languid pose and that petalless flower in the fingers of her trailing hand? No one can say: the truth is that Mr Whistler's work has a strange charm: in our view, the White Woman is the principal piece in the heretics' Salon.'[49]

Twenty-one years later, at the Salon of 1884, Sargent experienced the wrath of critics and public alike when he showed his *Madame X (Madame Pierre Gautreau)* (cat. 35). His friend Ralph Curtis wrote to his parents:

> There is a grande tapage before it all day. In a few minutes I found him [Sargent] dodging behind doors to avoid friends who looked grave. By the corridors he took me to see it. I was disappointed in the colour. She looks decomposed. All the women jeer . . . All that a.m. it was one series of bons mots, mauvaises plaisanteries and fierce discussions. John, poor boy, was navré. . . . In the p.m. the tide turned as I kept saying it would. It was discovered to be the knowing thing to say 'étrangement épatant'.[50]

The painter Marie Bashkirtseff also wrote of the painting's reception on the opening day: 'It is a success of curiosity; people find it atrocious. For me it is a perfect painting, masterly, true. But he has done what he saw. Beautiful Mme. – is horrible in daylight.'[51] For Sargent, accustomed only to praise, Paris turned from being 'the only place' to being a hostile one, and he moved to England that summer, settling permanently in London in 1886.

Between such extremes, many painters showed their work regularly at the Salons, hoping for some critical notice or at least for a place on the wall that rendered them visible. Most planned their submissions to the Salons with great care. When Thomas Eakins, who had shown at the Salon before, had his huge *Crucifixion* (cat. 20) rejected by the Salon jury of 1890, it was a great blow. The painting dated from 10 years earlier, and was intended to challenge comparison not only with the works of the Old Masters, but also with his own teacher Léon Bonnat. Eakins wrote in 1908: 'I think the picture is one of my very best',[52] but its disturbing realism evidently did not please the jury, this despite the fact that Bonnat's own realist rendering of the subject, which had been displayed at the 1876 Salon, had been based on study of a cadaver. The fact that Eakins waited for a decade after completing the painting to send it to Paris suggests how

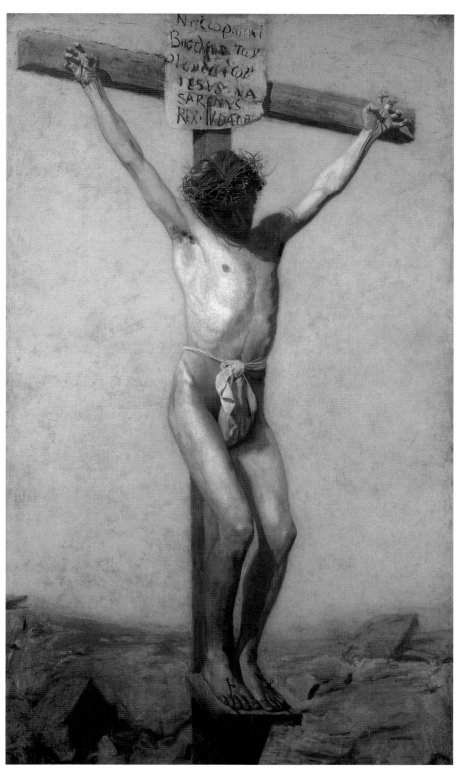

20 THOMAS EAKINS
The Crucifixion, 1880
Oil on canvas, 243.8 x 137.2 cm (96 x 54 in.)
Philadelphia Museum of Art, Pennsylvania
Gift of Mrs Thomas Eakins and Miss Mary Adeline Williams (1929-184-24)

deliberate a decision he was making with his submission, and how much must have been invested in its success. Strategies for showing were complex, however, and some artists, for example Charles Sprague Pearce, chose another route: he sent his very French *Fantasie* (cat. 21), painted in Paris, to the 1883 annual exhibition of the Pennsylvania Academy of the Fine Arts, where it was immediately purchased by the Academy.

For outsiders to break into the Salon system at all was a real challenge, and there was considerable relief when, by the 1880s, its dominance began to wane. The 1880 Salon was a turning point, marked not only by its enormous size – over 7,000 works were on view – but by the separation of foreign artists from French ones. In the following year, the organisation of the Salon was given over to the artists themselves, and this transfer was made official in 1882. By this date, there was a huge expansion in exhibition forums. Instead of focusing around the annual Salon, the artistic season continued throughout most of the year, and there was even a journal devoted to informing artists of the many exhibition opportunities available, *Le Journal des artistes*, founded in May 1882. By 1887, as C. H. Stranahan reported, there were at least 64 independent exhibitions, mainly arranged by artists' organisations or by dealers.[53] The establishment of the Salon des Indépendants in 1884 increased the range of exhibition choices. In 1889 the Salon de la Société Nationale des Beaux-Arts, a less conservative organisation, was founded by Louis Martinet, a painter and fine arts administrator, who had held exhibitions on the boulevard des Italiens since 1860.

By the 1880s, too, many dealers had moved beyond showing a few works in what was essentially a shop selling artists' supplies to establishing large and elaborate gallery spaces, with regular programmes of exhibitions, a steadily growing coterie of collectors and the assurance for the artist of regular sales. When Louisine Elder, later Havemeyer, bought her first work by Degas in 1877 (see p. 216), it was at a colour shop, probably that of père Tanguy on the rue Clauzel, but a decade later, the situation had changed. Paul Durand-Ruel, for example, the first dealer to buy and sell Impressionist paintings, began to hold monographic shows, to enlarge and improve his galleries and to show Impressionist paintings in New York. Although Monet was reluctant to have his pictures 'sent to the land of the Yankees',[54] the success of the exhibition at the premises of the American Art Association in 1886 encouraged Durand-Ruel to establish a New York gallery at 297 Fifth Avenue in 1887. Durand-Ruel wrote: 'it [the exhibition] aroused immense curiosity and, contrary to what had happened in Paris, provoked neither an uproar or stupid remarks nor raised any protests.'[55] While contemporary French painting could now be seen in the United States, this did not diminish the wish to see it at source: a young artist in 1888 commented that seeing a show of French painting in Boston 'set me wild to go to Paris and see more'.[56]

In Paris, Georges Petit became Durand-Ruel's great rival at this time, with his elaborate gallery, decorated in marble and red velvet, and carefully orchestrated retrospective exhibitions

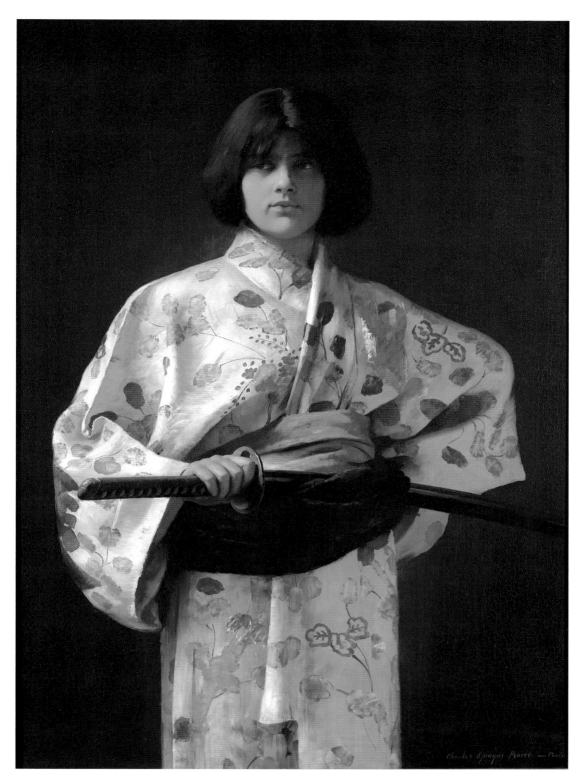

21 CHARLES SPRAGUE PEARCE
Fantasie, about 1883
Oil on canvas, 105.7 x 76.2 cm (41⅝ x 30 in.)
Courtesy of the Pennsylvania Academy of the Fine Arts, Philadelphia
Gift of Joseph E. Temple (1884.1.2)

of artists' work. An innovation of the time was the 'one-man show'. It was during this period that the relationship between dealer and artist which still prevails today was established, and while this was favourable for many artists, it discriminated against women artists, who found it more difficult to establish a niche,[57] and also left artists somewhat at the mercy of their dealers' intentions.

Among new exhibition venues were the series of independent exhibitions we call the Impressionist exhibitions, eight shows in all, beginning in 1874 and finishing in 1886. Mary Cassatt was the only American to show in this forum. She was first invited by Edgar Degas in 1877 to show with the Impressionists, and finally showed 12 works at the group's fourth exhibition in April and May 1879. Her father Robert wrote proudly to her brother Alexander: 'Every one of the leading daily French papers mentioned the Exposition & nearly all named Mame – most of them in terms of praise, only one of the American papers noticed it and it named her rather disparagingly!!'[58] Among the works shown was *Woman with a Pearl Necklace in a Loge* (cat. 22) and *Little Girl in a Blue Armchair* (cat. 34).

Those few American painters who reacted to the Impressionist shows were not always complimentary. Julian Alden Weir saw the third Impressionist exhibition in 1877 and commented:

> I went across the river the other day to see an exhibition of the work of a new school which call themselves "Impressionalists". I never in my life saw more horrible things. I understand they are mostly all rich, which accounts for so much talk. They do not observe drawing or form but give you an impression of what they call nature. It was worse than the Chamber of Horrors. I was there about a quarter of an hour and left with a head ache, but I told the man exactly what I thought. One franc entrée. I was mad for two or three days, not only having paid the money but for the demoralizing effect it must have on many.[59]

Such hostile comments notwithstanding, Claude Monet's approach to the painting of landscape, his light and bright palette, was imitated by many American painters, and American Impressionism owes more to this taste for Monet than to the work of any other painter. This is discussed at greater length in Barbara Weinberg's essay below (pp. 140–5). Other Impressionist painters gradually came to be perceived as interesting, even by such sceptics as Weir. In 1893 Theodore Robinson noted that he had been to see the collection of Albert Spencer in New York in the company of Weir and Twachtman, and that they had seen 'some fine pictures by Monet, Renoir, & Degas . . . A Renoir – a lady on a garden seat – flowers in profusion – the face very sweet . . . – a fine nude (Renoir)'.[60] Renoir's blend of classical figures and naturalist landscape in his later work was much admired by American painters.

However, painters like Jean-Charles Cazin were in fact often more highly valued than Monet, both in monetary terms (in 1893, for example, a landscape by Cazin, *An October Day in*

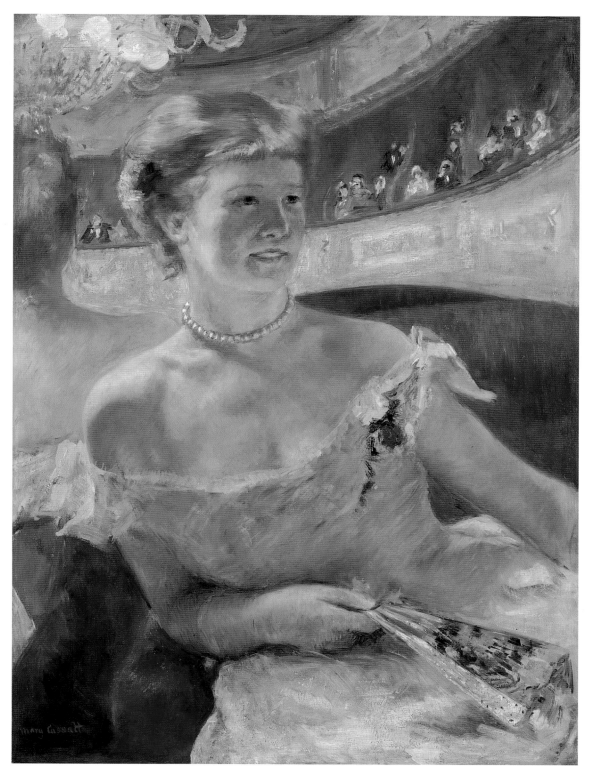

22 MARY CASSATT
Woman with a Pearl Necklace in a Loge, 1879
Oil on canvas, 81.3 x 59.7 cm (31⅝ x 23 in.)
Philadelphia Museum of Art, Pennsylvania
Bequest of Charlotte Dorrance Wright (1978-1-5)

France, fetched four times as much as Monet's *Road by the Hillside* at an auction in New York), and in terms of artistic integrity. Cazin's subdued naturalism was evidently easier to admire than Monet's more radical art. An article in *The Collector* put it strongly: 'My contempt for such a man as Monet is the greater, because I believe he really can see and feel Nature honestly, and that he distorts her for sensational effect. His followers are a rabble, too ridiculous to be even contemptible. With Cazin it is a different matter. He is a painter of technical force, of a temperate and sensitive spirit, and of fine artistic fibre.'[61]

Very much to the taste of many Americans was the manner of the naturalist figurative painter Jules Bastien-Lepage, who was greatly admired in the early 1880s, but whose reputation declined swiftly after his death in 1884. After the submission to the Salon of 1883 of *L'amour au village*, Bastien spent his summer at Concarneau in Brittany, where he was besieged by American and British followers wanting to study his method of painting. His art was seen to interpret nature in a direct and personal way, without traditional studio convention, and to combine observation with virtuosity in paint manipulation.[62] Edward Simmons recalled in his memoirs a conversation with the painter Alexander Harrison about the contrast between his manner and that taught by most of the masters under whom the Americans studied:

> 'M. Bastien,' I said (no one ever called him Lepage) 'we have all been taught by Lefebvre, Boulanger, Cabanel and Duran to ébaucher our subject broadly and put in only details that are absolutely necessary. I saw you today painting every slate on that roof for its own sake. How about it?'
>
> He laughed.
>
> 'I have tried all these different methods, but none of them got me what I saw; so now I do everything as truthfully as I am able, then take my picture to Paris, where, in my studio, away from nature, I can consider it broadly and remove all the unnecessary detail.'
>
> 'Yes,' said Harrison, 'but when we younger men see your picture in the Salon we do not think you have done what you say you do.'
>
> He threw his hands in the air.
>
> 'Hélas! Hélas! Sacre Nom de Dieu! Vous avez raison. I am so much in love with it when I see it in my studio that I cannot bear to touch it.'[63]

For American students, both male and female, Paris was at once entirely captivating and immensely challenging. Marie Adelaide Belloc wrote in 1890: 'To go to a foreign country in search of teaching has one incontestable advantage. The student is set free from the trammels of daily life, can start early in the morning, and unwisely consume the midnight oil. New associates, new ideas, new methods, must do something to stimulate the imagination.'[64] Students often had financial worries, and were frequently homesick and lonely, but the heady excitement

of being in Paris tended to overwhelm such feelings. Almost all of them could readily have explained why they were happy in Paris in a way they were not back home in Altoona, and why 'having Paris' sustained them when they returned.

Back in the USA, painters who had trained in Paris applied the varied styles they had learned there to a broad range of subjects. Thomas Eakins's paintings of hunting for rail (see cats 79 and 80, and pp. 152–3) are underpinned by his knowledge of anatomy and perspective gained in Jean-Léon Gérôme's studio, and Eakins echoed Bonnat's Realist directness in portraits and religious paintings (cats 20 and 98). Thomas Hovenden adopted the technique of Cabanel and other masters for scenes of American life and history. Cecilia Beaux evoked the famous black cat from Manet's *Olympia* (fig. 3) in the portrait *Sita and Sarita* (cat. 23), painted in a barn studio in New Jersey. She showed how she had absorbed the lessons of Manet and Degas (as well as those of Velázquez) in the radical cropping and free brushwork of the portrait of her two-year-old niece Ernesta Drinker, painted in Philadelphia (cat. 24).

Above all, many American painters successfully combined the lessons they had learned from the various academic masters under whom they had studied with the vividness of colouring and apparent spontaneity of effect of French Impressionism. Initially some Americans regarded Impressionism with hostility, since it ignored the very academic conventions that were so highly cherished by aspiring painters. There was also considerable confusion about what Impressionism was, with even Henry James asserting that 'none of the members [of the Impressionist group] show signs of possessing first-rate talent, and indeed the "Impressionist" doctrines strike me as incompatible . . . with the existence of first-rate talent'.[65] But as Impressionist paintings were collected in increasing numbers by adventurous Americans, and as exhibitions in the United States made Impressionism increasingly familiar even to those who had never travelled to France, the style gained great favour.

Impressionism made it apparent that the subject matter of art could be everyday life even in its most humdrum and ordinary manifestations, completely devoid of the sublime effects of landscape or history so beloved of earlier generations of American painters. This made it possible for Theodore Robinson to find beauty in the flat landscape surrounding Port Ben on the Delaware and Hudson Canal (see cat. 87, and p. 160), or for Tarbell to make an important exhibition piece that depicted only his family in the sunny backyard of their suburban home (see cat. 92).

In 1897, the foundation of the 'Ten', the group of ten American painters including Hassam, Weir, Twachtman, Metcalf, Tarbell and Benson, established an exhibition base for artists who had embraced what had already become a distinctive approach to painting: American Impressionism. By combining the luminosity and intensity of colour learned from Monet in particular with the solidity and substance of figure drawing of their training in Paris, these and other artists were able to re-examine American subjects in a new way. They did not focus on the

Fig. 3
Edouard Manet
(1832–1893)
Olympia, 1863
Detail of fig. 35

marvels of nature in the west of the country, but on quieter, more modest landscapes, often in areas outside New York or Boston. Barbara Weinberg considers these rural retreats in her essay below (pp. 150–74). The Ten also painted figural scenes – both interiors, like Tarbell's *Across the Room* (cat. 25), which shows a model in a carefully lit studio, and exteriors, as in Benson's *Eleanor* (cat. 93), an image of his daughter on the porch of their summer home. In these paintings, the figures and the landscape are handled differently – carefully delineated models sit in freely brushed settings. The paintings are an amalgamation of the lessons of Paris.

The market for such works was in the cities, and American Impressionism soon came to be regarded not as a foreign and radical style, but as a particularly American and conservative one. Social issues were rarely addressed, even in paintings that showed labour and changes in the patterns of work – for instance in Metcalf's *Gloucester Harbor* (cat. 90), with its view combining the power-plant chimney with old wooden houses and fishing shacks, and sailing craft indicative of new leisure pursuits. Breck's *Grey Day on the Charles* (cat. 91), with its focus on the water's surface and the idyllic quality of the view, gives no hint of the changes in agricultural practices and the industrialisation of the area. Figure paintings show beautiful women in white, and were soon conflated in the popular imagination with images of the ideal American girl – clean, wholesome, active and lovely.

With the popularity of their work in public exhibitions and the increasing prominence of the roles they held within the artistic establishment – as teachers, jury members, etc. – American Impressionist painters came to dominate art circles in the United States at the turn of the twentieth century. What had been a radical style in France eventually turned into a conservative one in America. It would take a younger generation of painters, many of them adherents of new styles from Paris, to challenge their position anew.

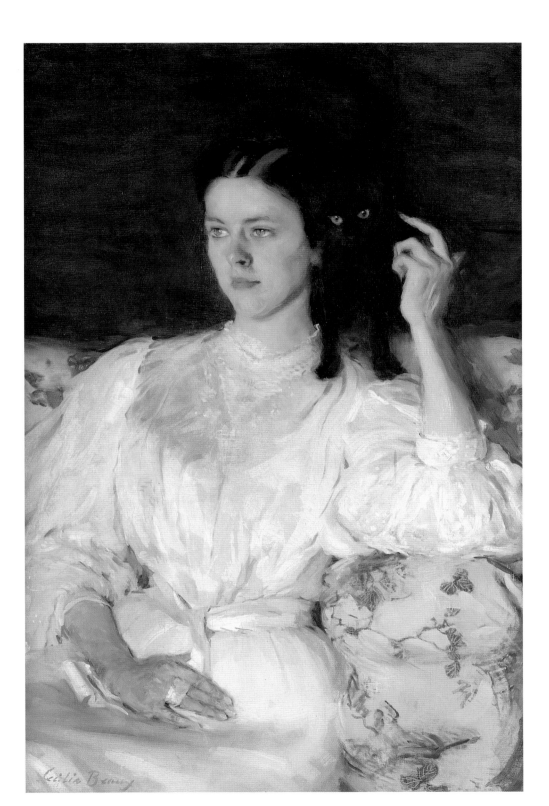

23 CECILIA BEAUX
Sita and Sarita (*Jeune fille au chat*), 1893–4
Oil on canvas, 94 x 63.5 cm (37 x 25 in.)
Musée d'Orsay, Paris
Gift of the artist to the Musée du Luxembourg, 1921 (1980-60)

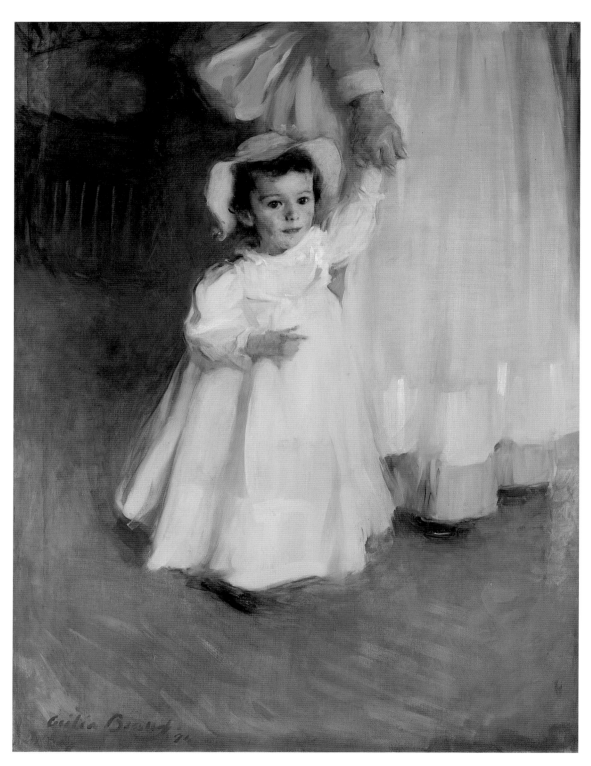

24 CECILIA BEAUX
Ernesta (*Child with Nurse*), 1894
Oil on canvas, 128.3 x 96.8 cm (50½ x 38⅛ in.)
The Metropolitan Museum of Art, New York
Maria DeWitt Jesup Fund, 1965 (65.49)

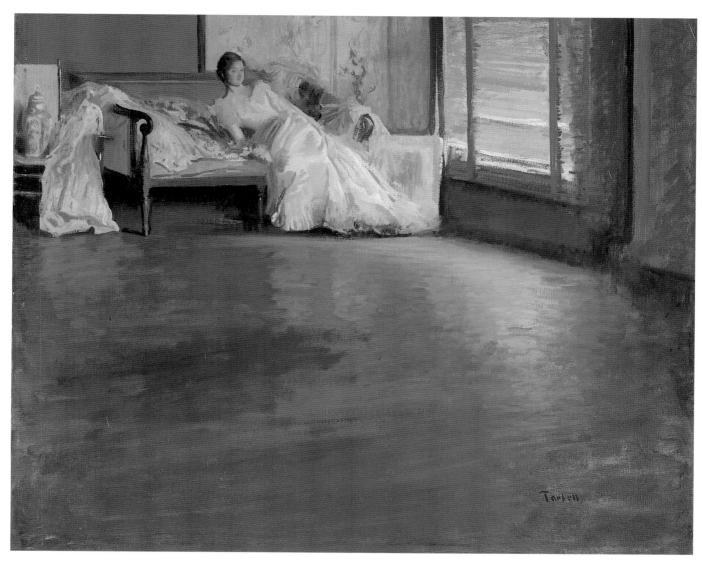

25 EDMUND CHARLES TARBELL
Across the Room, about 1899
Oil on canvas, 63.5 x 76.5 cm (25 x 30⅛ in.)
The Metropolitan Museum of Art, New York
Bequest of Miss Adelaide Milton de Groot (1876–1967), 1967 (67.187.141)

1 Nieriker 1879, p. 43.
2 Walter Benjamin, 'Paris, Capital of the Nineteenth Century' (1935) in *Reflections. Essays, Aphorisms, Autobiographical Writings*, ed. P. Demetz, New York, 1978.
3 James 1887 in James 1956, p. 216.
4 Thomas Eakins to Fanny Eakins, 26 March 1869, Thomas Eakins Letters.
5 Ferguson 1994, p. 133.
6 The quotation is of course from *Casablanca* (1942, directed by Michael Curtiz).
7 Although this remark is often ascribed to Jefferson, and he said essentially this in his 'Autobiography' (*The Writings of Thomas Jefferson*, ed. P. L. Ford (New York, 1892), vol. 1, p. 149), the exact phrase actually comes from Henri de Bornier's *La Fille de Roland*, act 11, scene ii, p. 65. Tom Paine also said: 'for every man the first country is his native land and the second is France.'
8 Appleton's remark is quoted in Stearns n.d. I am grateful to Erica Hirshler for this reference. Oscar Wilde, *A Woman of No Importance* (1892), New York 1993, p. 17. The words are also used in the film *Funny Face*.
9 Gopnik 2004b. Another version of this essay appears in Gopnik 2004a, pp. xiii–xxxiii. I came across Adam Gopnik's essay while researching this essay at the J. Paul Getty Museum, Los Angeles, in April 2004, and was captivated by its insights and understanding of exactly the issues addressed by this book and accompanying exhibition: what did it mean to be an American in Paris and what was so different about Paris, so unforgettable? I am indebted to Gopnik's beautifully expressed ideas on this, as I am by his views on contemporary Paris, in *Paris to the Moon* (Gopnik 2000).
10 Beaux 1930, p. 174.
11 Beaux 1930, p. 131.
12 Beaux 1930, p. 131.
13 Gopnik 2004b, p. xiv–xv.
14 Gopnik 2004b, p. xviii.
15 W. M. Chase, 'The Picture that First Helped Me to Success', *New York Times*, 28 January 1912, section 5, p. 5.
16 W. M. Chase, 'The Import of Art: An Interview with Walter Pach', *The Outlook* 95 (25 June 1910), p. 442, quoted in Pisano 1983, p. 175.
17 Hughes n.d.
18 Un artiste, 'Le Salon', *La Citoyenne*, 132 (May 1888), p. 2, quoted in Garb 1994, p. 25.
19 19 December 1874; Young 1960, p. 59.
20 C. Baudelaire, 'The Painter of Modern Life' (1863) in *The Painter of Modern Life and Other Essays*, trans. Jonathan Mayne, London 1964.
21 French 1928, p. 168. Thanks to Erica Hirshler for this reference.
22 Swinth 2001, p. 48.
23 Hirshler 2001, pp. 77–8.
24 Quick 1976, p. 16.
25 Quoted in Weinberg 1991, p. 19.
26 Weinberg 1991, p. 194.
27 Low, 'The Primrose Way', quoted in H. B. Weinberg, 'Sargent and Carolus-Duran', in Simpson 1997, p. 5.
28 Low 1908, p. 21.
29 *Art Age* 2, no. 23 (June 1885), p. 168, quoted in Simpson 1997, p. 21.
30 M. G. van Rensselaer, 'Spring Exhibitions and Picture-Sales in New York. – 1', *American Architect and Building News* 7, no. 227 (1 May 1880), p. 190.
31 Hatrick 1939, p. 11.
32 Information about Julian's and the proliferation of studios from Fehrer 1984.
33 Sutherland 1895, p. 52.
34 Tanner 1909, p. 11770.
35 Davis 1895, p. 205.
36 Quoted in Sellin 1996, p.24.
37 Ibid.
38 Swinth 2001, p. 5 and *passim*.
39 McCabe 1922.
40 Letter of 20 March 1896, quoted in Tufts 1987, n.p.
41 Quoted in Tappert 1995, p. 12.
42 Beaux 1930, p. 172.
43 Tappert 1995, p. 174.
44 In M. A. H. Burke 1983, p. 32.
45 Quoted in Tappert 1995, p. 213.
46 Elizabeth Gardner to Maria Gardner, 25 May 1868, quoted in Swinth 2001, p. 51.
47 Fink 1990.
48 J. M. Whistler, letter to George Aloysius Lucas, 16 March 1863, Whistler Correspondence, http://www.whistler.arts.gla.ac.uk / letters/10693.asp.
49 Mantz 1863.
50 Charteris 1927, pp. 61–2.
51 Marie Bashkirtseff, quoted in Olson 1989, p. 104.
52 Letter to John W. Beatty, 10 March 1908 (Carnegie Institute Museum of Art Records).
53 Stranahan 1888, p. 474.
54 Venturi 1939, vol. 1, p. 295.
55 Venturi 1939, vol. 2, p. 216.

56 In W. H. Downes, 'Private Collections', *Atlantic Monthly* 63 (December 1888), p. 780, quoted in Fink 1990, p. 126.

57 The establishment of a Union of Women Painters and Sculptors, and many other aspects of the art world in relation to women's practice is discussed extensively in Garb 1994.

58 Mathews 1984, p. 144.

59 Young 1960, p. 123. J. Alden Weir to his parents, 1 May 1877, quoted in Sellin 1996, p. 51.

60 Theodore Robinson Diaries.

61 'The Rise of the Curtain', *The Collector* 2 (1 October 1891), p. 225, quoted in Weitzenhoffer 1986, p. 85.

62 Sellin 1982, p. 45.

63 Simmons 1922, p. 145.

64 Marie Adelaide Belloc, 'Lady Artists in Paris', *Murray's Magazine* 8 (September 1890), p. 383, quoted in Swinth 2001, p. 40.

65 James 1887 in James 1956, pp. 114–15.

At Home in Paris

Erica E. Hirshler

A young man sits awkwardly, formally dressed in a suit and tie, palette and mahlstick in hand, sketches and a mannequin arrayed before him. He seems nervous and ill at ease, his art crowded into a bourgeois parlour (fig. 4). A drawing of a classical cast behind him suggests his careful training, while a laurel wreath around a landscape alludes to future honours. In a second image, made in Paris in a proper artist's studio, this same painter's cautious propriety and grave enterprise disappear (cat. 26). Cigarette in mouth, he lounges in an undignified pose, jacket abandoned, a loose red cravat at his neck. Palette and brushes are idle, and he holds a violin while he glares critically at his canvas. French novels line his shelves. Thomas Hovenden's two studio self portraits, one made before and one after his arrival in France, show the transformative effects of Paris, the city most considered an artist's natural home.

Like Hovenden, few of the American painters who made their homes in the French capital were immune from the idea of the Bohemian artist that French writer Henri Murger had established in the 1840s. Murger, an aspiring novelist, had published a series of stories about artistic life in the *Corsaire-Satan*, a small newspaper admired for its bold articles on contemporary literature and politics. Murger based his tales on the experiences of his own circle, a group of poets, writers, models and painters. In 1849, he turned them into a successful musical play, *La vie de Bohème*, which ran at the Théâtre des Variétés for years. With the 1851 publication of his collected articles, an English translation in 1888, and Puccini's 1896 operatic adaptation, Murger's *Bohème* continued to capture attention from Americans for decades.[1]

Despite the poverty and illness that characterise many of Murger's vignettes, an international audience perceived them romantically as a world in which domestic hardships could be overlooked in the

Fig. 4 Thomas Hovenden
Self Portrait of the Artist in his Studio, about 1870
Oil on canvas, 61 x 48.3 cm. Private collection

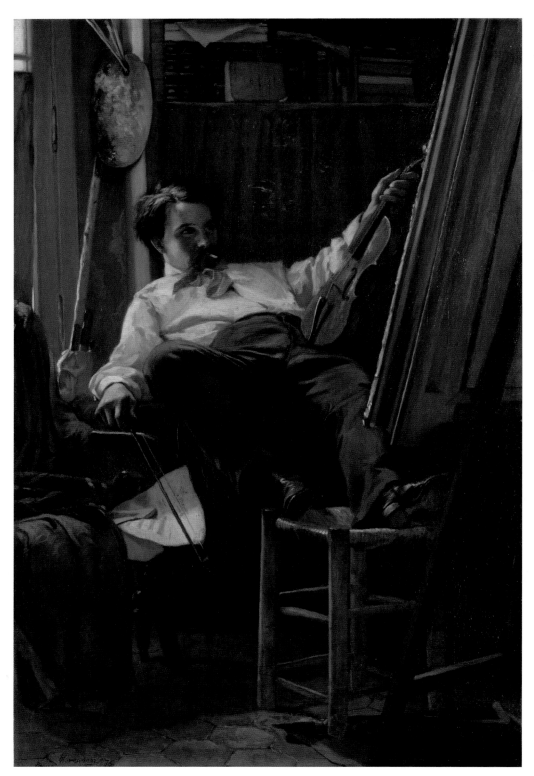

26 THOMAS HOVENDEN
Self Portrait of the Artist in his Studio, 1875
Oil on canvas, 67.6 x 44.8 cm (26⅝ x 17⅝ in.)
Yale University Art Gallery, New Haven, Connecticut
Mabel Brady Garvan and John H. Niemeyer Funds (1969.28)

pursuit of artistic ideals (fig. 5). Americans regarded it as a rejection of the self-satisfied life of the bourgeoisie – Bohemians were free to talk about art instead of the business of earning a living, to discuss new ideas and artistic styles unbound by the pressures of life at home. *La vie de Bohème* was a potent elixir for would-be painters in a country where art was often viewed with misgivings. For many Americans, raised on practicalities and with a healthy Protestant suspicion of the sensual, art was often regarded as an unnecessary frill. Few parents supported with enthusiasm the idea of a son or daughter who wanted to paint, despite the economic success of such mid-century figures as Frederic Church and Albert Bierstadt. With some exceptions, opportunities for professional training in the United States during the 1870s were homespun, clearly perceived as inferior to an education in Paris, where one could also study original works by acknowledged masters. Hopeful American artists were ready to put up with cold garrets and difficult landlords, and to risk their often complete ignorance of both French language and French customs in order to devote themselves to art.

Among the earliest Americans to establish himself firmly in the French capital was James McNeill Whistler. Whistler's experiences in Paris are unusual, for few other Americans felt so instantly at home there. Like most of his compatriots who truly were comfortable in Paris, Whistler was fluent in French, having mastered it during his youth in Russia. His familiarity with the language allowed him to become an integral member of Parisian art circles, not only as a young painter looking for guidance, but soon also as a friend and colleague. Whistler lived

in Paris for extended periods twice, once at the beginning and once at the end of his career. But throughout Whistler's life, other trips to Paris and to the French countryside, visits from French friends and portrait sitters to London, a voluminous correspondence and an active schedule of Paris exhibitions supplemented these extended sojourns and kept the American painter close to the French art scene. According to the art dealer Edward Guthrie Kennedy, Whistler's favourite theme was 'the superiority of the French in every thing', and despite his long habitation in London, France was never far from his mind.[2]

When Whistler first settled in Paris, he came as a student. He knew Murger's picturesque descriptions of the artist's life and the reality of his own existence echoed their particular combination of poor living and high thinking. In these early years Whistler's domestic arrangements constantly changed – in three years he listed at least nine addresses around Paris – but he nonetheless formed close friendships, nurtured in the cafés and studios, with French artists and he positioned himself at the

Fig. 5 Octave Tassaert (1800–1874)
Coin d'atelier (Intérieur d'atelier), 1845
Oil on canvas, 46 x 38 cm. Musée du Louvre, Paris (RF2442)

heart of the avant-garde in France. Whistler met the painter Henri Fantin-Latour when both were making copies at the Louvre in October 1858, and Fantin soon introduced Whistler to his colleague Alphonse Legros. Whistler, Fantin and Legros joined together to form the Société des Trois, a band of brothers devoted to truth in art. Also through Fantin, Whistler became acquainted with many of the leading writers and artists of the day, among them Charles Baudelaire, Gustave Courbet and Edouard Manet. Fantin immortalised several of these friends, including Whistler, in his 1864 painting *Hommage à Delacroix* (fig. 6 and detail, fig. 22). Writer and critic Edmond Duranty, who appears at the far left of the composition, described the painting as an image of 'controversial artists paying homage to the memory of one of the great controversial artists of our time'.[3] Aside from Fantin himself, who appears in a bright white smock, Whistler is the most captivating personality in the assembly. Not yet 30, with a string of contentious paintings already behind him (see pp. 40–2 and 179), Whistler had adopted the dramatic guise he would cultivate throughout his career. Elegant and slim, sporting tousled locks and a walking stick, he stands at the centre of things, looking back across his shoulder as if to judge the audience's response to his involvement with Fantin's artistic proclamation.

Whistler also worked closely with other French painters. Courbet, the French champion of realism, praised Whistler's *White Girl* (cat. 19) at the Salon des Refusés in 1863. In October 1865, in the company of his red-haired mistress and model Jo Hiffernan, Whistler painted with

Fig. 6 Ignace Henri Théodore Fantin-Latour (1836–1904). *Hommage à Delacroix,* 1864
Oil on canvas, 160 x 250 cm. Musée d'Orsay, Paris (1664)

Courbet on the coast of Normandy at Trouville (see also p. 120), Courbet describing Whistler as 'an Englishman who is my student'.[4] At just this moment Whistler was turning away from Courbet's style, but he did not reject the man. A dozen years later from his exile in Switzerland, Courbet wrote nostalgically to Whistler, recalling the time they spent together listening to Jo sing Irish songs, taking icy baths on the beach, eating shrimp with fresh butter and, above all, 'painting the spaces of the sea and the fish to the horizon'.[5]

Whistler also came into contact with French artists outside the realist circle, many from a younger generation, including the fashionable artists James Tissot, Jacques-Emile Blanche and Paul Helleu, all of whom interacted with a number of American painters. Whistler likewise knew the Impressionists, and his belief that the two-dimensional arrangement of shapes and colours on the flat surface of his canvas was of equal importance to the view he depicted was akin to one of their most revolutionary tenets. Whistler's emphasis on the formal aspects of his paintings, particularly in his landscapes, finds echoes in the spare, decorative seascapes produced by Degas and Monet in the late 1860s and early 1870s.

Both French painters knew and admired Whistler's work. Monet, six years younger but like Whistler a student of Gleyre, a friend of Courbet, and a protégé of dealer Durand-Ruel, doubtless came into contact with the American painter during this early period. Monet knew Fantin and Manet, both men who figure in Whistler's circle, and all four painters had an interest in the art of Japan. Monet seems to have visited Whistler in London in 1870–1. The two artists might have connected even more firmly had Whistler accepted Degas's invitation to participate in the group exhibition of independent artists that launched the Impressionist movement in 1874.[6]

Degas had praised Whistler's work as early as 1867, when Fantin reported to Whistler that Degas had complimented his *Symphony in White, No. 3* (1865–7; Barber Institute of Fine Arts, Birmingham, U.K.). Their respect was mutual and long-lasting: in 1898, Whistler is said to have remarked: 'as far as painting is concerned, there is only Degas and myself.' Whistler and Degas held similar attitudes about art, both believing in the superiority of the hand and mind of the artist over mere vision. Nature was a source of inspiration, but one that should be improved rather than replicated. Both men prized their personal freedom and the independence of their art from any prescribed school, they shared a keen intelligence and a sharp wit, their friends and associates overlapped considerably, and they saw one another as frequently as they could. There is evidence to suggest that Whistler's admiration for Degas was based, at least in part, on his recognition that in the French painter he had found his intellectual and artistic equal, a feeling the American seldom allowed himself to experience. 'I never come to Paris without making great efforts to find you,' Whistler wrote to Degas in 1889.[7]

For most Americans, life in Paris during the 1860s and 1870s was more bewildering than it had been for Whistler. They muddled along on the advice of friends and the notes in their Baedeker's or Murray's guides. Thomas Eakins, for example, even though he knew French,

arrived in Paris in the autumn of 1866 and checked into a hotel near the Louvre. He then spent considerable time and effort dealing with incessant bureaucratic details that delayed his entry into the Ecole des Beaux-Arts; few Americans had preceded him and he had little guidance, but his success paved the way for others in later years.[8] Eakins's letters home also provide an account of the dramatic changes taking place in Paris, both physical and political.

Eakins was in Paris before the 1870 outbreak of the Franco-Prussian War, which put an end to artistic activities for two years, although American diplomats stayed in the city and set up a field hospital. The war and the Commune that followed it ravaged large parts of Paris.[9] When peace returned, ambitious rebuilding began, some funded by contributions from the United States in recognition of the old alliance between the nations. By 1873, composer Jacques Offenbach had revived his light opera *La Vie Parisienne*, which gently satirised the sensual pleasures of Paris and included several rounds of the famous can-can. In 1875–6, he brought *La Vie Parisienne* to the United States, conducting it in Philadelphia at the Centennial celebration and in New York at the Booth Theatre. Perhaps as much as anything, the popular musical convinced Americans that Paris was alive and kicking.

Aspiring American painters quickly returned to the French capital after the war, and their increasing numbers made their experiences easier. Some wrote letters home that were published in local newspapers, and books and articles tailored to the art student began to appear, including information about where and how to make a home in Paris. Among the earliest was May Alcott Nieriker's *Studying Art Abroad and How to Do it Cheaply*, published in 1879; it offered tips, particularly for women, starting with the kind of trunk they should purchase and how to pack it. Nieriker recommended renting an apartment rather than staying in a hotel, advising that 'the real French way of doing it' was the most advantageous, particularly since one's furnishings and bric-a-brac, preferably bought inexpensively at a Drouot auction, could be brought home duty-free if they were declared 'artist's tools of trade'. For those with smaller budgets, a furnished room was a frugal choice, with meals to be taken at modest neighbourhood establishments. 'It may have a somewhat homeless sound', Nieriker wrote, 'yet the French live so entirely in the theatres, the cafés, and on the boulevards that a stranger looks in vain for anything corresponding to an English or American home' (cats 27, 28 and 29). Acceptable pensions were listed, including an enterprising establishment on the avenue de l'Alma that included French lessons in the price of room and board.[10]

Despite the status of French as the language of international diplomacy in upper-class circles, many Americans arrived in Paris without speaking a word of it. Those who did were much more likely to interact with French art, artists and society. Whistler, Cassatt and Sargent were not only more interested in modern French painting than many of their compatriots, but it was also much more accessible to them; they were all able to converse and correspond easily with their French colleagues. Eakins also knew French well, showing off to his sister by writing to her in

27 NELSON NORRIS BICKFORD
In the Tuileries Garden, Paris, 1881
Oil on panel, 30.5 x 40.6 cm (12 x 16 in.)
The Metropolitan Museum of Art, New York
Promised gift of The Hon. Marilyn L. Mennello and Michael A. Mennello

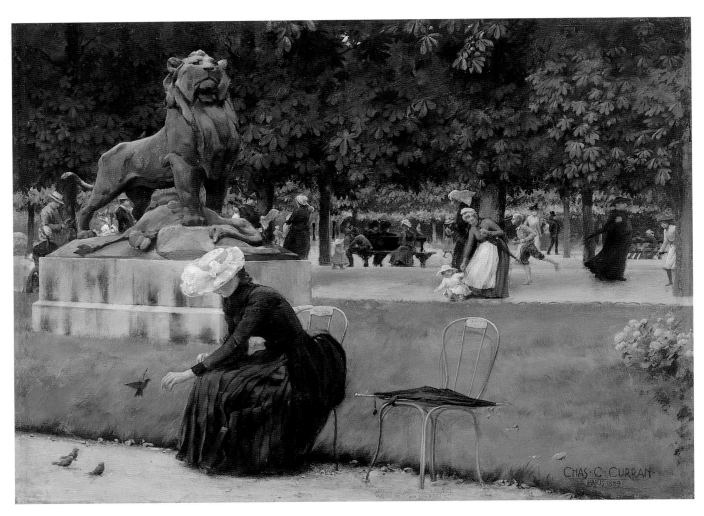

28 CHARLES COURTNEY CURRAN
In the Luxembourg Garden, 1889
Oil on panel, 23.3 x 31.1 cm (9³⁄₁₆ x 12¼ in.)
Terra Foundation for American Art, Chicago, Illinois
Daniel J. Terra Collection (1992.167)

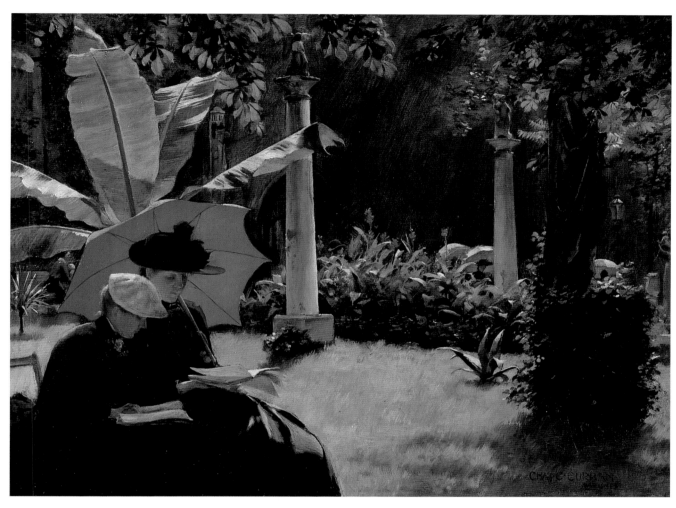

29 CHARLES COURTNEY CURRAN
Afternoon in the Cluny Garden, Paris, 1889
Oil on panel, 22.9 x 30.5 cm (9¼ x 12 in.)
Fine Arts Museums of San Francisco, California
Bequest of Constance Coleman Richardson (2002.55)

'le bon vieulx français', using old-style grammar and spelling.[11] He had different aesthetic standards from those of his expatriate colleagues, but his language skills, like theirs, allowed him a more intimate relationship with his French associates, and he corresponded with Jean-Léon Gérôme, his mentor and teacher at the Ecole, for some years after his return to Philadelphia.

For the many aspiring artists who did not know French, the learning curve was steep. Ernest Wadsworth Longfellow, son of the poet and a painter, recalled his feeling upon arrival in France in 1865 that all the children there seemed 'wonderfully clever to speak French so well', and that his own efforts to communicate 'went nowhere'. James Carroll Beckwith 'could understand nothing' and admitted that he 'used up' what little French he had on the way from Calais to Paris in 1873. Beckwith applied himself to study language along with art, and soon his diary entries were sprinkled with French: 'I am making rapid strides . . . living in an entirely French maison I have plenty of practice.' Julian Alden Weir hired a tutor, seeking to improve both his daily life and his studies, although he lamented his slow progress in both. Edmund Tarbell wrote to his fiancée in Boston in 1884, describing the helplessness so many Americans encountered:

> Paris [was] much pleasanter than London [but] it seems so queer not to be able to make yourself understood. We have to point to things on the bill of fare, which is rather an amusing way of ordering one's dinner don't you think? . . . I have just had an interview with the fellow who has charge of the rooms at the hotel as to what time the dinner was served. It was very funny: first he tried to tell me in words and then with signs and finally by sticking up six fingers and then crossing one which I suppose means 6:30. [12]

Tarbell's experiences are typical of those of many American painters in Paris who wrote home with a disarming combination of amusement and despair over their inability to interact on an adult level with anyone except their fellow countrymen and British colleagues.

These concerns affected both domestic and professional affairs. For example, Longfellow, the only American in a group of men studying with Ernest Hébert in the 1860s, remembered that he had relatively little to do with his classmates, since he could not communicate effectively in French and few of them spoke any English.[13] In consequence, many Americans stuck together, rooming, sometimes in pairs or trios, in inexpensive areas of Paris where the most thrifty could hold their costs to about 40 dollars a month. Large communities of Americans developed along the rue Notre Dame des Champs, in the small streets near the Ecole des Beaux-Arts and in the neighbourhoods near the passage des Panoramas, where the Académie Julian held classes. Women artists were even more apt to stay together, sometimes at establishments like the Villa des Dames, a hotel for women on the Left Bank, or in dedicated pensions, like the one Cecilia Beaux shared in 1888, well guarded by a severe elderly landlady and her tiny old dog. It

reassured their families that there was safety in numbers, for Americans were convinced that Paris, with all of its pleasures, was wicked. 'Don't go off exploring on your own, you will never be taken for an old married woman . . . by those vicious frenchmen!' cautioned one nervous mother to her departing daughter.[14]

Sharing rooms was also less expensive and provided an antidote to the homesickness many young adventurers experienced. Together, American rituals could be observed, including the Fourth of July and Thanksgiving. Weir told his mother that on 4 July 1874, 'we students of the land of the free will dine together', and the next year he was awakened on Independence Day to the chorus of 'Yankee Doodle' sung, after a fashion, by his Scandinavian room-mate, painter Albert Edelfelt, who marched into the room with an American flag. Elizabeth Gardner advised her family that on 14 July 1882, the French national holiday, she had put out 'the biggest flag in the street . . . the Stars and Stripes'. May Alcott (later Nieriker) wrote home from the rue Mansart that she and her room-mates had not forgotten Thanksgiving: 'We had a turkey of noble proportions . . . [it] proved a *pièce de resistance* . . . eagerly devoured by three jolly spinsters.'[15]

Many Americans spent much of their time with each other, comfortable in their shared experiences and relieved to be able to speak English. Friends Weir and Beckwith describe in their voluminous letters and diaries a variety of social engagements, many with fellow citizens. While they adapted a French schedule of meals, taking 'a bowl of coffee or chocolate and a piece of bread at seven, and at half past twelve . . . breakfast, and dinner at six', they occasionally submitted to their fondness for an American restaurant, which offered buckwheat pancakes and molasses.[16] Recent arrivals in the city were listed in the *American Register*, a weekly newspaper that served the expatriate community, and visitors treated their relatives and friends in Paris to meals and evenings on the town. Weir and Beckwith regretted the time such engagements took from their art, but they appreciated direct news from home and often benefited from the connections they made through such encounters. They also met frequently with fellow students at inexpensive restaurants near the Ecole des Beaux-Arts. As their skills in conversational French improved, their circles widened. Weir learned quickly – the only common language between him and his room-mate Edelfelt was French – and within a year he was socialising with aspiring painters from a number of different countries, all of them drawn to Paris, including the French artists Jules Bastien-Lepage and Pascal Dagnan-Bouveret.

Certain more established American artists made their homes gathering places for this growing expatriate community. G. P. A. Healy, for example, a former student and friend of Couture's and a prominent portraitist and history painter, lived in Paris for extended periods. Genial, fluent in French and a Roman Catholic, Healy moved easily in French society. During the 1870s and 1880s both Healy and his daughter Mary Healy Bigot held salons, receptions and balls which drew Americans together and made them feel at home. Weir attended Healy's

receptions in 1874, and May Alcott reported that during her visit 'this afternoon they gave us a cup of tea and talked about Paris and Art'[17] (see cat. 30).

The wealthy collector William Hood Stewart, father of painter Julius Stewart, also held popular receptions, mostly for artists, every Sunday morning at his elegant home on the avenue d'Iéna. The participants, linked together by style and taste rather than by nationality, included Spanish, Italian, American and French painters, among them Raimundo de Madrazo and Martin Rico, Giuseppe De Nittis and Giovanni Boldini, Julius Stewart and Robert Wylie, Gérôme and Ernest Meissonier. Among the Americans who visited in the early 1870s was Cassatt, fresh from her visit to Spain. Critic John C. Van Dyke related that 'art and artists were almost always discussed, and very intelligently, from very different points of view'.[18] In this company, surrounded by Stewart's impressive collection of paintings by artists such as Fortuny, Meissonier and Gérôme, the Barbizon school was dismissed with a shrug and Manet was reviled, proving that the opinions of Americans about art were as divided in Paris as they were at home.

There were also important society hostesses. Henrietta Reubell, characterised by British artist William Rothenstein as 'a maiden lady, with a shrewd and original mind', held regular receptions at her home at 42 avenue Gabriel. She knew John Singer Sargent, Henry James, the Edward Boit family, Whistler and Oscar Wilde, and she mixed and matched her guests, providing introductions for new arrivals. Rothenstein described her as:

> a striking figure, with her bright red hair . . . in face and figure she reminded me of Queen Elizabeth – if one can imagine an Elizabeth with an American accent and a high, shrill voice like a parrot's. All that was distinguished in French, English and American society came at one time or another to her apartment . . . she was adept at bringing out the most entertaining qualities of the guests at her table. She would often ask us to meet people whom she felt we would like, or who she thought might be of use.

James came to call Reubell 'la grande Mademoiselle', corresponding with her for years and using her as the model for Miss Barrace in his 1903 novel *The Ambassadors*. She, in turn, introduced him to Sargent.[19]

The expatriates also came into contact with one another at church. Beckwith and Weir, for example, worshipped, often together, every Sunday, Weir promising his father that he would not work on the Sabbath. An American chapel, where Protestant services were given in English, had been established in Paris in the 1830s, and eventually the community divided into two congregations, the non-denominational Protestant American Church and the Episcopal American Cathedral of the Holy Trinity. With a new building in 1886, the American Cathedral became an important social centre. Many of the Americans who commissioned portraits from Sargent in the 1880s were members, among them Daisy White (see cat. 32) and the Boits (see

30 MARY CASSATT
The Cup of Tea, about 1879
Oil on canvas, 92.4 x 65.4 cm (36⅜ x 25¾ in.)
The Metropolitan Museum of Art, New York
From the Collection of James Stillman, Gift of Dr Ernest G. Stillman, 1922 (22.16.17)

31 JULIUS LEBLANC STEWART
Woman in an Interior, 1895
Oil on canvas, 91.4 x 64.8 cm (36 x 25 ½ in.)
Private collection

cat. 33). Sargent himself had been confirmed at the cathedral in 1874, and Cassatt buried her father from it in 1891.[20]

By the 1890s, the permanent colony of Americans in Paris was described as 'a little city within a big one – having its own social cliques and customs, its charities, clubs, churches, shops, and pensions'.[21] It had been developing ever since 1763, when the Treaty of Paris brought an end to the Seven Years (French and Indian) War; it grew stronger in the 1770s with the military alliance between France and the American Revolutionary cause and diplomatic missions from Benjamin Franklin and Thomas Jefferson. After the Civil War, the American colony still included politicians and diplomats, but increasingly it was composed of business-men, entrepreneurs and the very wealthy, who favoured the city's social sophistication and the availability of the latest fashions. Painter Edward Simmons called it a 'transplanted America, vulgar with luxury'. John C. Van Dyke described one Wall Street financier in residence in an apartment on the Place Vendôme as a man immune to his aesthetic surroundings, 'engaged by day in cutting out plans for corporate combinations and by night dining at the Pied de Mouton [or] the Tour d'Argent'.[22]

As the colony grew, it became more disparate and inclined to gossip, both local and intercontinental. Elizabeth Gardner reported: 'it is difficult to sneeze in the American Colony without being heard on the other side of the Atlantic.' Membership was not only a matter of longevity, social position and income – it was also distinctly a matter of preference. Childe Hassam seems to have ignored it intentionally during the years he spent in Paris, recalling that he met no one: 'we lived among French people, spoke French . . . and we wanted to speak French.'[23] Likewise Cassatt, who with her wealthy and well-connected brother Alexander (see cat. 101) could have been unquestionably at the core of the colony, had no patience for it and kept it at arm's length. Her father explained that they did not encounter many Americans in Paris, for 'we do not go to either of the chapels or in any way court the *Colony*'. Nevertheless, he noted proudly that among the French, his daughter's 'circle among artists & litterary [*sic*] people is constantly extending', adding, 'she enjoys a reputation among them not only as an artist – but also for liter-ary taste & knowledge & which moreover she deserves for she is uncommonly well read especially in French literature'.[24] For Cassatt, the American colony was a distraction that above all else threatened to keep her from her work.

A number of artists, most of them socially well connected and conservative in style, did court the colony (fig. 7). These included Elizabeth Gardner, who was from an old merchant family in Portsmouth, New Hampshire; Charles Sprague Pearce, with distinguished roots in Boston's China trade; and Julius LeBlanc Stewart, heir to his father William Hood Stewart's sugar fortune (cat. 31). Gardner found the colony's connections a valuable asset to her as she marketed her work. Pearce moved easily through expatriate circles, serving on several official committees and juries. Stewart likewise prospered within the colony. Stewart's work achieved

Fig. 7 Charles Dana Gibson (1867–1944)
The American Colony is not Wicked
Illustration from Davis 1895

little notice until he exhibited a series of pictures that depicted Parisian society, giving his audiences a glimpse into a world of fashion and celebrity. Stewart 'paints the festivals and the diversions in which he shares', wrote one critic, noting that 'his great ladies are real great ladies of the Salons; his dandies are real dandies of the Boulevard and the clubs'.[25] A number of Stewart's canvases depict the circle of his expatriate friend James Gordon Bennett, the autocratic, wealthy and extravagant publisher of the *New York Herald*. Bennett started a Paris edition of his paper in which the parties, costumes and *bon mots* of the American colony were assiduously recorded and devotedly read. Stewart's images served as their visual equivalent. Like the French painters James Tissot, Alfred Stevens and his friends Jean Béraud and Henri Gervex (also a friend of Bennett's), Stewart included identifiable portraits in his genre scenes, inextricably linking his paintings to the fortunes of his sitters. Some critics of Stewart's work reveal their inability to separate the real people depicted from the work of art; as one remarked, they were 'pretty picture[s] of the world's airy nothings'.[26] Stewart, secure and well connected, seemed undeterred by such comments. He did not need to earn a living from his art, although he did paint portraits for members of his social

Fig. 8 Sargent in his studio in Paris, 41 boulevard Berthier, about 1884
From Photographs of Artists, Collection I, Archives of American Art,
Smithsonian Institution, Washington, D.C.

32 JOHN SINGER SARGENT
Mrs Henry White (Margaret Stuyvesant Rutherfurd), 1883
Oil on canvas, 221 x 139.7 cm (87 x 55 in.)
Corcoran Gallery of Art, Washington, D.C.
Gift of John Campbell White (49.4)

circle, both French and American. But this conflation of life and art profoundly affected another recorder of high society, John Singer Sargent (fig. 8).

Sargent straddled two worlds in Paris, both the expatriate colony and a sophisticated circle of French artists and writers. He lived in the city for about 10 years and his professional and social success led more than one observer to consider him a member of the French school. Sargent, although much younger in age, was, like Whistler, Eakins and Cassatt, completely fluent in both spoken and written French, an asset that eased his assimilation into Parisian life. Sargent was also spared the loneliness that frequently coloured the experiences of his compatriots, for (as Cassatt's would do) his family had settled with him in Paris in 1874. Weir frequented the Sargent household in 1875, describing them as 'the most highly educated and agreeable people I have ever met'.[27] Sargent's parents eventually resumed their peripatetic lifestyle, but he was easily able to visit them in Caen, Brittany or Nice. Born and raised in Europe, cosmopolitan by nature, and physically near to his close-knit family, Sargent made himself completely at home in Paris.

Beginning in October 1875, Sargent shared a studio with Beckwith on the rue Notre Dame des Champs and devoted himself to his studies, astonishing his classmates in Carolus-Duran's studio with his abilities. His early work consists of portraits of fellow students and of American visitors and expatriates. He also began to paint for a more international circle of Parisians. Among his earliest sitters were the French poet and playwright Edouard Pailleron, his wife and his children; Pailleron's mother-in-law Mme François Buloz, wife of the editor of *Revue des deux mondes*; aristocratic soldier Jean-Guy de Poillöe and his wife; Swiss merchant Edward Burckhardt, his wife and daughter Louise; Mme Subercaseaux, wife of the Chilean consul to Paris; and the French physician and collector Samuel Pozzi. Sargent was also interested in modern art and artists, and at this same time he became well acquainted with lithographer Albert de Belleroche, painters Albert Besnard and Jean-Charles Cazin, portraitist and illustrator Paul Helleu, Blanche, Monet and Auguste Rodin, most of whom appear in the informal portraits Sargent made during the 1880s and who would help him maintain connections to Paris throughout his career. Sargent's work also suggests links, if not documented friendships, with Whistler and Degas.

Sargent was a portraitist, and through his work in that genre he was inextricably attached to the American colony. Several of his Salon submissions depict Americans in Paris. In 1882, he painted the four young daughters of Edward and Louisa Boit, good friends of both Henrietta Reubell and Henry James, in the foyer of their elegant apartment on the avenue de Friedland (cat. 33). Boit was a lawyer-turned-painter, his wife a vivacious and genial woman from a wealthy New England family. They had first visited Paris in 1867, when Edward confessed in his diary that the city's 'grandeur grows on me daily'.[28] After some years in Boston and Rome, and several summers in Brittany and Normandy, the Boit family settled in Paris in about 1878.

33 JOHN SINGER SARGENT
The Daughters of Edward Darley Boit, 1882
Oil on canvas, 221.9 x 222.6 cm (87⅜ x 87⅝ in.)
Museum of Fine Arts, Boston, Massachusetts
Gift of Mary Louisa Boit, Julia Overing Boit, Jane Hubbard Boit and Florence D. Boit
in memory of their father, Edward Darley Boit (19.124)

Sargent's large painting of the four girls, which he first displayed as *Portraits d'enfants* at the luxurious Galerie Georges Petit in late 1882, was his most ambitious portrait to date, and its large scale and the unusual arrangement of the figures suggest that he had more than a simple likeness in mind. It is apparent that he had sympathetic patrons in Mr and Mrs Boit, for they allowed the features of their eldest daughter, Florence, to be entirely obscured – an unusual attribute for a portrait and probably a reflection of Sargent's larger aspirations for the painting. Many of the early reviews discuss it as a genre scene, an image of children interrupted at play, the shadowed foyer of the apartment lending an air of mystery to their game. Sargent based the composition on both the example of Velàzquez's *Las Meninas* (1656; Museo del Prado, Madrid), which he had copied in Spain in 1879, and on a series of interiors he had been painting in Venice, which share the subdued palette and stage-like setting of the Boit portrait.

Sargent's image is distinctly different from most of the portraits of children that were shown in Paris in the early 1880s.[29] James considered it instead a 'view of a rich, dim, rather generalised French interior (the perspective of a hall with a shining floor, where screens and tall Japanese vases shimmer and loom) which encloses the life and seems to form the happy play-world of a family of charming children'.[30] Sargent's compatriot and fellow Philadelphian Mary Cassatt had also painted a Parisian interior with an unselfconscious child which, when first exhibited in 1879, was titled *Portrait de petite fille* (cat. 34). Both of these interiors are lit from windows at the back, both depict comfortable bourgeois rooms, both are informal and employ an arbitrary arrangement of figures and furnishings, and both avoid narrative. Yet the two pictures, so similar in subject, show vast differences in style and intent. As unusual as his large canvas was, Sargent sought success within the conventions of art and society. He solicited attention, but not disapproval. Cassatt painted for herself, and the jurors of the American section of the 1878 Exposition Universelle rejected her canvas, no doubt offended by its lack of finish and its unusually distorted perspective. Sargent may have seen it when Cassatt showed it in 1879 in the fourth Impressionist exhibition.

In 1883 Sargent returned to the American colony for his subjects and completed portraits of two American women, Mrs Henry White (cat. 32) and Mme Pierre Gautreau (cat. 35), each a well-known figure in Parisian upper-class circles. It is perhaps not coincidental that during this same year Sargent moved from his crowded studio lodgings along the rue Notre Dame des Champs to a choice address on the boulevard Berthier, a few blocks from the Gautreaus in a fashionable and wealthy new neighbourhood. Here, as the writer Jules Claretie described it, lived 'the artist in white tie, painting in tails, the businessman who makes as much commerce in the salons [of fashion] he attends as in the Salon [of art] where he exhibits'.[31] Sargent's address reflected his ambitions, just as his elegant sitters did.

Sargent planned to show this pair of complementary portraits at the Salon of 1883, both of Americans in Paris, one in white and one in black, but delays in completing the pictures

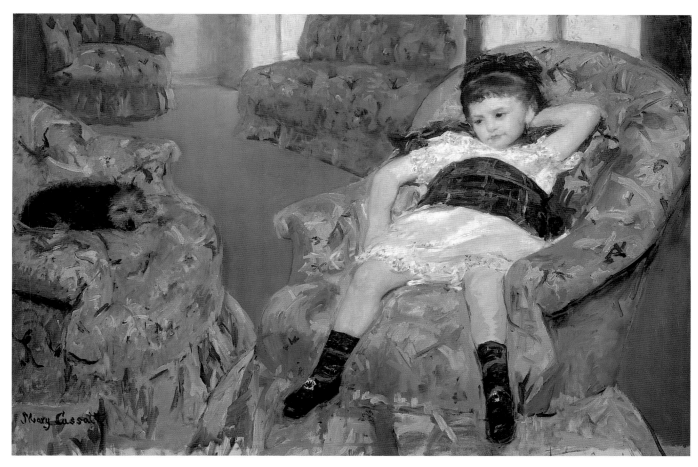

34 MARY CASSATT
Little Girl in a Blue Armchair, 1878
Oil on canvas, 89.5 x 129.8 cm (35½ x 51⅛ in.)
National Gallery of Art, Washington, D.C.
Collection of Mr and Mrs Paul Mellon, 1983 (1983.1.18)

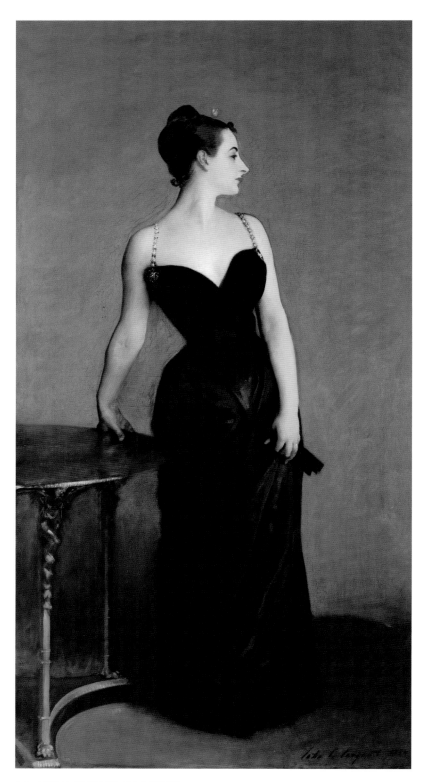

35 JOHN SINGER SARGENT
Madame X (*Madame Pierre Gautreau*), 1883–4
Oil on canvas, 208.6 x 109.9 cm (82⅛ x 43¼ in.)
The Metropolitan Museum of Art, New York
Arthur Hoppock Hearn Fund, 1916 (16.53)

postponed his strategy for a year. 'I have been brushing away at both of you for the last three weeks,' Sargent wrote to Daisy White in March 1883, 'in a horrible state of anxiety'. The Whites had commissioned Sargent after admiring his portraits at the Salon. Henry White, who selected Léon Bonnat to paint his own portrait, was a diplomat; his wife was described in a letter by Henry James as 'very handsome, young, rich, splendid [and she] has never read a book in her life'.[32] Sargent depicted her in an elegant white gown holding a fan in one hand and opera glasses in the other, as if she were about to leave for an evening entertainment. When the portrait was displayed in Paris for the second time, in May 1885 at the Galerie Georges Petit, critic Alfred de Lostalot described it in the *Gazette des Beaux-Arts* as 'a little empty', and one has the sense that it was to both sitter and painting that he referred.[33]

This conflation by critics of subject and object – sitter and painting – was commonplace, and with his portrait of Virginie Avegno Gautreau, *Madame X* (cat. 35), Sargent suffered double jeopardy. His transgressions against contemporary fashions in portraiture have been much discussed, but it is equally relevant that Sargent's American sitter was so notorious in French society that critics probably could not wait to say of her portrait what they would never say to her face. Vernon Lee described the painting at the Salon as 'surrounded by shoals of astonished and jibing women'. Mme Gautreau was a celebrated and self-conscious belle. Edward Simmons, then a student at the Académie Julian, described her in 1879–80:

> I remember seeing Madame De Gautrot [*sic*], the noted beauty of the day, and could not help stalking her as one does a deer. Representing a type that never has appealed to me (black as spades and white as milk), she thrilled me by the very movement of her body. She walked as Vergil speaks of goddesses – sliding – and seemed to take no steps. Her head and neck undulated like that of a young doe, and something about her gave you the impression of infinite proportion, infinite grace, and infinite balance. Every artist wanted to make her in marble or paint.[34]

Sargent was similarly entranced and he pursued Gautreau, no doubt with the Salon in mind, eventually convincing her to let him paint her portrait.

Sargent represented Mme Gautreau as she wanted to be seen – as a quintessential *parisienne*, sophisticated, perfectly groomed, elegantly dressed, urban and independent. The type was well known in popular illustrations, from fashion magazines to satiric commentary. Tissot was about to embark on a series of images of the refined women of Paris and Charles Giron's *Parisienne*, painted the same year as Mme Gautreau, shows a black-garbed woman with her head similarly turned to show off her beautiful profile

Fig. 9 Charles Giron (1850–1914)
Femme aux gants ('La Parisienne'), 1883
Oil on canvas, 200 x 91 cm.
Petit Palais, Musée des Beaux-Arts de la Ville de Paris (PPP3587)

(fig. 9). But what was one to make of a *parisienne* who was not French? A premonition of the hostile reception accorded to Sargent's portrait appeared in 1881 in the society journal *L'Illustration*. Cynical (if humorous) words were sparked when an American horse won the Grand Prix at Longchamp for the first time:

> I know, since the victory of Foxhall, one determined [French] patriot who can no longer, without a lot of grumbling, say the name America. He finds the Yankees a bit unbecoming . . . They have painters who carry off our medals, like Mr. Sargent, beautiful women who eclipse ours, like Mme. Gauthereau [*sic*], and horses that beat our steeds . . . It is a peaceful war, but they come to hoist their victory colours over our land.[35]

Sargent and Mme Gautreau had similar aims: they both wanted to be the best, not just in the American colony but in all of Paris. To a great extent they both succeeded, but there was one obstacle they could not conquer. They could never truly be French.

The most French of all the American painters in Paris was perhaps Mary Cassatt. She had first settled in 1874 near the place Pigalle in Montmartre, an area densely populated with artists. By 1884 she had moved to the prestigious 8th arrondissement, an elegant neighbourhood that became her permanent address. Cassatt's family had lived with her in Paris since 1877, and together with them, she made a comfortable home that would become the subject of many of her greatest paintings (cats 36, 37, 38, 48 and 101). At first Cassatt essayed the Salon system, submitting her work regularly until 1876, but the following year, when her paintings were rejected, she chose a different path. When Degas invited her to participate in the exhibitions of the Impressionists, she eagerly accepted, becoming the only American to be an 'official' member of the French movement.

Cassatt had deep and long-lasting friendships with many of the Impressionist painters, particularly with Pissarro and with Degas, who captured her as a fashionable spectator at the Louvre in a number of paintings, pastels and prints (fig. 1). Cassatt, like Whistler, was Degas's intellectual equal. She also was his peer financially and socially, and like him, she was singularly devoted to art, a calling that superseded any desire for conventional family life. Their spirited, sometimes even fierce, relationship was stimulating to them both. 'She has infinite talent', Degas remarked of Cassatt, while she recalled that Degas 'was magnificent, and however dreadful he was, he always lived up to his ideals'.[36] It was her highest praise.

Cassatt thrived in Paris, where the art scene was large enough to support a variety of styles and points of view, something that would not happen in the United States until after the turn of the century, and then only in New York. She exhibited on both sides of the Atlantic, but her favoured dealers were French and most of her American patrons had Paris connections: Louisine Havemeyer, who made frequent trips to the French capital; financier James Stillman, who lived in a large *hôtel particulier* overlooking the Parc Monceau; collector George Lucas,

36 MARY CASSATT
Reading Le Figaro (*Portrait of a Lady*), 1878
Oil on canvas, 104 x 83.7 cm (41 x 33 in.)
Private collection

37 MARY CASSATT
Mrs Robert S. Cassatt, the Artist's Mother (*Katherine Kelso Johnston Cassatt*), about 1889
Oil on canvas, 96.5 x 68.6 cm (38 x 27 in.)
Fine Arts Museums of San Francisco, California
Museum Purchase, William H. Noble Bequest Fund (1979.35)

38 MARY CASSATT
The Tea, about 1880
Oil on canvas, 64.8 x 92.1 cm (25½ x 36¼ in.)
Museum of Fine Arts, Boston, Massachusetts
M. Theresa B. Hopkins Fund (42.178)

who spent 50 years in Paris and lived near the Etoile; and Sarah Sears, who spent several years in a grand apartment on the place de l'Alma near Cassatt's home (and who formerly owned cat. 41 among other works). Cassatt was hospitable to visitors, but she guarded both her privacy and her independence. In Paris she was able to craft a singular career. Despite the fact that her work was rapidly entering collections in America, Cassatt felt that she could only have created it in Paris. 'After all give me France', she wrote to her friend Sara Hallowell. 'Women do not have to fight for recognition here, if they do serious work.'[37]

Many women artists found that Paris provided them with a chance to work as professionals that they would not have had in America. May Alcott, who had married Swiss businessman Ernest Nieriker and moved to the picturesque suburb of Meudon, explained that she meant 'to combine painting and family, and show that it is a possibility if *let alone*'. She added: 'in America this cannot be done, but foreign life is so simple and free, we can live for our own comfort not for company.' Her words echo those of Elizabeth Gardner, who had reported to her sister in 1865 that she and her fellow women students 'hire our own models, buy our own *charbon*, and do just as we please'.[38] American women artists found unprecedented autonomy in Paris, for not only had they escaped the strictures of their own society, but as foreigners, they were also free from the customs and rules of behaviour that applied to French women.

Conservative in her painting style, Gardner was more unconventional in other ways than most American women artists in Paris, who felt that they were testing social boundaries enough simply by choosing a professional career. Mary French, the wife of American sculptor Daniel Chester French, recalled 'interesting memories . . . of [William] Bouguereau's studio, where we used to go often, and where was also Miss Jennie Gardner, of Exeter, New Hampshire, whom he either married or didn't marry – I have forgotten the details. There was a certain glamour about that young woman of Puritan birth, a contemporary of my Puritan aunts, living there in the Latin Quarter, and doing something that all Paris talked about'.[39]

All Paris doubtless talked about more than Gardner's art. Gardner's abilities in several languages – English, French, German and Italian – eased her social circumstances and, as she confessed to her sister in 1865, 'we find no lack of gentlemen's society'.[40] In 1873, following in the footsteps of the admired *animalier* Rosa Bonheur, Gardner applied to the police for permission to wear male clothing, and was thus able to gain access to the government-run drawing classes at the Gobelin tapestry school. Six years later, she announced to her family her engagement to Bouguereau, one of the leading academic painters in Paris. But, she added: 'neither of us wish to be married at present', noting 'I have long been accustomed to my freedom'. She confessed that although their styles were similar, 'I wish to paint by myself a while longer'. In fact, the couple remained unwed for 17 years, in large part waiting for Bouguereau's 'peevish, tyrannical' mother, who disapproved of their union, to pass away. 'My friends here have all been lovely and not inquisitive. They think it a splendid thing for me and take it for granted that people of

our years and position may manage our private affairs as we think best', Gardner added, perhaps betraying with these words the extent to which she had adapted to French society.[41]

During this time Gardner painted significant works for public exhibition (including *The Shepherd David*, cat. 17), small portraits and pictures she described as 'little pot boilers, small canvases for sale'.[42] She supported herself successfully, occasionally forwarding money home to her family. She was knowledgeable about business and the art market, nurturing connections with dealers and collectors and holding receptions and matinées in her studio before sending her most recent work to the Salon. Before one such event, she told her sister that all the 'Big Bugs' had accepted her invitation, and that Mrs General Nathaniel Banks, wife of the Massachusetts war hero and politician, would serve as her chaperone.[43] Gardner cultivated the press and she socialised frequently, making calls and attending fashionable dinners and receptions, keeping up her many American contacts. These social networks led to sales and commissions. Gardner also conscientiously maintained ties to the United States, sending paintings to Boston and New York for exhibition and accepting orders from American dealers.

Unlike Cassatt, who often longed for serious attention from collectors in Europe and seemed annoyed that her dealer, Durand-Ruel, marketed so much of her work to the United States, Gardner was happy to sell to Americans. 'Many strangers [foreigners] are coming over and I hope they will bring plenty of money . . . I am very well and very hopeful', Gardner wrote to her brother.[44] Without altering her polished academic style, she added American subjects to her work, painting Priscillas and Evangelines from the verses of Longfellow in addition to her picturesque peasants and classical figures. As the 1880s progressed, she had more orders than she could easily fill.

Gardner's cultivation of the American expatriate community in Paris stands in marked contrast to the career of Elizabeth Nourse, her compatriot, acquaintance and (at one point) neighbour on the rue Notre Dame des Champs (fig. 10). Nourse lived in Paris for almost 50 years, but her name seldom appears in the abundant correspondence and reminiscences of the period. More humble and retiring, she apparently wanted little to do with the circle of upper-class patrons, art dealers and critics whom Gardner cultivated. Among her closest friends in Paris were the women she had met at the Académie Julian in 1887, but she also corresponded with French painters whom she befriended and admired, including Besnard, Dagnan-Bouveret, Cazin and the sculptor Rodin, all of whom linked American and French art circles. Despite her long residency in Paris and her success in both the new and old Salon shows, Nourse sold most of her paintings to American collectors.

Fig. 10 Elizabeth Nourse in her first studio in Paris, 1888
Photograph from the Nourse scrapbooks, Nourse Papers
Private collection. Courtesy of the Cincinnati Art Museum, Ohio

When she embarked for Paris in the summer of 1887, Nourse wrote in her journal 'there is so much to see and do before we come back and then,' she added wistfully, 'will we ever come back?'[45] She travelled with her sister Louise, who would, as Lydia Cassatt had done for her own sister, provide her with suitable companionship and help with her domestic and professional obligations. The Nourses adapted quickly to their new home and soon spoke, even to each other, only in French.[46] As a woman artist without many resources or social connections who needed to support herself and her sister through the sale of her work, Nourse was much less likely to take aesthetic risks. She thus set herself distinctly apart from her more famous and adventurous compatriot, Mary Cassatt.

The two women approached things quite differently, despite their shared interest in maternal subjects (cats 39, 40 and 41). They came into contact through the American Women's Art Association and similar groups and they liked each other well enough for Cassatt to give Nourse one of her pastels and to inscribe it 'to my friend Elizabeth Nourse'. Nourse, the academic painter, once served as the president of the Women's Art Association, but Cassatt was frustrated by its conventional rules, later railing against such organisations to Harrison Morris, president of the Pennsylvania Academy, when he had had the temerity to offer her a cash prize. Cassatt, reminding Morris of her connection with the 'Independents' (the Impressionists), wrote: 'I . . . must stick to my principles, our principles, which were, no jury, no medals, no awards.' She explained: 'I have no hopes of converting any one, I even failed in getting the women students' club here to try the effect of freedom for one year.'[47] In Paris, opportunities for exhibition and acclaim were many and varied, allowing painters like Cassatt and Nourse to follow divergent paths to artistic success.

Women were not the only aspiring professionals to find advancement, support and artistic camaraderie in France. The African-American painter Henry Ossawa Tanner (see cat. 13) also discovered Paris to be more hospitable to his ambitions for a career. Although Tanner made frequent and lengthy trips back to the United States, he centred his career in France. 'You are not necessarily ridiculous [in France] just because you differ from the crowd, as you are in America', Edward Simmons would state.[48] Freedom to be judged on one's merits was an important gift.

Tanner arrived in Paris in 1891 to feel like 'a stranger in a strange land'. Like many of his predecessors, he recalled 'how strange it was to have the power of understanding and being understood suddenly withdrawn' from him, for he was as yet unable to speak French. Tanner adapted to Paris fairly easily; it seems as if his difficulties had somewhat less to do with his race than with his strict observance of the Sabbath and his refusal to drink wine, which prevented his full participation in social events.[49] He first settled in an unheated basement studio on the rue de Seine and took his meals out, homesick for a substantial American breakfast. He found companionship with other Americans at an inexpensive local café that advertised 'English

39 ELIZABETH NOURSE
La mère (*Mother and Child*), 1888
Oil on canvas, 116.6 x 81.4 cm (45 ½ x 32 in.)
Cincinnati Art Museum, Ohio
Gift of the Procter & Gamble Company (2003.93)

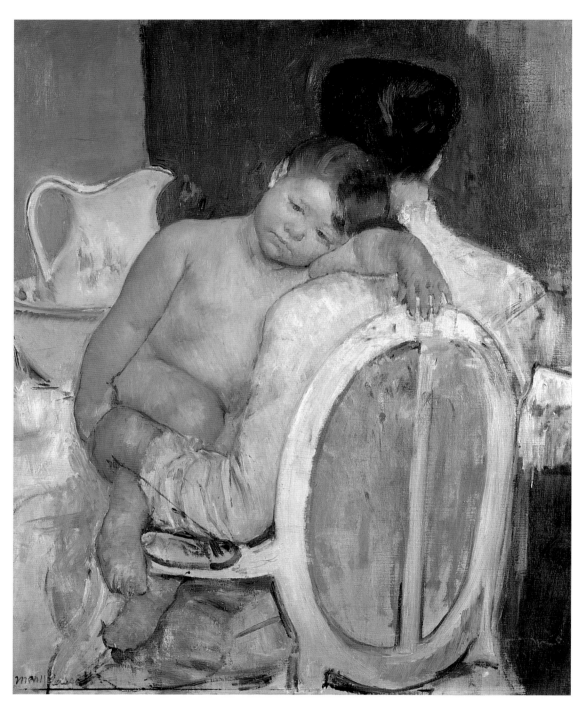

40 MARY CASSATT
Woman holding a Child in her Arms, about 1890
Oil on canvas, 81.5 x 65.5 cm (31½ x 25½ in.)
Museo de Bellas Artes de Bilbao, Spain (82/25)

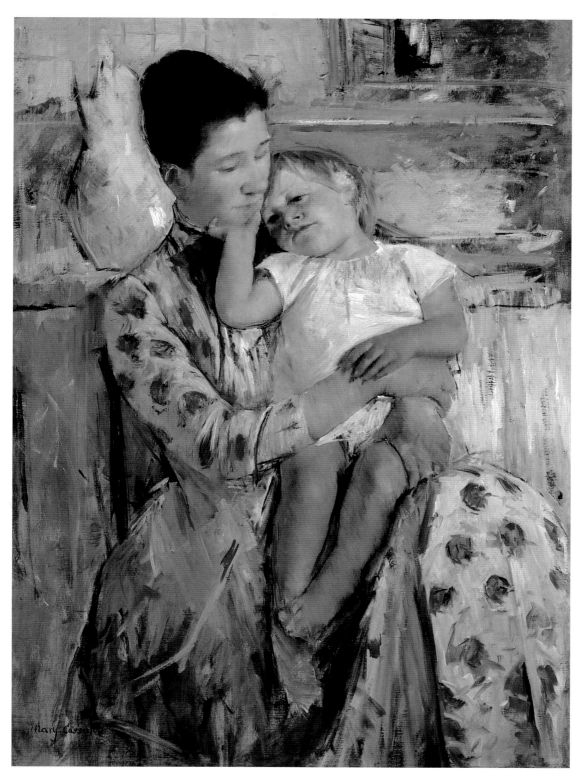

41 MARY CASSATT
Mother and Child, about 1889
Oil on canvas, 90 x 64.5 cm (35⅝ x 25⅜ in.)
Wichita Art Museum, Kansas
The Roland P. Murdock Collection (M.109.53)

spoken', although the cheery proprietor admitted that it was only Tanner's fellow customers who spoke it.

In 1895, with *Daniel in the Lion's Den* (location unknown), a painting he had made based on sketches of the animals at the Jardin des Plantes, Tanner turned to the biblical themes that would earn him the most critical success. Working on a shoestring budget, he stayed in Paris through the summer of 1896, after most artists had left the city and when models could be hired at a cheaper rate. When he showed the *Resurrection of Lazarus* (fig. 11) at the Salon in 1897 he received acclaim in the *Gazette des Beaux-Arts* and was honoured by its selection for the Musée du Luxembourg. A writer for the *Quartier Latin*, the monthly publication of the American Art Association, placed Tanner 'among the envied ranks of the "arrived"'.[50]

Tanner resisted returning to the United States, despite the increasing call from critics at the end of the nineteenth century for American painters to devote themselves to native subjects. 'I refused to come home and paint things I was not drawn to', he remembered, 'nor did I like the idea of quitting the helpful influences by which I was surrounded'.[51] His 'helpful influences' were not only artistic – Tanner also found patrons in Paris, among them Rodman Wanamaker, son of the Philadelphia department store magnate. Wanamaker worked in Paris from 1889 to 1899, selecting luxury goods to export to his family's store, ensuring that the American rage for

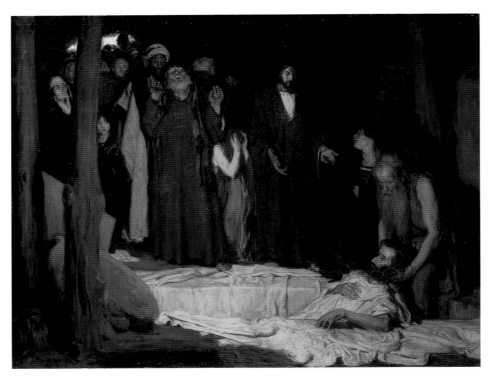

Fig. 11 Henry Ossawa Tanner. *Resurrection of Lazarus*, 1896
Oil on canvas, 94 x 119.4 cm. Musée d'Orsay, Paris (1980-173)

sophisticated French fashion and lingerie would be adequately met. He lived in an elegant apartment on the Champs-Elysées and was a discerning collector and art-lover. Wanamaker helped to found the American Art Association of Paris (fig. 12) in 1890, patronised several American artists and financed Tanner's first trip to the Near East.[52]

Tanner recalled that his adopted city inspired many of his artistic conceits. 'One evening,' he wrote, 'while riding in a jiggling ill-lighted omnibus in Paris, I was struck with the beauty of the effect around me. Inside, the figures dimly lighted with a rich cadmium; outside the cool night with here and there a touch of moonlight. I did not want to paint the interior of an omnibus – so "Judas Covenanting with the High Priest" is the result.'[53] But not all of Tanner's everyday experiences were transformed into religious images. He also painted several intimate views of Paris that capture the lively activity and mutable light of the city (see cat. 52). Along with a number of his American colleagues, he created an enduring sense of place.

Sketching outdoors in Paris was not always easy, although certain Americans made it a speciality. May Alcott Nieriker reported that there were many difficulties, 'from the permission which must be demanded from the authorities, to the impertinent rabble that immediately collects to look over one's shoulder'. Exactly what permissions were required remains to be explored, but Paris streets were busy, and a variety of regulations governed the flow of traffic and prohibited activities that caused obstacles or crowds.[54] Many painters who sought to record

Fig. 12 Members of the American Art Association, including Henry Ossawa Tanner (seated, front row, fourth from left) at the American Arts Club, boulevard Montparnasse, Paris, about 1900
Photograph from the Henry Ossawa Tanner Papers, 1850–1978, Archives of American Art, Smithsonian Institution, Washington, D.C.

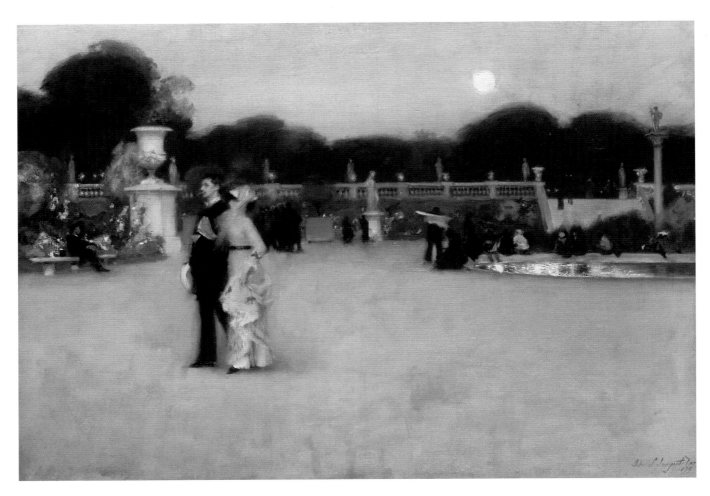

42 JOHN SINGER SARGENT
In the Luxembourg Gardens, 1879
Oil on canvas, 65.7 x 92.4 cm (25⅞ x 36⅜ in.)
Philadelphia Museum of Art, Pennsylvania
The John G. Johnson Collection 1917 (cat. 1080)

the city chose a vantage point from an upper-storey window or selected a view of one of its luxurious parks.

The parks of Paris provided a welcome respite and proved to be an appealing subject for Americans (see cats 2, 27, 28, 29, 42 and 55). The Jardin des Tuileries was described in an 1894 guide as 'the most popular promenade in Paris and the especial paradise of nursemaids and children'; the Luxembourg Gardens were admired for their elegant design and statuary.[55] Weir loved them both, describing the 'beautiful beds of flowers nicely arranged, marble statues amongst the green shrubs and fine bronze fountains throwing up jets of water' at the Tuileries. In 1873 he called the Luxembourg Gardens 'one of the loveliest spots I have seen', adding, 'there are large fountains, fine old trees, beautiful flowers, fine statues, vases, etc, all to make a place attractive and pleasant . . . at sunset one gets as beautiful sights as could be wished for. Last night was grand, the moon was nearly full, the atmosphere clear, and the sky cloudless'.[56] His description predicts the romantic scene of the park that Sargent made six years later, where an elegant couple strolls through the pearly twilight, a full moon reflected in the quiet fountain pool behind them (cat. 42). In subject, the painting recalls the stylish glimpses of Parisian streets and parks of Beraud and De Nittis, but Sargent omitted the blunt specificity of costume and pose that link their imagery so closely to fashion illustration. Instead, he concerned himself with composition, carefully positioning his figures in an almost blank foreground and using their vertical forms to balance the density of anecdotal details that he included in the middle ground – a man reading the newspaper, a boy with a toy sailboat, nursemaids with their distinctive round caps.

The American painter most devoted to images of Paris was Childe Hassam. He was predisposed to make urban views, for he had already earned his reputation with depictions of Boston's streets and parks in the rain and snow, and he continued his fascination with the subject in Paris. Hassam and his wife had settled into a studio and apartment on the boulevard de Clichy at the foot of Montmartre. There he came into contact with his neighbour Frank Boggs, an American expatriate who also specialised in painting Parisian views. Hassam especially favoured the shimmer of paved streets in the rain or as they were softened by snow, he explored the contrast between daylight and the glow of lamps, and he recorded the busy traffic of the grand boulevards, omnibuses piled high with passengers (cats 45 and 46). Like many visitors to Paris, Hassam was also impressed with the artistic arrangement of goods for sale, and in such compositions as *At the Florist* he recorded the vibrant display of autumn flowers, each bunch as perfectly wrapped as the elegant lady who admires them (cat. 43).

Most of Hassam's scenes record everyday events, albeit polite ones, but in 1887 he captured the sophisticated pageantry surrounding the prestigious annual horse race, the Grand Prix (cat. 44). The scene is the Etoile, the centre of 12 converging avenues; just visible at the left is the Arc de Triomphe. Hassam, who enjoyed depicting horses and carriages, painted the steady

43 CHILDE HASSAM
At the Florist, 1889
Oil on canvas, 93.4 x 137.8 cm (36¼ x 54¼ in.)
Chrysler Museum of Art, Norfolk, Virginia
Gift of Walter P. Chrysler, Jr.

44 CHILDE HASSAM
Grand Prix Day, 1887
Oil on canvas, 61.3 x 78.7 cm (24⅛ x 31 in.)
Museum of Fine Arts, Boston, Massachusetts
Ernest Wadsworth Longfellow Fund (64.983)

45 CHILDE HASSAM
Along the Seine, Winter, 1887
Oil on wood, 20.3 x 27.9 cm (8 x 11 in.)
Dallas Museum of Art, Texas
Bequest of Joel T. Howard

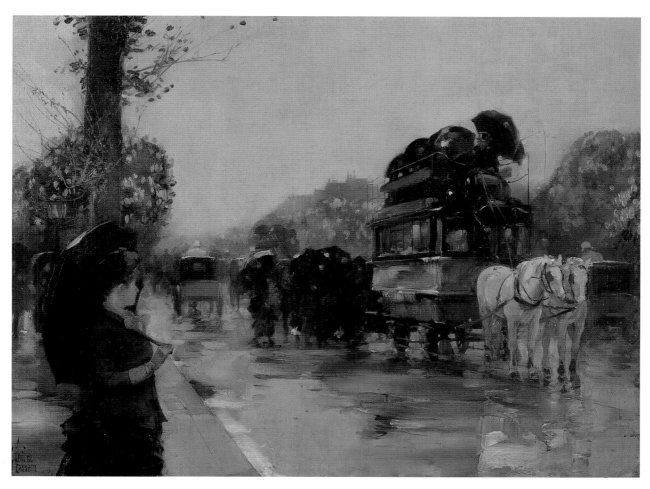

46 CHILDE HASSAM
April Showers, Champs Elysées, Paris, 1888
Oil on canvas, 31.7 x 42.5 cm (12½ x 16⅝ in.)
Joslyn Art Museum, Omaha, Nebraska
Museum Purchase, 1946 (JAM 1946.30)

procession of well-equipped vehicles that carried their fashionable occupants to and from the Bois de Boulogne for the race at Longchamp. It was the spectacle that fascinated Hassam, rather than the event itself. Even in the paintings he made at the track, Hassam concentrated on the onlookers rather than the race.

American artists also enjoyed cultural events, and although some were short of money, they tried to take advantage of the performances available in the capital. Attendance at the theatre was restricted to those who understood French, but music was accessible to all. Beckwith went to the Opéra, finding pleasure in it despite his position in inexpensive seats 'above the chandelier', while Eakins, Longfellow and Sargent all frequented the popular concerts given at the Cirque d'Hiver by Jules-Etienne Pasdeloup.[57] Sargent captured the orchestra in a vivid swirling sketch (cat. 47). With dashes and dots defining the forms of horns and drums, he echoed the form of musical notes. His unusual composition and perspective, as well as his monochromatic palette, recall paintings by Degas, whose work he clearly admired.

Of all the Americans to record the entertainments of Paris, Mary Cassatt devoted the most attention to the subject. She made a series of paintings showing fashionable women attending the theatre. Both Cassatt's pictures and the women in them are focused upon the audience rather than the performance (cats 22 and 49). Her paintings, with their opera glasses and mirrors, are about the spectacle of the theatre, about looking and being looked at. Cassatt's women actively inspect their surroundings, comfortable with the knowledge that they too are being observed. Cassatt extended the conceit to her own audience, who become a part of her sophisticated and fluctuating dance between subject and object, viewer and viewed.

While Cassatt showed women at the theatre, on the omnibus or driving in the Bois de Boulogne, she never depicted public spaces that would have been unsuitable for a woman of her class – presumably she did not visit places inappropriate for a lady. Such subjects were not left entirely untouched by Americans, but they were represented much more rarely and the images show little evidence of familiarity with backstage or music-hall culture. Willard Metcalf made a charming sketch of elegant couples at a café (cat. 50), using the ruddy tones of his wooden panel to evoke the nicotine-coloured walls that glow in the light of a gas chandelier. In John White Alexander's *In the Café* (cat. 51), a well-dressed woman sits behind a table with a crisp white cloth. Like Cassatt's theatregoers, she sits before a mirror that both reflects her and expands the space of the picture. Alexander's café scene is reminiscent of similar compositions by Manet, Blanche and others. In both subject matter and handling, Alexander had assimilated forms that were quintessentially French. His success, and that of his compatriots, was evident in 1898 when one critic warned that the Americans 'can almost out-French the French'.[58]

The Americans who worked in Paris during the 1890s were no longer necessarily alone or isolated. They had access to a large expatriate community that could offer many of the comforts of home. The American Art Association of Paris, for example, allowed its members to 'assemble

47 JOHN SINGER SARGENT
Rehearsal of the Pasdeloup Orchestra at the Cirque d'Hiver, about 1879–80
Oil on canvas, 57.2 x 46.1 cm (22½ x 18⅛ in.)
Museum of Fine Arts, Boston, Massachusetts
The Hayden Collection – Charles Henry Hayden Fund (22.598)

48 MARY CASSATT

Young Woman in Black (*Portrait of Madame J.*), 1883
Oil on canvas, 80.6 x 64.6 cm (31¾ x 25½ in.)
The Peabody Art Collection. Courtesy of the Maryland State Archives, Annapolis
On loan to the Baltimore Museum of Art (MSA SC 4680-10-0010)

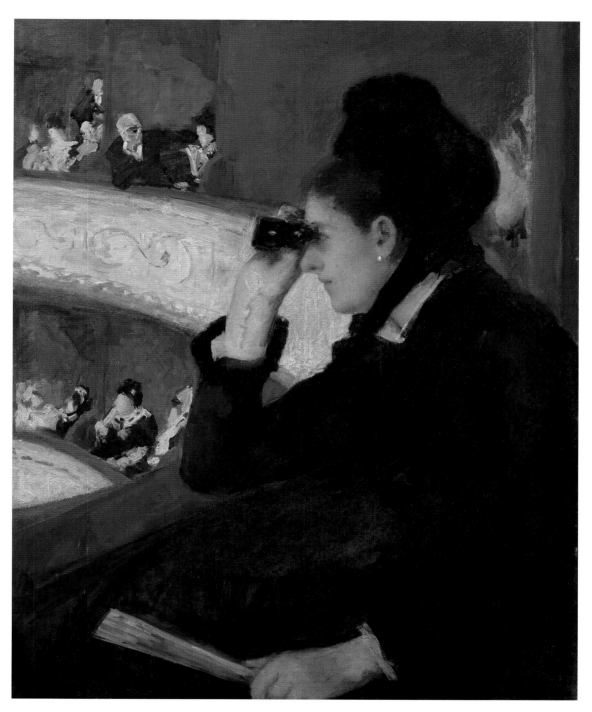

49 MARY CASSATT
In the Loge, 1878
Oil on canvas, 81.3 x 66 cm (32 x 26 in.)
Museum of Fine Arts, Boston, Massachusetts
The Hayden Collection – Charles Henry Hayden Fund (10.35)

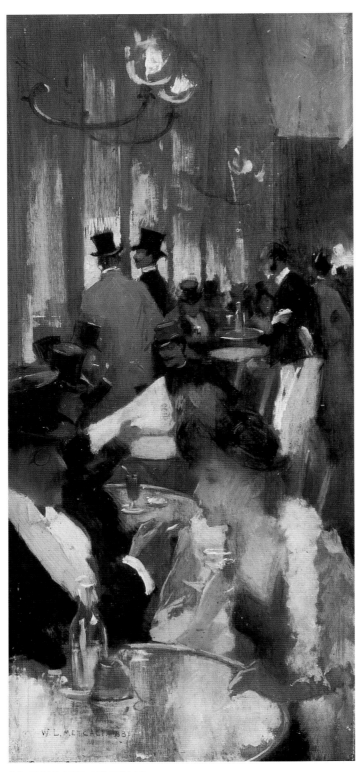

50 WILLARD METCALF
In the Café (*Au café*), 1888
Oil on panel, 34.8 x 15.4 cm (13⅝ x 6⅛ in.)
Terra Foundation for American Art, Chicago, Illinois
Daniel J. Terra Collection (1992.10)

In 1891 Alexander and his wife settled on the boulevard Berthier, the neighbourhood where both Sargent and Mme Gautreau had lived. 'I am working here as I have never worked before', Alexander wrote, adding that in Paris everything 'is in a higher place than in New York and the city is a constant delight to us . . . New York is a village beside it and an hour here is worth years there. People here know so much more'.[69] When Whistler returned to Paris the next spring, Alexander asked Henrietta Reubell to reintroduce him with a request that he pose for a portrait. Whistler refused the sitting, but was pleased to reacquaint himself with Alexander. He presented his young compatriot to a number of French colleagues and critics; as one writer noted, the Alexanders 'were in touch with French life and French art in a peculiarly intimate sense'.[70]

Alexander worked on both sides of the Atlantic, travelling back and forth to fulfil portrait commissions. 'I am not burning all my bridges on this side', he wrote after a summer in the United States, 'but I want to settle in Paris'.[71] While in France, Alexander painted likenesses of Rodin and a variety of international sitters. American critics equated the combination of restless movement and decorative immobility they found in Alexander's portraits with qualities they admired in Rodin's sculpture.[72] Whether or not he consciously echoed Rodin's approach, Alexander painted some of his most provocative and sensual works in France, including *Repose* and *Isabella and the Pot of Basil* (cats 53 and 54). The elegant curved patterns of the clothing his models wear, the sinuous contours of their bodies and their inescapable air of sexual decadence are inextricably allied with contemporary French fashion. Several American painters experimented with decorative figures during the 1890s, many in connection with mural projects, but Alexander's are more overtly erotic. His models seem considerably less wholesome than the blonde beauties that appear in Frank Benson's murals for the Library of Congress, for example, or in Abbott Thayer's lovely but sexless images of angels and madonnas. Alexander's refusal to translate the decadent stylistic language of fin-de-siècle European art to an innocent vocabulary befitting a more conventional American audience is unusual, and marks the degree to which he had assimilated French aesthetics.[73] If Alexander's paintings have an equivalent, it is more likely found in the decorative images of such French painters as Besnard or Edmond Aman-Jean, both also members of Mallarmé's group, than in American art. These painters, along with Blanche, Gervex and Helleu, present intriguing and as yet indistinct links between the art of France and that of America.[74]

Alexander and many of his compatriots felt completely comfortable in Paris during the 1890s. As Richard Harding Davis wrote in 1895: 'the American goes to Paris as though returning to his inheritance and to his own people . . . he is unsurpassed . . . in his ability to make himself immediately and contentedly at home.'[75] At just this moment however, an increasingly insular self-confidence and nationalism within American culture and society began to demand 'American' qualities in even the most cosmopolitan of painters. As Henry James had already

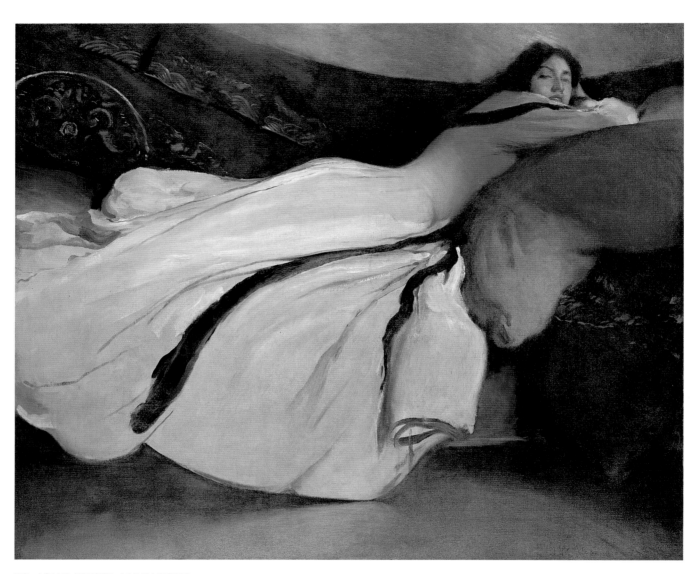

53 JOHN WHITE ALEXANDER
Repose, 1895
Oil on canvas, 132.7 x 161.6 cm (52¼ x 63⅝ in.)
The Metropolitan Museum of Art, New York
Anonymous Gift, 1980 (1980.224)

d'honneur, a winner, as he described it, of that 'little red ribbon, the most seductive that exists', which had been awarded to him in 1889.[63] He had returned to Paris to complete his portrait of the self-consciously spectacular Comte Robert de Montesquiou-Fezensac (see fig. 26). The two men had met in England in July 1885 through Henry James, who was, at Sargent's request, introducing to London the two French visitors Sargent described as the 'very brilliant creature' Dr Samuel Pozzi and 'the unique extrahuman Montesquiou'.[64] Whistler began Montesquiou's portrait in London in 1891, and finished the painting the following spring in Paris, in a studio that Montesquiou arranged for him to borrow on the rue Monsieur-le-Prince. With Montesquiou's encouragement, Whistler decided to stay in France.

Poet Georges Rodenbach described Whistler in *Le Figaro* in 1894 as a 'naturalised Parisian'.[65] The painter became a muse to a younger generation of artists and writers, both French and American. He was particularly involved with the Symbolist movement, whose disciples convened at Stéphane Mallarmé's home on the rue de Rome. Mallarmé had long admired Whistler, whom he had met through Monet in 1888, and he had translated Whistler's *Ten O'Clock Lecture* into French. Whistler appreciated Mallarmé's elegant sensibility and the importance of nuance and suggestion amidst the writers of his circle, among them Paul Verlaine, Henri de Régnier and the composer Claude Debussy. Among their philosophies, the group found deep connections between the arts of painting and music, something that had long fascinated Whistler, and in 1893, they worked together on a singular production of *Pelléas et Mélisande*, drawing together the sensual qualities of both arts.[66]

Whistler also intersected with a number of Americans at this time, soliciting new followers at the American Art Association. He most often mingled with those who moved effortlessly in French artistic circles. Dancer Loïe Fuller, for example, a native of Fullersburg, Illinois, made her debut at the Folies Bergère in November 1892, and her dramatic swirling movements and manipulation of fabric and coloured lights quickly caused her to become a sensation. Mallarmé described her as an 'enchantress' who had translated poetry into dance.[67] Whistler no doubt especially enjoyed her performance entitled 'The Butterfly'. He sketched her several times on a single sheet, first standing still, then in a series of dramatic ovals and twists that culminate in the exuberant pose of her finale, which he manipulated to look like his own butterfly signature (about 1892; Hunterian Art Gallery, University of Glasgow). Fuller also appeared in the critical reviews about another American painter in the Whistler–Mallarmé circle, John White Alexander. In his canvas *Repose* (cat. 53), a woman in billowing skirts reclines on a sofa, twisting her body so that her own languorous curves form the major decorative element of the composition. Satirised in the leftist periodical *La Lanterne* as 'Loïe Fuller au Repos', Alexander's sinuous composition may indeed have been inspired by the dancer, although his sitter does not resemble the short, red-haired, blue-eyed Midwesterner who managed to transform herself into a Parisian siren.[68]

together in rooms where our own tongue is spoken'. In addition to companionship, it offered the *Quartier Latin*, a literary magazine which publicised events, recommended merchants and exhibition opportunities, and reprinted critical notices. The Association also boasted a variety of social activities, lectures and demonstrations, a gallery, a library, a restaurant and a gymnasium. As one member confessed, in such a place 'where every thought is of home, we do not find the exile so dreary or the home so far away'.[59] Societies and organisations began to proliferate in the 1890s, among them the American Women's Art Association, founded in 1891; the French Société des Américanistes de Paris, established in 1893 and devoted to research on the Americas; the Girls' Art Club of 1893, offering supervised lodging and other support for women studying art or music; the American Chamber of Commerce in France, which opened with 11 members in 1894 and boasted 600 by 1919; the Franco-American Committee, founded in 1895 to promote intellectual exchange; the Paris Society of American Painters, which offered exhibition space beginning in 1897; and many smaller associations, from the Latin Quarter Club to the Pen and Pencil Club.[60] The abundance of such partisan groups, combined with the increased speed of international communication and travel, marked a profound shift in the experience of Americans in Paris, many of whom now felt comfortable and at ease in the French capital.

Even the topography of Paris had started to reflect the American presence. In 1881, a large and elegant square in the 16th arondissement between the Palais du Trocadéro and the Etoile was renamed the place des Etats-Unis. In 1895, it was ornamented with a monument to Washington and Lafayette donated by Joseph Pulitzer, publisher of the *New York World*. Pulitzer commissioned the bronze sculpture from Auguste Bartholdi, whose monumental *Liberté éclairant le monde* had towered over the roofs near the Parc Monceau from 1881 to 1884, before it was disassembled and shipped to New York. 'I expected to see a large statue,' wrote Tarbell, 'but when I . . . saw this huge black thing rising up against the sky above the tops of the houses I was startled.'[61] A small replica of Bartholdi's Statue of Liberty was erected in 1889 on an island in the Seine, and the American sculptor Paul Bartlett (see cat. 8) was commissioned to make a reciprocal piece, an equestrian Lafayette that was unveiled in the court of the Louvre in 1900. Americans had also staked a claim in French museums, boasting of their achievement to American constituents when their works were purchased from the Salon or other international expositions by the French state. The most notable of these came in 1891, when Whistler's *Arrangement in Grey and Black, No. 1: Portrait of the Artist's Mother* (cat. 16) entered the Musée du Luxembourg. It was not the first American painting to find a home there, but it received the most publicity, with a front-page notice in *Le Figaro* on 27 November 1891.[62] Such acquisitions for the French national museums also marked the high profile and permanent presence of Americans in Paris.

Whistler perceived this particular purchase as an international endorsement. When he settled in Paris again in the autumn of 1891, he was an elder statesman and a Chevalier of the Légion

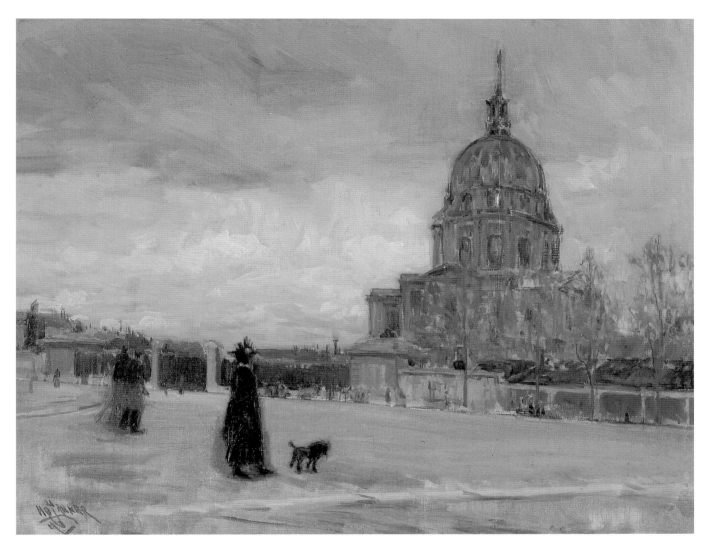

52 HENRY OSSAWA TANNER
Les Invalides, Paris, 1896
Oil on canvas, 33.3 x 41.3 cm (13 x 16¼ in.)
Terra Foundation for American Art, Chicago, Illinois
Daniel J. Terra Collection (1999.140)

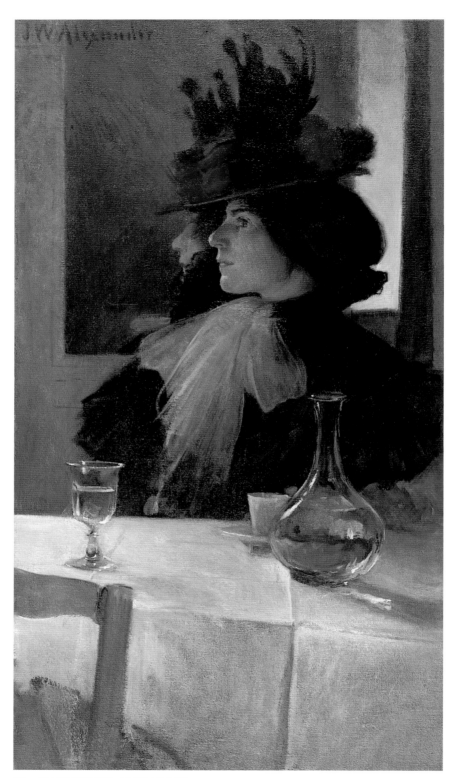

51 JOHN WHITE ALEXANDER
In the Café, 1898
Oil on canvas, 100.3 x 55.2 cm (39½ x 21¾ in.)
The Ann and Tom Barwick Family Collection

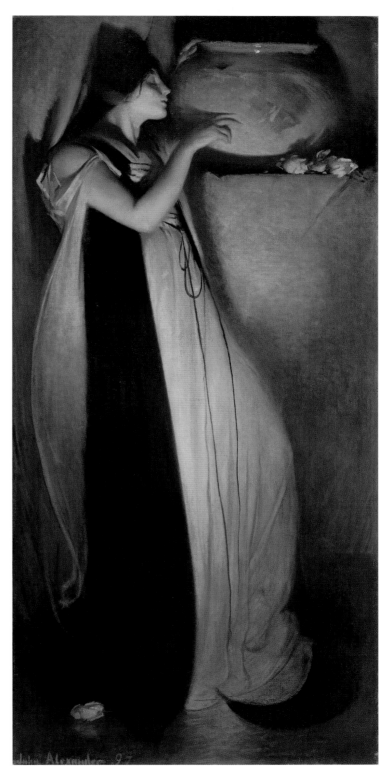

54 JOHN WHITE ALEXANDER
Isabella and the Pot of Basil, 1897
Oil on canvas, 192.1 x 91.8 cm (75⅝ x 36⅛ in.)
Museum of Fine Arts, Boston, Massachusetts
Gift of Ernest Wadsworth Longfellow (98.181)

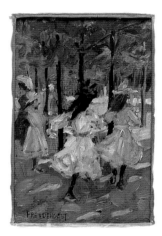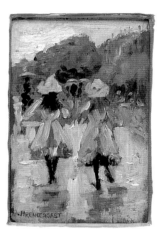

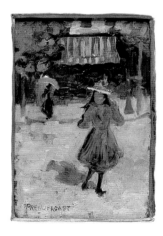

55 MAURICE BRAZIL PRENDERGAST
Sketches in Paris, about 1892–4
Seven oil on wood panels, each panel 17.1 x 9.5 cm (6¼ x 3¾ in.)
Addison Gallery of American Art, Phillips Academy, Andover, Massachusetts (1939.2)

proclaimed in 1872, being an American was 'a complex fate . . . and one of the responsibilities it entails is fighting against a superstitious valuation of Europe'. Shortly before Alexander left Paris to re-establish himself in New York in 1900, Gabriel Mourey, the French writer and publisher and a champion of Rodin and Debussy, wrote an article about him for *International Studio*. Mourey commented that Alexander had escaped 'the disadvantage of complete transplantation; for he is not altogether *déraciné* [uprooted], but has the benefit of periodical return to the land of his birth; and to the true strong artist, in whom foreign influences have served only to develop his personality, there is nothing so wholesome as the atmosphere of home. Thus Mr. Alexander has remained truly American'.[76]

The chorus demanding native qualities continued both formally and informally. Davis claimed that the best American painters were the ones that came home. He praised them for the way they 'made use of Paris, instead of letting Paris make use of them . . . they are now helping and enlightening their own people and a whole nation'. More vociferous comments came from critics like Ellis Clarke, who stated firmly that 'expatriation is a mistake, both as regards the future of the individual artist and as regards the future of American art'. As he had prepared to leave Paris in 1885, John Twachtman wrote: 'I hardly know what will take the place of my weekly visit to the Louvre . . . perhaps patriotism.'[77] It may have been no accident that the familiar and popular song 'Home, Sweet Home' had been written by an American in Paris. 'Mid pleasures and palaces Though we may roam', wrote John Howard Payne, 'Be it ever so humble, There's no place like home'.

This essay is dedicated to the memory of my mother, with whom I first saw Paris and who assured me that I would return.

1 See Seigel 1986 and Abélès and Cogeval 1986.
2 Edward Guthrie Kennedy, 7 June 1897, Edward Guthrie Kennedy Papers. See also G. Lacambre, 'Whistler and France' in Dorment and MacDonald 1994, pp. 39–48.
3 L.-E. Duranty, 'Ceux qui seront les peintres', *Almanach parisien pour 1867*, p.13, in Lacambre, 'Whistler and France' in Dorment and MacDonald 1994, p. 42.
4 Courbet to his family, 17 November 1865, in Dorment and MacDonald 1994, p. 111.
5 Courbet to Whistler, 14 February 1877, C 64, Glasgow University, in Macdonald and Newton 1986, p. 203.
6 Katharine Lochnan, 'Turner, Whistler, Monet: an artistic dialogue' in Lochnan 2004, pp. 21–3.
7 Fantin to Whistler, 12 February 1867, Glasgow University Library, MS Whistler F14, BP II L/35; J. Engelhart, 'Meine Erlebnisse mit James McNeill Whistler aus dem Jahre 1898', *Der Architekt*, 21 (1916–18), p. 53, in T. Reff, 'Le Papillon et le Vieux Boeuf', in *From Realism to Symbolism: Whistler and His World*, New York 1971, p. 23; Whistler to Degas, January 1889, in Reff, p. 23 (also Glasgow University Library, MS Whistler D22, http://www.whistler.arts.gla.ac.uk).
8 See H. B. Weinberg, 'Studies in Paris and Spain' in Sewell 2001, pp. 13–26.
9 See P. Tucker, 'The First Impressionist Exhibition in Context' in Moffett 1986, pp. 94–104, and Clayson 2002.
10 Nieriker 1879, pp. 44, 46, 75.
11 Thomas Eakins to Fanny Eakins, 29 August 1868, Thomas Eakins Letters.
12 Longfellow 1922, p. 104; J. C. Beckwith, diary entries for 31 December 1873 and 12 July 1874, Beckwith Papers; Julian Alden Weir to his father, 1 November 1874, J. Alden Weir Papers; letter from Edmund Tarbell to Emmeline Souther, 11 October 1884, Tarbell Papers.
13 Longfellow 1922, pp. 112–13.
14 *Art Student in Paris* 1887; Beaux 1930, pp. 115–16; Harriet Westcott to Lilian Westcott Hale, 11 June 1904, Box 52, folder 1398, Hale Papers.
15 Julian Alden Weir to his mother, 30 June 1874 and 4 July 1875, J. Alden Weir Papers; Elizabeth Gardner to Maria Gardner, 14 July 1882, Gardner Papers; Ticknor 1923, p. 148.

16 Julian Alden Weir to his mother, 12 October 1873, J. Alden Weir Papers.
17 Ticknor 1923, p.149.
18 Van Dyke 1993, p. 63.
19 Rothenstein 1931–40, vol. 1, p. 81; Henry James in Ormond and Kilmurray 1998–2003, vol. 1, p. 154.
20 Allen n.d., pp. 6, 123–4.
21 Ford 1893, p. 73.
22 Simmons 1922, p. 134; Van Dyke 1993, p. 82.
23 Elizabeth Gardner to Maria Gardner, 9 May 1894, Gardner Papers; Hassam, Lockman interview, 31 January 1927, p. 17 in Weinberg 2004, p. 56.
24 Robert Cassatt to Alexander Cassatt, 13 December 1878, in Mathews 1984, pp. 142–4.
25 Unidentified critic, in Hiesinger 1998, p. 10.
26 R. Hawkins, 'Report on the Fine Arts', *Reports of the United States Commissioners to the Universal Exposition of 1889 at Paris*, vol. 2, pp. 69–70, in Hiesinger 1998, p. 42.
27 Julian Alden Weir to his mother, 1 May 1875, J. Alden Weir Papers.
28 Edward Boit, 1 January 1867, in Ahrens 1990, p. 8.
29 See Gallati 2004, pp. 79–84, and Simpson 1997.
30 James 1887, p. 688.
31 J. C., 'La Vie à Paris: Paris Artiste', *Le Temps*, 2 May 1884, p. 3, quoted in Kilmurray and Ormond 1998b, p. 14.
32 Sargent to Margaret (Daisy) White, 15 March 1883; James, 1888; both in Ormond and Kilmurray 1998–2003, vol. 1, p. 106.
33 Lostalot 1885, pp. 529–32.
34 Vernon Lee [Violet Paget] to her mother, 8 June 1884, in Lee 1937, p. 143; Simmons 1922, pp. 126–7.
35 Perdican 1881, p. 412.
36 Degas to Ambroise Vollard, in *Degas: An Intimate Portrait*, trans. R. T. Weaver, New York 1927, p. 48; Havemeyer 1961, 1993, pp. 244–5. See G. T. M. Shackelford, 'Pas de Deux: Mary Cassatt and Edgar Degas', in Barter 1998, pp. 109–43.
37 Cassatt as quoted by Sara Hallowell to Bertha Palmer, 6 February 1894, in Mathews 1984, p. 254.
38 Ticknor 1923, p. 278; Elizabeth Gardner to Maria Gardner, 13 February 1865, in Fidell-Beaufort 1984, p. 3.
39 French 1928, p. 174.
40 Elizabeth Gardner to Maria Gardner, 13 February 1865, Gardner Papers.
41 Elizabeth Gardner to Maria Gardner, 8 June 1879, Gardner Papers; portions also quoted in Fidell-Beaufort 1984, p. 5.

42 Elizabeth Gardner to Perley Gardner, 14 June 1894, in Fidell-Beaufort 1984, p. 5.

43 Elizabeth Gardner to Maria Gardner, 18 March 1881, Gardner Papers.

44 Elizabeth Gardner to John Gardner, 12 April 1880, Gardner Papers.

45 Notebook, 1887, Nourse Papers, in M. A. H. Burke 1983, p. 30.

46 Nourse to Adelaide Pitman, as quoted in an unidentified clipping, Scrapbook 1, Nourse family collection, in L. M. Fink, 'Elizabeth Nourse: Painting the Motif of Humanity', in M. A. H. Burke 1983, p. 134.

47 Cassatt to Harrison Morris, March 1904, in Mathews 1984, p. 291.

48 Simmons 1922, p. 135.

49 Tanner 1909, pp. 11770–1.

50 Quartier Latin 1897a, p. 449.

51 Tanner 1909, p. 11772.

52 See Braddock 2004 and Leach 1993, pp. 99–101.

53 Tanner 1909, p. 11774.

54 Nieriker 1879, p. 55. Published Parisian by-laws of the period include various restrictions on street activity; my research on this topic continues.

55 Baedeker 1894, pp. 148, 253.

56 Julian Alden Weir to his mother, 12 October 1873, and to his father, 2 November 1873, both J. Alden Weir Papers.

57 James Carroll Beckwith, diary entry for 28 October 1874, Beckwith Papers.

58 'The Paris Salon', Magazine of Art, 21 (August 1898), p. 535, in Moore 1992, p. 218.

59 Wuerpel 1894, pp. 7, 25.

60 Boucher 1921.

61 Edmund Tarbell to Emmeline Souther, 7 November 1884, Tarbell Papers.

62 Grant 1992 and Wiesinger 1993.

63 Whistler to Montesquiou, December 1889, in Munhall 1995, p. 63.

64 Sargent to James, 29 June 1885, Houghton Library, Harvard University, Cambridge, Massachusetts, in Munhall 1995, p. 58.

65 G. Rodenbach, 'Quelques peintres – M. James M. N. Whistler', Le Figaro, 29 October 1894, in Dorment and MacDonald 1994, p. 143.

66 Herlin 2002.

67 S. Mallarmé, 'Considerations sur l'art du Ballet et La Loïe Fuller', National Observer, 13 March 1893, in Harris 1979, p. 28.

68 See the discussion of the identity of Alexander's sitter in Moore 1992, pp. 152, 163–5.

69 Alexander, 26 December 1891, in Moore 1992, p. 97.

70 Beatrix Whistler to Henrietta T. Reubell, 11 April 1892, Library of Congress, Manuscript Division, Pennell-Whistler Collection, PWC 14/1256/1 and http://www.whistler.arts.gla.ac.uk; Moore 1992, p. 136; Alexander 1916, p. 20.

71 Alexander to E. E. Phelps, 18 August 1893, in Moore 1992, p. 136.

72 Caffin 1904–5, pp. 5682–6.

73 See Gandell 1997. The decadence of British Pre-Raphaelite examples should also be considered.

74 See P.-G. Persin, Aman-Jean: Peintre de la femme, Paris 1993; C. Mauclair, Albert Besnard, Paris 1914; and G. P. Weisberg, 'Madame Henry Lerolle and Daughter Yvonne', Bulletin of the Cleveland Museum of Art, 64 (December 1977), pp. 326–43.

75 Davis 1895, pp. 48–9.

76 James 1920, vol. I, biographical note; Mourey 1900, p. 72. See also the discussion in Fischer 1999.

77 Davis 1895, p. 219; Clarke 1900, p. 36; Twachtman to J. Alden Weir, 2 January 1885, J. Alden Weir Papers.

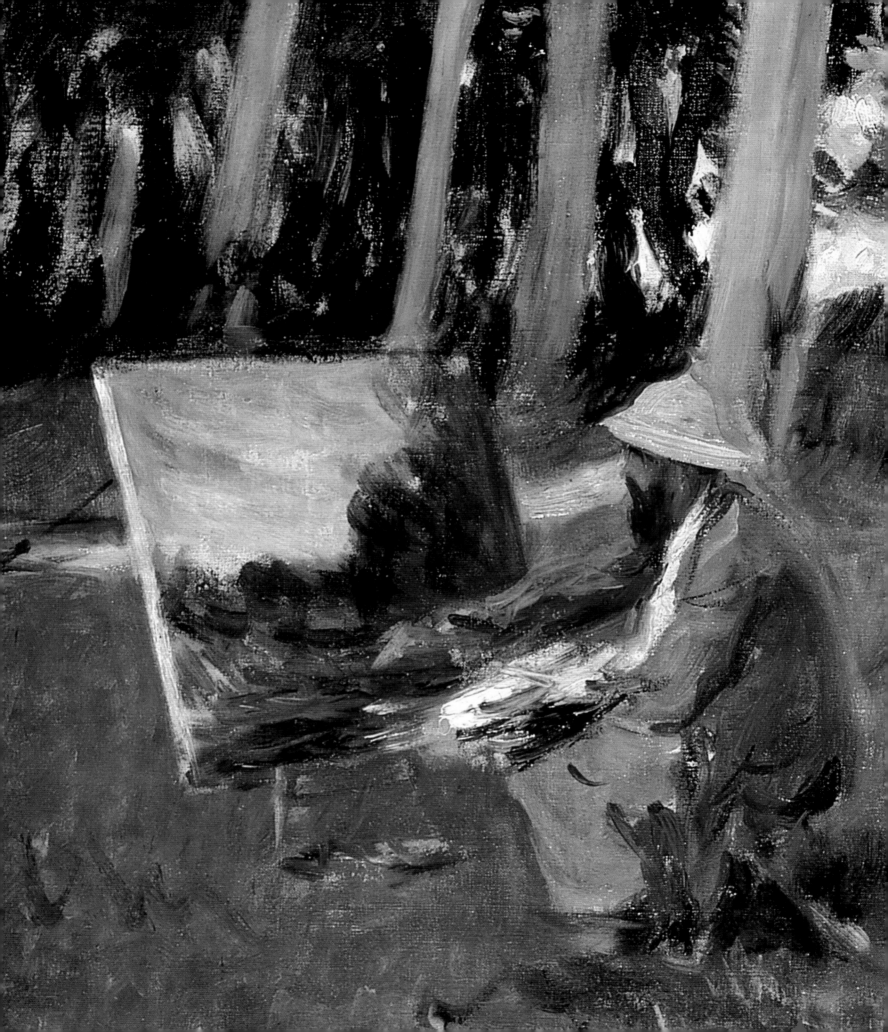

Summers in the Country

H. Barbara Weinberg

In France

'In May, with the appearance of balmy weather, the American colony begin talking of dispersing for the summer . . . "Where shall we go?" and "Where we are going," are the overruling questions and topics of conversation', the American painter Henry Bacon noted in his 1882 chronicle of an artist's year in Paris.[1] 'After the first of July Paris is an artistic desert, for the artists and art-students speed away in search of "green fields and pastures new"', a journalist reported in 1893.[2] Paris might be the City of Light, but the cold, dark and damp winters made summers in the country irresistible. 'After passing a winter in a city, even the smallest moss-covered rock seems in itself a picture', the art student Julian Alden Weir enthused from Barbizon in April 1877.[3]

Entwined with artists' quest for 'pastures new' was another distinctive nineteenth-century phenomenon: their keen desire to work outdoors, portraying rural life and landscape, usually in the company of colleagues.[4] In response, art colonies and other provincial villages in France (and elsewhere) flourished, attracting men and women of all nationalities, including, of course, Americans. Drawn by word of mouth, studio friendships, veteran visitors' published accounts (both fact and fiction),[5] or exhibited pictures, some artists affiliated themselves with one site,

others explored several. Suburban colonies such as Barbizon received visitors throughout the year. Both the suburban and the more remote locales appealed not only to students and recent graduates who had arrived after the Salon and art schools closed for the summer, but to established professionals who purchased homes, built studios and stayed for years.

Although most of the popular rural venues were in northern or north-western France, they differed from one another in character, gender balance and stylistic tendencies.[6] Artists could seek sociability and diversion (fig. 13) or relative solitude; an international, polyglot setting, or one filled with compatriots in

Fig.13 Henry Bacon (1839–1912)
A Rainy Day, The Artists' Tavern at Barbizon, 1874
Oil on canvas, 97.8 x 130.8 cm. Private collection, New England

which English sufficed; a site that revolved around a respected master in residence or core group, or one unfamiliar to artists; a place where traditional techniques prevailed or pictorial experiments thrived (although individualism was encouraged). Some Americans went to well-known colonies such as Barbizon; others founded new ones, at Pont-Aven, Grez-sur-Loing and Giverny, for example. During the movement's heyday – from 1870 until about 1910, when painting from nature ceased to interest the avant-garde – some art colonies drew more than 100 visitors each season.

Differences among these retreats notwithstanding, they were all accessible from Paris, first by railway to a larger nearby town and then by horse-drawn vehicle – a postman's cart, perhaps – or on foot.[7] They all offered escape from summer heat and a welcome change from academic strictures, crowded and noisy studios, deadlines and competitions, professors, critics and juries and even from the stimulation of the salons, galleries and museums that had brought the painters to Paris. Instead, their summer haunts allowed artists to live for a while in pastoral calm as Bohemians, even to don wooden clogs and straw hats as practical – and symbolic – accessories. Key enticements were modest living costs and cheap accommodation, often in small rustic hotels and pensions (some of which catered for English-speaking guests). Pont-Aven's principal inn, the Hôtel des Voyageurs, for example, took *pensionnaires* for about five francs a day, 'tout compris', in 1880, according to one visitor, who added that 'the living is as good and plentiful as can be desired'; the Pension Gloanec, 'the true Bohemian home at Pont-Aven', provided board and lodging for only 60 francs a month.[8] Purveyors of paints and canvas, procurers of models and props and providers of artists' other necessities served most locales.

Colonies featured similar routines: early rising; days spent working out of doors, in studios or in peasants' dwellings, depending on the weather; breaks for coffee and lunch; dinner at six, perhaps in the village inn, enlivened by informal criticism and artistic debate; and evening amusements such as billiards, dancing, singing and theatrical performances.[9] The colonies offered evocative remnants of traditional culture: timeworn buildings and quaint villagers, farmers, peasants or fisherfolk who performed manual labour, preserved old customs and folk-lore, wore regional costumes, accepted the presence of artists and were willing to pose. They inspired painters to make sketches for later reference or to complete more ambitious and considered canvases on the spot, the final products in either case being works for exhibition – perhaps in the next year's Salon – and sale.

In their very existence and their capacity to nurture creativity, rustic havens reflected a widespread yearning for immersion in unspoiled nature and connection to pre-modern spiritual authenticity as antidotes to increasing urbanisation, industrialisation and mechanised farming, even if artistic licence were needed to amplify nostalgic stereotypes. Americans in particular found in Old World agricultural practices an appealing 'retention of quasi-primitive conditions which we have lost in our immense tracts cultivated by machinery', as painter Will H. Low

noted.[10] And the Americans were enchanted by Old World charm in general. After art student Kenyon Cox spent New Year 1878 on a brief tour of Barbizon, Recloses and Grez, he gushed in a letter home: 'Just think of all these places and a dozen others all within the range of a circle of 15 miles radius from Fontainebleau and three hours ride in a slow train from Paris. And then to think of trying to live in America.'[11]

A colony's bracing effect was noted by the Irish painter Henry Jones Thaddeus, who worked in Pont-Aven and Concarneau in the summer of 1881: 'The life in the open air, together with the absorbing, delightful occupation of painting from nature, followed by the pleasant reunions in the evening, constituted an ideal existence to which I know no parallel.'[12] Ultimately, as the 'ideal existence' they permitted became known, some colonies, once cherished because they were remote and unsophisticated, became chic destinations for tourists who were intrigued by artists and their habitats. Writer Robert Louis Stevenson, a denizen of several French art colonies, traced an enclave's life cycle in 1884:

> The institution of a painters' colony is a work of time and tact. The population must be conquered. The innkeeper has to be taught, and he soon learns, the lesson of unlimited credit; he must be taught to welcome as a favoured guest a young gentleman in a very greasy coat, and with little baggage beyond a box of colours and a canvas; and he must learn to preserve his faith in customers who will eat heartily and drink of the best, borrow money to buy tobacco, and perhaps not pay a stiver for a year. A colour merchant has next to be attracted. A certain vogue must be given to the place, lest the painter, most gregarious of animals, should find himself alone. And no sooner are these first difficulties overcome, than fresh perils spring up upon the other side; and the bourgeois and the tourist are knocking at the gate.[13]

In the late 1840s, when, for the first time, more than a handful of Americans were studying in Paris, some journeyed to Barbizon, the oldest and largest European art colony.[14] Since about 1830 the hamlet on the western edge of the 42,000-acre Fontainebleau forest, about 60 kilometres south-east of Paris, had attracted French naturalistic landscapists, including Théodore Rousseau, Jean-Baptiste-Camille Corot, Charles-François Daubigny and the influential painter of peasants, Jean-François Millet (see fig. 36).[15] Often working outdoors in the unspoiled Fontainebleau forest – and elsewhere in France – these artists recorded intimate views and the labours of humble farmers, shepherds and woodchoppers.

As the rail service from Paris to Fontainebleau improved about 1850, Barbizon became less like a primitive refuge than a charming suburb. The village's best-known American resident in the 1850s was William Morris Hunt (see cat. 99 and pp. 208–11), who came to Barbizon to paint in Millet's company in 1852. Hunt's peasant images may seem a bit insincere,[16] like those of many other Americans who, unfamiliar with peasant culture, participated in the vogue for

peasant painting, whether they tried to depict the noble workers memorialised by Millet or the pathetic poor portrayed by Jules Bastien-Lepage and other younger artists. Hunt's appreciation of Barbizon deeply affected American taste. As a result of his influence in Boston and of dealers' marketing efforts, Barbizon pictures dominated local collections and exhibitions and inspired many painters. Barbizon continued to welcome American artists, with the first substantial numbers arriving in 1873 and the ensuing years.[17]

Boston-born Winslow Homer knew Barbizon art before he spent 10 months in France in 1866–7. At the 1867 Exposition Universelle, he would have seen many canvases by Rousseau, Corot, Daubigny and Millet, as well as pastoral scenes by Jules Dupré and Constant Troyon.[18] These must have struck a responsive chord in a painter of rural life and stimulated his quest for similar subjects. Joseph Foxcroft Cole, an associate from Boston who had studied with peasant painters Emile Lambinet and Charles Jacque, introduced him to Cernay-la-Ville, an art colony in Picardy, 50 kilometres south-west of Paris. Homer's *Cernay-la-Ville – French Farm* (cat. 56) reflects in its informal composition, poetic atmosphere and light and emphasis on geometric planes of architecture and landscape his appreciation of Corot's rural village scenes (fig. 14).

James Abbott McNeill Whistler was less susceptible to Charles Gleyre's academic instruction than to the example of Gustave Courbet, whom he met in 1858, and he maintained contact with Courbet and the Parisian avant-garde even after he moved to London in 1859. *Coast of Brittany* (*Alone with the Tide*) (cat. 57), which Whistler appears to have completed in November 1861, at the end of a three-month visit to Brittany's northern coast, was his first major landscape in oil.[19] He portrayed with Realist directness a peasant girl asleep against a rocky outcrop on a barren beach, describing the commonplace scene as if instantaneously, highlighting the region's

Fig. 14 Jean-Baptiste-Camille Corot (1796–1875)
Farm at Recouvières, Nièvre, 1831
Oil on canvas, 47.6 x 70.2 cm. Museum of Fine Arts, Boston, Massachusetts
The Henry C. and Martha B. Angell Collection (19.82)

56 WINSLOW HOMER
Cernay-la-Ville – French Farm, 1867
Oil on panel, 26.8 x 45.9 cm (10¾ x 18¹/₁₆ in.)
Krannert Art Museum, University of Illinois, Urbana-Champaign, Illinois
Gift of Mr and Mrs Merle J. Trees (1940-1-3)

isolation (even showing the girl's lone footprints in the wet sand), not its picturesqueness. He flattened spatial recession, echoed the rocks' abrupt planes with heavy impasto and quoted for the girl's pose Courbet's ungainly women.[20]

Working with Courbet at Trouville, the fashionable English Channel resort, in October and November 1865, Whistler painted at least five seascapes that respond to broad stretches of beach, water and sky and demonstrate his new susceptibility to Japanese art. In *The Sea* (cat. 58), he preserved the freshness of a plein-air sketch in a large canvas. Bold, square brushstrokes that suggest frothy clouds and foamy breakers contrast with the smoother planes of sky and sea along the horizon. A sailing yacht rolling through the waves at the right emphasises the blustery breeze. In *Harmony in Blue and Silver: Trouville* (cat. 59) he announced his rejection of Realism in favour of abstraction. The composition, which depends entirely on decorative bands of closely modulated tones rendered in thin pigment washes, distils from nature, rather than transcribes it. Although in 1886 Whistler referred to *Harmony in Blue and Silver: Trouville* as 'Courbet – on sea shore' and in 1895 remarked that it was 'the only painting by me of Courbet',[21] the canvas repudiated Courbet's influence. It also proclaimed a stylistic direction far more radical than the proto-Impressionism that Eugène Boudin was then exploring on the Normandy coast.

Many other Americans immersed themselves in remote, tradition-bound villages and portrayed peasant life and local history. A particularly compelling region was Finistère on Brittany's isolated southern coast, especially Pont-Aven and Concarneau, villages in which polyglot colonies dominated by Americans developed.[22] By the 1830s Brittany, as a distinctive region detached from modern French culture, had begun to attract writers and artists. The area's language sounded less like French than like Welsh; its customs and costumes were picturesque; its religious rituals were curious; its local lore was laced with superstition and primitive belief; and its landscape and villages were filled with ancient monuments and scenic haunts. Although improved rail services made Finistère more accessible in the 1850s, it remained little changed by the industrial revolution and it preserved mysterious, old-fashioned ways. American painter Benjamin Champney, who visited in 1866, described the region as a time capsule: 'It retains its ancient forms and times, and mixes the past with very little of the present, and in some places one could fancy himself gone back in history almost a thousand years.'[23] Thus, scenes of contemporary Breton life looked like history paintings.

Thomas Hovenden spent most of the period from 1875 to 1880 at Pont-Aven, a small commercial town on the Aven river's broad tidal estuary, which featured old flour mills and waterwheels, thatch-roofed granite houses and stone foot-bridges. There he produced ambitious pictures in the manner of Robert Wylie, who had initiated the village's American colony in summer 1865.[24] Hovenden's *In Hoc Signo Vinces* (*By this sign shalt thou conquer*) (cat. 60), for example, shows a woman pinning to her husband's chest the emblem of the Brotherhood of

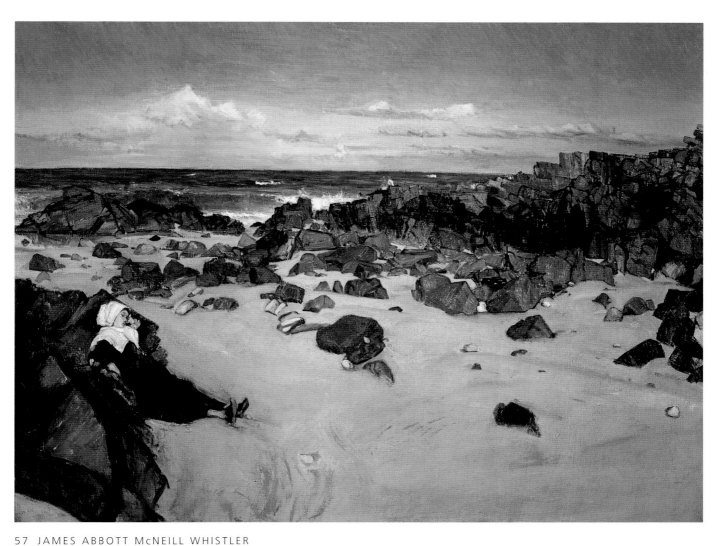

57 JAMES ABBOTT McNEILL WHISTLER
Coast of Brittany (*Alone with the Tide*), 1861
Oil on canvas, 87.3 x 115.6 cm (34⅜ x 45½ in.)
Wadsworth Atheneum Museum of Art, Hartford, Connecticut
In memory of William Arnold Healy, given by his daughter, Susie Healy Camp (1925.393)

58 JAMES ABBOTT McNEILL WHISTLER
The Sea, 1865
Oil on canvas, 52.7 x 95.9 cm (21 x 37¾ in.)
Montclair Art Museum, Montclair, New Jersey
Museum purchase. Acquisition Fund, 1960 (1960.82)

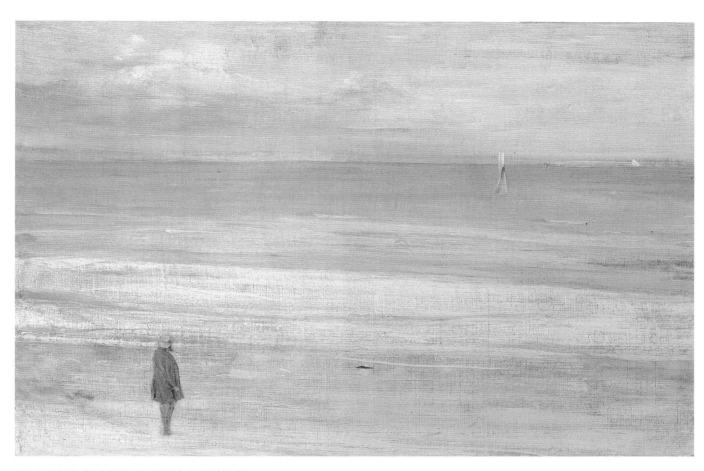

59 JAMES ABBOTT McNEILL WHISTLER
Harmony in Blue and Silver: Trouville, 1865
Oil on canvas, 49.5 x 75.5 cm (19½ x 29¾ in.)
Isabella Stewart Gardner Museum, Boston, Massachusetts

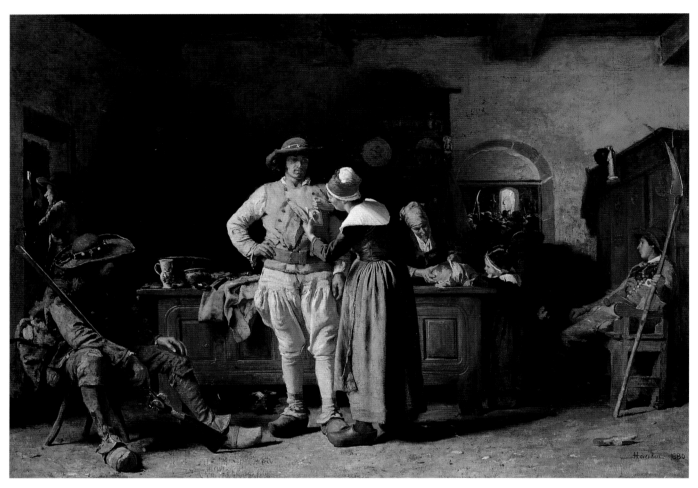

60 THOMAS HOVENDEN
In Hoc Signo Vinces (*By this sign shalt thou conquer*), 1880
Oil on canvas, 99.1 x 137.2 cm (39 x 54 in.)
The Detroit Institute of Arts, Michigan
Gift of Mr and Mrs Harold O. Love (72.249)

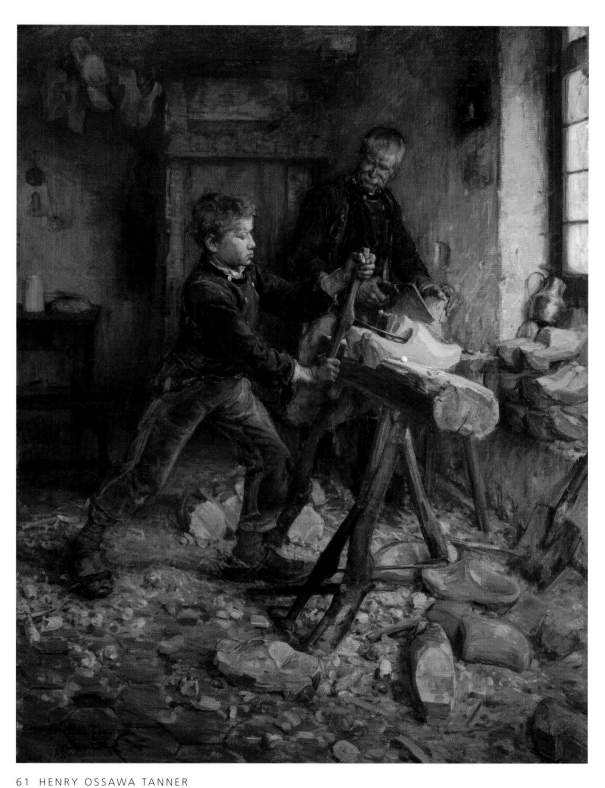

61 HENRY OSSAWA TANNER
The Young Sabot Maker, 1895
Oil on canvas, 104.1 x 88.9 cm (41 x 35 in.)
The Nelson-Atkins Museum of Art, Kansas City, Missouri
Purchase, The George O. and Elizabeth O. Davis Fund and partial gift of an anonymous donor (95-22)

the Sacred Heart, the insignia of the royalist uprising that occurred during the Reign of Terror in the Vendée region, along the Atlantic coast between Brittany and Bordeaux.[25] For this large canvas, which appeared in the 1880 Salon, Hovenden deployed academic skills he had learnt from Alexandre Cabanel to create a lucid stage set filled with local props and volumetric figures of peasant soldiers and civilians in historically correct costumes.

Later American visitors to Finistère included Frank W. Benson and Willard Metcalf, who came to Pont-Aven in 1884; Cecilia Beaux, who worked in 1888 in Concarneau, the fishing port 15 kilometres from Pont-Aven that became a popular art colony about 1880; and Henry Ossawa Tanner, who spent time in Pont-Aven in 1891 and Concarneau in 1892 and may have returned to the area in 1893 and 1894. In *The Young Sabot Maker* (cat. 61), Tanner explored the subject of an older man instructing a youth, to which he devoted several canvases in this period, and simultaneously invoked the iconography of Jesus in Joseph's workshop.

More peripatetic was Elizabeth Nourse, who specialised in portraying peasant women. Her *La mère* (cat. 39), with which she made her Salon debut in 1888, conveys maternal tenderness, an archetypal theme that engaged the popular imagination during a period when women's roles were being redefined. Nourse's composition reveals her command of solid draughtsmanship, masterly chiaroscuro, vigorous brushwork and ability to appeal to human emotion without undue sentimentality.

Some Americans combined an interest in rustic types with plein-air experiments. John Singer Sargent spent 10 weeks in the summer of 1877 on Brittany's northern coast in the company of fellow students. At Cancale, an old fishing port dramatically situated on the western shore of the Bay of Cancale, opposite Mont-St-Michel, he made oil sketches and drawings of the activity at the renowned oyster beds.[26] On these he based his shimmering *Fishing for Oysters at Cancale* (cat. 62), which depicts a procession of statuesque Cancalaises wearing prettily ragged costumes, kerchiefs and sabots and carrying their empty oyster baskets along the beach. Accompanied by barefoot children, these women exemplify the strength of the region's inhabitants, who had long coped with intemperate nature and frequent invasions.

Sargent's canvas won ecstatic reviews in the March–April 1878 inaugural exhibition of New York's Society of American Artists, a forum for the younger generation of Munich- and Paris-trained painters. Culminating his project was *The Oyster Gatherers of Cancale* (1878; Corcoran Gallery of Art, Washington, D.C.), a larger, more conservatively painted version of the same composition, which he sent in late May to the Paris Salon. There it received critical accolades and honourable mention, a great distinction for a 26-year-old artist exhibiting for only the second time.[27] Sargent's pictures revised with brilliant light and dynamic brushwork typical academic portrayals of Breton fisherfolk such as François-Nicolas-Augustin Feyen-Perrin's *Retour de la pêche aux huîtres par les grandes marées à Cancale (Ille-et-Villaine)* (1874; location unknown), which was awarded a medal in the 1874 Salon and purchased for the

62 JOHN SINGER SARGENT
Fishing for Oysters at Cancale, 1878
Oil on canvas, 41 x 61 cm (16⅛ x 24 in.)
Museum of Fine Arts, Boston, Massachusetts
Gift of Miss Mary Appleton (35.708)

63 CHARLES SPRAGUE PEARCE
The Arab Jeweler, 1882
Oil on canvas, 116.8 x 89.9 cm (46 x 35⅜ in.)
The Metropolitan Museum of Art, New York
Gift of Edward D. Adams, 1922 (22.69)

Musée du Luxembourg.[28] Sargent's Cancale summer may have inspired the freedom and candour apparent in works such as *In the Luxembourg Gardens* (cat. 42); his oyster gatherers anticipated the Venetian bead stringers, Egyptian water carriers and other picturesque types who would later attract his interest.

Luminous coastal atmosphere could even excite artists who were devoted to more academic styles. For example, Charles Sprague Pearce specialised in dark-toned, volumetric portraits and orientalist subjects in the manner of his teacher, Léon Bonnat (cats 21 and 63). During one of the summers Pearce spent in Normandy in the 1880s, he painted *Reading by the Shore* (cat. 64), a small, unusual portrait of Antonia Bonjean, his wife and favourite model, who is shown perusing a book on a rocky beach under the shelter of a vibrant Japanese paper parasol. While the figure retains academic solidity, the setting suggests Pearce's susceptibility to brilliant opalescent light, at least as a holiday diversion.

Holiday freedom also stimulated Mary Cassatt. In 1880, the year after she first showed with the Impressionists, she spent the summer with her family at Marly-le-Roi, 23 kilometres west of Paris, which boasted an old village centre, the remains of a *petit Versailles* built in 1680 by Louis XIV and a beautiful surrounding forest. Ignoring such landmarks for her art, Cassatt turned instead to the domestic environment. As models she enlisted her family, including her invalid elder sister, Lydia Simpson Cassatt, who posed for *Lydia crocheting in the Garden at Marly* (cat. 65). The canvas, which suggests the cosseted existence of many affluent women, portrays the sitter fashionably dressed, insulated by a walled garden from modern hurly-burly and absorbed in the sort of old-fashioned, genteel handicraft that was increasingly prized at a time when factory manufacture by working-class women was escalating. Although Cassatt, like her friend Degas, was generally uninterested in plein-air painting, she captured dazzling sunlight in this picture, especially in Lydia's large white hat, which is infused with hints of pink, blue and yellow. She implied with vivacious brushwork Lydia's plaid dress and the deep red coleus plants that recede along the garden pathway.

Many other American art students and artists in Paris experimented with new stylistic strategies in rural locales. For example, Dennis Miller Bunker worked in 1884 in the company of fellow artists Kenneth R. Cranford (see cat. 6) and Charles A. Platt in Larmor (now Larmor-Plage), a small harbour town near Lorient on Brittany's southern coast. Like nearby Pont-Aven and Concarneau, Larmor offered picturesque Breton architecture, distinctive rural traditions and bracing seaside atmosphere, but it was more isolated and it attracted few American visitors. (Platt remarked: 'no one comes to Larmor from the outside world at all.'[29]) Bunker's most ambitious Larmor canvas is *Brittany Town Morning, Larmor* (cat. 66). Bunker had already responded to Corot's poetic late works, but to record Larmor's ancient stone buildings he echoed the French painter's early landscapes, which emphasise geometric shapes (see fig. 14). His view celebrates the tonal contrasts among the silvery morning sky, the compact cluster of

64 CHARLES SPRAGUE PEARCE
Reading by the Shore, about 1883–5
Oil on canvas, 30.2 x 46 cm (11⅞ x 18⅛ in.)
Manoogian Collection

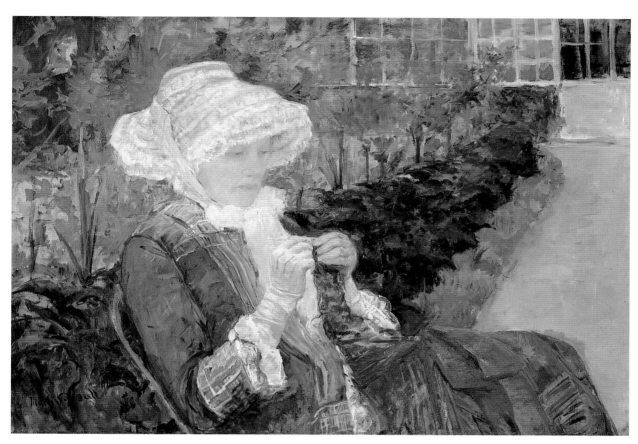

65 MARY CASSATT
Lydia crocheting in the Garden at Marly, 1880
Oil on canvas, 65.6 x 92.6 cm (25 $^{13}/_{16}$ x 36 $^{7}/_{16}$ in.)
The Metropolitan Museum of Art, New York
Gift of Mrs Gardner Cassatt, 1965 (65.184)

66 DENNIS MILLER BUNKER
Brittany Town Morning, Larmor, 1884
Oil on canvas, 35.6 x 55.9 cm (14 x 22 in.)
Terra Foundation for American Art, Chicago, Illinois
Daniel J. Terra Collection (1991.1)

stone dwellings punctuated by the formidable profile of the town's most prominent landmark – the early-medieval church of Notre Dame de Larmor – and the nearby lush fields. To enliven these broad passages of sunlight and shadow, Bunker added engaging details: birds fluttering around the massive stone tower; slate rooftops reflecting light; two women dwarfed by a heavy village wall; and a laundress spreading clothes to dry on bushes in the foreground.

John Henry Twachtman liberated himself from his earlier Munich style during the same summer, when he rented a château at Arques-la-Bataille in Normandy, 190 kilometres northwest of Paris. Arques welcomed visitors who came for the popular sea baths at the port of Dieppe, about six kilometres away. Indifferent as a painter to the imposing ruins of the eleventh-century castle of Arques, which overlooked the historic village, and to the handsome parish church built in the Romanesque and Gothic styles, Twachtman focused on commonplace views of the Arques river valley. In *Arques-la-Bataille* (cat. 67), he portrayed the edge of the Béthune, a tributary of the Arques, bordered by a fringe of reeds and meadow flowers and reflecting in its placid surface grassy fields, a low ridge and a pearly grey sky. In his Paris studio during the following winter, he reconsidered his naturalistic sketch to create his monumental *Arques-la-Bataille* (1885; The Metropolitan Museum of Art, New York), which suggests in its emphasis on flat veils of delicate greys, greens and blues the influence of Whistler's shorescapes (see cats 58 and 59), Japanese art and Bastien-Lepage's preferred palette.

In August 1875 several members of the Barbizon colony explored Grez-sur-Loing, 22 kilometres away, on the southern edge of the Fontainebleau forest and 80 kilometres from Paris (fig. 15).[30] Millet had died in January 1875 and tourists besieged Barbizon, which increased the appeal of idyllic Grez. The village offered picturesque remnants of its earlier significance – a twelfth-century church, the fortified Tour de Ganne and a handsome old stone bridge – and, most importantly, the Loing river, which permitted water sports.[31] The following summer,

Fig. 15
View of
Grez-sur-Loing,
about 1900
Photographic
postcard
Courtesy of May
Brawley Hill

67 JOHN HENRY TWACHTMAN
Arques-la-Bataille, 1884
Oil on canvas, 46.4 x 65.7 cm (18¼ x 25⅞ in.)
The Metropolitan Museum of Art, New York
Purchase, The Charles Engelhard Foundation Gift, 1991 (1991.130)

several Barbizon veterans – the American painters Will H. Low and Wyatt Eaton, the British painter Robert Alan Mowbray ('Bob') Stevenson and his writer cousin, Robert Louis Stevenson – transferred their allegiance to Grez, where several students in Carolus-Duran's atelier joined them. Two riverside inns served the village: the long-established, more Bohemian Hôtel de la Marne (known as Chevillon's), and the Hôtel Beau Séjour (known as Laurent's), which probably opened in 1878. In 1879 painter May Alcott Nieriker would recommend it to 'any one desirous to try roughing it a little in France': 'The place has its own bridge and ruin, its boating and bathing, the river making these possible for ladies as well as gentlemen, flannel shirts and tramp dresses being the order of the day.'[32] Grez and nearby Marlotte, Montigny, Moret and Nemours attracted landscapists working in both tonal and Impressionist styles, including many Scandinavians who arrived after about 1882. Ultimately, Bob Stevenson would complain about the invasion of the village by foreign artists, 'mostly females and mostly Americans', and their indecorous attire and demeanour.[33]

American habitués in the late 1880s included Robert Vonnoh, who established his career as a portraitist and teacher in Boston before returning to France in 1887 to begin a three- or four-year sojourn in Grez. There he painted *Poppies* (cat. 68), one of the most radical American Impressionist canvases of the late 1880s. Bordering on abstraction, *Poppies* reveals that Vonnoh could adopt excited brushwork and a brilliant palette, even if only for a transcription of an unprepossessing bit of nature on a canvas he may have deemed merely a sketch. By contrast, *November* (cat. 69), which Vonnoh sent to the 1890 Salon, recalls his more conservative bent. Developed from an oil study painted in Grez late in 1889, *November* reveals a deliberate compositional armature. Its silvery tonality echoes Bastien-Lepage's palette and typifies the colonists' predilection for portraying grey days.[34] Vonnoh would visit Grez again several times between 1907 and 1922, always yearning, even when he was no further away than Paris, to return to the village 'where it is comfortable and where I can forget myself and the world in my work'.[35]

Frederic Porter Vinton, who, like Vonnoh, was a successful Boston portraitist, painted landscapes for recreation, experimenting with the Barbizon style and Impressionism. His 18-month trip to Europe with his new wife in 1889–90, long after his student years, included a visit to Grez. There he painted *The River Loing at Grez, France* (cat. 70), a view that emphasises four broad bands of colour: luminous sky, clustered village dwellings, reflective water and a verdant field. The panoply of surface effects suggests Vinton's ability to respond candidly to invigorating nature and his susceptibility to influence from Eugène Boudin, Camille Pissarro and Alfred Sisley, all of whom he met in and around the village.

By the late 1880s, Grez and its grey days ceased to appeal to American painters, many of whom were instead seduced by Giverny, the ancient Norman farming hamlet on the Seine, about 85 kilometres north-west of Paris, where Monet had settled in April 1883. A San

68 ROBERT VONNOH
Poppies, 1888
Oil on canvas, 33 x 45.7 cm (13 x 18 in.)
Indianapolis Museum of Art, Indiana
James E. Roberts Fund (71.8)

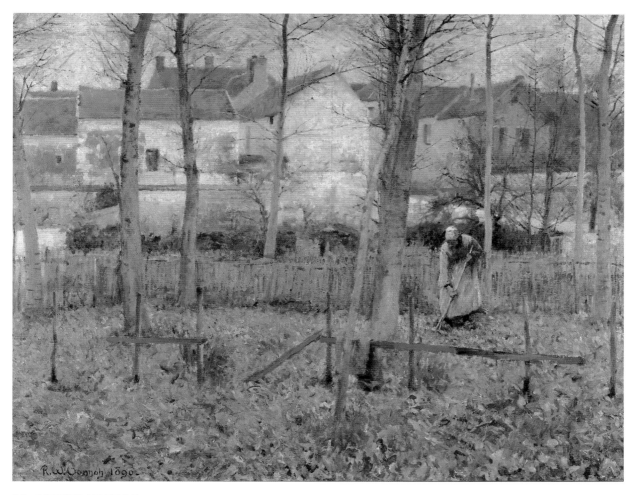

69 ROBERT VONNOH
November, 1890
Oil on canvas, 81.3 x 100 cm (32 x 39⅜ in.)
Courtesy of the Pennsylvania Academy of the Fine Arts, Philadelphia
Joseph E. Temple Fund (1894.5)

70 FREDERIC PORTER VINTON
The River Loing at Grez, France, 1890
Oil on canvas, 65.4 x 81.3 cm (25¾ x 32 in.)
Museum of Fine Arts, Boston, Massachusetts
Joseph Beale Glover Fund (11.1388)

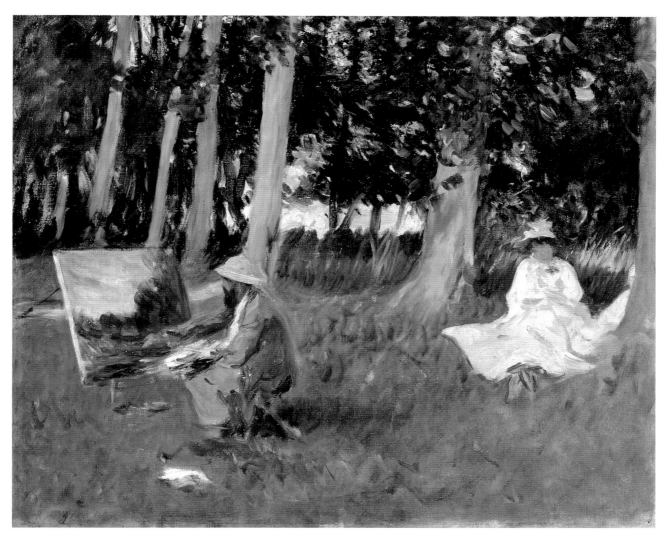

71 JOHN SINGER SARGENT
Claude Monet painting by the Edge of a Wood, 1885
Oil on canvas, 54 x 64.8 cm (21¼ x 25 ½ in.)
Tate, London
Presented by Miss Emily Sargent and Mrs Ormond
through the National Art Collections Fund 1925 (N04103)

Francisco newspaper reported in April 1891: 'For a year or two Grez has been given up to a craze for "Impressionism," and Monet is the god of the young landscapists.'[36]

American painters began to visit Giverny in 1885, although the precise dates of their arrival and prior awareness of Monet's presence cannot be verified. Sargent is the only American known to have been acquainted with Monet before he came to the village, apparently in midsummer 1885. His *Claude Monet painting by the Edge of a Wood* (cat. 71) shows the French master at work on his *Meadow with Haystacks near Giverny (Prés à Giverny)* (1885; Museum of Fine Arts, Boston), executed between late June and 22 August 1885.[37] Seated in deep grass towards the right canvas edge is an unidentified woman, perhaps Alice Hoschedé, Monet's longtime companion, or her daughter Suzanne. Sargent continued to call on Monet at Giverny until 1891, never remaining long or becoming involved in the burgeoning American art colony, but reinforcing his command of Impressionism. Monet's style would enliven Sargent's portraits and inflect subject pictures that he painted in the Cotswolds, Calcot Mill and Fladbury between 1886 and 1889 and during his frequent journeys to more distant locales.

Metcalf exemplifies the transfer of Americans' allegiance from Grez to Giverny and from tonalism to Impressionism. Having painted each year between 1884 and 1886 at Grez, Metcalf also stopped in 1885 and 1886 at Giverny, which he is said to have discovered by chance.[38] At Grez he had added to his customary low-key palette some brilliant colours and enlisted a freer stroke; at Giverny he made a radical conversion to Impressionism. Although Monet may have been incidental to Metcalf's discovery of the village, the American's *Poppy Field (Landscape at Giverny)*, probably painted in June 1886 (cat. 72), suggests his confident emulation of the French painter's technique and one of the latter's favourite – and recent – subjects, a field of poppies in bloom (fig. 16). Metcalf's delightful small canvas presents a broad foreground hillside and sharp geometries of distant houses, apparently including Monet's, described with

a play of contrasting complementaries. Admirable as an abstract exercise, the picture also celebrates vibrant spring foliage and hints at cosy rural domesticity.

Metcalf made his first extended visit to Giverny in September 1886. The following summer he was joined there by several Americans, including John Leslie Breck, Louis Ritter, Theodore Robinson and Theodore Wendel and the Canadian William Blair-Bruce.[39] The group's principal gathering place was the Hôtel Baudy, an old *épicerie-buvette* to which six rooms were added in 1887 to accommodate them (fig. 17). By the 1890s, Angélina and Lucien Baudy and their son Gaston presided over an inn that contained more than 20 guest rooms, a dining room,

Fig. 16 Claude Monet (1840–1926)
Poppy Field in a Hollow near Giverny, 1885
Oil on canvas, 65.1 x 81.3 cm. Museum of Fine Arts, Boston, Massachusetts. Juliana Cheney Edwards Collection (25.106)

72 WILLARD METCALF
Poppy Field (*Landscape at Giverny*), 1886
Oil on canvas, 27.3 x 45.7 cm (11 x 18 in.)
Private collection

Fig. 17
Hôtel Baudy, Giverny,
about 1905
Photographic
postcard
Courtesy of the
Musée d'Art
Américain, Giverny

several studios, vegetable and flower gardens and even a tennis court. Giverny would continue to flourish as a rural retreat, especially for American painters, until about 1915.[40]

Metcalf painted *The Ten Cent Breakfast* (cat. 73) during the colony's initial summer. In this conversation piece, Robert Louis Stevenson is shown seated at the right reading *Le Petit Journal* in a dimly lit room at Baudy's. The figure seated farthest from the viewer is almost certainly Robinson. The third man at the table may be Metcalf himself, whom he resembles, but the identity of the thin, moustached young man who stands at the left, lighting his pipe, is unknown.[41] The dark palette, strong chiaroscuro and careful modelling in this small picture bespeak Metcalf's academic studies and his willingness to turn away from Impressionist experiments to create a documentary indoor scene.

Like Metcalf, other Americans at Giverny quickly adopted Monet's methods. By October 1887 a writer for *Art Amateur* could marvel: 'Quite an American colony has gathered, I am told, at Giverny A few pictures just received from these young men show that they have all got the blue-green color of Monet's impressionism and "got it bad".'[42] Breck, for example, exchanged traditional techniques for Impressionism in views painted in and around the village. *Giverny Landscape* (cat. 74) is a tapestry of rapid strokes that suggest a marshy meadow strewn with bright yellow irises (*Iris pseudacorus*), punctuated by two small figures gathering blooms and set off by a screen of poplars. After a period back in Boston, Breck returned during the summer of 1891 to Giverny, where, in emulation of Monet's works in series, he painted 15 small canvases depicting the same subject at different times over the course of three days.[43]

Breck had more personal contact with Monet than did most Americans at Giverny, becoming romantically involved with Blanche Hoschedé, Alice Hoschedé's daughter, and painting Blanche's sister, Suzanne.[44] Monet, in fact, threatened to sell his house and to leave Giverny in March 1892 because of the attentions of Breck and of the American painter Theodore Earl Butler to the two Hoschedé daughters.[45]

Of the Americans at Giverny, Robinson seems to have enjoyed the warmest and most enduring relationship with Monet. Having worked at Barbizon under the influence of Corot and Daubigny and painted outdoors at Grez, he was predisposed to experiment with Impressionism. Robinson visited Giverny briefly in 1885, when he may have met Monet through the landscape painter Ferdinand Deconchy; made his first lengthy stay in the village in Metcalf's company in 1887; summered there in 1888; and spent more than half of each year there from 1889 to 1892, usually living at the Hôtel Baudy. He adopted Monet's techniques, his appreciation of art based on ordinary visual experience and his commitment to expressing the essence of a place.[46] Thus, in *A Bird's-Eye View* (cat. 75), Robinson focused on homely local

73 WILLARD METCALF
The Ten Cent Breakfast, 1887
Oil on canvas, 87.3 x 115.6 cm (15 x 22 in.)
Denver Art Museum, Colorado
Gift of T. Edward and Tullah Hanley Collection (1974.418)

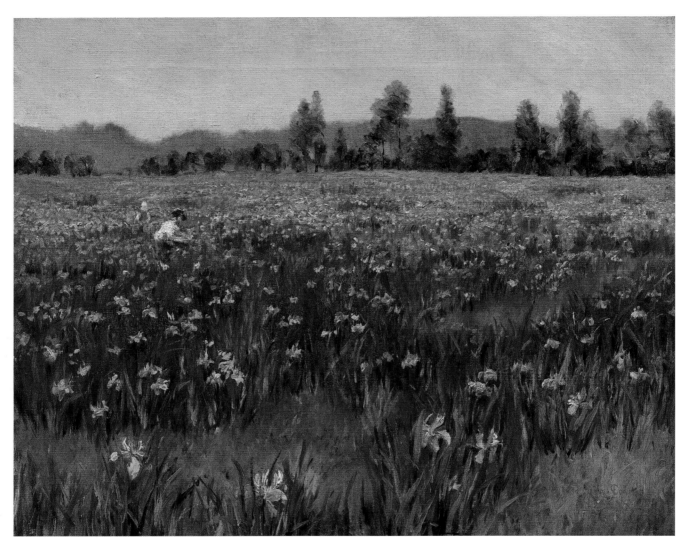

74 JOHN LESLIE BRECK
Giverny Landscape, 1888
Oil on canvas, 47 x 55.9 cm (18½ x 22 in.)
Private collection

attributes – low, stucco-clad stone houses and walls, red-tiled roofs and the surrounding fields – as seen from a hill high above Giverny, and captured the distinctive ambiance that his friend Will H. Low later described: 'Its greatest charm lies in the atmospheric conditions over the lowlands, where the moisture from the rivers, imprisoned through the night by the valleys bordering hills, dissolve before the sun and bathe the landscape in an iridescent flood of vaporous hues.'[47]

As Robinson spent more time in Monet's company, he grew more confident as an Impressionist. He understood Monet's aims in working in series to record different light conditions, writing in his diary on 3 June 1892, 'it is only a long continued effort that satisfies him [Monet], and it must be an important motif'.[48] Responding to Monet's example, Robinson executed a series of panoramic scenes at Vernon, across the Seine from Giverny.[49] In *Valley of the Seine* (fig. 18) and similar views, he exchanged the solid architectural forms of *A Bird's-Eye View* for more fluid paint handling and a varied palette, and paid new attention to atmospheric gradation and time of day.

Although Robinson increasingly devoted himself to landscapes at Giverny, he maintained his longstanding interest in figure painting. During his last stay in the village, between May and December 1892, he produced two unusual pictures that feature figures. *The Wedding March* (cat. 76) is a unique record of the links between Monet and Giverny's American colony. The canvas commemorates Butler's marriage on 20 July 1892 to Suzanne Hoschedé, a match that the French master opposed. The civil ceremony took place at the *mairie* (city hall), which Robinson depicted at the upper right, and was followed by a procession down a sun-drenched village street to the church of Ste Radégonde, where the religious vows were exchanged.[50] Robinson began the painting two weeks after the wedding, describing the scene from memory, and enlisting his most fluent Impressionist technique.[51] *La Débâcle* (cat. 77) takes its title from Emile Zola's best-selling new novel about the Franco-Prussian War, which Robinson read during the summer of 1892 and which his model holds.[52] The harmonies among the purple tones in the model's dress, the stone embankment on which she sits and the sky make this one of Robinson's most successful chromatic displays.

During his Paris sojourn from 1886 to 1889, Childe Hassam did not mingle with other artists and did not frequent the usual magnets for Americans such as Grez-sur-Loing or Giverny. Instead, each summer, he and his wife visited friends who resided

Fig. 18 Theodore Robinson
Valley of the Seine, 1892
Oil on canvas, 65.4 x 82.6 cm. Addison Gallery of American Art, Phillips Academy, Andover, Massachusetts (1934.3)

75 THEODORE ROBINSON
A Bird's-Eye View, 1889
Oil on canvas, 65.4 x 81.3 cm (25¾ x 32 in.)
The Metropolitan Museum of Art, New York
Gift of George A. Hearn, 1910 (10.64.9)

76 THEODORE ROBINSON
The Wedding March, 1892
Oil on canvas, 56.7 x 67.3 cm (22⅜ x 26½ in.)
Terra Foundation for American Art, Chicago, Illinois
Daniel J. Terra Collection (1999.127)

77 THEODORE ROBINSON
La Débâcle, 1892
Oil on canvas, 45.7 x 55.9 cm (18 x 22 in.)
Scripps College, Claremont, California
Gift of General and Mrs Edward Clinton Young, 1946 (Y052)

78 CHILDE HASSAM
Geraniums, 1888
Oil on canvas, 45.7 x 27.3 cm (18¼ x 13 in.)
The Hyde Collection, Glens Falls, New York (1971.22)

on the estate once occupied by the painter Thomas Couture in Villiers-le-Bel, in the Oise valley about 20 kilometres north of Paris. There Hassam recorded several delightful views of his hosts' classic French garden, which included terraces, raised flowerbeds, potted plants and shrubs clipped to standards. Hassam's *Geraniums* (cat. 78) for example, features natural elements controlled: a potted oleander and pots of brilliant red geraniums set on a deep window ledge and on two steps on a terrace. Two large watering cans emphasise the garden's artificiality. The geraniums create a dazzling screen of colour behind which appears a beautifully rendered sunlit wall to the right. To the left, under a glass awning that is announced by the shadows it casts, Mrs Hassam is seen sewing. The blossoms that encircle her head suggest the accord between the flowers and the woman: all are in bloom.

Back in the United States, Hassam would continue to be inspired by gardens, but would portray informal old-fashioned gardens in coastal New England (cats 84 and 85) instead of the orderly setting he portrayed at Villiers-le-Bel. Other Americans who had enjoyed productive seasons in Paris and summers in the country would also seek to recapitulate their experiences after their return to the United States.

Back in the USA

Many artists who had studied and worked in Paris and the French countryside settled in New York, Boston and Philadelphia, where American cultural energy was increasingly concentrated. They witnessed changes wrought by urbanisation, industrialisation, mechanisation, growing wealth, demographic shifts arising from immigration and domestic migrations and sometimes-convulsive social conflict. Repatriated artists were well aware, too, of the erosion of the Puritan work ethic, the upsurge in free time and the desire of city-dwellers for respite from crowding, traffic and noise, summer heat and unwholesome air. As hundreds of new suburban resorts and country retreats materialised to meet the demand for outing and holiday destinations, leisure became big business in America. Like other residents of burgeoning cities, artists found relief, recreation and rest in the suburbs and countryside. They also found subjects for pictures.[53]

Images of country retreats and of people being rejuvenated by outdoor pastimes signal two key changes in American art. Unlike earlier Hudson River School landscapists who celebrated awe-inspiring American scenery and minimised traces of human intrusion, late-nineteenth-century painters of American views described their personal encounters with mundane nature on modest canvases and acknowledged tourism and recreation. Concurrently, many American painters turned increased attention to the human figure, largely in response to their exposure to Parisian standards.

Thomas Eakins, for example, recorded leisure activities that he, his family and his friends

pursued in an unprepossessing area near his home city of Philadelphia, at the same time showing off technical skills he had honed in Paris. *Pushing for Rail* (cat. 79) and *Starting Out after Rail* (cat. 80) depict a sport popular in New Jersey's tidal marshes and along the Delaware river: hunting for rail, small game birds that were plentiful in the region. In the former canvas, he showed three hunters, each accompanied by a 'pusher' of his skiff, who act out the hunt's phases as if they were posing for a sequence of academic figure studies. The six men's convincing volumes and their minutely detailed physiognomies and garments also reflect Eakins's academic lessons. In the latter picture, which focuses on two of his friends sailing a skiff that holds the pusher's pole and a shotgun, Eakins demonstrated the mastery of perspective and commitment to portraiture that always inflected his genre scenes. Recognising Eakins's debt to French academic principles upon seeing these hunting scenes in the 1875 Salon, a critic for the *Revue des Deux Mondes* marvelled: 'These two canvases . . . resemble photographic prints covered with a light watercolour tint to such a degree that one asks oneself whether these are not specimens of a still secret industrial process and that the inventor may have maliciously sent them to Paris to upset M. Detaille and frighten the *école française*.'[54]

Other artists who had spent summers in the French countryside founded and frequented American colonies in which time-honoured architecture and activities evoked a more tranquil era, or they worked alone in other nostalgic pastoral places.[55] New England, a region that preserved Anglo-American tradition and represented – literally and figuratively – the nation's reassuring bedrock, appealed to many artists who were conscious of daunting change.[56] Hunt, for example, echoed Barbizon prototypes in New England landscapes and figure paintings; academics recorded the region's history and everyday life;[57] and Homer produced masterly views of Maine's rocky coast (see cat. 95). American Impressionists, who emerged in the mid-1880s and flourished in the 1890s, were also particularly inspired by New England. Minimising or ignoring modernity, they portrayed picturesque villages, white-columned churches, old-fashioned gardens, demure women and the rugged shoreline. Such motifs represented qualities cherished by these artists, most of whom shared Anglo-Saxon cultural roots; they also appealed to collectors as holiday souvenirs and as emblems of immutable American values.

After spending the summer of 1888 at Calcot Mill in the English Cotswolds with Sargent, who imparted his enthusiasm for Impressionism, Dennis Miller Bunker returned to the United States with a more fluent technique and a new awareness of sunlight effects. His Impressionist tendencies were encouraged by those of fellow Boston artists – and Giverny veterans – Willard Metcalf, Louis Ritter and Theodore Wendel, and by the fact that Monet's works were beginning to enter Boston collections.[58] Bunker's *Chrysanthemums* (cat. 81), which depicts a greenhouse interior at Green Hill, the suburban summer residence of John L. and Isabella Stewart Gardner, Boston socialites and collectors, reveals the liberation of his style. Focusing on Mrs Gardner's

79 THOMAS EAKINS
Pushing for Rail, 1874
Oil on canvas, 33 x 76.4 cm (13 x 30$\frac{1}{16}$ in.)
The Metropolitan Museum of Art, New York
Arthur Hoppock Hearn Fund, 1916 (16.65)

80 THOMAS EAKINS
Starting Out after Rail, 1874
Oil on canvas mounted on Masonite, 61.6 x 50.5 cm (24¼ x 19⅞ in.)
Museum of Fine Arts, Boston, Massachusetts
The Hayden Collection – Charles Henry Hayden Fund (35.1953)

favourite flowers, Bunker described a dynamic space in which a brick walkway, tipped up to the picture plane, is bordered by huge pots of lush early-autumn blooms and bowered by graceful palm fronds. The flat, tapestry-like composition insists upon the viewer's immersion in a dazzling display of suggestive brushwork and sensuous colour. A comparison between *Chrysanthemums* and Childe Hassam's contemporaneous *Geraniums* (cat. 78) underscores the radical quality of Bunker's Impressionism.

In 1889 and 1890, Bunker spent the summer in Medfield, a small historic town 43 kilometres south-west of Boston that welcomed vacationing New Yorkers and Bostonians. There he recorded intimate views of nature and vernacular architecture. In 1889 he lived and worked in the old clapboarded caretaker's cottage adjoining Miss Alice Sewell's boarding house. The modest dwelling became the subject of *Roadside Cottage* (cat. 82), a *tour de force* in rendering light and, especially, colour, in the deep green lawn splashed with chartreuse patches and the rough road streaked with grey, purple and salmon. *The Pool, Medfield* (cat. 83), painted during the same summer, is one of several similar compositions that show how Bunker adopted the French Impressionists' preference for unpretentious landscape motifs and their tendency to eliminate horizon lines, crop views abruptly and tilt the ground plane. Bunker's sympathy with his humble surroundings is clear in his letters to Mrs Gardner. He wrote in 1889: 'My room is filling up with canvases, and the country seems more tender and beautiful every day'; the following summer he proclaimed: 'I know every bush and bird and bull-frog in this place and they are all very friendly.'[59]

New York gained its foremost Impressionist chronicler in Childe Hassam, who settled there in late 1889 after three years in Paris. In 1890 he resumed the habit of making excursions along the New England shore that he had begun during his early career in Boston, often visiting several villages each year. In scores of paintings, drawings and etchings, Hassam proclaimed both his pride in his Yankee heritage and the prevailing belief that New England epitomised America.

The Isles of Shoals, a cluster of rocky islands 15 kilometres off the New Hampshire and Maine coasts, attracted Hassam from 1886 until about 1916 and inspired almost one-tenth of his immense oeuvre.[60] On Appledore, the largest of the islands, the poet Celia Laighton Thaxter hosted a summer salon of prominent writers, artists, and musicians in her cottage (fig. 19)

next to the Appledore House hotel, which she helped her brothers manage. Between 1890 and 1894 Hassam responded in many oils and watercolours to the small cutting garden of old-fashioned flowers that Thaxter cultivated despite Appledore's poor soil and harsh climate. Ignoring the nearby built environment, Hassam usually limited his views to the garden's luxuriant blooms, thus

Fig. 19 Celia Thaxter's Cottage, Isles of Shoals, New Hampshire, about 1887 Photographic postcard. Courtesy of the Portsmouth Athenaeum, New Hampshire

81 DENNIS MILLER BUNKER
Chrysanthemums, 1888
Oil on canvas, 90 x 121 cm (35½ x 48 in.)
Isabella Stewart Gardner Museum, Boston, Massachusetts

82 DENNIS MILLER BUNKER
Roadside Cottage, 1889
Oil on canvas, 63.8 x 76.2 cm (25$\frac{1}{16}$ x 30 in.)
Collection of Margaret and Raymond J. Horowitz, New York

83 DENNIS MILLER BUNKER
The Pool, Medfield, 1889
Oil on canvas, 47 x 61.6 cm (18½ x 24¼ in.)
Museum of Fine Arts, Boston, Massachusetts
Emily L. Ainsley Fund (45.475)

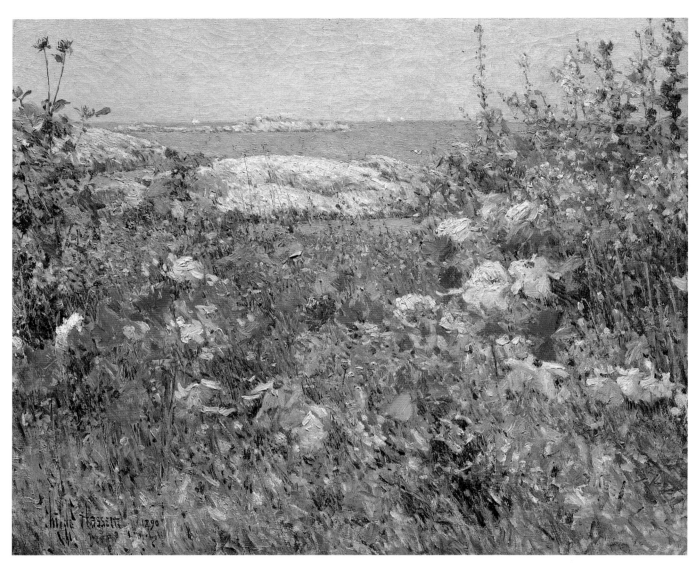

84 CHILDE HASSAM
Celia Thaxter's Garden, Isles of Shoals, Maine, 1890
Oil on canvas, 45.1 x 54.6 cm (17¾ x 21½ in.)
The Metropolitan Museum of Art, New York
Anonymous Gift, 1994 (1994.567)

85 CHILDE HASSAM
Poppies on the Isles of Shoals, 1890
Oil on canvas, 45.7 x 55.7 cm (18⅛ x 22⅛ in.)
Brooklyn Museum of Art, New York
Gift of Mary Pratt Barringer and Richardson Pratt, Jr.,
in memory of Richardson and Laura Pratt, 1985 (85.286)

implying that he was representing wildflowers. In *Celia Thaxter's Garden, Isles of Shoals, Maine* (cat. 84), for example, poppies and hollyhocks screen the garden's board fence and the nearby barren terrain. *Poppies on the Isles of Shoals* (cat. 85) portrays the poppies, Thaxter's favourite flowers, which she seeded beyond the enclosure to create a 'wild' effect. Babb's Rock in the centre, with the tip of Appledore behind it, and Londoner's Rock in the distance, are austere, enduring foils to the brilliant, fragile flowers.

Close friendships among Hassam, John Twachtman, Julian Alden Weir and Giverny veteran Theodore Robinson energised all four artists' Impressionist experiments during the 1890s.[61] In 1889, Twachtman acquired a property in Greenwich, Connecticut, that included a garden, brook, small waterfall and pool, all of which inspired him. *Brook in Winter* (cat. 86) suggests his poetic approach to familiar landscape vignettes, his appreciation of seasonal moods and some of his technical strategies. Working out of doors, he often painted *alla prima*, mixed pigments on the canvas and explored the expressive potential of bare canvas, muted tonalities, thick impasto and textured brushwork. The composition's asymmetry and tonal subtlety also suggest his continuing appreciation of Japanese design. Responding to works such as *Brook in Winter*, shown in New York in 1893 alongside those of Weir, Monet and Paul Besnard, one critic remarked that Twachtman came 'nearer than any New York artist to solving some of the problems of *plein aire* [*sic*] that Monet has set down'.[62]

Theodore Robinson used winter visits home between 1887 and 1892 to apply Impressionist principles to American subjects and imparted them to his friends. After he returned to full-time residence in New York in December 1892, he created many works that echoed his Giverny scenes in subject and spirit. For instance, in the summer and early autumn of 1893, Robinson taught plein-air painting at Napanoch, New York, 175 kilometres north-west of New York City in the Shawangunk mountains, and recorded that still rural region in several canvases. The largest of three similar views is *Port Ben, Delaware and Hudson Canal* (cat. 87), which commemorates an old canal that facilitated cheap transportation of coal from Pennsylvania to New York City. By 1893, however, this artificial waterway, like most others in America, had been rendered obsolete by the more efficient rail lines; by 1904 the canal was abandoned. Robinson's view, which shows the canal at Wawarsing, New York, emphasises empty foreground planes that underscore the absence of activity and the enduring beauty of the panoramic, sunlit landscape. Such a view, created in a former haunt of Hudson River School painters who had amplified the grandeur of nearby scenery, demonstrates the American Impressionists' commitment to the commonplace. 'One or two of my canal things are in a good direction, it seems to me', Robinson confided to his diary in late October 1893, adding, 'and still more courage, emancipation from old formulae and ideas of what is interesting or beautiful, from the European standpoint, will work wonders'.[63] Besides emancipating himself from 'old formulae', Robinson introduced his students to plein-air practices. Soon the towpaths were

86 JOHN HENRY TWACHTMAN
Brook in Winter, about 1892
Oil on canvas, 91.8 x 122.2 cm (36⅛ x 48⅛ in.)
Museum of Fine Arts, Boston, Massachusetts
The Hayden Collection – Charles Henry Hayden Fund (07.7)

dotted with white painters' umbrellas and even the bargemen could describe the 'tender purples' and 'fresh greens' of their surroundings.[64]

Robinson spent June and July 1894 in Cos Cob, Connecticut, on the shore of Long Island Sound, less than five kilometres from Twachtman's Greenwich farm. Cos Cob was both a picturesque village that preserved New England traditions and a suburb easily reached by rail from New York City, about 55 kilometres away. Although artists had worked in the region earlier, Cos Cob began to flourish as a colony dedicated to Impressionism when Twachtman organised a summer class there, perhaps as early as 1890.[65] The class, which attracted amateurs and professionals, lasted until 1899, with Weir sharing the teaching in 1892 and 1893. Camaraderie and opportunities for collaboration abounded at Weir's home, at Twachtman's and at Holley House, a genteel Cos Cob boarding house that overlooked the small rustic harbour and accommodated artists and art students.

During his 1894 visit to Cos Cob, Robinson stayed in Holley House and found his subjects nearby. By 1894, Cos Cob's fishing industry was in decline; the railway was supplanting market boats that carried local produce to New York; and suburbanites and summer visitors were pursuing leisure-time diversion. Robinson responded to recent changes in *Low Tide* (cat. 88), one of four similar canvases. The view features broad mudflats in the foreground and, across the harbour, the newly renovated Riverside Yacht Club, which was then enjoying an influx of members. Sleek recreational boats, moored offshore, await excursionists. Like Robinson's canal views, his pictures of the Riverside Yacht Club are American counterparts of two series of canvases painted in 1892, Robinson's last year in France: Monet's views of Rouen Cathedral and Robinson's views of the Seine Valley (fig. 18). In the Catskills and at Cos Cob, Robinson had found motifs that warranted multiple canvases and that were imbued with nostalgia or gently commented on modern developments.

Weir had disdained the Impressionist works he saw in France, grumbling that the third Impressionist exhibition in 1877 'was worse than the Chamber of Horrors' (see p. 46).[66] Yet he was enthusiastic about Edouard Manet's paintings, acquiring two of them as an agent for New York collector Erwin Davis in 1881, and echoing the French naturalist's subjects, palette and brushwork in his own figural and still-life paintings of the 1880s. Weir was increasingly drawn to Impressionism as he worked more often in the Connecticut countryside: at his Branchville farm, in industrial Willimantic and at Windham, in the state's rural eastern region, where his wife's family had a home. Influenced by Twachtman, Hassam and Robinson, and inspired by Japanese prints, Weir's conversion to Impressionism is signalled by *The Red Bridge* (cat. 89), for which he found his motif in a new iron truss bridge that had replaced a covered wooden bridge over the Shetucket river in Windham. Dismayed at first by the loss of the picturesque landmark, he came to appreciate the new bridge's geometric structure when a fresh coat of vibrant red-lead priming paint enhanced it.[67] A web of branches on the picture plane

87 THEODORE ROBINSON
Port Ben, Delaware and Hudson Canal, 1893
Oil on canvas, 71.8 x 81.9 cm (28¼ x 32¼ in.)
Courtesy of the Pennsylvania Academy of the Fine Arts, Philadelphia
Gift of the Society of American Artists as a memorial to Theodore Robinson (1900.5)

contrasts with the severe industrial form and echoes its reflection in the river. The subject of a bridge, asymmetrical composition and limited palette signal Weir's debt to Japanese prints, which he collected; the veneer of restrained broken brushwork epitomises his conservative Impressionism.

Although Metcalf had visited Giverny several times between 1885 and 1888, his most ambitious Impressionist canvases date from the mid 1890s, when contact with his American colleagues intensified his interest in the style. For example, in 1895 Metcalf worked at Hassam's invitation in Gloucester, Massachusetts, the historic seaport and art colony that Hassam had visited since 1880. The most dazzling product of Metcalf's Gloucester summer is *Gloucester Harbor* (cat. 90), which describes an evanescent panorama as seen from East Gloucester, the colony's hub. Smith's Cove appears just beyond the roof lines in the foreground; the tip of Rocky Neck with its bright red power-plant chimney is at the left; and Gloucester itself fills the horizon. Although the vantage point is precipitous, the nearly square canvas emphasises smooth sailing on clear waters, rendered with long strokes of bright blue pigment. Graceful sailing craft plying the harbour, along with the old wooden houses and fishing shacks, were reassuring remnants of fast-fading tradition in an increasingly industrialised town.

Other Giverny denizens announced their devotion to Impressionism upon their return home and found local subjects that echoed those they had painted in the Norman village. John Leslie Breck, for example, made a conspicuous debut as an Impressionist in Boston in an 1893 exhibition that included Giverny scenes. A local critic observed: 'It is stating it mildly to say that artistic Boston was nearly pushed off its critical equilibrium, and a fierce controversy at once arose between the champions of the old, or black, and the new, or light, landscape schools of which latter Mr. Breck was at once recognized, by friend and foe, to be the American head.'[68] Breck discovered a counterpart of the Seine in the Charles, the short, picturesque river that flows past colonial towns and empties into the sea at Boston. In *Grey Day on the Charles* (cat. 91), painted in 1894 near Waltham, he focused on the stream's reflective surface, punctuated by water lilies and slender reeds, and offered no hint of its legacy or of the farmland, factories and mills that were intruding on its banks and polluting its waters. Instead, as Bunker had done five years earlier in a similar view, *The Pool, Medfield* (cat. 83), he suggested only the enduring beauty of an idyllic bit of New England.

Leading Boston artists Edmund C. Tarbell and Frank W. Benson were linked throughout their careers; they experienced the same pattern of study in Boston and Paris, shared a Boston studio after their return and taught at the Museum School. Their images of genteel women and children, seen in tranquil outdoor settings or interiors filled with antique furniture and props, epitomise the American Impressionists' appreciation of New England subjects. Both Tarbell and Benson espoused a typically American version of Impressionist technique, one that was conservative, selective and intermittent, and included references to academic principles.[69]

88 THEODORE ROBINSON
Low Tide, 1894
Oil on canvas, 40.6 x 56.5 cm (16 x 22¼ in.)
Private collection

89 JULIAN ALDEN WEIR
The Red Bridge, 1895
Oil on canvas, 61.6 x 85.7 cm (24¼ x 33¾ in.)
The Metropolitan Museum of Art, New York
Gift of Mrs John A. Rutherfurd, 1914 (14.141)

90 WILLARD METCALF
Gloucester Harbor, 1895
Oil on canvas, 66 x 73 cm (26 x 28¾ in.)
Mead Art Museum, Amherst College, Amherst, Massachusetts
Gift of George D. Pratt (Class of 1893) (AC P1932.16)

Having established his reputation as a painter of portraits and indoor genre scenes, Tarbell conjoined his mastery of physiognomy with Impressionism in works such as *Three Sisters – A Study in June Sunlight* (cat. 92), which was hailed by an art critic as 'the picture of the year' upon its exhibition at Boston's St Botolph Club in March 1891.[70] This large canvas, which captures the pleasure of a leisurely summer afternoon spent outdoors in conversation, portrays Tarbell's wife, Emeline, wearing a bright red hat and holding her daughter Josephine in her lap, and two of her sisters, who are also dressed in gauzy summer frocks. The light-dappled garden is probably at the Tarbells' home in Dorchester, a historic village annexed to Boston in 1869. Bold and contrasting red, blues and greens intensify the scene's vivacity and verify Tarbell's later claim that he had read the colour theories of Michel-Eugène Chevreul and Ogden Rood.[71]

Tarbell showed works similar to *Three Sisters* at the World's Columbian Exposition in Chicago in 1893, where American Impressionism made a notable debut. The following year, an influential critic enthused: 'To-day there is no one in America who paints more directly and more forcibly the out-door effects which the modern thirst for more light demands.'[72] Although Tarbell was enjoying success as an Impressionist, he then reconsidered his stylistic commitments, opting to portray well-bred women in interiors and enlisting a warm, muted palette for compositions derived from seventeenth-century Dutch masters, especially Johannes Vermeer. He also exploited antique settings and props that reflected both Colonial Revival taste and the era of the old house that he purchased in 1904 in New Castle, New Hampshire.

During the 1890s, Benson was more devoted to academic ideals than was Tarbell, adopting a rich, tonal palette for portraits and pictures of women and children in interiors, and completing a series of mural allegories. Occasionally during the 1890s, but much more often after 1901 (when he purchased a summer retreat for his family on North Haven Island in Penobscot Bay, Maine) Benson turned to outdoor subjects that often featured his wife and children (see fig. 20). Typical canvases include *Eleanor* (cat. 93), a portrait of his 17-year-old daughter seen in profile on a garden bench at the Bensons' summer home. The painting combines Benson's skilful draughtsmanship and command of design with Impressionism's vibrant palette and expressive brushwork, particularly in the sea, the teenager's bright pink dress and the picture hat that she

holds. Although Benson rarely abandoned sculptural solidity and portrait details, and often worked in the studio with the aid of photographs, he was infatuated with outdoor light. One bemused writer speculated in 1909 that 'hidden somewhere about Mr. Benson's studio, I am convinced, there is a little jar marked "Sunshine", into which he dips his brush when he paints his pictures of summer.'[73] Bathed in invigorating sunlight, youthful Eleanor suggests the new century's fresh optimism, embodies middle-class decorum and personifies the Anglo-Saxon feminine ideal.

Fig. 20 Frank W. Benson painting *Mother and Children* in Newcastle, New Hampshire, about 1893
Photograph. Courtesy of the Peabody Essex Museum, Salem, Massachusetts

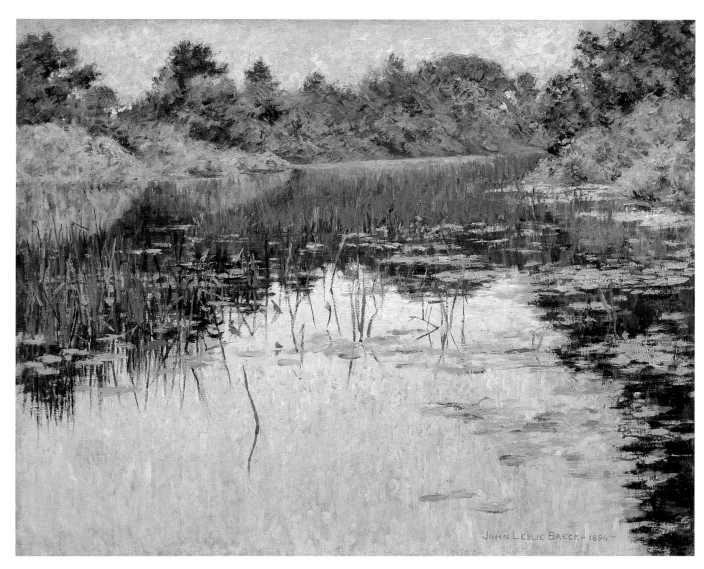

91 JOHN LESLIE BRECK
Grey Day on the Charles, 1894
Oil on canvas, 45.7 x 55.9 cm (18 x 22 in.)
Virginia Museum of Fine Arts, Richmond, Virginia
The J. Harwood and Louise B. Cochrane Fund for American Art (90.151)

92 EDMUND CHARLES TARBELL
Three Sisters – A Study in June Sunlight, 1890
Oil on canvas, 89.2 x 102.2 cm (35⅛ x 40⅛ in.)
Milwaukee Art Museum, Wisconsin
Gift of Mrs J. Montgomery Sears (M1925.1)

93 FRANK WESTON BENSON
Eleanor, 1907
Oil on canvas, 64.1 x 76.8 cm (25¼ x 30¼ in.)
Museum of Fine Arts, Boston, Massachusetts
The Hayden Collection – Charles Henry Hayden Fund (08.326)

Afterword

Americans in Paris were exposed to sophisticated and varied instructional facilities, diverse exhibition venues and sophisticated art criticism. On their return home they transformed not only American art but American art life in emulation of French prototypes, founding new art schools and exhibiting organisations, reinvigorating old ones and encouraging expansion of the art press. Yet, even after years back in the United States, some Americans returned to Paris and the French countryside to replenish their professional energies. Hassam, for example, visited France with his wife in 1897. He showed four paintings at the Société Nationale des Beaux-Arts, painted city views in Paris and made an excursion to Villiers-le-Bel. The Hassams also spent two or three months in the late summer and early autumn in Brittany, where Hassam recorded quaint buildings and picturesque peasants. His immersion in Old World sites may have stimulated both his appreciation for American historical architecture and artefacts and his sympathy for aspects of the modern urban scene upon his return home.[74]

Hassam, again accompanied by his wife, returned to Paris in 1910. Responding to the visual delights of the Bastille Day celebrations, he echoed in *July Fourteenth, Rue Daunou, 1910* (fig. 21) the Impressionists' commitment to urban themes and some of their technical strategies. To escape the summer heat, the Hassams retreated from Paris to Brittany's northern coast, spent some time in Grez-sur-Loing and made their way south to Spain in the early autumn.

Fig. 21 Frederick Childe Hassam
July Fourteenth, Rue Daunou, 1910, 1910
Oil on canvas, 74 x 50.5 cm. The Metropolitan Museum of Art,
New York. George A. Hearn Fund, 1929 (29.86)

Hassam's Bastille Day scene anticipated the Flag series that he painted in New York between 1916 and 1919. As the sole major American Impressionist to depict the home front during the First World War, he produced 30 or so canvases that represent Fifth Avenue as a vibrant skyscraper-lined stage decorated with colourful, patriotic banners, dynamic displays that reinvigorated his interest in Impressionism. One critic applauded: 'Mr. Hassam has done for the flag what Monet did for the haystack – shown it under all conceivable conditions of atmosphere and made beautiful by the caress of light.'[75]

Allies Day, May 1917 (cat. 94), painted a month after the United States entered the First World War, is Hassam's most famous flag image. The harmony among the leading Allies is symbolised by the fact that their banners, seen in reiterated

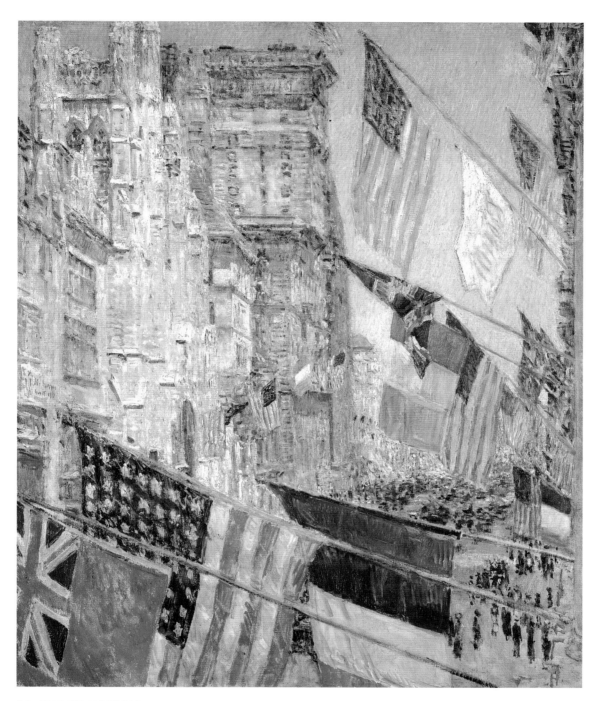

94 CHILDE HASSAM
Allies Day, May 1917, 1917
Oil on canvas, 92.7 x 76.8 cm (36½ x 30¼ in.)
National Gallery of Art, Washington, D.C.
Gift of Ethelyn McKinney in memory of her brother, Glenn Ford McKinney (1943.9.1)

groupings, offer variations on the theme of red, white and blue. The triad of flags also suggests Hassam's patriotism, indicated by the ascendancy of the Stars and Stripes; his appreciation of his Anglo-Saxon heritage, signified by the Union flag; and his lasting debt to Paris, encoded in the *tricoleur*, which he shared with so many American painters.[76]

1 Bacon 1882, p. 95. Niericker 1879 discusses summer destinations.

2 P. King, 'Paris Letter', *The Art Interchange*, 31 (September 1893), p. 65.

3 Julian Alden Weir, letter to his parents, Barbizon, 6 April 1877, quoted in Young 1960, p. 122.

4 Lübbren 2001 surveys the trend. Pese 2001 focuses on subjects portrayed by visiting artists. A pioneering study is Jacobs 1985.

5 See, for example, the *roman à clef*: Howard 1884.

6 Lübbren 2001, pp. 144–5, notes that all major European art colonies were north of the 46th parallel.

7 Benjamin Champney took the train to Quimperlé and was transported by a 'rough, little letter-carrier's cart' to Pont-Aven the next day (Champney 1900, p. 115). Lübbren 2001, pp. 145–50, discusses the significance of journeys that required modern and then pre-modern conveyances.

8 Blackburn 1880, p. 130. Sellin 1991, pp. 12–20, and 1992, pp. 26–31, summarises Pont-Aven lodgings.

9 Lübbren 2001, p. 20, describes the routine. Low 1908, p. 129, notes: 'On rainy days, or as the mood seized us, we worked in our studios or in the houses of the peasants.'

10 Low 1908, p. 80.

11 Kenyon Cox, letter to his mother, Paris, January 1878, quoted in Morgan 1986, p. 54.

12 H. J. Thaddeus, *Recollections of a Court Painter*, London and New York, 1912, p. 25, quoted in Lübbren 2001, p. 17.

13 Stevenson 1884, p. 266.

14 See Fink 1970, pp. 151–72; Bermingham 1975; Meixner 1982; Rosenfeld and Workman 1986. According to Lübbren 2001, pp. 166–7, Barbizon attracted (until 1907) the following: 253 artists; 3 per cent women; 53 per cent French; 11 per cent American; 6 per cent British; 8 other nationalities.

15 Overviews of peasant painting include Herbert 1970; Brettell and Brettell 1983.

16 See, for example, William Morris Hunt, *The Little Gleaner* (1854; Toledo Museum of Art) and *The Belated Kid* (1854–7; Museum of Fine Arts, Boston).

17 Low 1908, pp. 62–158, recounts the later phase of American artists' activity in Barbizon, to which Bacon's *A Rainy Day, The Artists' Tavern at Barbizon*, 1874 (fig. 13), pertains.

18 See *Exposition Universelle de 1867 à Paris. Catalogue Général Publié par La Commission Impériale. Première Partie, Groupes I à V,*

Contenant les Oeuvres d'Art, exh. cat., Paris [1867].

19 Whistler's destination is unknown; the sketchy documentation that places him either near St-Malo or near Perros-Guirec is reviewed in D. Delouche, 'J. A. M. Whistler, *Alone with the Tide, Seule avec le Flot*' in Delouche 1989, pp. 61–2. Delouche (p. 62) quotes a letter of 19 February 1862, from the artist's mother to James H. Gamble, noting the completion of the painting in November 1861 (Glasgow University Library, MS Whistler W512).

20 See, for example, Gustave Courbet, *The Winnowers* (1854; Musée des Beaux-Arts, Nantes).

21 Dorment and MacDonald 1994, cat. 41, p. 113.

22 See. Sellin 1982; Delouche 1986; Delouche 1989; Myers 1989; Belbeoch 1993; Sellin 1995. According to Lübbren 2001, p. 172, Pont-Aven attracted (until 1907) the following: 207 artists; 8 per cent women; 37 per cent American; 21 per cent French; 14 per cent British; 7 per cent Scandinavian; 13 other nationalities. (Although the Pont-Aven art colony was founded by Americans and its population was diverse, the term 'School of Pont-Aven' is now applied only to the French Synthetists, including Emile Bernard, Maurice Denis, Paul Sérusier and Paul Gauguin, who lived there between 1886 and 1891.) Concarneau attracted (until 1907) the following: 130 artists; 14 per cent women; 44 per cent American; 17 per cent French; 12 per cent Scandinavian; 8 per cent British; 8 other nationalities (Lübbren 2001, p. 167).

23 Champney 1900, p. 117.

24 For Wylie (1839–1877), see Myers 1997 and 2000.

25 A. G. Terhune 1995, pp. 20–4, discusses the historical theme in relation to Breton life in the 1870s.

26 See D. Delouche, 'J. S. Sargent, un jeune peintre américain à Cancale' in Delouche 1989, pp. 65–73. Sargent, who was in Cancale from mid-June until late August 1877, had visited the region in May–June and December 1875.

27 The critical reception of both canvases is discussed in Simpson 1997, cats 2 and 3, pp. 82–3. C. Troyen in a cat. entry for the Corcoran's canvas in Kilmurray and Ormond 1998a, p. 62, proposes that the luminous Boston canvas, which is inscribed 'Paris', was actually painted at Cancale.

28 Feyen-Perrin's lost painting is described and illustrated in Lacambre and Rohan-Chabot 1974, pp. 72–3; a copy by P. Leroux, dated 1888, is in the Musée National des Arts et Traditions Populaires, Paris.

29 Charles A. Platt, letter to his family, [Larmor] 5 July 1884, Platt Papers, quoted in Hirshler 1994, p. 31.

30 First-hand accounts of Americans at Grez include Bacon 1882, pp. 98–9; Morgan 1986; Harrison 1893; Stevenson 1894; Low 1908, pp. 134–9, 172–93; Harrison 1916. See also Hill 1987 and W. H. Gerdts, 'The American Artists in Grez' in Gunnarsson 2000, pp. 267–77.

31 Low 1908, pp. 134–6.

32 Nieriker 1879, p. 60.

33 W. H. Low, 'The Primrose Way' (MS), pp. 129–32. According to Lübbren 2001, pp. 169–70, Grez-sur-Loing attracted (until 1907) the following: 119 artists; 18 per cent women; 33 per cent Scandinavian; 30 per cent American; 21 per cent British; 7 per cent Irish; 3 per cent French. For the Japanese students who began to frequent Grez in 1888, see Gunnarsson 2000, *passim*.

34 N. Lübbren, 'North to South: Paradigm Shifts in European Art and Tourism' in Crouch and Lübbren 2003, pp. 125–46, discusses artists' preference for grey days instead of sunny skies during the 1870s and 1880s.

35 Robert W. Vonnoh, Paris, undated postcard to Bessie Potter Vonnoh, c.1908, quoted in Hill 1987, p. 35.

36 'The Village of Grez, France', *San Francisco Call*, 26 April 1891, p. 13, quoted in W. H. Gerdts, 'The American Artists in Grez' in Gunnarsson 2000, p. 272. First-hand recollections of Giverny appear in Low 1908, pp. 446–58. See also Meixner 1982, Sellin 1982 and Gerdts 1993.

37 Fairbrother 1986, p. 50; J. House, *Monet: Nature into Art*, New Haven, Connecticut 1986, p. 233, n. 16. Sargent is known to have been in France in July 1885, although a visit to Giverny is documented only by his painting of Monet at work.

38 See Dawson Dawson-Watson, 'The Real Story of Giverny', quoted in Clark 1979, pp. 65–6.

39 Gerdts 1993, pp. 26–30, summarises memoirs that mention these visitors.

40 According to Lübbren 2001, p. 169, Giverny attracted (until 1907) the following: 92 artists; 15 per cent women; 87 per cent American. Hôtel Baudy's *Registre pour Inscrire les Voyageurs* (1887–99) is available on microfilm at the Archives of American Art, Smithsonian

Institution, Washington, D.C. (roll 4236), and is transcribed by Carol Lowrey in Gerdts 1993, pp. 222–7.

41 De Veer 1977 discusses the likely identities of the men pictured.

42 Greta 1887b, p. 93.

43 Corbin 1988, pp. 1146–7.

44 Ibid., p. 1145.

45 Monet, letter to Alice Hoschedé, [Rouen] 10 March 1892, in Wildenstein 1974–85, vol. 3 (1979), pp. 264–5. The author thanks Kathryn Galitz for her insights. Suzanne Hoschedé would marry Butler in July 1892 (see cat. 76).

46 See P. Tucker, 'Monet, Giverny, and the Significance of Place' in Johnston 2004, pp. 15–45.

47 Low 1908, pp. 446–7.

48 Theodore Robinson Diaries, entry for 3 June 1892.

49 For the influence upon Robinson of Monet's habit of working in series, see Meixner 1982, pp. 141–3; Johnston 2004, p. 158.

50 Theodore Robinson Diaries, entry for 20 July 1892. Johnston 2004, pp. 56, 140.

51 Theodore Robinson Diaries, entry for 5 August 1892.

52 Theodore Robinson Diaries, entry for 3 August 1892: 'Finished Zola's "Debacle" it has interested me so much I have done little else.' Entries for 19, 20 and 21 December 1892 refer to the painting as 'Marie at the little bridge'; entries for 4 and 21 January and 17 February 1893, call it 'Debacle'. Marie was one of Robinson's favourite models and the object of his affections. The author thanks Sona Johnston for her assistance.

53 See Pisano 1988 and Weinberg 1994, pp. 88–133.

54 Quoted in Sewell 1982, p. 25.

55 A summary is provided by Shipp 1996.

56 See Truettner and Stein 1999.

57 See, for example, John Whetten Ehninger, *October* (1867; Smithsonian American Art Museum, Washington, D.C.); Henry Bacon, *The Boston Boys and General Gage, 1775* (1875; The George Washington University Permanent Collection, Washington, D.C.); Charles Yardley Turner, *John Alden's Letter (Miles Standish and John Alden)* (1887; Union League Club of Chicago); Henry Mosler, *Pilgrims' Grace* (1897; Allentown Art Museum, Pennsylvania).

58 See Hirshler 1994, p. 59.

59 Bunker to Isabella Stewart Gardner, n.d. [summer 1889 and summer 1890, respectively], quoted in D. P. Curry, 'Reconstructing Bunker'

in Hirshler 1994, p. 99.

60 See Curry 1990; S. G. Larkin, 'Hassam in New England' in Weinberg 2004, pp. 120–45.

61 In 1897 Hassam, Weir and Twachtman would found Ten American Painters, a progressive organisation for the display and promotion of American Impressionism; Robinson had died in 1896. See Gerdts 1990 and Hiesinger 1991.

62 *New York Sun* 1893, p. 6. See *Paintings, Pastels, and Etchings by J. Alden Weir, J. H. Twachtman, Claude Monet, and Paul Besnard*, New York [1893], advertisement, *New York Times*, 4 May 1893, p. 7; apparently the exhibition had no catalogue.

63 Theodore Robinson Diaries, entry for 29 October 1893.

64 'Women and Their Interests: Artists Afield', *New York World*, 8 August 1893, p. 11, quoted in Gerdts 1984, p. 151.

65 The indispensable source is Larkin 2001.

66 J. Alden Weir, letter to Mr and Mrs Robert W. Weir, 15 April 1877, quoted in Young 1960, p. 123.

67 Burke 1980, p. 140.

68 D. W. X. 1893, p. 10.

69 See Weinberg 1980.

70 *Boston Post* 1891, p. 4.

71 Tarbell quoted in Coburn 1907, pp. lxxviii, lxxx.

72 W. Howe, 'Edmund C. Tarbell, A.N.A.' in Howe and Torrey 1894, p. 167.

73 M. W. F., 'Vacation Days', *St. Nicholas*, 36, no. 10 (August 1909), p. 883, quoted in F. A. Bedford, 'Frank W. Benson: A Biography', in Bedford 1989, p. 57.

74 Hiesinger 1994, p. 115.

75 *New York Times* 1918, p. 46.

76 D. Chotner, cat. entry, in Kelly 1996, p. 286.

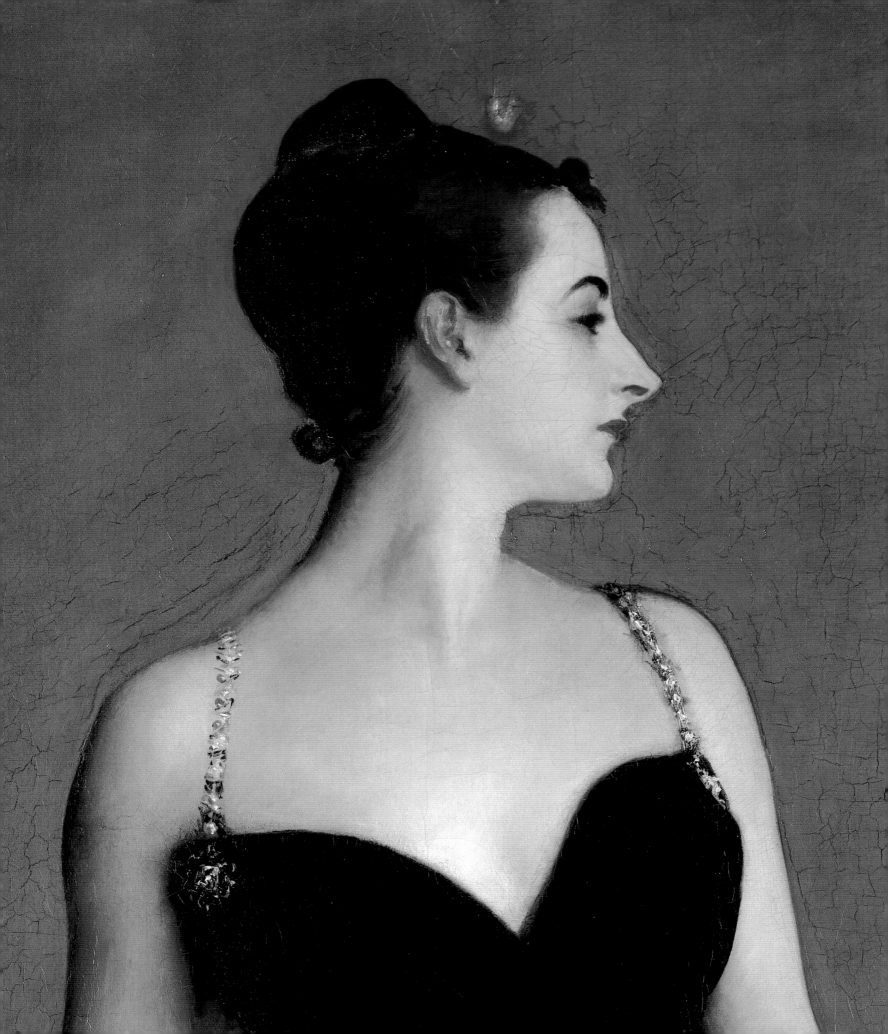

Assimilation and Resistance 1880–1900

Rodolphe Rapetti

Europe has the old masters. America must have the new ones.
The Quartier Latin, December 1897[1]

Henri Fantin-Latour exhibited his *Hommage à Delacroix* (fig. 22 and see fig. 6, p. 60) in the Salon of 1864. The painting shows a number of contemporary figures gathered around a portrait of the recently deceased artist, the group consisting of the people whom Fantin-Latour considered to be the inheritors of Delacroix's artistic legacy. In front of this gathering of 'controversial artists, paying homage to one of the most controversial artists of the period',[2] and easily distinguishable by his haughty pose, stands an American, the painter James Abbott McNeill Whistler. Although a newcomer to this illustrious association – he is still holding his walking stick and gloves – he could be considered, more than any of the others, to embody the future of art, as foreseen by Fantin in his selection of Delacroix's heirs. His unapologetic, almost impudent bearing and the confidence of his gaze emphasise this distinction. The paint-

ing's creator, Fantin, still wearing his painter's smock, sits lower down like a humble artisan, to one side of the lordly figure whose face is next to the face of Delacroix himself on the other. A number of critics that year recognised this figure as the artist responsible for *The White Girl* (cat. 19), which had caused a great stir when it had been exhibited the previous year in the Salon des Refusés. Although it is tempting to see *Hommage à Delacroix* as a premonition of the supremacy that, less than 100 years later, American art would exert over Europe, particularly over France, it has to be admitted that at the period we are dealing with in this exhibition there was nothing to suggest such an outcome.

American artists were nevertheless already well established in Paris by this time. In fact, it would be possible to trace the history of nineteenth-century French painting

Fig. 22 Ignace Henri Théodore Fantin-Latour (1836–1904)
Hommage à Delacroix
Detail of fig. 6

schools using solely American artists as examples: the portrait painter George Healy, who moved to Paris during the Romantic period; Homer and Hunt as representing the Barbizon school; Whistler and Naturalism in the wake of Manet; Cassatt and Robinson prominent among the Impressionists; Sargent embodying turn-of-the-century Salon art; and Pinckney Marcius-Simons (fig. 23) for the Symbolists. Americans were well represented in exhibitions in Paris throughout the whole period. During the 1880s, they were present in the Salon as pupils of the great figures of the day: Jean-Léon Gérôme, Jean-Jacques Henner, Carolus-Duran or, in the case of William T. Dannat, Mihály von Munkácsy. After 1886 sometimes more than 100 Americans featured at the Salons.

The first exhibition to be held by the Société Nationale des Beaux-Arts in 1890 revealed a considerable migration of artists, including Alexander Harrison and Dannat, from the Salon towards this more progressive organisation. Whistler and Sargent followed in 1891. Charles Sprague Pearce remained loyal to the Artistes Français, as did Walter Gay, who waited until 1899 before transferring to the 'Nationale', which had the advantage of permitting the showing of relatively large collections of works by the same artist, something that was never allowed at the Salon. Humphrey H. Moore showed 11 paintings there in 1890, and Alexander, Dannat and Elizabeth Nourse all made use of the opportunity it offered to gain greater visibility. Exhibition at the 'Nationale' could sometimes lead to a purchase by the Musée du

Fig. 23 Pinckney Marcius-Simons (1867–1909). *Clouds*, about 1895
Oil on canvas, dimensions unknown. Private collection

Luxembourg. The impressive number of Americans to be found among the non-French artists in this national museum of living artists gives some idea of the dogged effort the Americans were making to infiltrate the artistic life of Paris; their strategic shifting from one society or organisation to another provides further evidence of this effort.

The Americans undoubtedly represented the largest and most organised foreign artistic community in Paris during the 1890s. They jointly put considerable energy into becoming accepted. Nothing was left to chance, from the materials supplied at bargain prices by the Paris American Art Store,[3] to the social life pursued through the various groups and associations. The American Art Association of Paris, with Henry Ossawa Tanner on its board of directors, was created in 1890 with the aim of affording 'to such American students . . . a place of meeting, facilities for the promotion of good fellowship, and a stimulus to sustain attachment to home and country, and the advantages of organized effort'.[4] By the end of 1897, the Association's exhibition rooms at its headquarters in boulevard du Montparnasse could boast of being lit by electricity. Close study of the Anglo-American review *Quartier Latin*[5] reveals that dozens of artistic events took place, patronised by well-known artists as well as by students. Whistler, for example, showed two drawings in an exhibition organised by the Association in the impasse de Conti in 1898.[6]

It is easy to imagine the way that such groups nurtured a kind of artistic pride, a conjecture borne out by the following extract from a lecture given by William Merritt Chase in 1896: 'Of all the art work I have seen in France, there is no modern picture which would not suffer by comparison, were it hung among the canvases of Velasquez – with a single exception (and I take patriotic pride in saying this), that splendid painting in the Luxembourg, the portrait of his mother, by James McNeill Whistler.'[7] Various indications suggest that the American artists who were living in Paris between 1880 and 1900 were in the somewhat paradoxical situation of wishing to be recognised by the artistic capital of the world while also claiming a certain superiority over French art.

Nevertheless, during the last 10 years of the nineteenth century the portrait of American art painted by Parisian critics differed considerably from that flaunted by the Americans themselves when called upon to make official pronouncements on the status of their compatriots in Paris. The question of the specifically American features of contemporary art bred a certain degree of muddle, the result of confusing questions of style with what could be termed a characteristically American 'space'. References to America's 'virgin' landscape sometimes deflected the argument towards extravagant praise for its freedom from the excessive refinements of Old Europe: it was more natural, more human and maybe even more specifically masculine. 'There is a sanity, a virility, a wholesome element in much of the home art that is lacking in that done in the Old World . . . America has cleaner, more natural, more vital art done within its own borders', wrote Charles Francis Browne in 1899.[8] Any American painter

enjoying an international reputation at this time was invariably known for having spent time in Paris, and American painting had for some time been engaging with conceptual issues beyond those engendered by the contemplation of unspoilt nature, as embodied by Albert Bierstadt or Frederic E. Church in whose work realism generated epic landscape almost of its own accord. With regard to the contention that American space was inaccessible to Europeans, the last decade of the century was in fact characterised by competition, with European artists challenged on their home ground. Was this the enactment of the wish expressed in 1873 by William Page, president of the National Academy of Design: 'Why shall not the Art of the World be done by America, as the other work of the World is destined to be done by her in the inevitable course of human events?'[9]

Notwithstanding such expansionist dreams, the 1880s were marked by the growing supremacy of French art throughout the Western world. This phenomenon persisted until after the First World War, but met its end with the outbreak of the Second, when French art began to take second place to the art of the New York school. During the period covered by this exhibition, American commentators often noted the French influence on art in very negative terms. In a review of the Exposition Universelle of 1878, the sculptor William Wetmore Story, who had spent a number of years in Italy, remarked: 'The influence of France in art is greater than that of any other nation. It inoculates all the world with its disease, but nowhere is its contagion so deeply felt as in the United States.'[10] Negative observations such as these were not confined to the Americans, however. We should examine them in the broader context of France's relationship in matters intellectual with the rest of the Western world. We need look no further than to John Ruskin in England and to Arnold Böcklin in Switzerland for many examples of French art being condemned out of hand.

Lacking as they did any great artistic tradition, the Americans seemed to their compatriots to be especially susceptible to outside influences and consequently to be extremely vulnerable. There was a perceived need to improve the quality of American art; in this context the teaching dispensed by the Beaux-Arts in Paris was deemed to be admirable and it was therefore dissociated from the wider French influence on art, itself often considered pernicious. Why should the idea that French art was the best of all come as any surprise? During the last 20 years of the nineteenth century, large American collections were formed that consisted almost entirely of French paintings: for example, the collection of William Walters in Baltimore. This coincided with the formation of the big private collections of modern art in Paris. Later, American interest in Impressionism, spurred on by the audacious sales techniques of Durand-Ruel and by Puvis de Chavannes's monumental mural in Boston (1895; Boston Public Library), one of the largest of the period, could hardly fail to encourage the notion in France that the French artistic colony on the other side of the Atlantic would long remain. On another level, the remarks made by the society painter Théobald Chartran, who enjoyed considerable

success in the United States, are illuminating: 'French artists enjoy enviable conditions in the United States, and I am amazed that all our young painters do not emigrate to this Eldorado. To move from poverty to riches, to leave Rue Bréda for 30th Avenue, to set up a studio in a land where a *portrait in oils* sells for five thousand dollars . . . What a dream', he admitted to the journalist Adolphe Brisson.[11]

It would be fruitless, in fact, to search the succeeding generations for an artist in Paris to rival Whistler, or for one who would appeal so strongly to the critics, always on the lookout for something new. This is made stranger by the fact that French literature at this period, and particularly Symbolist poetry, numbered two American poets among its most important protagonists: Stuart Merrill and Francis Viélé-Griffin. Part of the attraction of Paris was that, along with good-quality training, it offered contact with all the latest trends. Although it is impossible to generalise without exaggerating, art historians seem agreed that the majority of Americans living in France at this time were relatively conservative, at least by European standards, if not by American ones. The movements they joined (Naturalism, plein-air painting linked to Impressionism, society portraiture) covered the range of styles that predominated in international exhibitions. Mary Cassatt, who was a member of the Impressionist group, remains even more exceptional because she was a woman, and because she was 10 or 20 years older than the generation of Sargent or Ernest Lawson. Theodore Robinson, who met Monet in 1888, took up Impressionism relatively late. There are no known American equivalents of the Hungarian József Rippl-Ronai or the Dutchman Jan Verkade, both members of the Nabi group and early exponents of Cloisonnisme. With the exception of Marcius-Simons, who was little known outside Paris (where in the 1890s he exhibited at both the Société Nationale des Beaux-Arts and the Salon de la Rose+Croix), no American artist living in Paris can be convincingly linked with Symbolism.

From an American angle, the spirit of provocation and the shock of the new seem to have been embodied single-handedly, for half a century, by the towering figure of Whistler. The generation of Americans living in Paris after 1880 was so eager to be part of the artistic establishment that they showed more caution. One of the most virulent contemporary denunciations of all forms of artistic innovation, *L'Anarchie dans l'art*, was in fact written by an American painter living in Paris, Frederick Arthur Bridgman, a pupil of Gérôme. The cover of the book (fig. 24), which was published by L. Henry May,[12] depicts a wild-haired woman dressed in red, wearing a Phrygian cap on her head and holding some worn-out paintbrushes and a palette dripping with paint while a bomb goes off nearby – the latter a reference to recent anarchist attacks. This undoubtedly expressed a widely held opinion: compare it for example with the following description of Impressionism which appeared in *Art Age* in 1886: 'Communism incarnate, with the red flag and the Phrygian cap of lawless violence boldly displayed.'[13]

The Americans' eagerness to integrate is evident also in their choice of subjects. As far as

Fig. 24
Frederick Arthur
Bridgman
(1847–1928)
Cover of *L'Anarchie
dans l'art*
Lithograph

landscape is concerned, the Salon catalogues for the years between 1880 and 1900 reveal that American painters in Paris seldom depicted their own country, although they were perfectly able, like Dannat or Sargent, to represent the picturesque as seen in Spain or Italy. The portrayal of details of local landscape or tradition as proof of belonging to a particular culture was to be found in the work of many northern European painters at this time, but it seems to have presented problems for Americans. American painters generally ignored many of the less-travelled French provinces, although the few exceptions to this rule would reward further study: Mary Franklin, for example, whose paintings are still to be found in public collections in the South of France, where she lived (fig. 25). Broadly speaking, expatriate painters painted Parisian life, urban and modern.

If one genre can be said to embody the Paris of the day it is the society portrait – or rather the type of painting connected to the development of the society portrait; here foreign artists such as Whistler, Boldini, Sargent, Laszlo and La Gandara played a more important role than did French painters pursuing the same genre, such as Blanche or Helleu. Contemporary critics followed the birth of this new style of portraiture with great interest. In the case of Giovanni Boldini, in particular, bravura so far exceeded *fa presto* that the sense of urgency he produced was sometimes ascribed to acute anxiety on the part of the sitter. Rapid painting was considered expressive of the modern world, with its cult of speed; this and the taste for elegance and extravagant clothes, for the restless pose and the psychological complicity between painter and model, betraying their membership of the same intellectual and social elite, can all be found in Whistler's *Robert de Montesquiou* (fig. 26) and Sargent's *Dr Pozzi at Home* (1881; Armand Hammer Museum of Art, UCLA, Los Angeles). Sargent's misadventure with his portrait of *Madame X* (cat. 35) illustrates the importance of the challenge posed by portrait commissions to any artist wishing to make a career in Paris. Such commissions proved that the painter was accepted in high society, and demonstrated his involvement with the Parisian passion for the latest fashion. Portraiture more than any other genre could raise the social prominence of both artist and model or could consolidate a reputation already established. It is hardly surprising therefore that the Americans, like other foreigners living in Paris, should have sought fame in this way.

In 1900 Remy de Gourmont wrote a review of the arts section of the Exposition Universelle for the Austrian magazine *Wiener Rundschau*. In his paragraph on American art, he comments on its lack of originality: 'American art is cosmopolitan. It is a reflection of Europe. Nowhere among the newest artist is there any special, individual character; here in this corner there

is a painter of genuinely German inspiration; there, another who is completely English; over there, one who is undoubtedly Dutch; and this one here has to be French.'[14] Although later observing that Whistler, Alexander and Sargent were exceptions to this rule, de Gourmont stood by his opinion on the grounds that 'they did not belong to the most recent group'. His comments are valuable because they are made by one of the great late nineteenth-century French writers; his words should be read in a different light from the many exhibition reviews in which mention is made of American art, often written by quite minor critics. De Gourmont had previously been employed as an art critic on the *Mercure de France*, with Aurier and Jarry, and the review quoted above marks a return to his former profession. It represents the opinion of one of the most knowledgeable commentators on French thought of the period.

The first conclusion to be drawn from this text is just how relative are the terms used by both sides to depict the relationship between the American artists in Paris. Even though almost all the important American painters flourishing between 1890 and 1900 had spent at least one spell in Paris during their career, their various styles cannot be analysed simply in terms of Franco-American relations. A great deal of non-French art could be seen in Paris, not only at the great annual exhibitions but also at all the other events that studded the artistic calendar of the capital. The position of the Americans in Paris should thus be viewed as participation in the life of the artistic capital of Europe, attracting the young and the not so young from all over the world. Sargent, as we know, trained in Italy before going to Paris. Edward Hopper's strangeness, already in evidence during his Paris period (1906–10), brought him closer to Félix Vallotton or William Nicholson than to the French art of the period. The American artist was therefore faced with a choice between provincialism and internationalism, rather than between American art and French art.

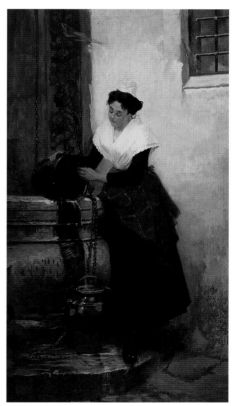

Secondly, de Gourmont's opinion seems more or less to agree with that of the French critics of the day: American art generally figures as subservient to contemporary European trends, and to French trends in particular. There is nothing especially unusual in this. The Americans in France shared their fate with the citizens of almost all the other countries of Europe. In his essay on contemporary English painting, Robert de la Sizeranne suggests that English artists were the only ones who managed to avoid French influence. It is no accident that one of the examples he gives to support his contention should have been one of the most prominent American painters of the day: 'It would require a great abundance of notices and placards to persuade me when I look at the work of Mr Sargent that the Atlantic lies between him and the studio of M. Carolus Duran.'[15]

We should be circumspect in our approach to critical texts about this

Fig. 25 Mary Franklin (probably 1842–1928)
Jeune arlésienne au puits (*Young woman from Arles at the well*), 1897
Oil on canvas, 226 x 152 cm
Collection Museon Arlaten, Musée Départemental d'Ethnographie, Arles (E1522)

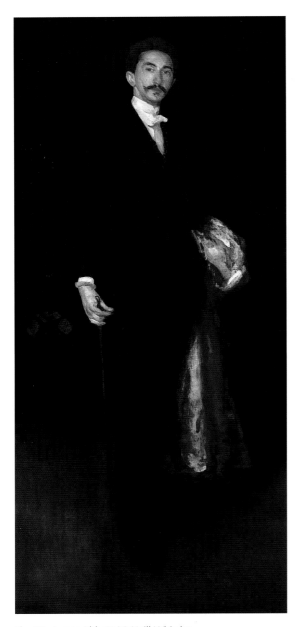

Fig. 26 James Abbott McNeill Whistler
Arrangement in Black and Gold: Comte Robert De Montesquiou-Fezensac, 1891–2
Oil on canvas, 208.6 x 91.8 cm
The Frick Collection, New York

period when they emphasise the autonomy of American art, however. Lois Marie Fink, for example, quotes a review of the Salon of 1883 written by the French journalist Charles Bigot; Bigot was of the opinion that France was gradually losing its lead, and that artists such as Whistler, Sargent, Julian Story or Charles Sprague Pearce, with other non-French artists, might in the future come to dominate the artistic scene in Paris.[16] In fact the author of this judgement, whose militant tone must have surprised the reading public, coming as it did from a Frenchman, had for 10 years been married to Marie Healy, one of George Healy's daughters. This may possibly have affected his view of the position of American artists in Paris.

French critics nevertheless picked out some of the most outstanding personalities, treating them as an integral part of the artistic community of Paris. Their American nationality is accorded secondary importance, however, if it is mentioned at all. Although de Gourmont gave the name 'Primary' to one of the characters in his *Proses moroses* to draw attention to the coarseness of contemporary Anglo-American manners,[17] he regarded Whistler, Sargent and Alexander as important artists who were fully integrated into the life of Paris: 'Sargent exhibited in our Salons every year. Photographs after paintings by Alexander can be seen in every shop window. Whistler, whose work is deliberately less widely circulated, enjoys worldwide fame as we know.'[18] To French minds, Whistler, who was celebrated for his friendship with Mallarmé and Wilde, was a Londoner rather than a graduate of West Point.

Critics seldom tried to discern what it was that was specifically American in the work of the American painters established in Paris. However, in his commentary on Dannat's *La dame en rouge* (fig. 27), exhibited (as *Symphonie en rouge*) at the Décennale des Beaux-Arts in 1889, the chronicler Jean Lorrain described the portrait as combining classical references with a strong American flavour:

A slender young redhead with very white skin, wearing a red tulle dress, stands against a deep purple background . . . the teeth of a young wolf can be glimpsed between her

thin lips; her face is tilted like the face of a bacchante, cold yet lascivious; her features are accentuated by bright red hair piled Roman fashion, low over the forehead and held at the back of the neck by a large pale tortoiseshell comb. The luminous V-shape of her delectable white back shines against the red of her bodice, inviting both caresses and blows. There is something of the young Messalina about this American girl; she is the seasoned, virginal seductress of the New York salon, Yankee and Pompeian at the same time.[19]

If we comb this text for references to America, all the current French clichés can be found: the coldness, efficiency, coarseness and ambition of a new nation ('the teeth of a young wolf'). Lorrain creates a striking effect by contrasting these characteristics with his dionysian view of Antiquity. Edmond de Goncourt was less open-minded in 1893 when Lorrain introduced him to Dannat. He denigrated the American as the painter of 'those brutalised Spanish women who look as if they are *belching*'.[20]

Two years later, in his collection of short stories *A se tordre*, the humorist Alphonse Allais included a story entitled 'Esthetic'.[21] In it he describes the imaginary inauguration of an art exhibition in Pigtown (Ohio). American art has three distinguishing features: huge size, state-of-the-art technology and the glorification of war and military might. The two main characters in the story, which is about the jury's selection of the winner of the first prize, are sculptors. One of them has created a vast pig complete with some electrically powered flies drawn inexorably towards its groin; after circling a few times the flies land on the pig and start tickling it. The other has created a life-sized group in commemoration of some battle or other; particularly remarkable is the painstaking rendering of an enormous machine-gun. The gun later proves to be the genuine article covered in plaster. The sculptor of this group, infuriated that the first prize has not been awarded to him, uses the gun to kill all the jury, and indeed everyone else except for his friend, who is hiding inside the bronze pig. The story ends in appalling carnage, like a horror movie. When all is over, the two sculptors stroll off to eat a quiet lunch at the local restaurant.

The United States, a modern and bellicose nation, is portrayed as incapable of putting up with any art that is neither naturalistic nor militaristic. The choice of a piece of sculpture in the shape of an animal is particularly apt. Allais chooses what was then considered a 'minor' genre as a metaphor for the food industry; he was probably alluding to Cincinnati, nicknamed 'Porcopolis' at the time. In addition, the practice of

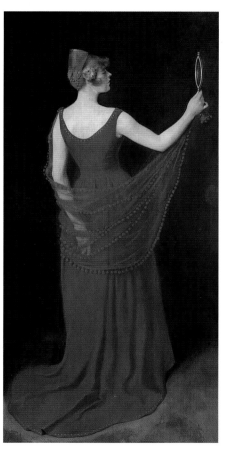

Fig. 27 William Turner Dannat (1853–1929)
La dame en rouge, 1889
Oil on canvas, 213 x 104 cm
Musée d'Orsay, Paris (867)

casting from nature (equivalent here to the plastering over of the gun) was relatively common in the late nineteenth century and was often criticised for being trivial. Finally the 'kinetic' aspect of one of the works invented by Allais not only indicates a childlike fascination with technology, but also symbolises the kind of art whose main aim is to reproduce reality in minute detail. Allais is lampooning all forms of technical wizardry that border on the absurd. Another comic writer, Gaston de Pawlowski, set a lot of his crazier *Inventions nouvelles et dernières nouveautés*[22] in the United States.

Stereotypical ideas such as these survived for a long time among the French intelligentsia. It was not until 1913 that the poetry of the American city was to make its appearance in French literature; Gustave Le Rouge set his adventures of *Docteur Cornelius* in an imaginary New York. In fact, fascination with the modern American megalopolis was to become a feature of the popular novel rather than of serious literature. Early cinema, too, echoes this fascination in *The New Exploits of Elaine* (1915) by Louis Gasnier, who was sent to the United States as a director by the Pathé brothers and gave Pearl White her first taste of success. These developments took place at the same time as the establishment of the Armory Show, which was to kickstart a completely different kind of dialogue between European and American art. The name Paris took on a new meaning, different from the meaning it had conveyed to those artists whose eyes were fixed firmly on it as the capital of the arts.

1 *Quartier Latin* 1897c, p. 592.
2 E. Duranty, 'Ceux qui seront les peintres', *Almanach Parisien pour 1867*, Paris 1867, p. 13, quoted by D. Druick in *Fantin-Latour*, exh. cat., Réunion des Musées Nationaux, Paris 1982, p. 173.
3 *Quartier Latin* 1897b.
4 *Quartier Latin* 1896a.
5 *The Quartier Latin* was 'Compiled monthly in Paris, and printed and published by Iliffe & Son, of London'.
6 *Quartier Latin* 1898.
7 *Quartier Latin* 1896b, p. 5.
8 C. F. Browne, 'The Editor', *Brush and Pencil*, 5, no. 3, December 1899, pp. 199–200 and 'The Exhibition at the Carnegie Galleries, Pittsburgh, Pennsylvania', *Brush and Pencil*, 3, no. 3, December 1899, p. 168, quoted in Fink 1990, p. 287.
9 Quoted in Fink 1990, p. 133.
10 Ibid., p. 286.
11 Quoted in Lorrain 1898.
12 Bridgman n.d.
13 'The Impressionists', *Art Age*, 3 (April 1886), p. 165, quoted in M. Marlais, 'Americans and Paris' in Marlais 1990, p. 7.
14 Gourmont 1900.
15 Sizeranne 1895, p. 1.
16 Fink 1990, p. 132.
17 Gourmont 1894.
18 Gourmont 1900.
19 Lorrain 1889.
20 Goncourt 1989, p. 830.
21 Allais 1955, p. 99. The first edition of the collection was published in 1895.
22 Pawlowski 1916.

Translated from the French by Caroline Beamish

American Art, American Power at the Paris Expositions Universelles

David Park Curry

In 1890 Winslow Homer captured two women dancing by moonlight on the lawn in front of his Prout's Neck studio (cat. 95). The following year, Homer temporarily assigned the canvas a hearty American title – *Buffalo Girls* – making reference to popular music. He offered it to a Chicago collector of French Impressionism, Potter Palmer, who declined. The picture appeared almost a decade later among Homer's submissions to the 1900 Exposition Universelle in Paris. It was awarded a gold medal and was subsequently acquired by the French government for the Musée du Luxembourg.[1] Accompanied by shadowy figures who might or might not be looking at them, Homer's entwined couple – at once lightsome and leaden – serves as a visual metaphor for the awkward two-step of ever-changing relations between French and American artists and their patrons during the period explored by *Americans in Paris*.

Five Parisian international expositions mounted between 1855 and 1900 offer ample evidence of these dynamics, providing artists from around the world with a high-profile arena for exhibiting their work in France. American art was featured at every fair. However, the nation's initial, somewhat off-hand showing of a few American artists conveniently resident in France in 1855 eventually evolved into a patriotically driven promotional campaign, celebrating the work of American painters with the extensive backing of the federal government in 1900.

Amidst the onslaught of new technologies, fresh products and artistic styles confronting visitors at the fair in 1900, Whistler's *Symphony in White, No. 2: The Little White Girl* (fig. 28) might have seemed a gentle anomaly. Back in 1865, when it debuted at the Royal Academy, it was a cutting-edge canvas. The figure was not

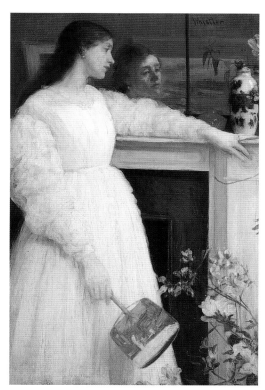

Fig. 28 James Abbott McNeill Whistler
Symphony in White, No. 2: The Little White Girl, 1864
Oil on canvas, 76.5 x 51.1 cm. Tate, London.

conventionally beautiful, and the composition incorporates the Japanesque asymmetries and low-toned colours that were just beginning to manifest themselves in avant-garde European art circles. However, by the turn of the century, this was a safe and appealing image, another gold-medal winner. Whistler exhibited the work in the United States section of the Exposition Universelle at the invitation of the American committee, who were eager to co-opt a once-controversial expatriate's Anglo-French synthesis into their eclectic, self-defined 'American school'.[2]

Whistler's *Little White Girl* holds at her side a fixed paper fan, the type of object made in profusion for export once the Western powers had forced Japan to open its doors to trade.[3] Simultaneously arguing for artistry (pleasingly distributed ornament) and practicality (the generation of a welcome breeze), the fan is at once exotic and mundane, Eastern and Western, old and new, evidence of the concerns that the late nineteenth-century expositions addressed. Here, Whistler distils some of the fairs' recurrent central themes: the meeting of cultures, the allure of decorative arts from distant parts and the use of feminine imagery to temper change, whether stylistic, economic or technological.

Over the course of the Second Empire (1852–70) it became clear to American artists, dealers and collectors that the Paris world fairs,[4] supplemented by official salons and controversial counter-exhibitions, offered opportunities too good to pass up.[5] Reinforced by the teachings of Hippolyte Taine at the Ecole des Beaux-Arts (where many American art students matriculated), the concept that a nation's fine art was an important power tool for establishing international status gained impetus.[6] Beginning in 1864, Taine's 20-year tenure coincided with the establishment of Paris as the leading international centre for then-contemporary fine art. In his lectures on art history and aesthetics, he averred that art is never produced in isolation. It depends not only on artistic genius but also on racial, geographical and socio-environmental context. Critics (the majority of them nationally biased) were supposed to assess these contextual matters. Not surprisingly, Taine concluded that the 'great' nations produced the 'great' art. Fuelled by the desire for national prestige and coloured by political infighting, it was international competition – not the enduring dominance of any particular painting style – that provided a thread linking the arts chosen for display at world fairs, whatever the configuration of artists, collectors and dealers convened to select them.[7]

The world fairs' atmosphere of commercial didacticism, as well as their privileging of machinery over art, derives from eighteenth-century industrial shows, in particular the *Exposition Publique des Produits de L'Industrie Française* (Paris, 1798).[8] The British had also staged industrial fairs during and after the reign of George III. In 1851 London hosted the first enormous world fair under the glass roof of Joseph Paxton's innovative Crystal Palace:[9] the Great Exhibition of Products of Industry of All Nations, to give it its full name, presented fine arts as a distinct category, chiefly to demonstrate commercial paints, tools, casting and printing

95 WINSLOW HOMER
A Summer Night, 1890
Oil on canvas, 76.8 x 101.9 cm (30¼ x 40¼ in.)
Musée d'Orsay, Paris

techniques used in the production of art. Napoleon III then trumped Victoria and Albert by inaugurating a full-scale fine arts exhibition at a world fair, cancelling the 1855 Salon in order to do so.

It was more than the emphasis on machinery that set world fairs somewhat apart from traditional fine arts enterprises. Enjoying extended runs of five to six months, the world fairs in Paris, London, Philadelphia, Chicago and elsewhere attracted enormous audiences, reaching beyond the dedicated art amateurs, collectors and dealers who frequented private galleries, government-sponsored salons and counter-exhibitions of the era.[10] Lured by a range of material that went considerably further than the fine arts displays of the time, millions of visitors wandered through orderly ranks of temporary booths within the vast reaches of semi-permanent structures where paintings, sculpture and decorative art jostled for ground space with new machinery or feats of agriculture or explorations of unfamiliar countries. While it is unlikely that everyone attended the fine arts displays while on the fairgrounds, opportunities for viewing art were dispersed beyond the avowed palaces of fine art into individual national pavilions and elsewhere.[11]

America's small, quickly assembled showing in 1855 included portraits, landscapes, allegories and genre scenes, most of them now forgotten. G. P. A. Healy dominated the American section with 20 works (40 per cent of the total).[12] His likeness of the inventor Charles Goodyear painted on a sheet of gutta-percha, an early form of rubber, nodded to the fascination with new technologies. But his large history painting of *Franklin Before Louis XVI*, a gold-medal winner, better reveals American ambitions at the Paris fairs.[13] A sketch survives (fig. 29), showing the proud yet supplicant American statesman presenting his case for a new republic to the soon-to-be-toppled French king. During the second half of the nineteenth century,

Fig. 29 George Peter Alexander Healy (1813–1894). *Franklin urging the claims of the American Colonies before Louis XVI*, about 1847
Oil on canvas, 61 x 91.4 cm
The American Philosophical Society, Philadelphia, Pennsylvania (FAP 82)

relations between American and European art, never entirely comfortable, remained as finely balanced as the ill-fated monarch's precarious sovereignty. Nonetheless, the strategies deployed between 1855 and 1900 all increasingly rested upon national pride.

The spate of ever-larger international exhibitions that began in 1851 followed the example of Britain's Great Exhibition in applying both arts and sciences to industry, education and society.[14] While art and science were twinned everywhere from colourful mass-produced tiles encrusting the staircase of the Victoria and Albert Museum (a legacy from the Great Exhibition) to soaring iron structures like the 1889 Eiffel Tower, science clearly had the upper hand. Not only were fine arts displays in the minority, compared with other exhibitions and entertainments available on the fairgrounds, but scientific theory also gradually overshadowed philosophy and religion, particularly after the publication of Darwin's *Origin of Species* in 1859.[15]

In 1867 a concerted effort to display American art at the Paris exposition featured canvases capturing wide-open spaces that were still attracting immigrants to American shores.[16] The selection rested with a committee of well-connected art connoisseurs controlled by New Yorkers favouring the Hudson River School.[17] Bierstadt's *Rocky Mountains*, Church's *Niagara*, Durand's *In the Woods* and Cropsey's *Mt Jefferson – Pinkham Notch, White Mountains* (fig. 30) typify the committee's unabashed emphasis on natural wonders capable of amazing European fairgoers.[18] Ablaze with bright autumn leaves, Cropsey's *Mt Jefferson* incorporated details such as a tiny sawmill and sturdy lumberjack with faithful dog. These resonate with vernacular buildings erected on the French fairgrounds – a rustic log cabin and a one-room schoolhouse – representing daily life in the United States. Eastman Johnson's *Negro Life at the South* (1859; New-York Historical Society, New York)[19] was among the genre

Fig. 30 Jasper Francis Cropsey (1823–1900). *Mt Jefferson – Pinkham Notch, White Mountains*, 1857
Oil on canvas, 80 x 125.7 cm
Virginia Museum of Fine Arts, Richmond, Virginia. The J. Harwood and Louise B. Cochrane Fund for American Art, 1996 (96.35)

scenes on view, prompting our consideration of perceived exoticism and the fairs' opportunities for virtual 'visits' to inaccessible places. Topical painting and sculpture, reinforced by various midway attractions as well as by representative vernacular architecture from around the globe, helped fuel the touristic urge to look.

So did scandal. Whistler's pictures at the 1867 Exposition Universelle signal changing tastes. Among his submissions, he sent a full-length figure painting, *Symphony in White, No. 1: The White Girl* (cat. 19, pp. 40–2), by then notorious for its appearance in the 1863 Salon des Refusés. As the picture had already been rejected by both the British and French art establishments (Royal Academy in 1862, Salon in 1863), Whistler requested that it be shown in the American section at the exposition.[20]

Homer's confrontational *Prisoners from the Front* (cat. 96), also shown in 1867, conjured up the just-concluded American Civil War. American artists were soon fighting a different economic battle, as Homer himself was reminded when trying to sell *Buffalo Girls* to Potter Palmer, one of many Americans devoted to buying French art. Boosted by world fairs, the growing taste for contemporary French pictures so dominated American collecting circles in the coming decades that by 1886 a concerned French government felt compelled to assess the flow of French art to the United States.[21]

Meanwhile, Americans were uncomfortably aware that the United States had demonstrated its power more forcefully through industry than fine art ever since a Corliss engine 'decorated like a jewel in silver and gold' mesmerised visitors to the 1867 Paris fair.[22] This is not surprising given that the world fairs were essentially an outgrowth of earlier industrial expositions. Moreover, John Adams had prioritised a national agenda early in the country's history:

> I must study politics and war that my sons may have liberty to study mathematics and philosophy. My sons study mathematics and philosophy, geography, natural history, naval architecture, navigation, commerce and agriculture in order to give their children a right to study paintings, poetry, music, architecture, statuary, tapestry and porcelain.[23]

When William Dean Howells assessed the American Centennial at Philadelphia in 1876, he revealed a nation on schedule. Its growing sense of industrial might, fostered by previous generations, was now increasingly tempered by artistic aspiration: 'The superior elegance, aptness, and ingenuity of our machinery is observable at a glance. Yes, it is still in these things of iron and steel that the national genius most freely speaks; by and by the inspired marbles, the breathing canvases, the great literature.'[24] His tentative 'by and by', however, recalls that negative critical response to the 1867 showing – which garnered the Americans a single paltry silver medal – had revived old feelings of cultural inferiority in the United States. As James Jackson Jarves put it: 'The Great Exposition of 1867 at Paris taught us a salutary lesson by

96 WINSLOW HOMER
Prisoners from the Front, 1866
Oil on canvas, 61 x 96.5 cm (24 x 38 in.)
The Metropolitan Museum of Art, New York
Gift of Mrs Frank B. Porter, 1922 (22.207)

placing the average American sculpture and painting in direct comparison with the European, thereby proving our actual mediocrity.'[25]

Many practical Americans saw more rigorous training as an obvious measure. Numerous studies document the enormous surge of expatriate artists flocking to the French capital after the American Civil War. The move by American collectors towards the acquisition of French pictures at the expense of their own artist-countrymen is also well documented.[26] The next two Paris fairs, in 1878 and 1889, attest the preponderance of French-trained Americans exhibiting large-scale portraits and figure paintings, often with an exotic topical twist. North Americans, most of them French-trained, also comprised the largest national group exhibiting annually at the salons. Between 1878 and 1900 the French government purchased 30 works by American artists.[27]

Frederick Arthur Bridgman began his studies with Jean-Léon Gérôme in 1867, the year of the second Exposition Universelle. The third Paris fair, in 1878, featured his *Funeral of a Mummy* (fig. 31), already shown to acclaim at the 1877 Salon. Bridgman's work is representative of American pictures looking so French that the pupil's work could hardly be distinguished from the master's. Earning Bridgman the Légion d'honneur, the *Funeral* typifies a dying away of indigenous American themes. Praised for its 'learned-looking details' the painting is filled with 'the erudite bric-a-brac of the museums', able to 'bear the scrutiny of the most careful Egyptologists'.[28] Period texts, such as George William Sheldon's lavishly illustrated *Recent Ideals of American Art* (1888–90) celebrated this international historicising trend, reproducing the *Funeral* and additional contemporary examples of such pictures.[29] Even Harry van der Weyden's Impressionist oil sketch of a construction site on the bank of the Seine (cat. 97) includes the picturesque twin towers of the Palais du Trocadéro, a collaboration between an architect (Gabriel Davioud) and an engineer (Jules Bourdais). Erected for the Exposition Universelle of 1878, the building was a mixture of historicist and orientalising details, as eclectic as some of the paintings it once presented to the public.

Fig. 31 Frederick Arthur Bridgman (1847–1928). *Funeral of a Mummy*, 1876–7
Oil on canvas, 113.3 x 231.8 cm. Collection of The Speed Art Museum, Louisville, Kentucky.
Gift of Mr Wendell Cherry, 1990 (1990.8)

97 HARRY VAN DER WEYDEN
Morning Labor on the Seine, April 20th 1891, 1891
Oil on panel, 15.24 x 22.86 cm (6 x 9 in.)
Private collection

Fig. 32 Lowell Birge Harrison
(1854–1929). *Novembre*, 1881
Oil on canvas, 132 x 248 cm.
Musée des Beaux-Arts, Rennes

French-trained artists again crowded the American section at the 1889 Exposition Universelle.[30] *Novembre*, Lowell Birge Harrison's moody image of a Barbizonesque peasant listlessly raking leaves (fig. 32) – quite distant from from the vigorous autumnal foliage celebrated in Cropsey's *Mt Jefferson* and other works at the 1867 exposition – applies the lessons Harrison learnt in the studios of Carolus-Duran and Cabanel. The French government acquired this vast, muted canvas – evidence that men like Harrison were influential in gaining international recognition for their brand of contemporary American art at the end of the nineteenth century. Yet only a few, including Harrison's friend John Singer Sargent, achieved canonical positions in the history of American art.[31] Later scholars have suggested that the conservative artists of the Gilded Age, indebted to their French teachers, still raise 'the specter of cultural inferiority'.[32]

If the style of art on view varied from one fair to the next, the general impetus to express national power did not. Finally, at the Exposition Universelle of 1900, under the aegis of President McKinley's frankly imperialistic administration, the United States Department of Fine Arts set out to establish the parity of American art with European schools in general – and France in particular.[33] Determined that expatriates would not dominate as they had in 1889, John Britton Cauldwell directed the United States Commission to the Paris Exposition of 1900. As in Paris in 1889, two juries of Americans were assembled, one on each side of the Atlantic. But this time, the larger, more powerful jury met in New York.[34] In 1900 America fielded a contingent of exhibitors three times the size of the one France sent to the 1893 Chicago fair. While *The Cello Player* (cat. 98) by Eakins shows the continuing predominance of figure painting, Theodore Robinson's *Port Ben, Delaware and Hudson Canal* (cat. 87) indicates a return to native landscape subjects, albeit touched by American artists' contact with French Impressionism.

98 THOMAS EAKINS
The Cello Player, 1896
Oil on canvas, 163.2 x 122.2 cm (64¼ x 48⅛ in.)
Courtesy of the Pennsylvania Academy of the Fine Arts, Philadelphia
Joseph E. Temple Fund, 1879 (1897.3)

Fig. 33 Francis Davis Millet (1846–1912). *The Expansionist* (*The Travelled Man*), 1899
Oil on canvas laid on board, 106.7 x 172.7 cm. High Museum of Art, Atlanta, Georgia (2000.199)

A globe on a stand occupies the foreground of Francis Davis Millet's genre scene exhibited in 1900 (fig. 33). Trenchantly titled *The Expansionist*, the scene is littered with bric-a-brac ranging from Javanese stick puppets to a heap of exotic footwear. Neither the maid in her elaborate costume *à la polonaise* nor the frock-coated master, scribbling his manuscript with a feather pen, can disguise a contemporary sense of cultural superiority over the curiosities strewn about the room. The American organisers in 1900 were driven by the presumption that the New World could and would supersede the Old.

This widely held belief was hard to miss when approaching the portico of the United States Pavilion. An enormous gilded Chariot of Progress, driven by Liberty, a determined woman in Grecian dress, was the building's chief ornament.[35] Searching for timelessness, the pavilion fell back upon a well-worn visual vocabulary. Far from such radical architectural statements as the Crystal Palace or the Eiffel Tower, America's neoclassical confection, frosted in plaster and gilt and topped with an ungainly tower-dome, embodies the conflicting ambitions of a young nation emerging as a significant world power. Wedged into the architectural hodge-podge of national pavilions lining the Seine, the atavistic American structure attracted unkind French comment.[36]

Around the curve of the Seine, out of sight of the city's storied medieval cathedral, Notre Dame de Paris, another disturbing structure reared its mechanistic bulk up over the fairgrounds in 1900. On the left bank, between the pont d'Alma and the pont d'Iéna, was a

long, narrow building, dominated by an enormous, squat dome (fig. 34). One American, on visiting this Palace of the Armies of the Sea and the Land, reflected:

> There is but little poetry and picturesqueness in the warfare of today. The modern fortress is constructed not by an architect but by an engineer. Armies today are clad in cloth and khaki – the steel is worn by the forts and ships. The Creusot dome, crimson stained and hideous, like a great gory menace, stands strikingly out amid the palaces of peace, an extremely discordant stain upon this Parisian Field of the Cloth of Gold.[37]

Built by the makers of the Creusot cannon, this ugly, threatening edifice intruded upon the jolly midway attractions scattered along the riverbank. Blood-red, it was a harbinger of things to come, as Henry Adams foreshadowed in his essay 'The Dynamo and the Virgin'. Adams chose the machine as a modern 'symbol of infinity', more impressive even than the daily revolution of planet Earth. He metaphorically described himself 'lying in the gallery of Machines at the Great Exposition of 1900, his historical neck broken by the sudden irruption of forces totally new'.[38]

As the Adams essay makes clear, artistic competition on the fairgrounds, supported by nationalistic economic forces, did operate under a common denominator: the tension between new and old. This extended to subject matter (the fashion for landscape versus that for figure painting, or native versus foreign topics); it underlay stylistic change (reassuring historical revivalism versus ever-bolder abstraction); it also marked the growing divide between religion and science, with the attendant rise of elitist attitudes supposedly justified by scientific data, as well as the changing patterns of collecting and new markets. Moreover, the world fairs had lasting impact on the way the public viewed works of art as a product whose commercial value was increasingly recognised. By the turn of the twentieth century, shopping, collecting and sightseeing intersected in a number of institutions concerned with visual display and with private or public ownership of art.[39] Museums and department stores, two mid-nineteenth-century building types linked to commercialised leisure and entertainment, regularly employed display techniques that governed the international fairs. Creating fanciful environments as a means of romanticising the act of looking or purchasing, these institutions made a chore into a tempting entertainment, something that the consumerist ethos of the international fairs had long fostered.

Fig. 34 *The Creusot Cannon*
Photograph from *The Paris Exposition of 1900* in
The Burton Holmes Lectures, vol. II, 1903

1 Cikovsky and Kelly 1995, pp. 317–19.

2 D. P. Fischer, 'Constructing the "American School" of 1900' in Fischer 1999, pp. 5–11.

3 In 1900 Japanese art still was a major force at the fair, with its own extensive displays, its recognised impact on Art Nouveau and even, with a troop of Japanese actors, as an inducement to swell the crowds at Loïe Fuller's theatre. J. Gautier, 'Le théâtre et la femme', *Femina*, 1 October 1901, pp. 324–5. Fixed fans date back to ancient times; see M. A. Flory, *The History of Fans and Fan-Painting*, New York and London 1895.

4 The city still holds a world record for such enterprises, hosting seven between 1855 and 1937. For a general study, see P. Ory, *Les Expositions Universelles de Paris*, Paris 1982. For a study of national and international exhibitions, their politics and economics from 1798 to 1900, see R. D. Mandell, *Paris 1900: The Great World's Fair*, Toronto 1967.

5 Almost a quarter of the paintings in the current exhibition were shown at various French Salons. Five works by Cassatt in the current exhibition were included in various Impressionist shows, the most famous of the counter-exhibitions. Counter-exhibitions began with David and were boosted by Courbet's Pavilion of Realism in 1855. For the Salons des Refusés, a not entirely successful compromise effort between the academy and independent artists, see A. Boime, 'The Salon des Refusés and the Evolution of Modern Art', *Art Quarterly*, vol. 28, no. 2 (winter 1969), pp. 411–26. For earlier counter-exhibitions, see W. Hauptman, 'Juries, Protests and Counter-Exhibitions Before 1850', *Art Bulletin*, vol. 67, no. 1 (March 1985), pp. 95–109.

6 T. H. Goetz, *Taine and the Fine Arts*, Madrid 1973.

7 All of the studies of major world fairs cited in these notes explore this complex issue in varying detail. Inevitably, the artists having input are those who are established.

8 Motivated chiefly by trade considerations while ostensibly celebrating the Revolution of 1789, this politicised enterprise also contributed the general organising principles followed by nineteenth-century fairs. The French national shows had large divisions including raw materials, machinery and manufactures, an example followed at similar industrial fairs in New York staged by the American Institute (founded 1829).

9 Starting in 1761, the Society of Arts held exhibitions of models and drawings of industrial machinery in London. In November 1928, the Bureau Internationale des Expositions was established to regulate world fairs. Thereafter, not every large-scale exposition has been considered an official world fair.

10 The French Salon customarily opened in May, inaugurating the spring season in Paris; it might attract a daily attendance of up to 10,000. However, at the 1900 Paris fair, the public entered the grounds through 76 turnstiles: 'By this ingenious and swiftly working arrangement, 60,000 people could be admitted in an hour.' See J. P. Boyd, *The Paris Exposition of 1900: A Vivid Descriptive View and Elaborate Scenic Presentation of the Site, Plan and Exhibits*, n.p., n.d., p. 119. He discusses statistics of various fairs, pp. 19–46. More than six million saw the Great Exhibition, five million the first Paris Exposition Universelle. The Royal Academy's Summer Exhibition extends from May to August. In the last three decades of the nineteenth century, annual attendance at the London Summer Exhibitions ranged between 250,000 and 350,000 visitors. See S. C. Hutchison, *The History of the Royal Academy, 1768–1968*, New York 1968, p. 149.

11 The 1900 Paris fair featured 18 large groups, divided into 120 classes. See *Catalogue of Exhibitors in the United States Sections of the International Universal Exposition Paris, 1900*, Paris 1900. Group II, 'Works of Art', comprised four classes, including: no. 7, paintings, cartoons, illustrations; no. 8, engravings and lithographs; no. 9, sculpture and engraving on medals and gems; no. 10, architecture. One searched elsewhere for the decorative arts, particularly in group XII, 'Decoration and Furniture of Public Buildings and Dwellings', and Group XV, 'Diversified Industries', where jewellery, silver and goldsmiths' work, as well as bronzes such as a Remington statue, were listed. Photography, not yet clearly established as a fine art, was relegated to category III, 'Appliances and General Processes relating to literature, science, and art'.

12 Twelve additional artists showed at the 1855 fair. Of them, William Morris Hunt and Richard Greenough are the names most familiar today. See L. M. Fink, 'List of American Exhibitors and Their Works, 1800–1899', in Fink 1990, pp. 313–409.

13 The picture led Healy to a prestigious position in Chicago, where the canvas itself was lost in the Great Fire of 1871.

14 The French expanded their industrial fair categories to include fine art, textiles and chemical and mechanical arts in 1806. M. Stevens, 'The Exposition Universelle: "this vast competition of effort, realization and victories"', in R. Rosenblum, M. Stevens and A. Dumas, *1900:*

Art At The Crossroads, exh. cat., London 2000, p. 55.

15 Fink 1991, pp. 38–9.

16 Carol Troyen notes that the nation's first ambitious showing of landscapes in Paris was also its last. While American landscape based on the meticulous observation of nature would be promoted once more, at the American Centennial Exhibition in Philadelphia (1876), by the time of the next French Exposition Universelle the influence of the Hudson River School had dissipated. See Troyen 1984, p. 22.

17 The National Academy of Design appointed Frederic Edwin Church and Jasper Francis Cropsey to form a committee. It was made up of dealers Samuel P. Avery and Michael Knoedler, the critic Henry Tuckerman, and wealthy collectors linked to both the National Academy of Design and the Century Association. Cropsey and Church did not serve on the committee, but naturally their works were among those selected. See Troyen 1984, pp. 4–5.

18 Unlike the largely forgotten works shown in 1855, many pictures exhibited in 1867 have since become American icons. For a complete list, see Troyen 1984, pp. 24–7. The Church is now in the Corcoran Gallery, Washington, D.C.; the Bierstadt and the Durand belong to The Metropolitan Museum of Art, New York.

19 By 1867 the picture, painted in Washington, D.C., was popularly called *Old Kentucky Home* after Stephen Foster's popular song.

20 Whistler showed in the British section in 1878 and 1889, but with the Americans in 1900, reflecting a sense of fluidity regarding his nationality.

21 E. Durand-Greville, 'La Peinture aux Etats-Unis', *Gazette des Beaux-Arts*, 36 (July 1887), p. 65, quoted by A. R. Murphy in 'French Paintings in Boston: 1800–1900' in A. L. Poulet, *Corot to Braque: French Paintings from the Museum of Fine Arts, Boston*, exh. cat., Boston, 1979, p. xvii.

22 F. Ducuing, ed., *L'Exposition Universelle de 1867 Illustrée*, 2 vols, Paris 1867, vol. 2, p. 366, quoted in Troyen 1984, p. 13.

23 Quoted and discussed in D. McCullough, *John Adams*, New York 2001, pp. 236–7.

24 W. D. Howells, 'A Sennight of the Centennial', *Atlantic Monthly*, vol. 38, no. 225 (July 1876). ('Sennight' is an archaic term for the period of a week.)

25 J. J. Jarves, *Art Thoughts*, New York 1869, pp. 297–9.

26 'Beginning with Hunt's generation, study in Paris radically altered late-nineteenth-century American painting, with more and more students enrolling in a variety of studios and at schools in each succeeding decade. If . . . students who went to Paris in the 1890s stayed for shorter periods of time than did those who had gone in the 1860s and 1870s, it was probably because they had already experienced training in the French manner at home', Weinberg 1984, p. 3.

27 A. Boime, 'Foreword', in Fink 1990, p. xv.

28 E. Strahan, ed., *The Chefs-d'Oeuvre d'Art of the International Exhibition, 1878*, Philadelphia 1878, p. 60.

29 Sheldon 1888–90.

30 For an annotated, illustrated catalogue of American paintings shown, see Blaugrund 1989, pp. 268–97.

31 Fink 1991. William Merritt Chase, another significant exhibitor, had German training.

32 Fink 1991, p. 36.

33 Fischer 1999, pp. 1–15.

34 For participants, see Fischer 1999, Appendix A, p. 193.

35 For a close-up stereopticon view of Alexander Phimister Proctor's *Liberty on the Chariot of Progress*, see Fischer 1999, fig. 220, p. 135.

36 For example, see A. Quantin, *L'Exposition du Siècle*, Paris 1900, p. 131. To be just, world fairs only occasionally stimulated brilliant architectural *tours de force*. More often, exhibition buildings sank into bombastic historicism, no matter what country erected them.

37 E. B. Holmes, *The Burton Holmes Lectures, with Illustrations from Photographs by the Author*, 10 vols, Battle Creek, Michigan 1903, vol. II (1903), pp. 230–1.

38 Henry Adams, 'The Dynamo and the Virgin', (1900), in *The Education of Henry Adams*, ed. with intro and notes by E. Samuels, Boston 1974, p. 382. Adams first studied the Corliss engine at the 1893 Chicago fair. By the following summer that very machine powered the Pullman railcar factory, where a seminal labour dispute raised issues of company towns, exploitative wages, national rail strikes and the use of federal troops to break them.

39 N. Harris, 'Museums, Merchandizing, and Popular Taste: the Struggle for Influence', in Ian Quimby, ed., *Material Culture and the Study of American Life*, New York 1979, pp. 140–74. See also G. Crossick and S. Jaumain, eds., *Cathedrals of Consumption: The European Department Store, 1850–1939*, Aldershot 1999.

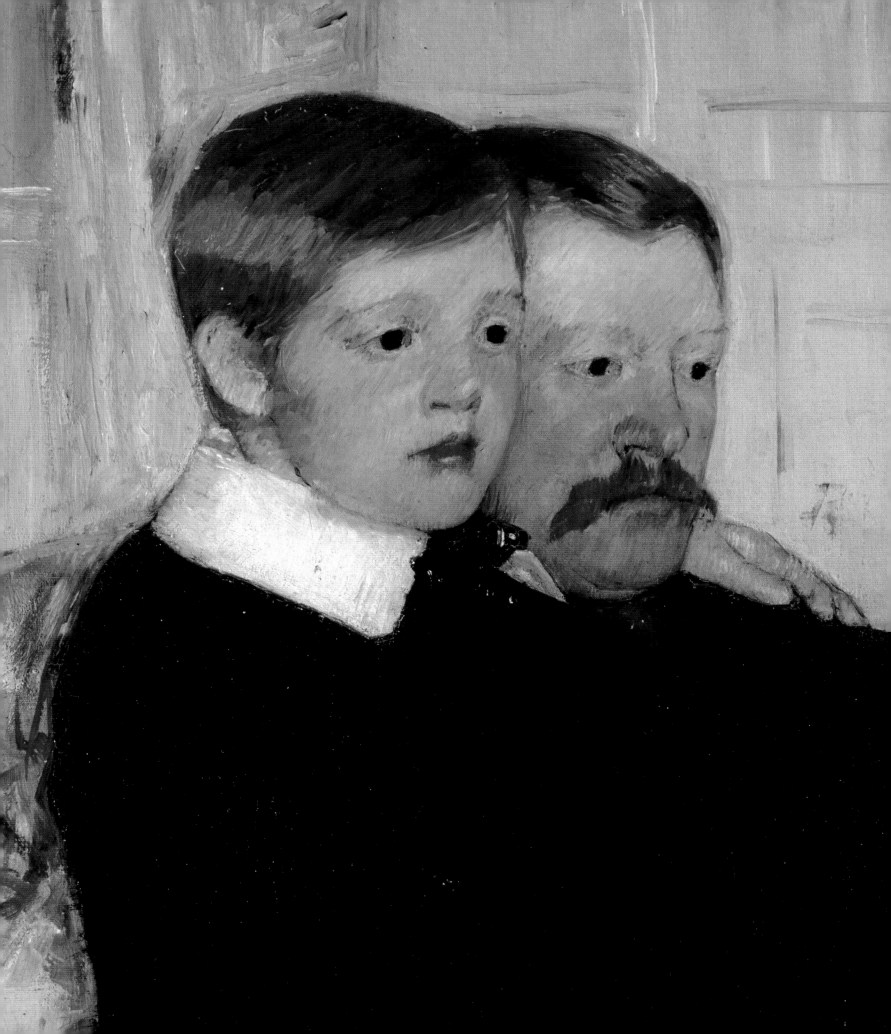

American Artists in France / French Art in America

Christopher Riopelle

By the time of the eighth and final Impressionist exhibition in 1886 the core members of the Impressionist group were drifting apart. They had stopped painting side by side as they had in the past. The group shows they had organised since 1874 no longer seemed to offer an effective means of self-promotion. Impressionism ceased to constitute the avant-garde of Parisian painting, and the sense of solidarity that such a role implies had dissipated. Still, the bonds of friendship held. When called upon, the Impressionists were ready to rally to the defence of old comrades-in-arms and of the long-contested art that had first brought them together. In 1889, for example, when it seemed likely that Edouard Manet's *Olympia* (fig. 35) would be sold to America, Claude Monet led a successful subscription campaign among the Impressionists to save their late colleague's most provocative masterpiece for the French nation. Writers, critics

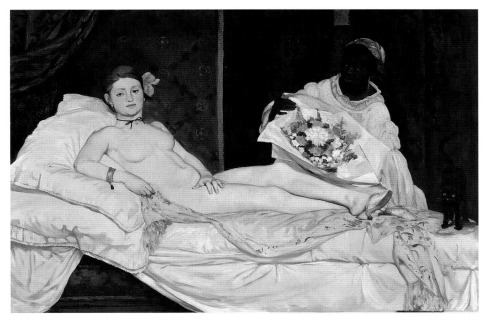

Fig. 35 Edouard Manet (1832–83). *Olympia*, 1863
Oil on canvas, 130.5 x 190 cm. Musée d'Orsay, Paris (RF644)

and collectors sympathetic to the cause joined the artists' crusade. Among the Impressionist old guard, however, one notable abstention raised eyebrows. Mary Cassatt, a participant in four Impressionist exhibitions and a fervent champion of modern French painting, declined to contribute money to the subscription. The reason was simple. As she told Camille Pissarro, she wanted *Olympia* to go to America.[1]

Cassatt's apostasy reflected more than a wide streak of independence. She admired Manet as much as she did any artist, recognised the central role he had played in the Impressionists' collective artistic endeavours and realised that *Olympia* was a touchstone of his career. In her mind, however, the campaign to save the painting was misguided, as the painting would have played as important a role across the Atlantic as it did in France itself. America needed to acquire the masterpieces of French art, the young Republic to ally itself with what was most vital and innovative in Gallic culture. In this way alone it would at last come into its own artistically. Cassatt's refusal attests, rather, to an undimmed allegiance to the land of her birth – despite years of productive work in France – and to the importance she attached to a role she had assumed since arriving in Paris. In addition to being an innovative painter and printmaker she was coming to exert a powerful influence on American taste from afar by serving as an adviser to American collectors and museums, helping to ensure that important works of art of the kind she championed entered American public and private collections. Wanting to see *Olympia* go to America was entirely consistent with that role.

Cassatt was not alone here. A number of contemporary American artists, studying or living permanently in France, also advised American collectors and museums on acquisitions, kept an eye on the art market, formed their own collections destined for America, offered judicious introductions to dealers and artists when their countrymen came to visit on the lookout for art. Some of them were paid for such services. Moreover, many of the works these artists purchased, or recommended others to acquire, ultimately ended up in art museums across the United States. Thus, American artists in nineteenth-century Paris can be said to have played a role in shaping the superlative collections of modern French painting that are a distinctive feature of America's major art museums today. The story has been told before, particularly as it concerns Cassatt, but in the context of an exhibition celebrating American artists who painted in France or under decisive French influence, it is worth remembering that some among them also played this added role in the burgeoning visual culture of the United States.

Among the first American painters to serve as a cultural intermediary between France and America in this way was William Morris Hunt (cat. 99). He was the son of a wealthy Vermont businessman, lawyer and Congressman who died in the cholera epidemic of 1832. Leaving Harvard College in his junior year, young Hunt travelled to Europe in 1843 with his mother

99 WILLIAM MORRIS HUNT
Self Portrait, 1866
Oil on canvas, 77.2 x 64.8 cm (30⅜ x 25½ in.)
Museum of Fine Arts, Boston, Massachusetts
Warren Collection, William Wilkins Warren Fund (97.63)

Notes on the Artists and Paintings

John White Alexander

1856, Allegheny City, Pennsylvania – 1915, New York

Alexander moved to New York in 1875 and began working as a cartoonist and illustrator for *Harper's Weekly* magazine. Two years later he sailed for Europe, where he enrolled in classes at the Royal Academy in Munich and met Cincinnati-born artist Frank Duveneck. Duveneck led a group of American art students, including Alexander, to the Bavarian countryside and to northern Italy in 1879, and Alexander became acquainted with James Abbott McNeill Whistler in Venice. During this first trip abroad, Alexander painted landscapes and informal portraits using the thick impasto and dramatic lighting favoured by Duveneck. Alexander resumed his work for *Harper's Weekly* on his return to New York in 1881 and also painted portraits of notable actors and writers. In the mid 1880s he visited North Africa, Spain and London.

Alexander and his wife settled in Paris in 1891 and became prominent members of the international community. He exhibited in the Salons of the Société Nationale des Beaux-Arts in the 1890s and sent canvases to avant-garde exhibitions in Brussels, Munich and Vienna. While in Paris, he maintained contact with the American art world, returning regularly to the United States to work on a variety of commissions. He was appointed head of the Paris selection jury for the 1897 Carnegie International Exhibition in Pittsburgh. In 1898 the French state purchased *Le noeud vert* (1898; later exchanged for *Portrait gris*, 1893) for the Musée du Luxembourg.

Alexander returned to New York in 1901. He was elected to the National Academy of Design and held the post of president of the group from 1909 until his death. He worked on commissions for public murals and continued to paint portraits and figure studies.
SOURCES: Goley 1976; Leff 1980; Moore 1992

53 *Repose*, 1895

Oil on canvas, 132.7 × 161.6 cm (52¼ × 63⅝ in.)
The Metropolitan Museum of Art, New York. Anonymous Gift, 1980 (1980.224)

Alexander achieved his first international success as a painter in the 1890s with the theme of the idealised woman in elegant interior settings, of which *Repose* is an important example. The unidentified model's sinuous curves and provocative gaze demonstrate Alexander's familiarity with contemporary French aesthetic taste. This composition was one of 10 such studies he exhibited in the 1895 Salon of the Société Nationale des Beaux-Arts in Paris. In America, it was shown in the 1895 Carnegie International Exhibition in Pittsburgh, Pennsylvania, and in the 1896 annual exhibition at the Pennsylvania Academy of the Fine Arts in Philadelphia. It was in the artist's collection when he died, and remained with his family until 1979. (See also p. 106.)

54 *Isabella and the Pot of Basil*, 1897

Oil on canvas, 192.1 × 91.8 cm (75⅝ × 36⅛ in.)
Museum of Fine Arts, Boston, Massachusetts. Gift of Ernest
Wadsworth Longfellow (98.181)

Taking his subject from the 1820 poem by John Keats, 'Isabella; or, The Pot of Basil', the retelling of a story from Giovanni Boccaccio's collection of tales, *The Decameron* (1348–58), Alexander painted an image at once macabre and beautiful, like those favoured by his friends and colleagues among the Symbolists. The beautiful daughter of a Florentine merchant, Isabella fell in love with her father's handsome apprentice Lorenzo. Isabella's brothers disapproved of the romance and murdered her lover. Upon discovering the body buried in a forest, Isabella severed Lorenzo's head, bathed it with her tears and hid it in a pot planted with sweet basil, a herb associated with lovers.

Included in the 1897 Salon of the Société Nationale des Beaux-Arts, as well as in progressive art exhibitions in Vienna, Munich and Pittsburgh that same year, *Isabella* attracted the attention of Musée du Luxembourg curator Léonce Bénédite, who tried to acquire the painting for the museum's collection. American painter Ernest Wadsworth Longfellow had already purchased it, probably with the intention of giving it to the Museum of Fine Arts, Boston, which he did in 1898. (See also p. 108.)

51 *In the Café*, 1898

Oil on canvas, 100.3 × 55.2 cm (39½ × 21¾ in.)
The Ann and Tom Barwick Family Collection

Alexander shows his favourite model, Juliette Véry (who also posed for *Isabella and the Pot of Basil*, cat. 54), in an elaborate and thoroughly modern costume, in a shallow, flattened space expanded by the mirror. The painting clearly reveals how conversant Alexander was with the prevailing idiom of avant-garde French art. He exhibited this quintessentially Parisian scene in Paris in 1898 and in Philadelphia in 1900. (See also p. 98.)

Cecilia Beaux

1855, Philadelphia – 1942, Gloucester, Massachusetts

Although she was often noted for her distinguished Philadelphia lineage, Beaux's father was French and she grew up with both an affection for France and fluency in its language. She received her early art training in Philadelphia from the Dutch émigré painter Adolf van der Whelen in 1872 or 1873; at the Pennsylvania Academy of the Fine Arts (1877 and 1878–9); and from William Sartain in 1881–3. Her first major canvas, *Les derniers jours d'enfance* (cat. 15), was painted in Philadelphia and exhibited at the 1887 Salon. In January 1888 Beaux went to Paris, where she worked under William Adolphe Bouguereau and Tony Robert-Fleury at the Académie Julian. She spent that summer at Concarneau, in Brittany, painting plein-air landscapes and peasant subjects. She toured Italy in October, and then returned to Paris. Dissatisfied with conditions at Julian's, she rented her own studio and sought criticism from her compatriots Alexander Harrison and Charles 'Shorty' Lasar. She also took drawing classes at the Académie Colarossi under Pascal Adolphe Jean Dagnan-Bouveret and Gustave Courtois, and received private instruction from Jean-Joseph Benjamin-Constant. In March 1889 she re-enrolled briefly at the Académie Julian before exhibiting at the 1889 Salon and at the Exposition Universelle. She returned to Philadelphia in August 1889, and taught at the Pennsylvania Academy from 1895 to 1915. About 1900 she settled in New York and began spending summers in Gloucester, Massachusetts. She returned to Europe several times, and in 1896 exhibited six works in the Salon of the Société Nationale des Beaux-Arts, including *Ernesta* (cat. 24) and *Sita and Sarita* (cat. 23).

SOURCES: Beaux 1930; Tappert 1990; Tappert 1995

15 *Les derniers jours d'enfance*, 1885

Oil on canvas, 116.8 × 137.2 cm (46 × 54 in.)
Courtesy of the Pennsylvania Academy of the Fine Arts,
Philadelphia. Gift of Cecilia Drinker Saltonstall

Beaux painted this double portrait of her sister, Etta Aimée (Ernesta Beaux Drinker), and first-born nephew, Henry Sandwith Drinker, in the studio she shared with her cousin Emma Leavitt in the Artists' Fund Building at 1334 Chestnut Street, Philadelphia. To create the setting, she brought in family heirlooms, including the Leavitts' oriental rug and the Drinkers' table and vase. The source for the aesthetic interior is Whistler's *Arrangement in Grey and Black, No. 1: Portrait of the Artist's Mother* (cat. 16), which Beaux no doubt saw when it was exhibited at the Pennsylvania Academy in 1881. This portrait received favourable reviews at the American Art Association in April 1885, and it won the Mary Smith Prize for best picture by a Philadelphia woman at the Pennsylvania Academy's annual exhibition in May that year. Its successful entry at the 1887 Salon encouraged Beaux in her pursuit of a career as a painter and inspired her to seek training in Paris. The work remained in the artist's family until 1989. (See also p. 34.)

23 *Sita and Sarita* (*Jeune fille au chat*), 1893–4

Oil on canvas, 94 × 63.5 cm (37 × 25 in.)
Musée d'Orsay, Paris. Gift of the artist to the Musée du Luxembourg, 1921 (1980-60)

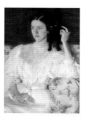

Beaux painted this enigmatic portrait of her cousin, Sarah Allibone Leavitt, with her black cat in a barn studio in Essex Fells, New Jersey. The cat is strongly reminiscent of the one in Manet's *Olympia* (1863; Musée d'Orsay, Paris), purchased for the French State in 1891. Beaux showed *Sita and Sarita* in New York at the 1895 spring exhibition of the Society of American Artists, when a reviewer wrote: 'I don't see how even Mr. Sargent could paint a portrait with more distinction than that of the woman with a black cat by Miss Beaux' ('The Lounger', *The Critic*, 26 [30 March 1895], p. 247). In 1896 *Sita and Sarita* was one of six portraits that Beaux sent to the Salon of the Société Nationale des Beaux-Arts in a well-received showing that earned her election to the Société. It remained in her possession until 1921, when she presented it to the Musée du Luxembourg.

24 *Ernesta* (*Child with Nurse*), 1894

Oil on canvas, 128.3 × 96.8 cm (50½ × 38⅛ in.)
The Metropolitan Museum of Art, New York. Maria DeWitt Jesup Fund (65.49)

This portrait shows two-year-old Ernesta Drinker, Beaux's niece and favourite model, with, just visible, the cropped arm of her nurse, Mattie. *Ernesta* is among several uncommissioned portraits of family members that Beaux undertook for exhibition. It was shown widely in America and abroad, and received favourable reviews at the Society of American Artists in New York in 1894 and at the Pennsylvania Academy of the Fine Arts in 1895. In 1896 it was among a group of six works, including *Sita and Sarita* (cat. 23), that Beaux showed at the Salon of the Société Nationale des Beaux-Arts. (See also p. 49.)

James Carroll Beckwith

1852, Hannibal, Missouri – 1917, New York

Beckwith received early instruction at Chicago's Academy of Design (1868–71) and at New York's National Academy of Design (winter 1871/2–73). He was in Paris from October 1873 to August 1878. He entered the atelier of Carolus-Duran in autumn 1873 and early the next year was admitted to the Ecole des Arts Décoratifs. In October 1874 he failed the examination for matriculation at the Ecole des Beaux-Arts, and, sceptical of Carolus-Duran's non-traditional teaching methods, began to supplement his instruction by drawing from life at the Académie Suisse, copying Old Master paintings in the Louvre, and studying in the independent atelier of Léon Joseph Florentin Bonnat. He retook the Ecole's entrance exam in February 1875 and was successful. In March 1875 he matriculated there for the first of six consecutive semesters, studying drawing under Adolphe Yvon and gaining three honourable mentions for drawing in 1877. He first exhibited at the Salon in 1877, and showed there regularly until 1890.

Beckwith travelled to Fontainebleau, Barbizon, Moret, the Seine valley, the Champagne region and Brittany in summer 1874; to Italy in May 1875 and April 1878; to Munich in July 1875; and Normandy in August 1878. On his return to the United States, he taught at the Art Students League from 1878 to 1882 and 1886 to 1897, keeping abreast of international developments in painting by returning frequently to Europe. His voluminous diaries (James Carroll Beckwith Papers, Archives of American Art) are a major source of information about the art world.
SOURCES: Beckwith 1919; Burnside 1984; Franchi and Weber 1999

5 *Portrait of William Walton*, 1886

Oil on canvas, 121.6 × 72.2 cm (47⅞ × 23⅜ in.)
The Century Association, New York (1918.1)

Pennsylvania-born William Walton had studied at the Pennsylvania Academy of the Fine Arts and the National Academy of Design in New York before entering Carolus-Duran's Paris studio in 1877, where he met Beckwith. The young art students quickly became inseparable, touring Italy together before sailing home to America in August 1878. Walton worked in New York as a painter, writer and art critic, becoming a member of the National Arts Club and the Century Association.

This portrait shows Walton in Beckwith's New York studio. With its background of Beckwith's own Impressionistic landscape paintings and its strength of characterisation, this painting demonstrates the impact of Carolus-Duran's teaching on Beckwith, as well as the probable influence of Manet's portrait of Emile Zola (fig. 2), shown in Paris in 1884. Praised when it was exhibited at the Society of American Artists in New York in 1886, this portrait was sent by Beckwith to the 1887 Salon and the 1889 Exposition Universelle in Paris and the Pan-American Exposition in Buffalo, New York, in 1901. (See also p. 19.)

Frank Weston Benson

1862, Salem, Massachusetts – 1951, Salem, Massachusetts

After three years' training at the School of the Museum of Fine Arts, Boston, Benson went to Paris to study at the Académie Julian in 1883. He spent the following summer at the popular artists' colony in Concarneau, and visited Germany, Italy and London, where he exhibited a painting at the Royal Academy in 1885.

Benson returned to New England in 1885, eventually joining the faculty of the School of the Museum of Fine Arts, Boston, in 1889. His early works are primarily interior scenes rendered with subtle light effects and muted colours. He began to experiment with Impressionist techniques in the 1890s and, in 1897, became a founding member of Ten American Painters, a group of French-trained artists who sought freedom from the traditional system of juried exhibitions. Benson purchased a summer home in Maine in 1901, and began to paint his family in plein-air studies that featured brilliant light, fluid brushstrokes and vibrant colours, always tempered by his firm foundation in academic figure painting.

One of the most influential artists and art teachers in turn-of-the-century Boston and a nationally popular painter who brought French styles into the mainstream of American art, Benson won awards at the National Academy of Design in 1889 and the World's Columbian Exposition, Chicago, in 1893.

SOURCES: Bedford 1989; Bedford 1994; Bedford 2000

3 Portrait of Joseph Lindon Smith, 1884

Oil on canvas, 64.8 × 52.7 cm (25½ × 20¾ in.)
Collection of Grant and Carol Nelson

Benson and Smith had met at the School of the Museum of Fine Arts, Boston, and travelled together to France in 1883. Both were on tight budgets and unable to enjoy the city's more expensive leisure activities. Instead, they spent evenings in their modest rooms across the hall from one another in a hotel on the rue des Petits Champs, playing music with friends and painting. Embracing the techniques he was learning at Julian's, Benson employed a sombre palette and dramatically dark shadows for this portrait of his friend. (See also p. 16.)

93 Eleanor, 1907

Oil on canvas, 64.1 × 76.8 cm (25¼ × 30¼ in.)
Museum of Fine Arts, Boston, Massachusetts. The Hayden Collection – Charles Henry Hayden Fund (08.326)

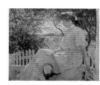

At his summer retreat in Maine, Benson explored the effects of direct sunlight on figure and landscape, as the French Impressionists had done. Rather than using the light to dissolve forms, he defined and modelled his 17-year-old daughter with sunlight, emphasising the solidity of her figure. He carefully recorded Eleanor's facial features with delicate brushwork, but painted other areas of his composition much more freely.

Benson's cheerful Impressionist paintings were extremely popular, and the Museum of Fine Arts, Boston, purchased Eleanor almost immediately after it was completed. Critics praised the painting when it was shown in an exhibition of Ten American Painters at the Pennsylvania Academy of the Fine Arts in 1908. (See also p. 168.)

Dennis Miller Bunker

1861, New York – 1890, Boston, Massachusetts

Bunker first studied painting in New York at the National Academy of Design and the Art Students League. He travelled to Paris in 1882 to continue his instruction at the Ecole des Beaux-Arts under Ernest Hébert and Jean-Léon Gérôme and spent summers in the French countryside working on picturesque landscape views. He was one of the first American artists to incorporate fully the techniques and palette of French Impressionism.

Bunker returned to New York in 1885 and promptly accepted a teaching position in Boston. He applied the academic painting techniques he had perfected in Paris to his portrait commissions and mounted his first solo exhibition in Boston in 1885. Bunker met Sargent, with whom he became close friends, in the autumn of 1887 and worked with him in the English countryside the following summer. Bunker continued to use the bold brushwork and brilliant colours of modern French painting in the landscapes he painted in New England, but he applied the darker palette and careful draughtsmanship of academic painting to his portraits and figure studies. He exhibited regularly in Boston, New York and Chicago, usually receiving positive reviews and winning prizes.

Bunker returned to New York in 1889. He painted a series of figure studies, hoping to encourage potential portrait commissions, and began work on ceiling decorations for the Madison Avenue home of wealthy New York publisher and diplomat Whitelaw Reid, then United States minister to France. Before completing his work for Reid, Bunker died suddenly from meningitis.
SOURCES: Gammell 1953; Ferguson 1978; Hirshler 1994

6 Portrait of Kenneth R. Cranford, 1884

Oil on canvas laid down on board, 41.9 × 33 cm (16¼ × 13 in.)
Lent by Mr Graham D. Williford

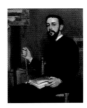

Bunker painted this portrait of Kenneth Cranford in late March or early April 1884, when the two friends were studying in Paris. They had first met as art students in New York, and Bunker followed Cranford and their mutual friend Charles Platt to Paris in 1882. Cranford completed portraits of Bunker and Platt earlier in 1884 and exhibited the former (location unknown) in that year's Salon. Returning his friend's compliment, Bunker gave this picture to Cranford, inscribing it 'A Mon Cher Ami'. The portrait exemplifies the practice of the time of painting one's friends in the absence of commissions for portraits. (See also p. 19.)

66 Brittany Town Morning, Larmor, 1884

Oil on canvas, 35.6 × 55.9 cm (14 × 22 in.)
Terra Foundation for American Art, Chicago, Illinois.
Daniel J. Terra Collection (1991.1)

Bunker produced at least six paintings in Larmor, a small town on the south coast of Brittany, during the summer of 1884. He was fascinated by the simple stone buildings and dark slate roofs of the vernacular architecture and also by the region's pearly grey light, which he described as characteristically French. This carefully composed scene is the masterpiece of his series. (See also pp. 129–33.)

81 *Chrysanthemums*, 1888

Oil on canvas, 90 × 121 cm (35½ × 48 in.)
Isabella Stewart Gardner Museum, Boston, Massachusetts

 Bunker's portrayal of the interior of Mr and Mrs John L. Gardner's greenhouse is, perhaps, one of the first canvases painted in the United States to use the bright colours and divided brushwork characteristic of French Impressionism. Bunker first met Isabella Stewart Gardner in 1885, shortly after he arrived in Boston. Cosmopolitan and wealthy, Isabella Gardner would amass a vast collection of art spanning several centuries. She was a fixture on the Boston social and cultural scene and became close friends with both Bunker and John Singer Sargent. (See also pp. 151–4.)

82 *Roadside Cottage*, 1889

Oil on canvas, 63.8 × 76.2 cm (25¹⁄₁₆ × 30 in.)
Collection of Margaret and Raymond J. Horowitz, New York

 Bunker spent the summer of 1889 with his friend and fellow Francophile, composer Charles Martin Loeffler, in Medfield, Massachusetts, where the pair rented the eighteenth-century New England clapboard cottage shown here. The painting reveals Bunker's complete mastery of the lessons of Impressionism and his ability to adapt that style to American subjects. (See also p. 154.)

83 *The Pool, Medfield*, 1889

Oil on canvas, 47 × 61.6 cm (18½ × 24¼ in.)
Museum of Fine Arts, Boston, Massachusetts. Emily L. Ainsley Fund (45.475)

 Bunker painted these lush, marshy fields near the source of the Charles River during the first of the two summers he spent at Medfield. He remarked that the Charles at this point was 'very charming – like a little English river – or rather a little like an English River'. He exhibited four of his Medfield landscapes at the St Botolph Club in Boston in the winter of 1890, and although some conservative critics disliked his adoption of Impressionism, Bunker helped to establish it as the leading American style in the 1890s. (See also p. 154.)
SHOWN IN BOSTON AND NEW YORK ONLY

Mary Stevenson Cassatt

1844, Allegheny City, Pennsylvania – 1926,
Le Mesnil-Théribus, Oise, France

After a childhood spent travelling through Europe, Cassatt enrolled in the Pennsylvania Academy of the Fine Arts in 1861. She continued her artistic training in Paris in 1865, studying privately with Charles Chaplin and receiving advice from Jean-Léon Gérôme; she also worked with Edouard Frère, Paul Soyer and Thomas Couture. Cassatt exhibited at the Salons in 1868 and 1870, and annually from 1872 to 1876. She travelled back to Philadelphia during the Franco-Prussian War in 1870, returning to Europe in 1871, when she visited Italy, Spain, Belgium and Holland.

She settled in Paris in 1874, and her parents and sister Lydia joined her there three years later. At the invitation of Degas, her lifelong friend and mentor, Cassatt participated in the fourth Impressionist exhibition in 1879. Cassatt was the only American officially associated with the Impressionists and she exhibited in three more of their eight exhibitions (1880, 1881, 1886).

Cassatt painted scenes of women in domestic interiors and as spectators at stylish social events in the 1870s and 1880s. She later concentrated her paintings, pastels, and prints on images of mothers and children. Her enthusiasm for Japanese art is apparent in a group of colour prints she included in her first one-woman exhibition at the Galerie Durand-Ruel in Paris in 1891. Acting as an adviser to many prominent American collectors, Cassatt encouraged their acquisition of Old Master paintings and avant-garde French works (see pp. 214–16).

SOURCES: Breeskin 1970; Mathews 1994; Barter 1998

36 Reading Le Figaro (*Portrait of a Lady*), 1878

Oil on canvas, 104 × 83.7 cm (41 × 33 in.)
Private collection

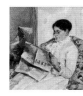

Cassatt's mother, Katherine Kelso Cassatt, was fluent in French and interested in culture and current events. She reads the daily newspaper *Le Figaro*, which was devoted to politics and literature. Her casual white morning dress indicates her relaxation, and her pince-nez and concentrated expression emphasise her absorption in what she is reading.

Cassatt shipped the painting to her brother Alexander in Philadelphia the year it was made. American critics praised it upon its public debut at the second exhibition of the Society of American Artists, New York, in 1879, and at the Pennsylvania Academy of the Fine Arts the same year. It was included in the first New York exhibition of French Impressionist paintings, organised by Durand-Ruel and held at the American Art Association in 1886 (and later seen at the National Academy of Design). The portrait was a treasured family possession and remained with Cassatt's descendants until 1983.

SHOWN IN BOSTON AND NEW YORK ONLY

34 *Little Girl in a Blue Armchair*, 1878

Oil on canvas, 89.5 × 129.8 cm (35½ × 51⅛ in.)
National Gallery of Art, Washington, D.C. Collection of Mr and Mrs Paul Mellon 1983 (1983.1.18)

Cassatt composed an informal scene of a child sprawled unself-consciously in a richly furnished domestic interior. Cassatt's dog rests in a chair at left and the deep background space ends with a series of French doors that illuminate the scene. The painter sought advice from Degas regarding this composition and elicited his help with the background.

Cassatt submitted this painting to the American section of the 1878 Exposition Universelle in Paris and was enraged when the jury rejected it. She showed it the following year in the fourth Impressionist exhibition. She kept the painting until about 1903, when she sold it to dealer Ambroise Vollard. (See also p. 76.)

49 *In the Loge*, 1878

Oil on canvas, 81.3 × 66 cm (32 × 26 in.)
Museum of Fine Arts, Boston, Massachusetts. The Hayden
Collection – Charles Henry Hayden Fund (10.35)

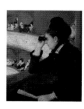

For Cassatt and her fellow Impressionists, the theatre supplied both an elegant and ornate setting filled with dazzling lights and reflections and an audience of thoroughly modern socialites – the perfect opportunity for capturing the essence of contemporary life. This canvas portrays a fashionable woman dressed for an afternoon performance at the Théâtre Français and actively engaged in the scenes surrounding her.

Cassatt sent the painting to Philadelphia dealer H. Teubner in 1878 and it was shown that year in Boston, making it the first of her Impressionist paintings to be displayed in America. Durand-Ruel bought the canvas in 1893 and included it in the 1893 Cassatt retrospective. After appearing in exhibitions in New York, Boston and Cincinnati, the painting was purchased by the Museum of Fine Arts, Boston, in 1910.

22 *Woman with a Pearl Necklace in a Loge*, 1879

Oil on canvas, 81.3 × 59.7 cm (31⅝ × 23 in.)
Philadelphia Museum of Art, Pennsylvania. Bequest of Charlotte
Dorrance Wright (1978-1-5)

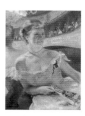

This painting was first shown at the fourth Impressionist exhibition in 1879 in a room devoted to works by Cassatt with similar themes. Although Degas had tried to convince his closest friends among the Impressionists to submit fan-shaped paintings in order to unify the presentation, and he and Pissarro contributed a number of these, Cassatt chose instead to include fans as objects within her compositions. Her young red-haired model is clearly a visitor to France enjoying an evening of cosmopolitan entertainment. Cassatt illuminates this opulent scene with the reflections from the mirror and the artificial light of a chandelier. She used bright, almost glaring colours for this canvas, and emphasised them by displaying the canvas in a green frame (now lost). French collector Alexis Rouart purchased the painting immediately upon seeing it at the exhibition.

30 *The Cup of Tea*, about 1879

Oil on canvas, 92.4 × 65.4 cm (36⅜ × 25¾ in.)
The Metropolitan Museum of Art, New York. From the
Collection of James Stillman, Gift of Dr Ernest G. Stillman,
1922 (22.16.17)

This may have been one of the 11 works by Cassatt included in the Impressionist exhibition of 1879, but it does not appear in the catalogue nor was it discussed by reviewers. It was certainly included in the sixth Impressionist exhibition of 1881. In his review, French novelist Joris-Karl Huysmans singled it out for its '*fine odeur d'élégances parisiennes* [fine sense of Parisian elegance]'.

The Cup of Tea was with Galerie Durand-Ruel from 1891 to 1911, when it was purchased by Cassatt's friend, the Paris-based financier and collector James Stillman, whose son gave it to the Metropolitan.
SHOWN IN LONDON AND BOSTON ONLY

38 *The Tea*, about 1880

Oil on canvas, 64.8 × 92.1 cm (25½ × 36¼ in.)
Museum of Fine Arts, Boston, Massachusetts. M. Theresa B.
Hopkins Fund (42.178)

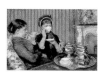

Seated in the drawing room of the Cassatts' carefully appointed Paris apartment, the artist's sister Lydia (at left) enjoys tea with an unidentified visitor dressed for an afternoon outing in fur-trimmed hat and kid gloves. Cassatt obscured the guest's face with a teacup and accorded equal importance to human figures and inanimate objects, balancing the two women with a silver tea service, a Cassatt family heirloom.

Included in the fifth Impressionist exhibition in 1880, *The Tea* met with mixed critical reviews. Henri Rouart purchased the canvas the following year, and Cassatt kept close tabs on it. It appeared in the Durand-Ruel exhibitions of Cassatt's work in Paris in 1893, in New York in 1895 and again in Paris in 1908.

103 *Mother about to Wash her Sleepy Child,*
1880

Oil on canvas, 100.3 ¥ 65.8 cm (39 $\frac{7}{16}$ ¥ 25$\frac{7}{8}$ in.)
Los Angeles County Museum of Art, California. Mrs Fred
Hathaway Bixby Bequest (M.62.8.14)

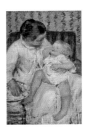

*Mother about to Wash her Sleepy
Child*, also called *The Child's Bath*
and *La toilette de l'enfant*, has been
considered the artist's first major
painting on the mother and child
theme. For many years it was
believed to have been included in the
fifth Impressionist exhibition in Paris
in 1880 (Ségard 1913, p. 203),
but that claim is not supported by the catalogue or
contemporary reviews (Moffett 1986, pp. 310–11, and
Barter 1998, pp. 319, 356). In April 1895 it was one of
54 works included in Cassatt's first large one-woman
exhibition in the United States, held at Durand-Ruel's
New York gallery. By 1900 the picture had been
purchased by Cleveland iron magnate Alfred Atmore
Pope and his wife, Ada Brooks Pope (the daughter of
a lawyer for the Pennsylvania Railroad, for which
Cassatt's brother Alexander served as vice president
and president). In 1909 it was one of 24 works
exhibited in a one-woman exhibition at the
St Botolph Club, Boston.

SHOWN IN NEW YORK ONLY

65 *Lydia crocheting in the Garden at Marly,*
1880

Oil on canvas, 65.6 ¥ 92.6 cm (25$\frac{13}{16}$ ¥ 36$\frac{7}{16}$ in.)
The Metropolitan Museum of Art, New York. Gift of
Mrs Gardner Cassatt, 1965 (65.184)

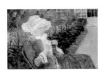

By 1877 the artist's sister, Lydia,
had been diagnosed with Bright's
disease, a slowly progressing,
painful and deadly affliction of
the kidneys. She was increasingly
confined to home until her death on 7 November 1882.
Lydia's illness and the family's preoccupation with it
appear to have prompted Cassatt to focus more on
domestic life and to adopt a more meditative manner.
This work appeared, along with 10 other pictures by
Cassatt, in the sixth Impressionist exhibition in 1881
as *Le Jardin*. Bought by Philadelphia railroad executive
P. A. B. Widener from the Galerie Durand-Ruel, Paris,
in 1894, the painting was back in the Cassatt family by
1906. (See also p. 129.)

48 *Young Woman in Black (Portrait of
Madame J.),* 1883

Oil on canvas, 80.6 ¥ 64.6 cm (31$\frac{3}{4}$ ¥ 25$\frac{1}{2}$ in.)
The Peabody Art Collection. Courtesy of the Maryland State
Archives, Annapolis. On loan to the Baltimore Museum of Art
(MSA SC 4680-10-0010)

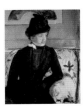

This painting, sometimes identified
as the *Portrait of Madame J.* that
appeared in the fifth Impressionist
exhibition in 1880, seems more likely
to date from 1883 and to portray the
artist's sister-in-law, Eugenia Carter
Cassatt, known as Jennie. The
portrait was probably painted when
Jennie and her husband, Cassatt's youngest brother
Joseph Gardner Cassatt, visited Paris in 1883. Cassatt,
a connoisseur of all things fashionable, depicts the latest
style in clothing (the black hat with a stuffed bird
perched on the brim and a lace veil) and in Parisian art
(a fan painted by Degas, a gift from the artist to
Cassatt). This boldly painted canvas remained in
Cassatt's possession until 1924 when she sold it to
dealer Paul Durand-Ruel.

SHOWN IN LONDON ONLY

101 *Portrait of Alexander J. Cassatt and his Son
Robert Kelso Cassatt,* 1884–5

Oil on canvas, 100.3 ¥ 81.3 cm (39$\frac{1}{2}$ ¥ 32 in.)
Philadelphia Museum of Art, Pennsylvania. Purchased with the
W. P. Wilstach Fund and with funds contributed by Mrs William
Coxe Wright, 1959 (1959-1-1)

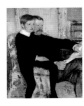

Cassatt began this double portrait of
her eldest brother and his son during
their impromptu Christmas visit to
Paris in 1884. The setting is the
family apartment. Eleven years old at
the time, Robert had little patience
for the lengthy sittings his aunt
requested, and as his grandmother
related, 'wriggled about like a flea'. This composition
depicting two males is rare in the oeuvre of an artist
who later made a speciality of images of women and
children. The two figures, gazing fixedly at the same
point, are shown so close together that their dark
clothing fuses into a solid black mass, which emphasises
the closeness and affection between them.

Cassatt sent this portrait to Alexander in Philadelphia
upon its completion. It was shown only once, at the
1927 memorial exhibition of the artist's work in
Philadelphia, and remained in the Cassatt family until
1959. (See also p. 214.)

100 *Lady at the Tea Table*, 1883–5

Oil on canvas, 74.7 ¥ 61 cm (29 ¥ 24 in.)
The Metropolitan Museum of Art, New York. Gift of the Artist,
1923 (23.101)

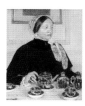

Cassatt began this portrait of Mrs Robert Moore Riddle, her mother's first cousin, in 1883, as a gesture of thanks for a gift of porcelain from Mrs Riddle, and finished it two years later. Mrs Riddle's daughter, Annie Riddle Scott, disliked this portrait, objecting to the size of her mother's nose.

Cassatt's close friend Louisine W. Havemeyer prompted Durand-Ruel to exhibit it in 1914 in Paris, where it received favourable attention. In April 1915 it was included in an exhibition of works by Degas, Cassatt and others organised by Havemeyer at Knoedler and Company, New York, in support of women's suffrage. The painting was lent to The Metropolitan Museum of Art in 1918, and accepted as a gift from Cassatt in 1923.

SHOWN IN NEW YORK ONLY

37 *Mrs Robert S. Cassatt, the Artist's Mother*
(*Katherine Kelso Johnston Cassatt*),
about 1889

Oil on canvas, 96.5 ¥ 68.6 cm (38 ¥ 27 in.)
Fine Arts Museums of San Francisco, California. Museum Purchase,
William H. Noble Bequest Fund (1979.35)

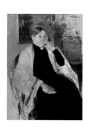

Cassatt's brother, Alexander J. Cassatt, owned this tender portrait of his elderly mother by 1895, when it made its debut at an exhibition in Boston, the same year Mrs Cassatt died. The portrait was included in a 1908 exhibition of Cassatt's work at the Galerie Durand-Ruel in Paris, in a 1909 Cassatt exhibition in Boston and in a 1920 Pennsylvania Academy of the Fine Arts exhibition. It remained in the Cassatt family until at least 1966.

SHOWN IN BOSTON AND NEW YORK ONLY

41 *Mother and Child*, about 1889

Oil on canvas, 90 ¥ 64.5 cm (35⅝ ¥ 25⅜ in.)
Wichita Art Museum, Kansas. The Roland P. Murdock
Collection (M.109.53)

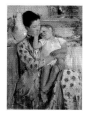

Cassatt emphasised here the physically sensuous relationship between the two figures, connected at many points in the composition. She also contrasted physicality and evanescence, allowing her solid figures to dissolve into a flurry of brushstrokes.

Cassatt sold this canvas to Durand-Ruel in about 1899. The Parisian collector Georges Viau had purchased it by 1903, when it appeared in an exhibition of Impressionist works at the Galerie Bernheim-Jeune in Paris. Boston collector Sarah Choate Sears, a friend of Cassatt's, acquired the painting from Durand-Ruel in 1907.

SHOWN IN LONDON AND BOSTON ONLY

40 *Woman holding a Child in her Arms*,
about 1890

Oil on canvas, 81.5 ¥ 65.5 cm (31½ ¥ 25½ in.)
Museo de Bellas Artes de Bilbao, Spain (82/25)

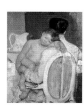

Not only were the topics of motherhood and child-rearing prominent in late-nineteenth-century social thought, but Cassatt herself especially liked children, doting on her nieces and nephews and her friends' children. Her depictions of mothers and children elicited critical praise and found a favourable market.

Cassatt did not display this composition until 1919, when it was included in the First International Exhibition of Painting and Sculpture in Bilbao, Spain, where it was acquired for the collection of the Museo de Bellas Artes de Bilbao.

Jefferson David Chalfant

1856, Sadsbury Township, Pennsylvania – 1931, Wilmington, Delaware

Chalfant followed his father's trade as a cabinet-maker before embarking on a career as a fine artist in Wilmington, Delaware, about 1880. He had no early professional training. From April 1890 to 1892 Chalfant was in Paris, where he studied at the Académie Julian under William Adolphe Bouguereau and Jules-Joseph Lefebvre. He spent the summers of 1891 and 1892 in Giverny, where he stayed at the Hôtel Baudy and painted plein-air figural compositions. He returned to Wilmington in 1892.
SOURCES: Chalfant 1959; Gorman 1979

12 *Bouguereau's Atelier at the Académie Julian, Paris*, 1891

Oil on wood panel, 28.6 × 36.8 cm (11¼ × 14½ in.)
Fine Arts Museums of San Francisco, California. Gift of
Mr and Mrs John D. Rockefeller III (1979.7.26)

A label on the reverse identifies the scene as Bouguereau's studio. (See also p. 30.)
SHOWN IN BOSTON AND NEW YORK ONLY

William Merritt Chase

1849, Williamsburg, Indiana – 1916, New York

Chase spent his student years, from 1872 to 1878, in Munich, where he enrolled at the Royal Academy – then a popular alternative to the Paris art schools – and adopted the bravura brushwork and dark palette identified with Munich realist Wilhelm Leibl. In 1878 he returned to New York to take a position at the Art Students League, embarking on what would become a distinguished teaching career. He enhanced his reputation by exhibiting at the Paris Salons (1881–3) and Expositions Universelles (1889, 1900), and was among the earliest American artists to create Impressionist canvases in the United States. During the summers of 1881 and 1882, he travelled to Paris, where he had his first significant encounters with the work of the French Impressionists and met John Singer Sargent and Carolus-Duran, who later lectured in Chase's classes in New York. Frequent trips to Europe in the early 1880s gave Chase a broad, international perspective that influenced his mature style.
SOURCES: Pisano 1983; Gallati 1995; Gallati 1999

14 *Portrait of Miss Dora Wheeler*, 1883

Oil on canvas, 158.8 × 165.7 cm (62½ × 65¼ in.)
The Cleveland Museum of Art, Ohio. Gift of Mrs Boudinot Keith
in memory of Mr and Mrs J. H. Wade, 1921 (1921.1239)

Dora Wheeler was Chase's first private pupil after his return to New York from Munich in 1878. She also took courses at the Art Students League in New York (1878–84 and 1885–9), and studied at the Académie Julian in Paris (1884–8). She was a chief designer at Associated Artists, the New York interior design and decorative arts firm established in 1883 by her mother, Candace Wheeler, and became a noted portrait and figure painter and illustrator.

Chase depicted Wheeler in her studio at 115 East 23rd Street, New York. The composition recalls Whistler's *Arrangement in Grey and Black, No. 1: Portrait of the Artist's Mother* (cat. 16), which Chase probably saw at the Pennsylvania Academy of the Fine Arts in 1881 or the Society of American Artists in New York in 1882. This portrait was not commissioned, but was painted specifically for exhibition in Europe. It won a gold medal at the Internationale Kunstaustellung in Munich in 1883, and was one of two works Chase showed in the 1883 Paris Salon.

Charles Courtney Curran

1861, Hartford, Kentucky – 1942, New York

Curran displayed an interest in French painting while he was still an art student, first in Cincinnati and later at the Art Students League and the National Academy of Design in New York. Familiar with the works produced by Americans who worked in France in the 1880s, he exhibited and received acclaim for paintings with Breton peasant themes and similar French subjects before he ever visited France.

Curran finally travelled to Paris in 1888 and studied at the Académie Julian for two years. During this time he concentrated on plein-air figure studies of fashionable young women on bustling city streets or in secluded urban parks. Curran exhibited at the 1889 and 1890 Salons des Artistes Français, and then returned to the United States for a few months. He came back to Paris for a short stay in 1891, and later made several additional visits to France, exhibiting at the Exposition Universelle in 1900. Curran settled in New York, accepting teaching positions at the National Academy of Design and at the Pratt Institute in Brooklyn. After 1903, he spent most of his time at the Cragsmoor artists' colony in New York's Catskill mountains.
SOURCES: Cook 1895; St-Gaudens 1906; Silver 1974

28 In the Luxembourg Garden, 1889

Oil on panel, 23.3 × 31.1 cm (9³⁄₁₆ × 12¼ in.)
Terra Foundation for American Art, Chicago, Illinois. Daniel J. Terra Collection (1992.167)

Curran completed this scene during his second year in Paris, presenting on a small panel a detailed account of the activities Parisians enjoyed in the city's parks. Curran captured the blend of art with daily life so typical of Paris, including in this scene Auguste-Nicolas Cain's regal sculpture of a lion (1870).

29 Afternoon in the Cluny Garden, Paris, 1889

Oil on panel, 22.9 × 30.5 cm (9¼ × 12 in.)
Fine Arts Museums of San Francisco, California. Bequest of Constance Coleman Richardson (2002.55)

The Musée de Cluny opened to the public in 1844 on the rue de Sommerard in a Gothic building erected as an abbey on a site once occupied by a Roman palace. Its peaceful, secluded garden contained medieval sculptures and architectural remnants, among them the Romanesque portal visible in the background of this composition. Curran represented this spot as a peaceful refuge for ladies of fashion.

SHOWN IN BOSTON AND NEW YORK ONLY

Mary Fairchild
later MacMonnies, later Low

1858, New Haven, Connecticut – 1946, Bronxville, New York

Fairchild began studying art at the St Louis School of Fine Arts in Missouri after having been a school teacher for five years. In 1885, with a three-year scholarship to study in Paris, she entered the Académie Julian. After spending the summer of 1887 painting Barbizon-style landscapes in Picardy, she returned to Paris to join the women's class offered by Carolus-Duran.

Fairchild exhibited at the Salon from 1886 to 1890. In 1895 she began to show her work at the Salon of the Société Nationale des Beaux-Arts. She also exhibited throughout the United States, often assisted by her friend Sara Hallowell (see cat. 102). In August 1888 Fairchild married the American sculptor Frederick MacMonnies whom she met in Paris. The couple first visited Giverny in April 1890 and returned in August and October 1893. Beginning in 1895, they rented and spent several summers in the Villa Bêsche, then moved to the grander Le Prieure. At Giverny, Mary MacMonnies painted several Impressionist-inspired views of Giverny's gardens and interiors (see cat. 10).

MacMonnies remained in Giverny while her husband spent extended periods in Paris and New York. The couple divorced in 1909. Soon afterwards she married American painter Will Hicok Low and moved to New York, where she worked as a portraitist.

SOURCES: Smart 1984; Smart 1996; Cartwright 2001

102 Portrait of Mlle S. H. (Sara Tyson Hallowell), 1886

Oil on canvas, 97.5 × 112.1 cm (38¼ × 44 in.)
The Warden and Fellows of Robinson College, University of Cambridge

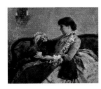

This portrait, Fairchild's earliest extant work, was painted during her first year at the Académie Julian and was accepted for the Salon of 1886. Hallowell was a friend of both Fairchild and Mary Cassatt. She was an agent in Paris for American collectors and museums and was instrumental in introducing Impressionist painting to the United States (see pp. 216–18). Fairchild and Hallowell remained close after this painting's completion and in 1891, largely as a result of Hallowell's influence, Fairchild was commissioned to paint a mural for the Woman's Building at the 1893 World's Columbian Exposition in Chicago that was to be installed opposite a complementary mural by Cassatt.

Fairchild captured the elegantly dressed Hallowell enjoying a teatime visit, a fashionable motif that Cassatt had used repeatedly a few years earlier (cats 30, 38 and 100). She departed from traditional portraiture by showing Hallowell in the act of drinking, with her facial features in shadow. Hallowell, whose Quaker beliefs discouraged vanity, may have preferred this conceit.

10 In the Nursery – Giverny Studio (Dans la nursery), about 1896–8

Oil on canvas, 81.3 × 43.2 cm (32 × 17 in.)
Terra Foundation for American Art, Chicago, Illinois. Daniel J. Terra Collection (1999.91)

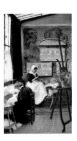

This is the room in her summer home at Giverny that Mary Fairchild MacMonnies used as both studio and nursery. Here she combines in one psychologically compelling image the public and private spheres of her life. Her Giverny canvases celebrate the independence she enjoyed while her husband worked in Paris and the United States. She used her children and servants as models, chronicling the daily routine of her household in a bright, light-filled style. (See also pp. 24–7.)

Elizabeth Jane Gardner,
later Bouguereau

1837, Exeter, New Hampshire – 1922, St Cloud, France

Gardner arrived in Paris in 1864, in advance of the many American art students who travelled there after the Civil War. During her first summer in France, she filled orders from home for copies of paintings in the Louvre and the Luxembourg museums. Gardner studied privately. She eventually joined a women's cooperative studio and applied to the Prefecture of Police for permission to wear male attire in order to attend drawing classes restricted to men.

With her entry to the 1868 Salon, Gardner became one of the first American women to show there. She exhibited annually at the Salon, winning honourable mention in 1879 and a bronze medal in 1887. She showed in the Exposition Universelle in 1878 and won a bronze medal in the Exposition Universelle in 1889. She also displayed her work in galleries in New York and Boston and at the Philadelphia Centennial Exhibition. In 1877 Gardner began studying with William Adolphe Bouguereau, who became her most important teacher, mentor and, in 1896, her husband. She specialised in religious, historical and mythological subjects painted in a polished academic style popular with Salon jurors and collectors. Gardner helped many American collectors to acquire French paintings.
SOURCES: *Exeter News-Letter* 1922; McCabe 1922; Fidell-Beaufort 1984

Abbott Fuller Graves

1859, Weymouth, Massachusetts – 1936, Kennebunkport, Maine

Graves first studied art at the School of Design of the Massachusetts Institute of Technology, establishing a studio in Boston in the early 1880s. In 1884, he travelled to Paris, where he studied for a year with flower painter Georges Jeannin and met fellow Bostonian Edmund Charles Tarbell, of whom he became a lifelong friend. Upon returning to Boston, Graves accepted a teaching position at the Cowles School of Art and became admired for his floral still lifes. In spring 1887 he went back to Paris, and he and his wife took an apartment on the fashionable avenue Wagram. They integrated themselves into the artistic and social life of the American colony and befriended compatriot Childe Hassam. Graves studied figure painting with Georges Jeannin and Fernand Cormon and mural and decorative painting at the Académie Julian with Henri Gervex and Jean-Paul Laurens, and showed at the Salons in 1888 and 1889 and at the 1889 Exposition Universelle. By 1891, Graves had returned to Boston and established his own school. He lived in Paris again from 1902 to 1905.
SOURCES: Robinson 1888; Williams 1923; Butler 1979

1 *The Boating Party*, late 1880s

Oil on academy board, 16.5 × 24.1 cm (6½ × 9½ in.)
Collection of Remak Ramsay

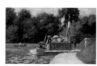

Graves probably painted this small study in the late 1880s, during his second visit to Paris. It echoes similar scenes of fashionable groups at leisure by Monet and Renoir, who had worked in 1869 at Bougival, on the Seine, west of Paris. Graves may have painted this panel at a similar village along the Seine or at a boating lake in the redesigned Bois de Boulogne, which had become a popular recreation spot. Graves animated the scene with two large French flags, which clearly identify this unassuming place as France.

17 *The Shepherd David*, about 1895

Oil on canvas, 156.2 × 107.6 cm (60½ × 41⅜ in.)
National Museum of Women in the Arts, Washington, D.C.
Gift of Wallace and Wilhelmina Holladay (1986.24)

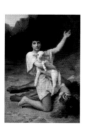

Gardner took her subject from the First Book of Samuel in the Old Testament, in which David, to prove that he would be able to confront Goliath, told Saul how he had rescued a lamb from the mouth of a lion. Gardner's triumphant David clutches his precious lamb and kneels in victory over the defeated beast, gazing toward the heavens to acknowledge the source of his strength. Gardner fashioned this painting as an exhibition piece and submitted it to the 1895 Salon, where it met with considerable success. Shortly after its public debut, Mary Copley Thaw of Pittsburgh, one of Gardner's numerous American patrons, purchased it directly from the artist during a studio visit. (See also p. 34.)

Ellen Day Hale

1855, Worcester, Massachusetts – 1940, Brookline, Massachusetts

Born into a prominent Boston family, which included the patriot Nathan Hale and the author Harriet Beecher Stowe, Hale was the daughter of the Unitarian clergyman and novelist Edward Everett Hale. Her younger brother was the American Impressionist painter Philip Leslie Hale. In Boston she studied anatomy with William Rimmer and painting with William Morris Hunt and Helen Knowlton. During spring visits to Philadelphia in 1878 and 1879, she attended classes taught by Thomas Eakins at the Pennsylvania Academy of the Fine Arts.

In 1881 Hale spent nine months touring Europe with Knowlton, after which she settled in Paris. She enrolled in the Académie Colarossi and in the women's class organised by Carolus-Duran and Jean-Jacques Henner, and also spent three years at the Académie Julian. While in France, Hale acted as correspondent for the *Boston Traveller*, providing commentary on the Paris art scene. She developed a bold style during her time abroad, using asymmetrical, radically cropped compositions and dark, strong colours. She admired Old Master works as well as modern ones by Courbet and Manet. As her career progressed, her style grew lighter and more impressionistic, and she often depicted elegant women in interiors. She exhibited widely, at the Paris Salon, the National Academy of Design and the Pennsylvania Academy, and supported herself by teaching art, painting portraits and decorating church interiors.
SOURCES: Schpero 1994; Hirshler 2001; Swinth 2001

Frederick Childe Hassam

1859, Dorchester, Massachusetts – 1935, East Hampton, New York

Hassam began his career apprenticed to George E. Johnson, a wood engraver in Boston. He studied drawing and anatomy at Boston's Lowell Institute (c.1881), and enrolled in drawing classes at the Boston Art Club (December 1883). He first visited Paris in the summer of 1883 with Boston artist Edmund H. Garrett. In the autumn of 1886 he returned with his wife, Maud, for a three-year stay, and by the end of that year Hassam enrolled at the Académie Julian under Gustave Clarence Rodolphe Boulanger and Jules-Joseph Lefebvre. By the spring of 1888, inspired by the modern French artists who chronicled everyday scenes, including the Impressionists, he left Julian's to concentrate on painting urban life. He spent the summers at the home of friends at Villiers-le-Bel, about 20 kilometres north of Paris, where he painted garden scenes that reflect his lifelong interest in the subject. He exhibited at the Salons from 1887 until 1890 and at the Exposition Universelle of 1889 (bronze medal).

Hassam left Paris in late summer 1889, and had settled in New York by December. In the summer of 1890 he began his habit of making long painting excursions to picturesque New England sites, including Old Lyme and Cos Cob, Connecticut; Gloucester, Massachusetts; and Appledore in the Isles of Shoals, located off the coast of Maine and New Hampshire. He visited Paris again in 1897 and 1910, and showed paintings in the Salons of the Société Nationale des Beaux-Arts in 1897 and 1898 and the Exposition Universelle of 1900 (silver medal).
SOURCES: Hiesinger 1994; Adelson 1999; Weinberg 2004

9 *Self Portrait*, 1885

Oil on canvas, 72.4 × 99.1 cm (28½ × 39 in.)
Museum of Fine Arts, Boston, Massachusetts. Gift of Nancy Hale Bowers (1986.645)

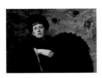

The last work Hale completed in Paris, the *Self Portrait* makes apparent her independence of spirit and courage. Daring not only for its confrontational attitude, but also for its unusual horizontal format and bold handling of paint, this portrait received praise from a reviewer when it was exhibited in Boston in 1887. The critic thought Hale's canvas displayed 'a man's strength in the treatment and handling of her subject – a massiveness and breadth of effect attained through sound training and native wit and courage' (Greta 1887a). The painting remained in her family until 1986. (See also p. 24.)

44 Grand Prix Day, 1887

Oil on canvas, 61.3 × 78.7 cm (24⅛ × 31 in.)
Museum of Fine Arts, Boston, Massachusetts. Ernest Wadsworth
Longfellow Fund (64.983)

Hassam shows the parade of stylish Parisians on their way to the Grand Prix de Paris, one of the oldest and most prestigious horse races in Europe, held annually in late June at the Hippodrôme de Longchamp in the Bois de Boulogne. The site is probably the chestnut-tree-lined avenue Bois de Boulogne (now Foch), near the Arc de Triomphe, which is partially visible to the left. Hassam sold this painting to his Boston dealer, Williams and Everett, while he was still in Paris. It was first displayed in an exhibition of his work at the Noyes, Cobb, and Co. Gallery in Boston in 1889. A second, larger version of the picture (New Britain Museum of American Art, Connecticut) was exhibited at the Salon of 1888. (See also pp. 93–8.)

SHOWN IN BOSTON AND NEW YORK ONLY

45 Along the Seine, Winter, 1887

Oil on wood, 20.3 × 27.9 cm (8 × 11 in.)
Dallas Museum of Art, Texas. Bequest of Joel T. Howard

This is one of many small oil sketches of everyday life that Hassam made in Paris. These spontaneous, informal, often experimental works, painted on the spot, were important counterparts to his more conservative, large-scale Salon submissions such as At the Florist (cat. 43). (See also p. 93.)

46 April Showers, Champs Elysées, Paris, 1888

Oil on canvas, 31.7 × 42.5 cm (12½ × 16⅝ in.)
Joslyn Art Museum, Omaha, Nebraska. Museum Purchase, 1946
(JAM 1946.30)

At the centre of this composition, which shows an unidentified stretch of the Champs Elysées, is an omnibus, a favourite subject of Hassam's. Originally introduced in Paris in 1662 and revived in April 1828, the omnibus was a French innovation; by the 1880s horse-drawn omnibuses were criss-crossing the city. (See also p. 93.)

78 Geraniums, 1888

Oil on canvas, 45.7 × 27.3 cm (18¼ × 13 in.)
The Hyde Collection, Glens Falls, New York (1971.22)

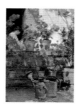

Hassam painted Geraniums in Villiers-le-Bel, in the garden of his friends and summer hosts Mr and Mrs Ernest Blumenthal, and he displayed it in the 1889 Salon as Soleil et fleurs. (A stamp on the back of the painting reads 1889/Salon.) Louis and Charlotte Hyde purchased it from Milch Galleries in New York in 1930. (See also p. 150.)

56 *Cernay-la-Ville – French Farm*, 1867

Oil on panel, 26.8 × 45.9 cm (10¾ × 18¹⁄₁₆ in.)
Krannert Art Museum, University of Illinois, Urbana-Champaign,
Illinois. Gift of Mr and Mrs Merle J. Trees (1940-1-3)

Homer was introduced to Cernay-la-Ville by Joseph Foxcroft Cole, a fellow painter from Boston who became an agent for American collectors of Barbizon and Impressionist pictures. With its low, solid rustic buildings and animated sky, this painting demonstrates Homer's familiarity with the Barbizon style. (See also p. 118.)

95 *A Summer Night*, 1890

Oil on canvas, 76.8 × 101.9 cm (30¼ × 40¼ in.)
Musée d'Orsay, Paris (1977-427)

Homer painted *A Summer Night* in his studio in Prout's Neck, Maine. He first visited Prout's Neck in the summer of 1875, and in subsequent years the Homer family began acquiring property and building a summer colony. The artist settled there permanently in 1884. This scene is said to have been inspired by Homer's observation one summer night of two young women waltzing together on a front porch, dramatically lit by the lamps that glowed from within the unseen house behind them.

In 1900 Homer sent *A Summer Night* with several other works to the Exposition Universelle in Paris, where he received a gold medal. The French government purchased it for the Musée du Luxembourg. (See also p. 191.)

Thomas Hovenden

1840, Dunmanway, County Cork, Ireland – 1895, Trenton, New Jersey

Irish-born Hovenden was apprenticed to a woodcarver and frame-maker and enrolled in art classes at the Cork branch of the South Kensington School of Design before emigrating to New York in 1863. He took night classes at the National Academy of Design from 1864 to 1868, and worked at framing, colouring photographs, illustrating and other odd jobs. In 1874 he committed himself to a career as a painter and went to Paris, where he entered the studio of Alexandre Cabanel at the Ecole des Beaux-Arts. In summer 1875 Hovenden joined Robert Wylie and several other Americans in the artists' colony at Pont-Aven in Brittany. He stayed for five years, painting local genre subjects and scenes from Breton history. He exhibited at the Salon annually from 1876 to 1880, and at the Expositions Universelles in 1878 and 1889.

Hovenden returned to the United States in 1880 and settled in the town of Plymouth Meeting, Pennsylvania, near Philadelphia, where his wife's family had a farm. Hovenden distinguished himself as a genre painter, transposing his earlier scenes of French peasant life to depictions of rural Americans. He succeeded Thomas Eakins as the head of instruction at the Pennsylvania Academy of the Fine Arts, where he taught from 1886 to 1888, and 1890 to 1891.

SOURCES: Terhune 1983; Edwards 1987; Terhune 1995

26 *Self Portrait of the Artist in his Studio,*
1875

Oil on canvas, 67.6 ¥ 44.8 cm (26⅝ ¥ 17⅝ in.)
Yale University Art Gallery, New Haven, Connecticut. Mabel Brady
Garvan and John H. Niemeyer Funds (1969.28)

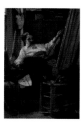

Cigarette in mouth, the painter focuses intently on the large canvas in front of him, his playing of the violin temporarily suspended. Palette and brushes, musical instrument, French novels on the shelves, all bear witness to the intellectual aspects of the Bohemian life in Paris, while the artist's dishevelled appearance proclaims its unconventionality. (See also pp. 16, 57.)

60 *In Hoc Signo Vinces (By this sign shalt thou
conquer),* 1880

Oil on canvas, 99.1 ¥ 137.2 cm (39 ¥ 54 in.)
The Detroit Institute of Arts, Michigan. Gift of Mr and
Mrs Harold O. Love (72.249)

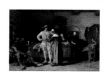

In Hoc Signo Vinces was exhibited at the 1880 Salon as *Le dernier préparatif.* It was well received by French critics, but reviews in the United States were mixed when the canvas was shown at the National Academy of Design in New York in 1881 as *Hoc Signo Vinces (La Vendée, 1793).* Some praised it, but others condemned Hovenden's choice of a subject from French history, recommending that the painter turn his attention to more innovative and American subjects. (See also pp. 120–6.)
SHOWN IN BOSTON AND NEW YORK ONLY

William Morris Hunt

1824, Brattleboro, Vermont – 1879, Appledore,
Isles of Shoals, New Hampshire

After studying art during his years at Harvard College, Hunt made his first trip to Europe in 1843 with his family. He travelled to Düsseldorf in 1845 and, after nine months of art instruction there, made his way to Paris in 1846. Intending to study sculpture, Hunt turned to painting after seeing the work of Thomas Couture. He became Couture's favourite pupil, working with him from 1847 to 1852. Hunt became friendly with Jean-François Millet and moved to Barbizon in 1852 to work more closely with the French artist, whose heroic rural subjects and broad paint handling strongly influenced Hunt's own style.

Returning to New England in 1855, Hunt married a member of Boston's high society and became a leading figure in the city's cultural circles. He not only taught art, beginning a class for women students in 1868, but was also a collector, and he was instrumental in introducing modern French painting, particularly works by Millet, to Boston. (For Hunt's importance as an adviser to Boston collectors, see pp. 208–11.) During the 1860s he was the city's leading artist, painting portraits and figure studies and inspiring numerous students to further their instruction in France. Hunt returned to Europe in 1866, visiting Millet in Barbizon and attending the 1867 Exposition Universelle in Paris.
SOURCES: Knowlton 1899; Hoppin and Adams 1979;
Webster 1991

99 *Self Portrait,* 1866

Oil on canvas, 77.2 ¥ 64.8 cm (30⅜ ¥ 25½ in.)
Museum of Fine Arts, Boston, Massachusetts. Warren Collection,
William Wilkins Warren Fund (97.63)

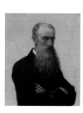

Hunt's mastery of contemporary French techniques is revealed in this bold self portrait. He set himself before a creamy yellow background, favouring a device popularised by his former teacher Couture instead of employing the dark backdrops more commonly used by American painters. He also followed Couture's technique of applying pigment vigorously and directly on the canvas. Hunt posed himself dramatically and powerfully alone, without any of the attributes of profession or social status that were characteristic of more traditional portraits. His long beard was an eccentricity unfashionable in Boston at the time, but indicative of his Bohemian status.

Hermann Dudley Murphy

1867, Marblehead, Massachusetts – 1945, Lexington, Massachusetts

After studying in Boston at the School of the Museum of Fine Arts, Murphy travelled to Nicaragua in 1888 as a member of the canal survey expedition. He returned to Boston and worked as an illustrator; his earliest known drawings are copies after Whistler for reproduction in *American Art Illustrated*. In 1891 Murphy began five years of study at the Académie Julian and matriculated for one semester in the Ecole des Beaux-Arts. Nonetheless, Whistler remained the primary influence on his art. Murphy showed portraits at the 1895 and 1896 Salons of the Société Nationale des Beaux-Arts. He returned to the United States in 1897, and settled in Winchester, Massachusetts.
SOURCES: Morrell 1899; Coles 1982; Murphy 1985

13 *Henry Ossawa Tanner*, about 1896

Oil on canvas, 73 × 50.2 cm (28¾ × 19¾ in.)
The Art Institute of Chicago, Illinois. Friends of American Art Collection (1924.37)

Beginning in 1891, Murphy and Tanner studied together at the Académie Julian and shared quarters on the boulevard St-Jacques. Murphy exhibited this portrait at the Salon of the Société Nationale des Beaux-Arts in 1896, the same year that Tanner's *Daniel in the Lion's Den* (1895; location unknown) won honourable mention at the Salon des Artistes Français. Widely shown in the United States during the following decade, the portrait won a silver medal in 1904 at the Louisiana Purchase Exposition in St Louis. (See also p. 30.)

Elizabeth Nourse

1859, Mt Healthy, Ohio – 1938, Paris

Nourse began her art studies at the age of 15 in Cincinnati, completing eight years of training there and in New York before she moved to Paris in 1887. She settled in the Latin Quarter and enrolled at the Académie Julian. After only three months, her teachers told her that she should work independently. Nourse favoured images of women and children, often in domestic settings. A devout Catholic dedicated to charitable service, Nourse recorded the humble people and rural communities she visited during the summers, making sketches to be transformed during winters in Paris into more tightly composed paintings for exhibition.

She displayed her paintings at the Salon in 1888 (cat. 39) and 1889. In 1890 she was invited to exhibit with the Société National des Beaux-Arts, to which she sent paintings annually. During the 1890s she began to use brighter colours and a bolder technique, although the paintings she intended for exhibition are often more subdued.

Nourse showed her works widely and successfully, winning medals at the 1893 World's Columbian Exposition in Chicago, the 1900 Exposition Universelle in Paris and other exhibitions. With no allowance from her family and no regular patrons, Nourse worked hard to support herself and her sister Louise, her constant companion and business manager. Although she returned to the United States only once after settling in Paris, she maintained strong contacts with friends and family in Cincinnati, where there was a steady market for her paintings.
SOURCES: Nourse Papers; M. A. H. Burke 1983

39 *La mère (Mother and Child)*, 1888

Oil on canvas, 116.6 × 81.4 cm (45½ × 32 in.)
Cincinnati Art Museum, Ohio. Gift of the Procter & Gamble
Company (2003.93)

Nourse made her debut at the Paris Salon in 1888 with *La mère*, for which she had solicited advice from Carolus-Duran. The rich, dark palette suggests his influence, although her technique is more academic. Nourse concentrated on the bond between mother and child, illuminating the points at which they connect: psychologically, with the mother's gaze, and physically, at her arms, lap and chest.

La mère was hung 'on the line' at the Salon, the prime level reserved for the jury's favourite entries. Nourse sent the canvas to exhibitions in London, Liverpool and Glasgow in the early 1890s. It was included in retrospectives of her work at the Cincinnati Art Museum in 1893 and in Washington, D.C., in 1894. (See also pp. 40, 126.)

Charles Sprague Pearce

1851, Boston, Massachusetts – 1914, Paris

Pearce worked in his father's mercantile office before he began painting in 1872. Although he had planned to study in Munich, he took the advice of his friend William Morris Hunt and went to Paris instead, entering the independent atelier of Léon Joseph Florentin Bonnat in 1873. Poor health soon forced Pearce to make the first of many winter trips south with fellow art students. In 1873 he travelled along the Nile for four months with Frederick A. Bridgman, and in 1874 he visited Algiers with William Sartain. On his return to Paris, Pearce's weakened condition forced him to take a private studio, where Bonnat frequently visited to criticise and aid his progress. For the next several years Pearce travelled to the Mediterranean during the winters and painted in his studio in the summers. In 1876 he made his debut at the Salon, where he exhibited portraits, religious subjects and occasional oriental genre scenes regularly until 1900. He was awarded honourable mention in 1881 and a third-class medal in 1883.

In 1884 Pearce purchased a farm in Auvers-sur-Oise, where he lived for the next three decades painting interpretations of rural life in the manner of Jules Bastien-Lepage and Jules Breton. At Auvers he had a glass-enclosed outdoor studio, where he could work under all weather conditions.

SOURCES: Sheldon 1888–90; Lublin 1993; Thompson 1993

63 *The Arab Jeweler*, 1882

Oil on canvas, 116.8 × 89.9 cm (46 × 35⅜ in.)
The Metropolitan Museum of Art, New York. Gift of
Edward D. Adams, 1922 (22.69)

Pearce's *Arab Jeweler* was inspired by his travels to North Africa and the Near East and by the French fashion for exotic subjects. Recalling the style and compositional format preferred by Bonnat, the picture is also an exotic counterpart of the craftsman themes popular in American art during the 1880s and 1890s. Exhibited at the 1882 Salon, the painting was illustrated in one of the Salon's *éditions de luxe* and described as a souvenir 'above all painted for those who knew Egypt'.

SHOWN IN NEW YORK ONLY

21 *Fantasie*, about 1883

Oil on canvas, 105.7 × 76.2 cm (41⅝ × 30 in.)
Courtesy of the Pennsylvania Academy of the Fine Arts,
Philadelphia. Gift of Joseph E. Temple (1884.1.2)

Pearce depicts a European man posing in the manner of a young Japanese *daimyo*, or feudal lord, in one of a series of *japonaiseries* that show Japanese motifs in a Western style. That this young man wears a traditional woman's garment has provoked scholarly debate; some argue that it was merely a device to attract attention while others describe it as a witty comment on contemporary fashions. The painting was acclaimed at the Pennsylvania Academy's 1883 annual exhibition, from which the Academy purchased it. (See also p. 44.)

64 *Reading by the Shore*, about 1883–5

Oil on canvas, 30.2 × 46 cm (11⅞ × 18⅛ in.)
Manoogian Collection

This painting combines acute realism in the treatment of the rocks, distant cliff and pebbles on the sand, with a strong element of fantasy in the figure of the elegant reclining woman, shaded by a splendid Japanese parasol, interrupted from her reading. The contrast between her fashionable dress and the rocky isolated beach is striking. The picture's small scale, intimate subject, high-key palette and loose brushwork depart significantly from the large, narrative and academic works that the artist regularly submitted to the Paris Salon. (See also p. 129.)

8 *Paul Wayland Bartlett*, about 1890

Oil on canvas, 108.6 × 76.2 cm (42¾ × 30 in.)
National Portrait Gallery, Smithsonian Institution. Gift of Caroline Peter (Mrs Armistead Peter III), 1958 (NPG.65.20)

The sculptor Paul Wayland Bartlett, like Pearce, spent most of his life abroad. Born in New Haven, Connecticut, the son of neoclassical sculptor and art critic Truman H. Bartlett, Paul moved to Paris with his family at the age of nine. He studied sculpture at the Jardin des Plantes under Emmanuel Frémiet, at the Ecole des Beaux-Arts and later with Rodin. He made his debut at the Paris Salon in 1880 at the age of 15. By 1895 he had been named Chevalier of the Légion d'honneur. Pearce's elegant portrait of Bartlett was exhibited at the 1892 Salon. (See also p. 19.)

Maurice Brazil Prendergast

1858, St. John's, Newfoundland – 1924, New York

Prendergast began his career as an illustrator in Boston, turning to painting in 1891 when he travelled to Paris with his brother Charles, himself a gifted craftsman and artist. For two years he studied at the Académie Colarossi and the Académie Julian, and sketched in the city's cafés and along its boulevards. He travelled to Dieppe and St-Malo and made monotypes, water-colours and small oil paintings of elegantly dressed women and playful children. He was particularly influenced by the work of Edouard Vuillard and Pierre Bonnard.

Prendergast returned to Massachusetts in 1895 and found a ready market for his charming scenes of urban leisure. He went back to Europe in 1898, spent a year in Venice, and in 1907 returned to Paris, where he began to use more intense colours and patterned forms. In 1914, Prendergast moved from Boston to New York, where he found a more receptive audience for his increasingly avant-garde work.

SOURCES: Clark 1990; Mathews 1990; Wattenmaker 1994

2 *The Luxembourg Garden, Paris,* 1892–4

Oil on canvas, 32.7 × 24.4 cm (12⅞ × 9⅝ in.)
Terra Foundation for American Art, Chicago, Illinois. Daniel J. Terra Collection (1992.68)

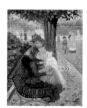

Prendergast was interested in decorative pattern as well as colour, and here he contrasted a variety of designs, including the slats of the bench, the leaves of the large central tree and the vertical lines of the foliage in the far distance at right.

55 *Sketches in Paris,* about 1892–4

Seven oil on wood panels, each panel 17.1 × 9.5 cm (6¼ × 3¾ in.)
Addison Gallery of American Art, Phillips Academy, Andover, Massachusetts (1939.2)

These diminutive images, with their bright, expressive colours, focus on surface pattern and design rather than upon precise detail. Prendergast never intended to display his quickly composed exercises to the public, but his brother Charles, who acquired these examples upon the artist's death in 1924, framed them together for a 1933 gallery exhibition in New York.

Theodore Robinson

1852, Irasburg, Vermont – 1896, New York

Robinson first studied at Chicago's Academy of Design in 1869/70 and 1873, and at New York's National Academy of Design in 1874. He went to Paris in 1875, working briefly in Henri Lehmann's atelier in the Ecole des Beaux-Arts and matriculating in the school in 1875–6. In 1876 he left Lehmann to work in Carolus-Duran's independent studio. Robinson toured France in the summer, and from 1876 to 1878 studied at the Ecole with Gérôme, matriculating again in the school in 1877 and 1878. In 1877 his first work was accepted into the Salon, where he would show five times more, until 1890. Robinson spent the summer of 1877 in Grez-sur-Loing. In the autumn of 1878 he toured Italy, possibly meeting Whistler in Venice. He visited Grez again in 1879 before sailing to New York.

Robinson spent about half of each year in France between 1884 and 1892. He probably first visited Giverny in 1885 with the painter Ferdinand Deconchy, who introduced him to Claude Monet. He returned to Giverny for a lengthy stay in 1887, spent the summer of 1888 there and from 1889 to 1892, lived in Giverny for about half the year, usually at the Hôtel Baudy. He became friendly with Monet and started making Impressionist paintings.

Robinson moved to New York in December 1892. He frequently travelled to the countryside to paint landscapes, visiting John H. Twachtman in Greenwich, Connecticut, in 1893 and teaching summer classes in Napanoch, New York. In 1894 he visited Branchville, Cos Cob and Greenwich in Connecticut, as well as Brielle, New Jersey, and taught summer painting classes in Princeton, New Jersey. He spent the summer of 1895 in his native Vermont and died in New York the following spring.
SOURCES: Baur 1946; Johnston 1973; Johnston 2004

75 A Bird's-Eye View, 1889

Oil on canvas, 65.4 × 81.3 cm (25¾ × 32 in.)
The Metropolitan Museum of Art, New York. Gift of George A. Hearn, 1910 (10.64.9)

This image of the village of Giverny from the surrounding hills was first shown at the 1890 Society of American Artists exhibition in New York, where it was described as 'flat and chalky' and criticised for its Impressionist technique (*The Nation*, 8 May 1890, p. 382). It remained in the artist's possession until his death, and was sold at his estate sale. By 1908 it was in the collection of noted American art patron George A. Hearn, who gave it to The Metropolitan Museum of Art in 1910. (See also pp. 142, 145.)

76 The Wedding March, 1892

Oil on canvas, 56.7 × 67.3 cm (22⅜ × 26½ in.)
Terra Foundation for American Art, Chicago, Illinois. Daniel J. Terra Collection (1999.127)

On 20 July 1892 American painter Theodore Butler married Claude Monet's stepdaughter, Suzanne Hoschedé, at Giverny. Robinson depicts the march from the *mairie* (the town hall, in the upper right corner), where the civil ceremony was performed, to the church where the religious vows would take place. Although Robinson noted in his diary: 'The wedding party in full dress – ceremony first at the *mairie* – then at the church. Monet entering first with Suzanne, then Butler and Mme. Hoschedé' (quoted in Johnston 1973, p. 42), the identities of the figures in the procession are unclear, apart from that of the bride. (See also p. 145.)

77 *La Débâcle*, 1892

Oil on canvas, 45.7 × 55.9 cm (18 × 22 in.)
Scripps College, Claremont, California. Gift of General and Mrs
Edward Clinton Young, 1946 (Yo52)

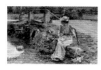 Robinson's favourite model, known only as Marie, holds Zola's latest novel, *La Débâcle*, about the Franco-Prussian war. Serialised in *La Vie populaire* and published by Charpentier et Fasquelle on 21 June 1892, this book quickly became Zola's greatest commercial success. Robinson noted in his diary that Monet, on visiting his studio on 15 September 1892, found this painting 'amusing'. (See also p. 145.)

87 *Port Ben, Delaware and Hudson Canal*, 1893

Oil on canvas, 71.8 × 81.9 cm (28¼ × 32¼ in.)
Courtesy of the Pennsylvania Academy of the Fine Arts,
Philadelphia. Gift of the Society of American Artists as a memorial
to Theodore Robinson (1900.5)

 After returning to the United States, Robinson continued to paint landscapes that echoed his Giverny works. This waterway in upstate New York provided him with an unassuming subject to explore, allowing him to emphasise geometric form and the harsh quality of the American light. After the painting appeared in the 1900 Exposition Universelle, the Society of American Artists presented it to the Pennsylvania Academy in Robinson's memory. *Port Ben* had previously been offered to The Metropolitan Museum of Art but had been rejected. The director of the Pennsylvania Academy, Harrison Morris, recounted in his memoirs that The Metropolitan 'had not grown up yet to the lure of Impressionist painting; they held it, like even lesser critics, under suspicion' (Morris 1930, p. 174). (See also pp. 160–2.)

88 *Low Tide*, 1894

Oil on canvas, 40.6 × 56.5 cm (16 × 22¼ in.)
Private collection

 From the west side of Cos Cob harbour, Robinson painted the mudflats that make up more than half the width of the Mianus river at low tide. He could have been describing *Low Tide* when he recorded a scene in his diary on 9 June: 'Pretty view of Coscob from the RR bridge – low tide – the river making a serpentine wind, a schooner, and the boat-yards, etc. behind. Charming, misty sunlight' (quoted in Larkin 1996 p. 120). (See also p. 162.)

John Singer Sargent

1856, Florence – 1925, London

Born to expatriate American parents, Sargent travelled throughout Europe as a child. After briefly studying art in Florence, he moved with his family to Paris in 1874 and entered the atelier of Carolus-Duran. Sargent's portraits and genre scenes reflect these early influences. Although Sargent developed connections with the avant-garde, he also cultivated the official establishment, matriculating at the Ecole des Beaux-Arts for three semesters between 1874 and 1877 and exhibiting regularly at the Salon between 1877 and 1888.

By the early 1880s, Sargent had integrated himself into French society, befriending painters, writers and musicians. Through these connections, he received portrait commissions from notable Parisians, knew Rodin well and developed a mutually influential artistic relationship with Monet. Sargent moved to England in 1886 where he remained for the rest of his life, achieving great success as a portraitist. However, he maintained friendships with many Parisian residents and painted a number of French portraits. He exhibited widely, showing with such organisations as the Société Internationale des Peintres et Sculpteurs and the Société Nationale des Beaux-Arts in Paris; the Royal Academy in London; the Salon des XX in Brussels; and the Society of American Artists in New York. Although he moved effortlessly in European social and professional circles, he strove to maintain his American identity, painting portraits of fellow Americans, promoting his work in the United States and exhibiting in the American sections of international expositions (including the Expositions Universelles in 1878, 1889 and 1900).

SOURCES: Simpson 1997; Kilmurray and Ormond 1998a; Ormond and Kilmurray 1998–2003

62 *Fishing for Oysters at Cancale*, 1878

Oil on canvas, 41 × 61 cm (16⅛ × 24 in.)
Museum of Fine Arts, Boston, Massachusetts. Gift of Miss Mary Appleton (35.708)

Sargent was attracted by Cancale's dramatic location on the bay of Mont St-Michel, and by the picturesque qualities of the oyster beds at low tide, when women and girls could be seen hard at work. *Fishing for Oysters at Cancale*, the first painting Sargent exhibited in the United States (at the Society of American Artists, New York, in April 1878), received rave reviews from the American press and was sold immediately to the American artist Samuel Colman. A larger version was shown at the Salon in 1878 (Corcoran Gallery of Art, Washington, D.C.). (See also p. 126.)

42 *In the Luxembourg Gardens*, 1879

Oil on canvas, 65.7 × 92.4 cm (25⅞ × 36⅜ in.)
Philadelphia Museum of Art, Pennsylvania. The John G. Johnson Collection 1917 (cat.1080)

The Luxembourg Gardens in Paris's Latin Quarter were depicted by many of the artists who had their studios in the vicinity, including Sargent, who worked on the nearby rue Notre Dame des Champs. Sargent exhibited his romantic twilight view, one of two versions he painted, at the National Academy of Design, New York, in 1879. (See also p. 93.)

11 *Portrait of Carolus-Duran*, 1879

Oil on canvas, 116.8 × 96.2 cm (46 × 37¾ in.)
Sterling and Francine Clark Art Institute, Williamstown,
Massachusetts. Acquired by Sterling and Francine Clark

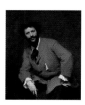

Carolus-Duran so admired Sargent's
work as his assistant for his murals
at the Palais du Luxembourg that
he invited his star pupil to paint his
portrait. Sargent finished the canvas
early in 1879, just in time to send it
as his third submission to the Salon,
where it earned extensive praise
for its deft characterisation of a popular personality.
Sargent exhibited the painting in New York and Boston
in 1880, in London in 1882 and at the Ecole des Beaux-
Arts, Paris, in 1883. Carolus-Duran kept the picture
throughout his life. (See also pp. 28–30.)
SHOWN IN LONDON AND NEW YORK ONLY

47 *Rehearsal of the Pasdeloup Orchestra at the Cirque d'Hiver*, about 1879–80

Oil on canvas, 57.2 × 46.1 cm (22½ × 18⅛ in.)
Museum of Fine Arts, Boston, Massachusetts. The Hayden
Collection – Charles Henry Hayden Fund (22.598)

Conductor Jules Etienne Pasdeloup
held 'Concerts Populaires' on
Sunday afternoons in winter between
1861 and 1887 at the Cirque
d'Hiver. His programme, which
included such contemporary
composers as Wagner and Fauré,
attracted many Parisian artists. Sargent, a gifted
musician, attended regularly. His painter friend William
Coffin recalled that 'Sargent . . . was struck by the odd
picturesqueness of the orchestra at Pasdeloup's, seen in
the middle of the amphitheater, the musicians' figures
foreshortened from the high point of view on the rising
benches' (*Century Magazine*, 1896, p. 172). Scholars
have thought that he made this version, one of two, for
fellow American artist Henry Bacon, who owned it and
reproduced it in his 1883 book, *Parisian Art and
Artists*. It was included in Sargent's 1899 exhibition in
Boston. (See also p. 98.)

33 *The Daughters of Edward Darley Boit*, 1882

Oil on canvas, 221.9 × 222.6 cm (87⅜ × 87⅝ in.)
Museum of Fine Arts, Boston, Massachusetts. Gift of Mary Louisa
Boit, Julia Overing Boit, Jane Hubbard Boit and Florence D. Boit
in memory of their father, Edward Darley Boit (19.124)

In his portrait of the four
daughters of American expatriate
artist Edward Boit and his first
wife, Mary Louisa Cushing,
Sargent created an unconventional
composition influenced by
Velázquez's *Las Meninas* (1656),
which he had recently copied at the Prado. The girls are,
from left to right, Mary Louisa, Florence, Jane and
Julia. Sargent exhibited the portrait at the Galerie
Georges Petit at the end of 1882, and then at the 1883
Salon. It met with mixed reviews in Paris, where it was
criticised for its oddness, but it was championed by
Henry James, who praised 'the naturalness of the
composition, the loveliness of the complete effect, the
light, free security of the execution, the sense it gives us
as of assimilated secrets and instinct and knowledge'
(James 1887). Sargent sent the painting to Boston in
1888 and to the Paris Exposition Universelle in 1889.
The Boits owned the painting until 1919, when the
four sisters gave it to the Museum of Fine Arts, Boston.
(See also pp. 74–6.)

32 *Mrs Henry White (Margaret Stuyvesant Rutherfurd)*, 1883

Oil on canvas, 221 × 139.7 cm (87 × 55 in.)
Corcoran Gallery of Art, Washington, D.C. Gift of John
Campbell White (49.4)

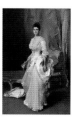

Following Sargent's success at the
Salon of 1882, Margaret (Daisy)
Stuyvesant Rutherfurd White
commissioned him to paint her
portrait. Mrs White, daughter of a
well-known New York astronomer
and wife of an American diplomat,
was a prominent member of the
American community in Paris. This
was Sargent's first important commission outside his
own circle of family, friends and colleagues. Unable
to complete the painting by the deadline for the 1883
Salon, Sargent exhibited it at the Royal Academy in
London in 1884, the year Henry White was appointed
Secretary to the American legation there. The painting
secured Sargent's reputation in England and America.
He borrowed it from Mrs White to show it in Paris at
the Galerie Georges Petit (1885) and the 1889
Exposition Universelle. The portrait remained in the
possession of the White family until 1949, when
Mr and Mrs White's son gave it to the Corcoran.
(See also pp. 76–9.)

35 *Madame X (Madame Pierre Gautreau),*
1883–4

Oil on canvas, 208.6 ¥ 109.9 cm (82⅛ ¥ 43¼ in.)
The Metropolitan Museum of Art, New York. Arthur Hoppock
Hearn Fund, 1916 (16.53)

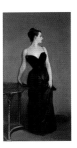

Born in Louisiana in 1859, Virginie
Avegno became a celebrated beauty.
Her father, Major Anatole Placido
Avegno, died in the Civil War in April
1862, and her mother left the United
States to raise her two daughters in
Paris. In 1881 Virginie married Pierre
Gautreau, a wealthy banker. Sargent
met Mme Gautreau late in 1882,
became obsessed with her appearance
and persuaded her to let him paint her portrait. Sittings
began in Paris in the winter of 1882–3 and continued
the following summer at the Gautreaus' summer home
on the Breton coast. When Sargent showed the portrait
at the 1884 Salon, it created a
scandal that effectively marked the conclusion of his
Parisian career. The painting remained in Sargent's
possession until he sold it to The Metropolitan Museum
of Art in 1916, calling it 'the best thing I have done' and
asking the museum not to identify the sitter, who came
to be known as *Madame X*. (See also pp. 42, 76–80.)

71 *Claude Monet painting by the*
Edge of a Wood, 1885

Oil on canvas, 54 ¥ 64.8 cm (21¼ ¥ 25½ in.)
Tate, London. Presented by Miss Emily Sargent and Mrs Ormond
through the National Art Collections Fund 1925 (No4103)

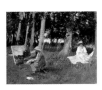

Sargent may have met Monet in
Paris as early as 1876 and the two
artists remained lifelong friends,
even after Sargent had moved to
London. During the mid 1880s,
particularly after his portrait
commissions diminished in
the wake of the exhibition of *Madame X*, Sargent
experimented with Impressionism and painted with
Monet at Giverny. Sargent also bought four paintings
by Monet between 1887 and 1891 and he encouraged
an interest in French Impressionism among American
painters and patrons. Sargent kept this canvas for his
own collection, including it in an 1899 exhibition of
his work in Boston. (See also p. 140.)

Julius LeBlanc Stewart

1855, Philadelphia – 1919, Paris

The son of a wealthy sugar-plantation owner, Stewart
moved to Paris with his parents at the age of 10 and
remained there for the rest of his life. His father
collected contemporary art, particularly works by
Mariano Fortuny, and socialised with a group that
included artists Giovanni Boldini, Léon Joseph Florentin
Bonnat and Jean-Léon Gérôme. Stewart's paintings
combine portraiture and genre on an ambitious scale,
often depicting members of his elite circle of friends at
fashionable Parisian social events. He also made
portraits and, starting in the mid 1890s, plein-air
landscapes and nudes, and enjoyed a reputation as a
'Parisian from Philadelphia'.

Stewart first exhibited at the Salon in 1878 and
displayed works in numerous international exhibitions
through the 1880s and 1890s, including the Expositions
Universelles of 1889 and 1900. He was a leading figure
in the expatriate community, maintaining ties with the
United States by sending paintings to the annual exhibi-
tions of the Pennsylvania Academy of the Fine Arts.
SOURCES: Joyner 1982; Thompson 1986; Hiesinger
1998

31 *Woman in an Interior,* 1895

Oil on canvas, 91.4 ¥ 64.8 cm (36 ¥ 25½ in.)
Private collection

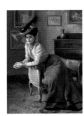

This charming portrayal of a
stylish young woman indicates how
thoroughly Stewart had assimilated
the naturalism of such popular artists
as Jean Béraud and Jean-Jacques
Tissot. The relaxed pose of the figure,
who twists in the chair and gazes
directly at the viewer, the firmness
of her mouth and the confidence of
her expression suggest that she is a 'New Woman'.

Stewart's elegant portraits of fashionable women in
luxurious interiors brought him great success. His
portraits of such renowned beauties as Lillie Langtry,
Sarah Bernhardt and the Vicomtesse de Gouy d'Arcy
prompted the American commissioner of fine arts for
the 1889 Exposition Universelle to declare: 'he is a
painter of thoroughly chic portraits of women, and . . .
always produces genteel results. He never paints a
woman who appears to be of lower rank than that of
baroness, and all his young girls look like daughters
of duchesses' (quoted in Thompson 1986, p. 1047).

Henry Ossawa Tanner

1859, Pittsburgh, Pennsylvania – 1937, Paris

The son of an African Methodist Episcopal bishop, Tanner studied intermittently from 1879 to 1885 with Thomas Eakins at the Pennsylvania Academy of the Fine Arts. In 1889 he settled in Atlanta, Georgia, where he opened a photography gallery and taught drawing at Clark University. In 1891 he left for a study trip to Rome via London and Paris. Enchanted by Paris, he remained there for the rest of his life. Tanner studied at the Académie Julian, with Jean-Joseph Benjamin-Constant and Jean-Paul Laurens, from 1891 to 1892, and with William Adolphe Bouguereau and Tony Robert-Fleury by 1897. In 1891 he joined the American Art Association of Paris. There he met American businessman Rodman Wanamaker, who became an important patron.

Tanner exhibited at the Salon des Artistes Français annually from 1894 to 1914. He received honourable mention in 1896 and a third-class medal in 1897 for the *Resurrection of Lazarus* (fig. 11). He soon began to specialise in biblical scenes and toured Palestine and Egypt in 1897 and 1898 to study the terrain and people. He travelled extensively in Europe, the Near East, and North Africa; spent some summers in art colonies in Brittany, including Pont-Aven (in 1891) and Concarneau (in 1892); and may have returned to Brittany in 1893 and 1894. About 1900 he adopted a more evocative, painterly approach inspired by the Symbolists and by Whistler. Tanner joined artists' associations in both France and America and exhibited frequently in both countries; he also made occasional visits to the United States.

SOURCES: Mathews 1969; Mosby 1991; Mosby 1995

61 *The Young Sabot Maker*, 1895

Oil on canvas, 104.1 × 88.9 cm (41 × 35 in.)
The Nelson-Atkins Museum of Art, Kansas City, Missouri
Purchase, The George O. and Elizabeth O. Davis Fund and partial gift of an anonymous donor (95-22)

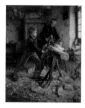

This painting of Breton subjects explores the relationship between youth and experience, a theme Tanner pursued in several major paintings from the 1890s. Like his compatriot Elizabeth Nourse, Tanner infused humble scenes of daily labour with religious significance: here the young man making typically Breton wooden shoes also evokes the idea of Christ in Joseph's carpenter's shop.

Tanner made several studies for this composition and his deliberate and careful process reflects his academic training in Philadelphia and Paris. *The Young Sabot Maker* was exhibited at the 1895 Salon as *Le jeune sabotier*. The picture remained in the artist's collection and descended in his family until 1995, when it was sold to the Nelson-Atkins Museum.

52 *Les Invalides, Paris*, 1896

Oil on canvas, 33.3 × 41.3 cm (13 × 16¼ in.)
Terra Foundation for American Art, Chicago, Illinois. Daniel J. Terra Collection (1999.140)

Les Invalides, a building complex in the 7th arrondissement, originally functioned as a home and hospital for soldiers. In 1861 Napoleon's remains were buried beneath the dome. By 1896, several members of Napoleon's family and a number of his military officers were also buried there, making Les Invalides an important mausoleum and popular tourist attraction. *Les Invalides, Paris* is one of several informal views Tanner made of his adopted city. In it he seemed to delight in the contrast between the grand architecture and the quintessentially French poodle dancing in the foreground. Never exhibited in the artist's lifetime, this picture probably remained in Tanner's possession until his death.

Edmund Charles Tarbell

1862, West Groton, Massachusetts – 1938, New Castle, New Hampshire

Tarbell studied from 1879 to 1883 at the School of the Museum of Fine Arts, Boston, where he met fellow student Frank Benson. In 1883 Tarbell travelled to Paris and enrolled for three years at the Académie Julian. He visited Germany and, partly to avoid an outbreak of cholera in Paris, spent a winter in Venice with Abbott Graves (see cat. 1). He returned to Boston in 1888 and became one of the city's most influential painters.

Tarbell taught at the School of the Museum of Fine Arts, Boston from 1889 to 1913 and earned a national reputation as an artist. During the 1890s, he produced such ambitious plein-air subjects as *Three Sisters – A Study in June Sunlight* (cat. 92), demonstrating his characteristic combination of academic draughtsmanship and Impressionism's broken brushwork and bright colours. Along with Benson, Tarbell was a founding member of Ten American Painters in 1897 and had his first one-man show at the St Botolph Club in Boston in 1898. By about 1900, his style and subject matter began to change, and he concentrated on subdued paintings of women in interiors (see cat. 25).

SOURCES: Coburn 1907; Buckley 2001; Strickler 2001

92 *Three Sisters – A Study in June Sunlight*, 1890

Oil on canvas, 89.2 × 102.2 cm (35⅛ × 40⅛ in.)
Milwaukee Art Museum, Wisconsin. Gift of Mrs J. Montgomery Sears (M1925.1)

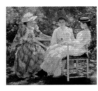

Tarbell posed his wife Emeline, her sisters and his baby daughter in a New England garden setting for this, his first important work in the Impressionist style. Such plein-air compositions allowed Tarbell to experiment with the effects of natural light and to celebrate and chronicle his family life. *Three Sisters* met with praise when it was first exhibited in Boston in 1891. Tarbell's paintings particularly appealed to Boston collectors, who were among the first Americans to purchase French Impressionist paintings. Sarah Choate Sears, who also owned works by Bunker, Sargent, Cassatt, Manet and Monet, purchased *Three Sisters* shortly after it was completed. (See also p. 168.)

25 *Across the Room*, about 1899

Oil on canvas, 63.5 × 76.5 cm (25 × 30⅛ in.)
The Metropolitan Museum of Art, New York. Bequest of Miss Adelaide Milton de Groot (1876–1967), 1967 (67.187.141)

Across the Room reflects the change in Tarbell's style and subject matter in the late 1890s. Working in the studio rather than outdoors, he investigated carefully controlled light effects, show-casing his skilful rendering of patterns, texture and design. Perhaps based on his admiration for Degas, he employed radically spare compositions, often cropping his subjects. Entitled *The White Dress* when it was first shown at the second annual exhibition of Ten American Painters at Durand-Ruel Galleries, New York, in 1899, this picture quickly became known as *Across the Room* in acknowledgement of its distinctive composition. It was also shown at the 1900 Exposition Universelle in Paris.

John Henry Twachtman

1853, Cincinnati, Ohio – 1902, Gloucester, Massachusetts

Twachtman's father, a German immigrant, was employed as a scene painter at a Cincinnati window-shade factory. About 1867 Twachtman joined him there while taking night classes in drawing at the Ohio Mechanics Institute. In 1871 he enrolled at the McMicken School of Design, where he studied with Munich-trained painter Frank Duveneck. Twachtman went to Europe in 1875 and studied for two years at the Royal Academy in Munich. Back in America, he enrolled intermittently at the Art Students League in New York from 1878 to 1880. In 1878 he was in Venice with Duveneck and William Merritt Chase. He returned to Cincinnati in 1879 to teach a women's art class and in 1880 he taught with Duveneck in Florence. Twachtman married painter Martha Scudder in 1881, then visited England, Belgium, Germany and Holland.

Twachtman was in Paris from 1883 to 1885. Determined to improve his drawing and lighten his Munich-inspired palette, he enrolled at the Académie Julian under Gustave Rodolphe Boulanger and Jules-Joseph Lefebvre. He spent the summers of 1884 and 1885 in the Normandy countryside and at Arques-la-Bataille, near Dieppe, painting tonal landscapes out-of-doors.

In 1889 Twachtman settled in Greenwich, Connecticut, there developing an American Impressionist style. Perhaps as early as 1890 he established summer painting classes in Cos Cob, Connecticut. In 1897 he helped found Ten American Painters. The next year he taught in Norwich, Connecticut, at the first summer school held by the Art Students League outside New York City. From 1900 to 1902 Twachtman led summer classes in Gloucester, Massachusetts.

SOURCES: Hale 1957; Boyle 1979; Peters 1999

67 *Arques-la-Bataille*, 1884

Oil on canvas, 46.4 × 65.7 cm (18¼ × 25⅞ in.)
The Metropolitan Museum of Art, New York. Purchase,
The Charles Engelhard Foundation Gift, 1991 (1991.130)

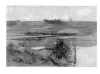

Twachtman painted this sketch in the small town of Arques-la-Bataille in Normandy, close to Dieppe. The medieval castle dominates the town, but Twachtman focuses entirely on the river, using a limited tonal palette of cool greens, greys and blues. The broad horizontal bands of colour that form the sky, landscape and river are enlivened only by the mass of vigorously brushed reeds in the foreground. This interest in design and contemplative appreciation of nature suggest the influence of Japanese prints. Twachtman's method of using a preliminary oil sketch such as this one as the basis for a larger, more finished work completed in the studio reflects the academic practices he learned at the Académie Julian. (See also p. 133.)

86 *Brook in Winter*, about 1892

Oil on canvas, 91.8 × 122.2 cm (36⅛ × 48⅛ in.)
Museum of Fine Arts, Boston, Massachusetts. The Hayden
Collection – Charles Henry Hayden Fund (07.7)

In 1889 Twachtman moved to a farm in Greenwich, Connecticut, where he worked out of doors in all seasons. Twachtman's winter landscapes were especially admired by critics and were commercially successful. He wrote to his friend Julian Alden Weir in 1891: 'We must have snow and lots of it. Never is nature more lovely than when it is snowing. Everything is so quiet and the whole earth seem [*sic*] wrapped in a mantle. That feeling of quiet and all nature is hushed to silence' (quoted in Chotner 1989, p. 53). *Brook in Winter* was exhibited at the 1893 World's Columbian Exposition in Chicago. With the encouragement of the artist's friends Thomas Wilmer Dewing and Julian Alden Weir, the Museum of Fine Arts, Boston, purchased it from the artist's estate in 1907. (See also p. 160.)

Baur 1946
J. I. H. Baur, *Theodore Robinson, 1852–1896*, exh. cat., Brooklyn Museum, New York 1946

Beaux 1930
C. Beaux, *Background with Figures: Autobiography of Cecilia Beaux*, Boston and New York 1930

Beckwith 1919
J. C. Beckwith, 'Confessions of Carroll Beckwith', ed. H. W. Stewart, *International Studio*, 66 (January 1919), pp. xc–xci.

Bedford 1989
F. A. Bedford, S. C. Faxon and B. W. Chambers, *Frank W. Benson: A Retrospective*, exh. cat., Berry-Hill Galleries, New York 1989

Bedford 1994
F. A. Bedford, *Frank W. Benson, American Impressionist*, New York 1994

Bedford 2000
F. A. Bedford et al., *The Art of Frank W. Benson: American Impressionist*, exh. cat., Peabody Essex Museum, Salem, Massachusetts 2000

Belbeoch 1993
H. Belbeoch, *Les Peintres de Concarneau*, Quimper 1993

Bermingham 1975
P. Bermingham, *American Art in the Barbizon Mood*, exh. cat., National Collection of Fine Arts, Smithsonian Institution, Washington, D.C. 1975

Bizardel 1960
Y. Bizardel, *American Painters in Paris*, trans. R. Howard, New York 1960

Blackburn 1880
H. Blackburn, *Breton Folk: An Artistic Tour in Brittany*, London 1880

Blanche 1938
J. E. Blanche, *Portraits of a Lifetime*, ed. and trans. W. Clement, New York 1938

Blaugrund 1989
A. Blaugrund et al., *Paris 1889: American Artists at the Universal Exposition*, exh. cat., Pennsylvania Academy of the Fine Arts, Philadelphia 1989

Boston Post 1891
'Some Remarkable Pictures at the St. Botolph and Other Galleries – Messrs. Tarbell and Benson's Work', *Boston Post* (9 March 1891), p. 4

Boucher 1921
American Footprints in Paris, compiled F. Boucher, ed. and trans. F. W. Huard, New York 1921

Boyle 1979
R. J. Boyle, *John Twachtman*, New York 1979

Boyle 2003
R. J. Boyle, B. W. Chambers and W. H. Gerdts, *Willard Metcalf (1858–1925), Yankee Impressionist*, exh. cat, Spanierman Gallery, New York 2003

Braddock 2004
A. C. Braddock, 'Painting the World's Christ: Tanner, Hybridity, and the Blood of the Holy Land', *Nineteenth-Century Art Worldwide*, 3 (autumn 2004), e-journal (www.19thc-artworldwide.org)

Braden 1988
D. R. Braden, *Leisure and Entertainment in America*, Dearborn, Michigan 1988

Breck 1899
Memorial Exhibition of Paintings by John Leslie Breck, exh. cat., St Botolph Club, Boston 1899; National Arts Club, New York 1900

Breeskin 1970
A. D. Breeskin, *Mary Cassatt: A Catalogue Raisonné of the Oils, Pastels, Watercolors, and Drawings*, Washington, D.C. 1970

Brettell and Brettell 1983
R. R. Brettell and C. B. Brettell, *Painters and Peasants in the Nineteenth Century*, Geneva 1983

Bridgman n.d.
F. A. Bridgman, *L'Anarchie dans l'art*, Paris n.d. [1898]

Bruce 2002
M. Bruce, *Henry Ossawa Tanner: A Spiritual Biography*, New York 2002

Buckley 2001
L. Buckley, *Edmund C. Tarbell: Poet of Domesticity*, New York 2001

Burke 1980
D. B. Burke, *American Paintings in the Metropolitan Museum of Art, Volume III, A Catalogue of Works by Artists born between 1846 and 1864*, ed. K. Luhrs, New York 1980

Burke 1983
D. B. Burke, *J. Alden Weir: An American Impressionist*, exh. cat., Metropolitan Museum of Art, New York 1983

M. A. H. Burke 1983
M. A. H. Burke, *Elizabeth Nourse, 1859–1938: A Salon Career*, exh. cat., National Museum of American Art, Smithsonian Institution, Washington, D.C. 1983

Burnside 1984
K. Burnside, 'James Carroll Beckwith (1852–1917): His French Training and His American Career', unpublished paper for a class taught by H. B. Weinberg on the subject of 'American Painting 1860–1900: The Impact of Foreign Training and Travel', Graduate School of the City University of New York 1984

Butler 1979
J. Butler and S. M. Vose, *Abbott Fuller Graves: 1859–1936*, exh. cat., Brick Store Museum, Kennebunk, Maine 1979

Caffin 1904–5
C. H. Caffin, 'John White Alexander', *The World's Work*, 9 (1904–5), pp. 5682–6

Carr 1993
C. K. Carr et al., *Revisiting the White City, American Art at the 1893 World's Fair*, exh. cat., National Museum of American Art and National Portrait Gallery, Smithsonian Institution, Washington, D.C. 1993

Cartwright 2001
D. Cartwright, J. Robinson and M. Smart, *Mary et Frederick MacMonnies: un atelier à Giverny*, exh. cat., Musée d'Art Américain Giverny 2001

Cassatt 1927
Memorial Exhibition of the Work of Mary Cassatt, exh. cat., Philadelphia Museum of Art 1927

Century Magazine 1881
'The American Student at the Beaux-Arts', *Century Magazine*, 23, no. 2 (December 1881), pp. 259–72

Chalfant 1959
Jefferson D. Chalfant, exh. cat., The Wilmington Society of the Fine Arts, Delaware 1959

Champney 1900
B. Champney, *Sixty Years' Memories of Art and Artists*, Woburn, Massachusetts 1900 (repr. New York 1977)

Charteris 1927
E. Charteris, *John Sargent*, New York 1927 (repr. New York 1972)

Chesebro 1981
A. Chesebro, *Ellen Day Hale*, exh. cat., Richard York Gallery, New York 1981

Chotner 1989
D. Chotner, L. N. Peters and K. A. Pyne, *John Twachtman: Connecticut Landscapes*, exh. cat., National Gallery of Art, Washington, D.C. 1989

Cikovsky 1990
Winslow Homer: A Symposium, ed. N. Cikovsky, Jr., *Studies in the History of Art*, 26, Washington, D.C. 1990

Cikovsky and Kelly 1995
N. Cikovsky, Jr. and F. Kelly, *Winslow Homer*, exh. cat., National Gallery of Art, Washington, D.C. 1995

Clark 1924
E. Clark, *John H. Twachtman*, New York 1924

Clark 1979
E. C. Clark, *Theodore Robinson: His Life and Art*, exh. cat., R. H. Love Galleries, Chicago 1979

Clark 1990
C. Clark, N. M. Matthews and G. Owens, *Maurice Brazil Prendergast and Charles Prendergast: A Catalogue Raisonné*, Munich and Williamstown, Massachusetts 1990

Clarke 1900
E. Clarke, 'Alien Element in American Art', *Brush and Pencil*, 7 (October 1900), p. 36

Clayson 2002
H. Clayson, *Paris in Despair: Art and Everyday Life under Siege (1870–71)*, Chicago 2002

Coburn 1907
F. Coburn, 'Edmund C. Tarbell', *International Studio*, 32 (September 1907), pp. lxxiv–lxxxvii

Cochran 1931
J. W. Cochran, *Friendly Adventures: A Chronicle of the American Church of Paris*, Paris 1931

Cohen-Solal 2001
A. Cohen-Solal, *Painting American: The Rise of American Art, Paris 1867 – New York 1948*, trans. with L. Hurwitz-Attias, New York 2001

Cole 1976
A. P. Cole, 'An Adolescent in Paris: The Adventure of Being an Art Student Abroad in the Late Nineteenth Century', *American Art Journal*, 8 (November 1976), pp. 111–15

Coles 1982
W. Coles, *Hermann Dudley Murphy (1867–1945)*, exh. cat., Graham Gallery, New York 1982

Cook 1895
C. Cook, 'A Representative American Artist', *Monthly Illustrator*, 11 (November 1895), pp. 289–92

Corbin 1988
K. Corbin, 'John Leslie Breck, American Impressionist', *Antiques*, 134 (November 1988), pp. 1142–9

Crouch and Lübbren 2003
Visual Culture and Tourism, eds D. Crouch and N. Lübbren, Oxford and New York 2003

Cummings 1991
H. Cummings, H. K. Fusscas and S. G. Larkin, *J. Alden Weir: A Place of His Own*, exh. cat., William Benton Museum of Art, University of Connecticut, Storrs 1991

Curry 1990
D. P. Curry, *Childe Hassam: An Island Garden Revisited*, exh. cat., Denver and New York 1990

D. W. X. 1893
D. W. X., 'Mr. John L. Breck's Landscapes', *Boston Daily Globe* (25 January 1893), p. 10

Davis 1894
R. H. Davis, 'The Streets of Paris', *Harper's New Monthly Magazine*, 89, no. 533 (October 1894), pp. 701–12

Davis 1895
R. H. Davis, *About Paris*, New York 1895

De Veer 1977
E. de Veer, 'Willard Metcalf's *The Ten Cent Breakfast*', *Nineteenth Century*, 3 (winter 1977), pp. 51–3

De Veer 1987
E. de Veer and R. J. Boyle, *Sunlight and Shadow: The Life and Art of Willard L. Metcalf*, New York 1987

Delouche 1977
D. Delouche, 'Peintres de la Bretagne: découverte d'une province', thesis, Université de Haute Bretagne, Rennes 1975; Paris 1977

Delouche 1986
Pont-Aven et ses peintres à propos d'un centenaire, ed. D. Delouche, Rennes 1986

Delouche 1989
Artistes étrangers à Pont-Aven, Concarneau et autres lieux de Bretagne: ouvrage collectif, ed. D. Delouche, Rennes 1989

Dorment 2003
R. Dorment, 'James McNeill Whistler', in J. Wilson-Bareau et al., *Manet and the Sea*, exh. cat., Philadelphia Museum of Art 2003, pp. 187–99

Dorment and MacDonald 1994
R. Dorment and M. F. MacDonald, *James McNeill Whistler*, exh. cat., Tate Gallery, London 1994

Downes 1912
W. H. Downes, 'The Vinton Memorial Exhibition', *Art and Progress*, 3, no. 4 (February 1912), pp. 474–7

Drinker 1955
H. S. Drinker, *The Paintings and Drawings of Cecilia Beaux*, exh. cat., Pennsylvania Academy of the Fine Arts, Philadelphia 1955

Dulles 1965
F. R. Dulles, *A History of Recreation: America Learns to Play*, New York 1965 (second edn)

Dwyer 1999
B. C. Dwyer, *Anna Klumpke: A Turn-of-the-Century Painter and Her World*, Boston 1999

Edwards 1987
L. M. Edwards, 'Noble Domesticity: The Paintings of Thomas Hovenden', *American Art Journal*, 19 (1987), pp. 4–38

Exeter News-Letter 1922
'Elizabeth Jane Gardner Bouguereau', Obituary, *The Exeter News-Letter*, 92, no. 5 (3 February 1922), p. 1

Fairbrother 1981
T. J. Fairbrother, 'John Singer Sargent and America', Ph.D. dissertation, Boston University 1981

Fairbrother 1986
T. J. Fairbrother et al., *The Bostonians: Painters of an Elegant Age, 1870–1930*, exh. cat., Museum of Fine Arts, Boston 1986

Fairbrother 1994
T. J. Fairbrother, *John Singer Sargent*, New York 1994

Fairbrother 2000
T. J. Fairbrother, *John Singer Sargent: The Sensualist*, exh. cat., Seattle Art Museum 2000

Falk 1999
P. H. Falk, ed., *Who Was Who in American Art 1564–1975: 400 Years of Artists in America*, vol. III, Madison, Connecticut, p. 3385

Fehrer 1984
C. Fehrer, 'New Light on the Académie Julian and Its Founder (Rodolphe Julian)', *Gazette des Beaux-Arts*, 103 (1984), pp. 207–16

Fehrer 1989
C. Fehrer, *The Julian Academy, Paris, 1868–1939*, exh. cat., Shepherd Gallery, New York 1989

Ferguson 1978
C. Ferguson, *Dennis Miller Bunker (1861–1890) Rediscovered*, exh. cat., New Britain Museum of American Art, Connecticut 1978

Ferguson 1994
P. Ferguson, *Paris as Revolution: Writing the Nineteenth Century*, Berkeley, California 1994

Fidell-Beaufort 1984
M. Fidell-Beaufort, 'Elizabeth Jane Gardner Bouguereau: A Parisian Artist from New Hampshire', *Archives of American Art Journal*, 24, no. 2 (1984), pp. 2–9

Fink 1970
L. M. Fink, 'The Role of France in American Art, 1850–1870', Ph.D. dissertation, University of Chicago 1970

Fink 1973
L. M. Fink, 'American Artists in France, 1850–1870', *American Art Journal*, 5, no. 2 (November 1973), pp. 32–49

Fink 1990
L. M. Fink, *American Art at the Nineteenth-Century Paris Salons*, Washington, D.C., and Cambridge 1990

Fink 1991
L. M. Fink, 'American Art at the 1889 Paris Exposition. The Paintings They Love To Hate', *American Art* (autumn 1991), pp. 35–53

Fischer 1999
Paris 1900: The 'American School' at the Universal Exposition, ed. D. P. Fischer, exh. cat., Montclair Art Museum, New Jersey 1999

Fleming 1984
S. Fleming, 'The Boston Patrons of Jean-François Millet', in A. R. Murphy, *Jean-François Millet*, exh. cat., Museum of Fine Arts, Boston 1984, pp. ix–xviii

Ford 1893
M. B. Ford, 'American Society in Paris', *Cosmopolitan*, 15 (May 1893), pp. 72–9

Forster-Hahn 2001
F. Forster-Hahn et al., *Spirit of an Age: Nineteenth-Century Paintings from the Nationalgalerie, Berlin*, exh. cat., National Gallery, London 2001

Fort 1988
I. S. Fort, *The Flag Paintings of Childe Hassam*, exh. cat., Los Angeles County Museum of Art 1988

Fosdick 1954
J. W. Fosdick, *Happy Days at Julian's*, Manchester, Maine 1954

Foster 1997
K. A. Foster, *Thomas Eakins Rediscovered: Charles Bregler's Thomas Eakins Collection at the Pennsylvania Academy of the Fine Arts*, Philadelphia and New Haven 1997

Franchi and Weber 1999
P. M. Franchi and B. Weber, *Intimate Revelations: The Art of Carroll Beckwith, 1852–1917*, exh. cat., Berry-Hill Galleries, New York 1999

Frelinghuysen 1993
A. C. Frelinghuysen et al., *Splendid Legacy: The Havemeyer Collection*, exh. cat., Metropolitan Museum of Art, New York 1993

French 1928
M. French, *Memories of a Sculptor's Wife*, Boston 1928

***From Realism to Symbolism* 1971**
From Realism to Symbolism: Whistler and His World, exh. cat., Columbia University, New York 1971

Gallati 1995
B. D. Gallati, *William Merritt Chase*, New York 1995

Gallati 1999
B. D. Gallati, *William Merritt Chase: Modern American Landscapes, 1886–1890*, exh. cat., Brooklyn Museum of Art, New York 1999

Gallati 2004
B. D. Gallati, *Great Expectations: John Singer Sargent Painting Children*, exh. cat., Brooklyn Museum, New York 2004

Gammell 1953
R. H. I. Gammell, *Dennis Miller Bunker*, New York 1953

Gandell 1997
S. Gandell, 'From Femme Fatale to Floradora: The Transformation of the Decadent in American Art Nouveau', paper presented at the College Art Association 85th Annual Conference, New York, 12–15 February 1997

Garb 1994
T. Garb, *Sisters of the Brush: Women's Artistic Culture in Late Nineteenth-Century Paris*, New Haven and London 1994

Gerdts 1984
W. H. Gerdts, *American Impressionism*, New York 1984 (second edn 2001)

Gerdts 1990
W. H. Gerdts et al., *Ten American Painters*, exh. cat., Spanierman Gallery, New York 1990

Gerdts 1992
W. H. Gerdts et al., *Lasting Impressions: American Painters in France 1865–1915*, exh. cat., Terra Foundation for the Arts, Evanston, Illinois 1992

Gerdts 1993
W. H. Gerdts, *Monet's Giverny: An Impressionist Colony*, New York 1993

Goley 1976
M. A. Goley, *John White Alexander (1856–1915)*, exh. cat., National Collection of Fine Arts, Smithsonian Institution, Washington, D.C. 1976

Goncourt 1989
E. and J. de Goncourt, *Journal. Mémoires de la vie littéraire III, 1887–1896*, Paris 1989

Goodrich 1982
L. Goodrich, *Thomas Eakins*, 2 vols, Cambridge, Massachusetts 1982

Goodyear and Bailey 1974
F. H. Goodyear and E. Bailey, *Cecilia Beaux: Portrait of an Artist*, exh. cat., Pennsylvania Academy of the Fine Arts, Philadelphia 1974

Gopnik 2000
A. Gopnik, *Paris to the Moon*, New York 2000

Gopnik 2004a
A. Gopnik, *Americans in Paris: A Literary Anthology*, New York 2004

Gopnik 2004b
A. Gopnik, 'Americans in Paris', *The American Scholar*, 73, no. 2 (spring 2004), pp. 13–30

Gorman 1979
J. H. Gorman, *Jefferson David Chalfant, 1856–1931*, exh. cat., Brandywine River Museum, Chadds Ford, Pennsylvania 1979

Gourmont 1894
R. de Gourmont, *Proses moroses*, Paris 1894

Gourmont 1900
R. de Gourmont, 'Die Internationale Kunst in Paris. Notizen aus dem Grand Palais der Weltausstellung', *Wiener Rundschau* (August–September 1900), pp. 285–8, 301–5

Gourvennec 1990
J.-C. P. Gourvennec, *Un Journal Américain a Paris: James Gordon Bennett et le New York Herald 1887–1918*, exh. cat., Musée d'Orsay, Paris 1990

Grant 1983
S. Grant, 'American Paintings Acquired by the French Government, 1879–1900', M.A. essay, George Washington University, Washington, D.C. 1983

Grant 1992
S. Grant, 'Whistler's Mother Was Not Alone: French Government Acquisitions of American Paintings, 1871–1900', *Archives of American Art Journal*, 32, no. 2 (1992), pp. 2–15

Grant 1997
S. Grant, *Paris: A Guide to Archival Sources for American Art History*, Archives of American Art, Smithsonian Institution, Washington, D.C. 1997

Greta 1887a
Greta, 'Art in Boston', *Art Amateur*, 16 (January 1887), p. 28

Greta 1887b
Greta, 'Boston Art and Artists', *Art Amateur*, 17 (17 October 1887), p. 93

Gunnarsson 2000
T. Gunnarsson et al., *The Painters in Grez-sur-Loing*, exh. cat., Yomiuri Shimbunsha and Japan Association of Art Museums, Tokyo 2000

Hale 1957
J. D. Hale, 'The Life and Creative Development of John H. Twachtman', 2 vols, Ph.D. dissertation, Ohio State University, Columbus 1957

Harris 1979
M. H. Harris, *Loïe Fuller: Magician of Light*, exh. cat., Virginia Museum of Fine Arts, Richmond 1979

Harrison 1893
B. L. Harrison, 'In Search of Paradise with Camera and Palette', *Outing*, 21 (January 1893), pp. 310–16

Harrison 1916
B. L. Harrison, 'With Stevenson at Grez', *Century Magazine*, 93 (December 1916), pp. 306–14

Hartigan 1985
L. R. Hartigan, *Sharing Traditions: Five Black Artists in Nineteenth-Century America*, exh. cat., National Museum of American Art, Smithsonian Institution, Washington, D.C. 1985

Hatrick 1939
A. Hatrick, *A Painter's Pilgrimage through 50 Years*, Cambridge 1939

Havemeyer 1961, 1993
L. W. Havemeyer, *Sixteen to Sixty: Memoirs of a Collector*, New York 1961; ed. S. A. Stein, 1993

Healy 1894
G. P. A. Healy, *Reminiscences of a Portrait Painter*, Chicago 1894

Hendricks 1979
G. Hendricks, *The Life and Work of Winslow Homer*, New York 1979

Herbert 1970
R. L. Herbert, 'City vs. Country: The Rural Image in French Painting from Millet to Gauguin', *Artforum*, 8 (1970), pp. 44–55

Herlin 2002
D. Herlin, 'Genèse et création de Pelléas et Mélisande', *Revue Musicale de Suisse Romande*, 55 (June 2002), www.rmsr.ch/articles/2002-2/herlin.htm

Hibbard 1980
H. Hibbard, *The Metropolitan Museum of Art, New York*, London and Boston 1980

Hiesinger 1991
U. W. Hiesinger, *Impressionism in America: The Ten American Painters*, exh. cat., Jordan-Volpe Gallery, New York 1991

Hiesinger 1994, 1999
U. W. Hiesinger, *Childe Hassam: American Impressionist*, exh. cat., Jordan Volpe Gallery, New York 1994; second edn Munich 1999

Hiesinger 1998
U. W. Hiesinger, *Julius LeBlanc Stewart: American Painter of the Belle Epoque*, exh. cat., Vance Jordan Fine Art, New York 1998

Hill 1986
M. B. Hill, 'The Early Career of Robert William Vonnoh', *Antiques*, 130 (November 1986), pp. 1014–23

Hill 1987
M. B. Hill, *Grez Days: Robert Vonnoh in France*, exh. cat., Berry-Hill Galleries, New York 1987

Hills 1986
P. Hills et al., *John Singer Sargent*, exh. cat., Whitney Museum of American Art, New York 1986

Hirshler 1994
E. E. Hirshler, *Dennis Miller Bunker: American Impressionist*, exh. cat, Museum of Fine Arts, Boston 1994

Hirshler 1995
E. E. Hirshler, *Dennis Miller Bunker and His Circle*, exh. cat., Isabella Stewart Gardner Museum, Boston 1995

Hirshler 2001
E. E. Hirshler, *A Studio of Her Own: Women Artists in Boston 1870–1940*, exh. cat., Museum of Fine Arts, Boston 2001

Hirshler 2005
E. E. Hirshler, *Impressionism Abroad: Boston and French Painting*, exh. cat., Royal Academy of Arts, London 2005

Hoopes 1979
D. F. Hoopes, *Childe Hassam*, New York 1979

Hoppin and Adams 1979
M. Hoppin and H. Adams, *William Morris Hunt: A Memorial Exhibition*, exh. cat., Museum of Fine Arts, Boston 1979

Hoschedé 1960
J.-P. Hoschedé, 'Les Amis de Claude Monet à Giverny', in *Claude Monet: Ce Malconnu*, 2 vols, Geneva 1960, vol. 1, pp. 99–105

Howard 1884
B. W. Howard, *Guenn: A Wave on the Breton Coast*, Boston and London 1884

Howe and Torrey 1894
W. Howe and G. Torrey, 'Some Living American Painters. Conversations by Howe and Torrey. Third Paper', *Art Interchange*, 32 (June 1894), pp. 164–7

Hughes n.d.
L. G. Hughes, 'Thomas Appleton', www.uua.org/uuhs/duub/articles/thomasappleton.html

Ingram 1905
Who's Who in Paris: Anglo-American Colony, ed.
W. H. Ingram, Paris 1905

***International Studio* 1923**
'Vonnoh's Half Century', *International Studio*, 77
(June 1923), pp. 229–33

Ives 1892
A. E. Ives, 'Talks with Artists: Mr. Childe Hassam
on Painting Street Scenes', *Art Amateur*,
27 (October 1892), pp. 116–17

Jacobs 1985
M. Jacobs, *The Good and Simple Life: Artist
Colonies in Europe and America*, London 1985

James 1884
H. James, *A Little Tour in France*, Boston 1884
(second edn 1900)

James 1887
H. James, 'John Singer Sargent', *Harper's New
Monthly Magazine*, 75 (October 1887), pp. 683–91
(repr. with emendations in *Picture and Text* [1893];
the latter version repr. in *The Painter's Eye: Notes
and Essays on the Pictorial Arts by Henry James*,
ed. J. L. Sweeney, London 1956, pp. 216–28)

James 1920
H. James, *Letters of Henry James*, ed. P. Lubbock,
New York 1920

James 1956
H. James, *The Painter's Eye: Notes and Essays on
the Pictorial Arts by Henry James*, ed. J. L. Sweeney,
London 1956

James 1999
Henry James: A Life in Letters, ed. Philip Horne,
London 1999

Johns 1983
E. Johns, *Thomas Eakins: The Heroism of Modern
Life*, Princeton 1983

Johnston 1973
S. Johnston, *Theodore Robinson, 1852–1896*,
exh. cat., Baltimore Museum of Art 1973

Johnston 2004
S. Johnston, *In Monet's Light: Theodore Robinson
at Giverny*, exh. cat., Baltimore Museum of Art
2004

Joyner 1982
S. Joyner, 'Julius L. Stewart: Life and Work',
M.A. thesis, Hunter College, City University of
New York 1982

Junkin 1986
S. C. Junkin, 'The Europeanization of Henry Bacon
(1839–1912), American Expatriate Painter', Ph.D.
dissertation, Boston University 1986

Kellogg 1902
A. W. Kellogg, 'The Charles River Valley', *New
England Magazine*, n.s. 26 (August 1902),
pp. 645–66

Kelly 1996
F. Kelly et al., *American Paintings of the Nineteenth
Century, Part I*, National Gallery of Art,
Washington, D.C. 1996

Kettlewell 1981
J. K. Kettlewell, *The Hyde Collection Catalogue*,
Glens Falls, New York 1981

Keyzer 1898
F. Keyzer, 'Some American Artists in Paris',
International Studio, 4 (1898), pp. 246–52

Kilmurray and Ormond 1998a
John Singer Sargent, eds E. Kilmurray and R.
Ormond, exh. cat., Tate Gallery, London 1998

Kilmurray and Ormond 1998b
E. Kilmurray and R. Ormond, 'Sargent in Paris',
Apollo, 148 (September 1998), pp. 13–22

Klumpke 1908
A. E. Klumpke, *Rosa Bonheur, Sa Vie, Son Oeuvre*,
Paris 1908

Klumpke 1940
A. E. Klumpke, *Memoirs of an Artist*, ed. Lilian
Whiting, Boston 1940

Knowlton 1899
H. Knowlton, *Art-life of William Morris Hunt*,
Boston 1899

Kornhauser 1996
E. M. Kornhauser, *American Paintings Before 1845
in the Wadsworth Atheneum*, 2 vols, Hartford,
New Haven and London 1996

Kysela 1964
J. D. Kysela, 'Sara Hallowell Brings "Modern Art"
to the Midwest', *The Art Quarterly*, 27, no. 2
(1964), pp. 150–67

Lacambre and Rohan-Chabot 1974
G. Lacambre and J. de Rohan-Chabot, *Le Musée du
Luxembourg en 1874*, exh. cat., Grand Palais, Paris
1974

Langdale 1975
C. Langdale, *Charles Conder, Robert Henri, James Morrice, Maurice Prendergast: The Formative Years, Paris 1890s*, exh. cat., Davis & Long Company, New York 1975

Larkin 1990
S. G. Larkin, *On Home Ground: Elmer Livingston Mac Rae at the Holley House*, exh. cat., Historical Society of the Town of Greenwich and the Bruce Museum, Greenwich, Connecticut 1990

Larkin 1996
S. G. Larkin, '"A Regular Rendezvous for Impressionists": The Cos Cob Art Colony 1882–1920', Ph.D. dissertation, City University of New York, 1996

Larkin 2001
S. G. Larkin, *The Cos Cob Art Colony: Impressionists on the Connecticut Shore*, exh. cat., National Academy of Design, New York 2001

Le Voyage de Paris 1990
Le Voyage de Paris: Les Américains dans les écoles d'art, 1868–1918, exh. cat., Musée National de la Coopération Franco-Américaine, Château de Blérancourt, Paris 1990

Leach 1993
W. Leach, *Land of Desire: Merchants, Power, and the Rise of a New American Culture*, New York 1993

Leader 1980
B. K. Leader, 'The Boston Lady as a Work of Art', Ph.D. dissertation, Columbia University, New York 1980

Leader 1982
B. K. Leader, 'Antifeminism in the Paintings of the Boston School', *Arts Magazine*, 56 (January 1982), pp. 112–19

Lee 1937
Vernon Lee's Letters, London 1937

Leff 1980
S. Leff, *John White Alexander 1815–1915: Fin-de-Siècle American*, exh. cat., Graham Gallery, New York 1980

Leininger 1992
T. Leininger, 'The Transatlantic Tradition: African American Artists in Paris, 1830–1940' in *Paris Connections: African American Artists in Paris*, exh. cat., Bomani Gallery, San Francisco 1992, pp. 9–22

Lindsay 1985
S. G. Lindsay, *Mary Cassatt and Philadelphia*, exh. cat., Philadelphia Museum of Art 1985

Lochnan 2004
K. Lochnan et al., *TurnerWhistlerMonet*, exh. cat., Tate Britain, London 2004

Lomax and Ormond 1979
J. Lomax and R. Ormond, *John Singer Sargent and the Edwardian Age*, exh. cat., Leeds Art Galleries 1979

Longfellow 1922
E. W. Longfellow, *Random Memories*, Boston 1922

Longstreet 1972
S. Longstreet, *We All Went to Paris: Americans in the City of Light: 1776–1971*, New York 1972

Lorrain 1889
J. Lorrain, 'Chronique de Paris. Portraits de femmes. – Coins de l'Exposition', *L'Evénement* (13 September 1889)

Lorrain 1898
J. Lorrain, 'Pall-Mall Semaine. Promenades et visites. Le Peintre de Léon XIII', *Le Journal*, 16 (October 1898)

Lostalot 1885
A. de Lostalot, 'Exposition internationale de peinture', *Gazette des Beaux-Arts*, 31 (June 1885), pp. 529–32

Love 1985
R. H. Love, *Theodore Earl Butler: Emergence from Monet's Shadow*, Chicago 1985

Low 1908
W. H. Low, *A Chronicle of Friendships, 1873–1900*, New York 1908

Lübbren 2001
N. Lübbren, *Rural Artists' Colonies in Europe, 1870–1910*, Manchester 2001

Lublin 1993
M. Lublin, *A Rare Elegance: The Paintings of Charles Sprague Pearce (1851–1914)*, exh. cat., Jordan-Volpe Gallery, New York 1993

MacDonald 1995
M. F. MacDonald, *James McNeill Whistler: Drawings, Pastels, and Watercolours: A Catalogue Raisonné*, New Haven 1995